CARNEGIE INTERNATIONAL 2004–5
CARNEGIE MUSEUM OF ART, PITTSBURGH
LAURA HOPTMAN, CURATOR

54TH CARNEGIE INTERNATIONAL
OCTOBER 9, 2004–MARCH 20, 2005

ISBN 0-88039-044-1
ISSN 1084-4341

© 2004 Carnegie Museum of Art, Carnegie Institute.
All rights reserved.

Carnegie Museum of Art
4400 Forbes Avenue
Pittsburgh, Pennsylvania 15213-4080
www.cmoa.org

Arlene Sanderson, Head of Publications
Ian Finch, Publications Associate
Heather Domencic, Coordinator of Rights
and Reproductions

Editor: Michelle Piranio
Proofreader: Sharon Vonasch
Design: Graphic Thought Facility, London
Production: Martin Lee Associates, London
Printing: Mondadori Printing, Italy

Typeface: ITC Century Book,
Carnegie Grot, and Rundfunk Grotesk
Paper: Fedrigoni Aquarello Blanco
and Fedrigoni Freelife Satin

The paper used in this publication meets
the minimum requirements of the American
National Standard for Information Sciences—
Permanence of Paper for Printed
Library Materials, ANSI Z39.48-1984.

54th Carnegie International

Laura Hoptman, *Curator*

Elizabeth Thomas, *Assistant Curator*
Sarah Hromack, *Curatorial Assistant*
Elizabeth A. T. Smith, *Co-curator for Lee Bontecou*
Branka Stipančić, *Co-curator for Mangelos*

Advisory Committee

Francesco Bonami
Gary Garrels
Midori Matsui
Cuauhtémoc Medina
Rirkrit Tiravanija

Carnegie Prize Jury of Award

Richard Armstrong, *Pittsburgh*
Francesco Bonami, *Chicago*
Gary Garrels, *New York*
Jane Haskell, *Pittsburgh*
Midori Matsui, *Tokyo*
Cuauhtémoc Medina, *Mexico City*
Alexander C. Speyer III, *Pittsburgh*
Rirkrit Tiravanija, *New York*

Major support for the 54th *Carnegie International* has been
provided by the A. W. Mellon Educational and Charitable Trust Fund and
The Henry L. Hillman Fund. Additional generous gifts and grants have
been provided by Friends of the *Carnegie International*; Commonwealth of
Pennsylvania, Department of Community and Economic Development;
Mr. and Mrs. Stanley R. Gumberg; Kraus Family Foundation; National City;
The Andy Warhol Foundation for the Visual Arts; Sheila and Milt Fine;
and The Pittsburgh Foundation.

Major gifts have also been provided by The Grable Foundation; The National
Endowment for the Arts; the LLWW Foundation; the Woodmere Foundation;
and The Juliet Lea Hillman Simonds Foundation, Inc.

Additional support has been provided by TIAA-CREF; Pro Helvetia;
The Arts Council of Switzerland; The Trust for Mutual Understanding;
The Japan Foundation; The British Council; The MAT Charitable
Foundation, Inc.; American-Scandinavian Foundation; David Teiger;
Staley Communications; and the Embassy of the Republic of Poland.

Contents

Foreword

Political crises change the contexts that so color our
understanding of art. Given the dire turn of events of the recent past,
Andrew Carnegie's wish that this exhibition "spread goodwill among nations
through the international language of art" seems at once more relevant,
prescient, and poignant than ever. The changing world, particularly
Americans' understanding of their role in it, has set a different stage for
this *Carnegie International*—the fifty-fourth in a series begun in 1896.
Though the need for salon exhibitions of contemporary art has diminished
since then, the worldwide appetite for new art has increased many times
over—as evidenced by the amazing (and I would say welcome) proliferation
of annual, biennial, and triennial survey exhibitions around the globe.
Many more people than ever before seek communication through art as
a common language. May goodwill result.

Besides its unparalleled longevity, the *Carnegie International* is
unique for being located within a museum and molded by the hands of a
single curator working with advisors. Curator Laura Hoptman has been
particularly well served by the exhibition's advisory committee,
and I share her gratitude toward them. Her own empathy for artists and
her well-formed ideas for this exhibition have distinguished the three years
of its assembly, and I am confident that it will be seen widely and quickly
as among the best survey shows of its kind in recent history.
Her willingness—insistence, really—to probe through art the central
ethical issues of life distinguishes the exhibition. The members of
the museum's Board join me in saluting her for such an exceptional and
successful effort. Her coworkers are also to be congratulated, and similarly,
we cite with gratitude the generosity of so many lenders and
donors who have supported the project.

A carefully pondered exhibition such as this represents a widespread,
sustained labor; the hope is that from its epiphanies comes a clearer
understanding of the aesthetic impulses and achievements of our moment.
The essential catalysts in these reactions are the artists, and our responses
to their work must be no less forceful than their ambitions for it.
We acknowledge them as visionaries as well as arbiters.

Richard Armstrong
The Henry J. Heinz II Director

Acknowledgments

The *Carnegie International* is an ambitious project, and one
that gathers support from many sources and interests in Pittsburgh
and worldwide. The ongoing support of the A.W. Mellon Educational and
Charitable Trust Fund and The Henry L. Hillman Fund enables Carnegie
Museum of Art to undertake this exhibition. We are grateful to the
Commonwealth of Pennsylvania, Department of Community and Economic
Development; Mr. and Mrs. Stanley R. Gumberg; the Kraus Family
Foundation; National City; The Andy Warhol Foundation for the Visual Arts;
Sheila and Milt Fine; and The Pittsburgh Foundation for taking the lead
with major funding for the show. We are also grateful to The Grable
Foundation; The National Endowment for the Arts; the LLWW Foundation;
the Woodmere Foundation; and The Juliet Lea Hillman Simonds
Foundation, Inc., for generous support.

Among our many friends and generous supporters,
Jill and Peter Kraus and Sheila and Milt Fine must be singled out for
their dedication to the exhibition. As co-chairs of the Friends of the
Carnegie International, they have assembled a group of more than thirty
contemporary art aficionados and collectors from all over the world who
have graciously helped in the realization of this exhibition;
the Friends are listed elsewhere.

The *International* is a team effort that includes, at one time or
another, the entire staff of Carnegie Museum of Art. Thanks must go first
to Richard Armstrong, The Henry J. Heinz II director, curator of the
1995 *Carnegie International*, and a true believer in this triennial exercise.
His curatorial know-how, diplomacy, compassion, and love of everything
having to do with art and artists have created a close-to-perfect climate
for an exhibition of this scope. Alongside Richard, Marcia Gumberg,
chair of Carnegie Museum of Art's Board, has been a wise ally, guiding
the 2004–5 *International* from its inception. Making visions a reality
is the purview of Maureen Rolla, assistant director; without her careful
administration, this exhibition could not have come to fruition.
She was ably assisted in this effort by Champ Knecht.

Under the direction of Christopher Rauhoff, the coordination
of Kristen Roddy, and the supervision of Frank Pietrusinski and Ray
Sokolowski, the exhibitions department staff, consisting of Chris Craychee,
Jim Dugas, Cara Erskine, Lauren Friedman, Andy Halapin, James Hawk,
Dale Luce, Dan Pickering, Erin Pischke, Jason Sorvari, and Tom Weinrich,
was responsible for making the exhibition physically possible. They,
along with Gordon Nelson, technology consultant, deserve our thanks
for the care they have taken toward the exemplary execution of all
aspects of the show's installation.

Led by Monika Tomko, the registrars office, including Allison Revello,
Heather Kowalski, and Elizabeth Hansen, professionally organized the
complex shipping arrangements. The museum's conservators, Ellen Baxter
and Rhonda Wozniak, took excellent care of the objects in the show.

Marilyn Russell, curator and chair of the education department,
along with Emily Gaines Buchler, Lucy Stewart, and the entire education
department staff, created and implemented first-rate programs to
engage visitors to the exhibition. Thanks are due also to the dedicated
publications staff, Arlene Sanderson, Ian Finch, and Heather Domencic,
who guided the catalogue and all the attendant printed matter to completion.
Michelle Piriano was the talented editor of the catalogue, and Sharon
Vonasch was the discerning proofreader. Translation services were provided
by Michael Gilson for Jean-Pierre Mercier's essay on Robert Crumb and
by Maja Šoljan for Branka Stipančić's essay on Mangelos.

Thanks also to Meg Bernard, director of development, along with
Julia Wozniak and Juniper Leherissey, for their diligence in securing funding,
and to marketing director Marnie Conley, assisted by Mark Bertolet, and
the media relations staff, Robin Dannahower and Tey Stiteler. Mark Leach
and Jerry Farber were responsible for product development and catalogue
sales in the museum's store. The New York firm of Livet Reichart, Anne
Livet principal, served as our New York public relations consultant.

For their collegial support during this three-year process,
my deep appreciation goes to the museum's curatorial staff: chief curator
Sarah Nichols, along with Elisabeth Agro, Linda Batis, Lulu Lippincott,
Tracy Myers, and Raymund Ryan. Clodagh Keogh, Jyeong Yeon (Janice) Kim,
and Evan Neu were our able interns. At the Andy Warhol Museum,
thanks go to Tom Sokolowski, director, and to Matthew Wrbican, archivist
extraordinaire, who gave generously of his time. Ed Bucholtz aided as
well with his impressive knowledge of music and performance.

The Women's Committee of Carnegie Museum of Art, specifically
Gail Murphy, chair, Peggy McKnight, gala chair, and Deborah Dick,
co-chair, worked tirelessly to plan a memorable opening, and they
have our sincere gratitude.

The group who worked most closely on the project consists of
our architectural, design, and curatorial collaborators, my advisors, and
the staff of the contemporary art department. Michael Maltzan and his
associates Thomas Goffigon and Steven Lee of Michael Maltzan Architects
made exhibition design a joy; their creativity, elegance, and sensitivity
to the art is unsurpassed, and it was a privilege to collaborate with them.

London-based Graphic Thought Facility (GTF) designers
Andrew Stevens and Huw Morgan, along with Roland Brauchli, were
equally brilliant collaborators. Their innovative mark, signage, and opulent
catalogue design have given the exhibition just the right contemporary
edge and electric energy. Brett Yasko ably executed graphic design
projects in Pittsburgh.

Organizations, colleagues, and friends from all over the world who, over the course of three years of research and preparation, have generously supported this exhibition by giving of their resources, time, and expertise are listed below.

Bruce Altshuler
American-Scandinavian
Foundation
Andrew Arnot
Fernanda Arruda
The Arts Council of Switzerland
Uthit Atimana
Claire Barclay
Nada Beroš
Shoshana Blank
Holly Block
Detmar Blow
Timothy Blum
Karla Boos
Jiesław Borowski
Nathalie Boutin
The British Council
Eric Brown
Gavin Brown
Bruno Brunnet
Donald Bryant
Daniel Buchholz
Adam Budak
Chana Budgazad
Sabrina Buell
Ralph Burnet
Constance Butler
Dan Cameron
The Constance
R.Caplan Foundation
Chen Yan
Angela Choon
Michael Clifton
Bellatrix Cochran-Hubert
Sadie Coles
David Conrad
Lynne Cooke
Lisa Grasioso Corrin
Manuel da Costa Cabral
Chantal Crousel
Aline Kominsky-Crumb
Amada Cruz
Pauline Daly
Karen Daubmann
Frank del Deo
Vishakha Desai

I have been fortunate to have the support of three curatorial colleagues who generously collaborated on sections of the exhibition and made major contributions to the catalogue. Elizabeth Smith, James W. Alsdorf Chief Curator of the Museum of Contemporary Art in Chicago, co-organized the section of the show that features the newest work of Lee Bontecou. The art historian Branka Stipančić co-organized our small retrospective of the work of Mangelos. Both are acknowledged worldwide as experts on their respective artists, and their generosity with that expertise shows in the quality of the exhibitions. Elizabeth and Branka contributed important essays to the catalogue, as did Jean-Pierre Mercier, curator at the Musée des Bandes Dessinées in Angoulême, France. A scholar of all things comics, Jean-Pierre also gave important advice on the creation of the Crumb portion of the show.

Those lenders, public and private, who made these three monographic exhibitions possible, and those who have lent work to the exhibition are listed elsewhere, but Carnegie Museum of Art thanks them all for their help in allowing us to ambitiously expand the purview of the *International*.

The appointment of an advisory board comprising esteemed experts in the field of contemporary art who guide the curator through the exhibition-making process is a valued and time-honored tradition of the *International*. I am deeply indebted to five colleagues who have been active participants in the development of the exhibition and catalogue, sagacious critics of the process of creation, intellectual guides, hosts, and most of all, friends: Francesco Bonami, Manilow Senior Curator at Chicago's Museum of Contemporary Art; Gary Garrels, chief curator in the Department of Drawings at the Museum of Modern Art, New York; Midori Matsui, critic, scholar, and faculty member at Japan's Tama and Musashino Art universities; Cuauhtémoc Medina, professor at the National University of Mexico, Mexico City, and associate curator of Latin American Art at Tate Modern, London; and Rirkrit Tiravanija, perhaps the most important artist of his generation. These individuals have over the past three years given their time, their cherished opinions, and their support. They have added immeasurably to this exhibition and publication. Also to be mentioned here with love and respect is Verne Dawson, my *hors concours* advisor for the exhibition as well as for most everything else.

Most important, I would like to acknowledge Elizabeth Thomas, assistant curator of contemporary art, and Sarah Hromack, curatorial assistant, with whom I have worked most closely to organize this *International*. They gave freely of their physical and emotional strength as well as their keen intelligence. Their input has been vast and their dedication impressive, and I thank them wholeheartedly.

In the end, of course, it is the artists who make the exhibition, and the thirty-seven living artists whose work is on display in the 2004–5 *International* have our collective thanks for their close collaboration on this show. It is their *International*, and we are profoundly grateful to them.

Laura Hoptman
Curator, Contemporary Art

Joanna Diem
Corinna Durland
Embassy of
the Republic of Poland
Thomas Erben
Russell Fergusen
João Fernandes
Cheryl Finley
Peter Fonda
Katharina Forero
Mark Francis
Ann Freedman
Peter Freeman
Stephen Friedman
Sharon Gallagher
Gridthiya Jeab Gaweewong
Massimiliano Gioni
John Giorno
Cavas Gobai
Thelma Golden
Marian Goodman
Shannon Goodwin
Cornelia Grassi
Juliet Gray
Carol Greene
Madeleine Grynsztejn
Gu Zhenqing
Karin Guenther
Cristina Guerra
Solène Guillier
Ina and Lawrence Gumberg
David Hammons
John Hanhardt
Yuko Hasegawa
Christian Haye
Lorenz Helbling
Göran Hellström
Dave Hickey
Matthew Higgs
Mats Hjelm
Motoaki Hori
Chrissie Iles
Zon Ito
The Japan Foundation
Maaretta Jaukkuri
Yoshinori Kanada
Ellen Weiss Kander
Casey Kaplan
Magnus Karlsson
Anton Kern
Emily King
Martin Klosterfelde
Kimiyoshi Kodama
Irmeli Kokko
Atsuko Koyanagi

Wojciech Krukowski
Erkki Kurenniemi
José Kuri
Carl Kurlander
Rachel Lehmann
Kamin Lertchaiprasert
Jay Levenson
James Lingwood
Lu Jie
Gerd Harry Lybke
Michael Lynne
Eve MacSweeney
Frank de Maegd
Meg Maggio
Monica Manzutto
Matthew Marks
Patricia Martín
The MAT
Charitable Foundation, Inc.
David Maupin
Molly McIver
Victoria Miro
Laura Mitterand
Jorge Molder
Michael Morris
Paul Morris
Maria Morzuch
Christopher Müller
Alexandra Munroe
Takashi Murakami
Tim Neuger
Jockum Nordstrum
Hans Ulrich Obrist
Santo Oshima
Kay Pallister
Franklin Parrasch
Ann Philbin
Francesca Pietropaolo
Jeffrey Poe
Tom Poole
Apinan Poshyananda
Eva Presenhuber
Pro Helvetia
Ute Proellochs
Maria Ramos
Sheri Ranis
Andrew Richards
Burkhard Riemschneider
Marcus Rischgasser
Gabriel Ritter
Ann Rorimer
Hilary Rubenstein
Yuko Sakata
Jerry Saltz
Magda Sawon

Itala Schmelz
Alissa Schoenfeld
Hanna Schouwink
Marketta Seppälä
Stuart Shave
Rebecca Shulman
Sigurjon Sighvatsson
João Silvério
Matthew Slotover
Terry Smith
Salome Sommer
Lisa Spellman
Darthea Speyer
Mari Spirito
Staley Communications
Rebecca and Alexander Stewart
Ali Subotnik
Sutthirat Supaparinya
Niklas Svennung
Andrzej Szewczyk
Aneta Szylak
Miwako Takeda
Clay Tarica
Victor Zamudio Taylor
David Teiger
Barbara Thumm
TIAA-CREF
Philip Tinari
Vicente Todoli
Lillian Tone
The Trust for
Mutual Understanding
Stephen Uhlhorn
Jeffrey Uslip
Heather Vallone
Tricia Van Eck
Gordon Veneklausen
Nathalie Viot
Ralph Vituccio
Joel Wachs
Dianne Wallace
Gen Watanabe
Toby Webster
Ziba and Pierre de Weck
Daniel Weinberg
Glenn Scott Wright
Hanna Wróblewska
Yuko Yamamoto
Meo Yipintsoi
Donald Young
Lynn Zelevansky
Paul Zelevansky
Zhou Hongxiang
Laura Zhou
David Zwirner

Friends of the 54th Carnegie International

Suzy and Jim Broadhurst, *Pittsburgh, Pennsylvania*
James-Keith Brown and Eric Diefenbach, *New York, New York*
Peggy and Kip Condron, *New York, New York*
Henry Cornell, *New York, New York*
Inge and Cees de Bruin, *Wassenaar, The Netherlands*
Rebecca and Martin Eisenberg, *New York, New York*
Katherine Farley and Jerry Speyer, *New York, New York*
Sheila and Milton Fine, *Pittsburgh, Pennsylvania*
Edith H. and James A. Fisher, *Pittsburgh, Pennsylvania*
Marcia and Stanley Gumberg, *Pittsburgh, Pennsylvania*
Elsie and Henry Hillman, *Pittsburgh, Pennsylvania*
Maja Hoffmann and Stanley Buchthal, *Zurich, Switzerland*
Miryam and Bob Knutson, *Pittsburgh, Pennsylvania*
Jill and Peter Kraus, *New York, New York*
Marion Lambert, *Geneva, Switzerland*
Wendy Mackenzie and Sandy Cortesi, *New York, New York*
Ann and Marty McGuinn, *Pittsburgh, Pennsylvania*
Anne W. and John P. McNulty, *Short Hills, New Jersey*
Eric Mindich, *New York, New York*
Brooke and Daniel Neidich, *New York, New York*
Peter Norton, *Santa Monica, California*
Maja Oeri, *Basel, Switzerland*
Idamae and James Rich, *Pittsburgh, Pennsylvania*
Hilary Rubenstein, *New York, New York*
Michael S. Rubinoff, *New York, New York*
Lea Simonds, *Pittsburgh, Pennsylvania*
Teri and Damian Soffer, *Pittsburgh, Pennsylvania*
David Teiger, *Bernardsville, New Jersey*
Corinne Van der Elst and Alexandre van Damme, *Brussels, Belgium*
Ellen and James Walton, *Pittsburgh, Pennsylvania*
Nancy and Milton Washington, *Pittsburgh, Pennsylvania*
Gisela and Konrad M. Weis, *Pittsburgh, Pennsylvania*
Laura-Lee and Robert Woods, Jr., *Los Angeles, California*

15

Lenders

Burt Aaron
Abrams Family Collection
Myrna Aronoff
ARTEAST COLLECTION 2000+,
Moderna Galerija, *Ljubljana*
Dorothy and Martin Bandier
Mrs. Zdravka Bašičević
Mr. Pontus Bonnier
Boros Collection
J.K. Brown and Eric Diefenbach
Mario Bruketa
T. Hall Cannon
Constance R. Caplan
The Frank Cohen Collection
Dallas Museum of Art
Takanori Ebihara
Martin and Rebecca Eisenberg
Dora G. Flash
Peter Freeman, Inc., *New York*
Fukugan Gallery, *Osaka*
Fundação de Serralves,
Museu de Arte Contemporânea,
Porto
Gallery Iskra, *Nagoya*
Tony and Gail Ganz
The Carol and
Arthur Goldberg Collection
Goetz Collection
Heritage Galleries and Auctioneers
Gallery Honjoh, *Tokyo*
Masato Iwata
Mitsuhiro Kaji
Ann Kaplan
Yuzo Kato
Judy Graf Klein
Kodama Gallery, *Osaka*
Christian Larsen
Elizabeth Levine
Jeffrey and Jeanne Levy-Hinte
Scott J. Lorinsky
Miller Meigs Collection
Hisanao Minoura
Moderna Museet, *Stockholm*
Victor Moscoso
Musée national d'art moderne,
Centre Georges Pompidou/Centre
de création industrielle, *Paris*
Museum of Contemporary Art, *Chicago*
Muzej suvremene umjetnosti, *Zagreb*

National Gallery of Art,
Washington, D.C.
Morris Orden
Jeffrey Peabody
Pinakothek der Moderne,
Munich
Mark Pollack
Private Collection (8)
Private Collection, *Aichi*
Private Collection, *Berlin*
Private Collection, *London*
Private Collection, *London*
Private Collection, *New York*
Private Collection, *New York*
Private Collection, *Paris*
Private Collection, *Pittsburgh*
Dr. Ljubomir Radovančević
W. G. Revine
Jill and Dennis Roach
The Judith Rothschild
Foundation Contemporary
Drawings Collection
Eric Sack
Tatsumi Sato
Rudolf Scharpff
Barrie Schwartz
and Patrick Hayne
Judith Schwartz
Yukinari Shimono
Mladen Stilinović
Branka Stipančić
Gayle and Paul Stoffel
Tezukayama Gallery, *Osaka*
UCLA Hammer Museum,
Los Angeles
Joel Wachs
Dianne Wallace
Daniel Weinberg
and Elizabeth Topper
Zacheta National Gallery
of Art, *Warsaw*
Jerry Zolten

The Essential Thirty-eight

Laura Hoptman

*Now we begin to witness the return of traditional philosophy
all over the world, beginning with its hoariest subfields,
such as ethics; can metaphysics be far behind ... if not theology?*
—Fredric Jameson, *A Singular Modernity*

Immanuel Kant defined the unknowable as "whatever is
omnipresent, eternal, or without antecedent cause." Later philosophers
used the catchy shorthand of "the Ultimates" to refer to a series of
interrelated subjects considered unknowable, including the nature of
free will, immortality, the existence of God, and the extent of the universe,
to name a few.[1] However constant in human thought, if not in the daily
newspapers, these questions may be, they have not played a very large role
in the cultural discourse of the past thirty years. As Terry Eagleton has
recently observed, cultural theory "has been shamefaced about love,
biology, religion and revolution, largely silent about evil, reticent about
death and suffering, dogmatic about essences, universals and foundations,
and superficial about truth, objectivity and disinterestedness."
"This," he adds dryly, "on any estimate, is rather a large slice of human
existence to fall down on."[2] It should come as no surprise that, as part
of the cultural ecosystem, the discourse around art, if not contemporary
art itself, has fared no better. Especially in the last ten years, it has
preferred to concentrate on phenomenology over metaphysics, the micro
over the macro, and the anatomy of the real over reality itself and the
human beings living in it.

While decrying the absence of emphasis on these questions,
Eagleton reminds us that the expulsion of the Ultimates from cultural
discussion is a recent phenomenon, dating from the advent of critical theory
in the late 1960s. Lately, however, the siren's call of the observable surface
of things and the gospel of the perpetual slippage of those observations
have become less and less useful as tools for understanding our world.
In art, where grappling with such grand ideas as God, free will, immortality,
and ethics was stock in trade for most of its history, the contemporary
embrace of the prosaic, especially over the past twenty years,
served as a strategy for merging art and life and making art relevant to
a broader, less elite audience. These desiderata have obsessed easily a
century's worth of art-makers, and in some of our most contemporary art,
their achievement stands as both an aesthetic and a political act. For some,
ephemerality, aleatory beauty, and democracy can all be embodied in one
graceful recontextualization of a visually appealing aspect of the everyday.
Though such gestures create an allusive picture, they are meant to be
open allegories—as open as any of the thousands of lovely acts we
execute or come upon in a typical day. Such work might hint at any

1 Louis Menand, *The Metaphysical Club:
A Story of Ideas in America* (New York: Farrar,
Straus and Giroux, 2001), 263.

2 Terry Eagleton, *After Theory*
(New York: Basic Books, 2003), 101–2.

number of larger significances, but what is crucial to its very makeup is the fact that it has no one fixed meaning. And while one cannot have too many poetically open signifiers coming back into our world barely sullied by the artist's hand, it can be argued that different times call for and create different kinds of art. At this moment in the United States, our undeniable taste for the banal does not quash our need for art that is not merely extracted from aspects of the everyday, but rather wholeheartedly participates in it by wrestling with its fundamental mysteries.

The aim of elucidating some sort of meaning from our world retains the musty odor of the Enlightenment, and particularly of a kind of nineteenth-century essentialism,[3] which in Europe and the United States took forms ranging from a smug Social Darwinism to an idealistic pragmatism. While the former trusted in the amoral law of nature to sort out the worthy from the worthless, the latter put forth that belief systems, ethics, and values exist but are the result of neither divine dictate nor natural law. Rather, as American pragmatists such as John Dewey and William James argued, these systems grew in response to human needs and desires. Mercifully mothballed—at least in philosophy—by the end of the Second World War, such anachronistic notions as "universal values"[4] quite rightly cause skepticism today when applied to a cultural topography that now encompasses the entire planet. It is equally understood that it is no more feasible to make generalizations that would fit cultural production from every corner of the earth than it is to exhibit examples of it. However, the idea that these understandings, peculiar to the postmodern period, preclude the admissibility of more profound investigations is equally of a moment—which has passed. Just as the capturing of everyday life within the parameters of art was a strategy (perhaps uninflected) to rejoin culture with the quotidian, so one might argue that artworks that radically engage with what Eagleton has called the "necessities of the human condition"[5] achieve the goal by different but no less effective means. Without succumbing to the local or the anecdotal, the work on display in this *Carnegie International* broadly investigates what it is to be a human being on this earth right now. It does this using a panoply of strategies from empirical observation and scientific deduction to ideological framing to faith and metaphysical speculation, and even mythmaking. And what more appropriate time to do so? As Eagleton notes, "At just the point that we have begun to think small, history has begun to act big."[6]

This said, to characterize the works in this exhibition as united by a theme would be inaccurate. Theme is not the proper term because it connotes content, and the works included in this *International* run the gamut from anime fantasies to monochromatic meditations. But words like *trait* or *tendency* are not much better; this exhibition also cannot be charted in terms of some sort of stylistic thread running throughout, even if there are episodic instances in which a common strategy— formalist abstraction, or a satirical update of Socialist Realism, for example— emerges. The term that most closely describes the interrelationship of the works in the show is *impulse*, because such a word emphasizes *why* rather than how these works came into being. The works in this *International* share an impulse toward the ethical, which in its simplest definition concerns the search for what it is to be human.[7] Although no claim is made to identify a group of ascendant typologies for our contemporary art moment, the exhibition does assert that ethics is the engine that fires some of the most consequential art of the past five years.

The exhibition is divided into a number of different chapters and in a sense can be read as a narrative. It begins on the ground, with Robert Crumb, the epic raconteur of the everyday. For forty years, through a steady stream of underground comic publications, and more recently, books of drawings, Crumb has been both a bard and a witness. If Mr. Natural, the guru-cum-Afghani cab driver from the Bronx, can feel only pity mixed with disdain for the searcher who in desperation begs him for the Answer but cannot seem to formulate a question, Crumb himself has never given up his relentless questioning of the human character or his amazement at the unshakable human quest for enlightenment. Dead-on specific to the perspective of a middle-class American white guy born at mid-twentieth century, Crumb's stories are, more importantly, telling portraits of human weakness, cruelty, and stupidity, and indictments of human indifference, superstition, fear, paranoia, and narrow-mindedness. They can also be ringing huzzahs for human sexuality, solitude, and individuality. Over the years, Crumb has been taken to task for illustrating, so vividly and with such relish, a lexicon of the basest impulses of the human psyche at its most sexually violent, racially ignorant, and virulently misanthropic. It is uncomfortable and sometimes painful to have our ugliness served up to us with such exquisite chiaroscuro cross-hatching, such razor-sharp line drawing, such recognizable caricature. At the same time, Crumb has never shied away from the most important social issues of the past fifty years, and a summary collection of his best-known strips creates an unblinking chronicle of his generation's fruitless search for spiritual enlightenment, social justice, and psychic peace.

Crumb's political affiliations are often hard to discern, although his personal passions are not; they are as peculiar to him as the hangdog features and lanky silhouette of the Robert Crumb character that often appears in his strips. Crumb depicts himself as an outsider, a stranger in the world he observes so keenly, but he actually is an Everyman whose drawings comprise a collective psychological portrait not just of a period of American life but of life writ large. The thousands of drawings, comic books, and illustrations that make up Crumb's oeuvre might be compared to the works of Hieronymus Bosch, Pieter Brueghel the Elder, William Hogarth, or Honoré Daumier because, like those of past masters of genre, they supercede their own timeliness and local reference. Crumb's drawings provide a lexicon for the issues that the artists in this *International* meditate on, from the search for meaning in the drudgery of the everyday to the nature of evil and of love. While Crumb's Nerds muse on the notion of living an ethical life over pie and coffee, his wide-eyed counterculturists—who include hippies, drug addicts, and feminists— search for Utopia in a manifesto, a syringe, or a commune in Canada. Subject matter aside, it is the spirit of Crumb's pursuit—that of a keen social observer who is devastatingly critical but deeply empathetic— that links his work to several artists in this exhibition.

The photographer Saul Fletcher shares Crumb's sense of *Geworfenheit*, the feeling, described by Martin Heidegger, of being a stranger in one's own world. And yet, like Crumb, Fletcher has devoted himself to the study of the world's every human element, creating grand narratives from the smallest details. His unassuming photographs of everyday objects have the precision of a painted still life, a Morandi perhaps, in which shape and color are carefully balanced and calibrated to create an otherworldly stillness, an airless calm undisturbed by human presence. Set one after another, as if each were a tick of a clock, every photo seems to memorialize a moment

that has been forever lost to time. Despite Fletcher's concentration on the profoundly inanimate, there is a very human character to his pale pastel detergent boxes, empty mantels, and mirrored medicine cabinets. Old, neglected, and vulnerable to being cleared away once and for all, they seem quashed and forgotten, like elderly inmates of a rest home, which is, in fact, the location depicted in these works. "Pathetic fallacy" is the term coined by John Ruskin and used by Robert Rosenblum to describe the attribution of qualities of the animate to the inanimate, and in Rosenblum's landmark study on the topic, he identified its origin in the Northern Romantic tradition that stretches from Caspar David Friedrich to Mark Rothko.8 There is an incipient Romanticism in Fletcher's still-life work, and it is most evident in his portraiture. Several, of him alone or with his young son, are narrative tableaux featuring characters ranging from a naked, Christ-like sufferer to a Dickensian hunchback. These dark, small-format pictures with their limited palette of deep black, brown, and gray-pink seem ancient and otherworldly in the manner of spirit photography. Fletcher plays most of the roles, but it would be a mistake to assume that these works aim only for self-analysis; the loneliness, inner turmoil, and spiritual struggle enacted in each picture are as emblematic as his characters. Fletcher's photographs cast him as an archetype from folk or sacred traditions, and he is, in his own way, a soothsayer.

In contrast, filmmakers Oliver Payne and Nick Relph are bards. Like Crumb and Fletcher, they share a certain fascinated horror of a world crammed to overflowing with objects of powerful beauty and devastating banality. If Crumb is, in a sense, an essayist on this subject, and Fletcher a spinner of fables, Payne and Relph are poets of our *jolie-laid* everyday. However, beauty in a film such as *Driftwood* (1999) is not of the twee, lonesome-plastic-bag-in-the-wind variety. Made, not found, with shaky, handheld shots and effects of lighting, focus, and the surface of film itself, as well as the slips and burps of on-the-fly editing, the look of a Payne and Relph video hearkens back to experimental animations of the early 1960s, just as the incantatory spoken-word soundtrack recalls the intense flood of word-pictures in recordings by Beat poets such as Allen Ginsberg.

Kathy Butterly is the only artist in the exhibition whose work could be said to have a morphological connection to Crumb's signature style. A ceramicist, her colorful cartoony and highly ornamental style comes directly from her mentor Robert Arneson, a major contributor, along with Crumb, to the San Francisco funk aesthetic of the 1960s. Butterly's small vessels have anthropomorphic attributes, such as bandy legs and goofy names, that give each work a distinct personality. Anachronistic or deliberately awkward details read like foibles: a vessel with an encephalitic head held up by a neck as thin as a spaghetti noodle elicits sympathy; another with bold and mawkish ornaments, condescension. It is a feat in itself for a pot to radiate such poignancy, and viewing Butterly's creations en masse one cannot help but see them as a kind of community, albeit of oddities. Although clearly not human, these inanimate little objects exhibit human qualities, not in the way a portrait or a straight description does, but rather in the manner of a good caricature, in which the subject's most obvious attributes are exaggerated in a satiric, but playful manner.

Filmmaker Kutlug Ataman is far from the Jeremiah-like Crumb who casts himself as a public witness to society's failings; but with a documentarian's rather than a caricaturist's eye, Ataman has displayed a similar interest in, and sympathy for, subcultural communities. In the forty-channel video installation *Kuba* (2004), he creates a portrait of a town through individual

8 See Robert Rosenblum, *Modern Painting and the Northern Romantic Tradition: Friedrich to Rothko* (New York: Icon, 1977).

interviews with forty inhabitants of a squatter's camp on the outskirts of Istanbul. Unincorporated by the city or state government and barely policed by its authorities, Kuba is a place where thieves, prostitutes, murderers, transvestites, and revolutionaries live by their own rules of cooperation and tolerance. Ataman's interviewing style is straightforward and discreet to the point of invisibility; the subject speaks directly to the camera without interruption. This strategy dispels any aura of objectification and allows the subject of each video a measure of empowerment. The stories told by these individuals describe lives lived in defiance of accepted social, religious, and cultural mores, and they are sometimes lurid, violent, and perverse. However, the cumulative impression of these life testimonies is one of overwhelming idealism. Together, these people have created a model of a free society—in spite of, or perhaps because of, the isolation and wretchedness of their community.

If *Kuba* represents an appreciation of extreme difference as well as an acute (perhaps Crumbian) study of everyday perversity, Robert Breer's animations of the past half-century extract the element of parable from the simplest of human activities and natural occurrences, from a man walking his dog to a leaf falling from a tree. Breer made his first animated film in 1952. Hand-drawn, it married the abstract vocabulary of his concretist paintings of that decade with simply drawn figurative elements whose herky-jerky, quick-cutting rhythms lent them humor, personality, and a jazzy energy. What Breer accomplished with this and subsequent short animated films was to give narrative back to abstraction. Later, in classic films such as *A Man and His Dog Out for Air* (1957), abstraction and figuration merge symphonically: photographs cavort graphically with line drawings, and geometric shapes attain the status of things in the world.

What Goes Up (2003) is the artist's latest work, and in many ways it is classic Breer: the jarringly quick cuts that cause pictures to flash on the screen like subliminal advertisements; the delightful line drawings that wriggle and morph and insistently insert themselves into the frozen tableau of a still photograph; the promiscuous commingling of abstraction and figuration, drawing and photography, photography and film. Although the string of images starts with a childlike drawing of airplanes flying overhead to the ominous whistling of payloads being dropped, subsequent images in this extremely short work offer a succinct summary of the joys of being alive. Images of sexual potency, women, kids, leaves, a barking dog, and red wine zoom past us like a flashback précis of a thousand perfectly lived moments rolled into one four-minute epic. It is fitting that the penultimate image in this film is of a derailed train; it provides a metaphor for the absurdity of the notion that a big, beautiful, well-lived life simply runs out.

The ability of film to recapitulate reality so closely as to be mistaken for it is one inspiration for Pawel Althamer's *Film* (2000/2004), a restaging of a random half hour of daily life. A carefully choreographed scenario with numerous actors playing the roles of people on the street going about their business, the "film" is devoid of drama but nonetheless has an epic quality precisely because of our knowledge that it is being performed. Like Breer, Althamer has an almost visceral appreciation of unremarkable physical acts, such as taking a walk or drinking a cup of coffee; this alone provides enough material to carve out a slice of life for audience delectation. But the fact that he chooses to remake, with much pain and labor, a bit of the world in real time is not only a tour de force of artistic craft akin to the making of a photorealistic painting, but also a gesture of belief in the power

of an individual to re-envision society. Although Althamer does not share Crumb's horror of what he has discovered in his keen study of human veniality, he does partake of the optimism that underlies all social satire— the belief that something can be done about it.

Lee Bontecou began her professional career as an artist about the same time that Crumb began to draw comics, and early on she set the stakes high for her sculpture: "My concern is to build things that express our relation to this country—to other countries—to this world—to other worlds—in terms of myself," she stated in 1963.[9] She did this by developing a unique language, inspired in equal measure by organic forms and mechanical structures. Hovering between abstraction and figuration, her reliefs and freestanding sculptures of the early and mid-1960s, made primarily of rough canvas sections stretched on wire armatures, powerfully expressed the awe and terror of the inexplicable, whether natural or man-made. Bontecou's most recent works are delicate wire and ceramic sculptures in forms that resemble macrocosmic systems such as constellations or microcosmic ones such as insects. They are quite distinct from her dense and lowering earlier objects, but they are linked nonetheless, as they continue to merge the empirical with the transcendental, the scientific with the spiritual.

The thread of figuration—from the viciously dentated voids of the early 1960s to the floral and aquatic forms of the 1960s and 1970s and finally, to the satellite/planetary aspect of her delicate and heroic hanging forms of recent years—courses through Bontecou's entire body of work. But this does not imply that any existent form, man-made or natural, can be identified. A scientist of the unseeable, Bontecou offers up in her sculptures carefully observed specifics as evidence of much larger ends. "My most persistently recurring thought," she has said, "is to work in a scope as far-reaching as possible; to express a feeling of freedom in all its necessary ramifications—its awe, beauty, magnitude, horror and baseness. This feeling embraces ancient, present and future worlds; from caves to jet engines, landscapes to outer space, from visible nature to the inner eye, all encompassed in cohesive works of my inner world."[10] The boldness and contemporaneity of Bontecou's oeuvre lies in this attitude, with its unswerving faith in empirical observation and abstract innovation as tools to explore what Immanuel Kant called "supersensible" ideas such as the shape of the universe or of human thought.

Truth is different from fact, but for the empiricist, the latter is proof of the former. The careful, scientific marshaling of evidence provides the structure for Harun Farocki's trilogy *Eye/Machine* (2001–3), the fruit of a decade of gathering film and television footage documenting some sixty years of electronic surveillance and remote-control assaults on military targets. Exploiting the graphic elegance of the aerial bomber's crosshairs, or the geometric clarity of a target seen from the sky, Farocki's vast catalog of destruction is clinical, computable, and utterly convincing as a warning against the chilling convergence of advanced technology and human belligerence. With one channel of archival footage juxtaposed with another of deadpan commentary, each volume of *Eye/Machine* unfolds with the cool analytical presentation and dry inexorability of a scientific proof. This kind of precision and distancing has caused some to describe Farocki as an engineer more than an artist; but the work's purposeful emotional restraint serves only to make his passionate and partisan message stronger. A product of the European independent film scene of the mid-1960s, which gave the world Jean-Luc Godard, Chris Marker, and other activist filmmakers, Farocki has spent the last thirty years creating films that

9 Bontecou, as quoted by Dorothy Miller in *Nine Americans*, exh. cat. (New York: Museum of Modern Art, 1963), 12.

10 *True Grit: Lee Bontecou, Louise Bourgeois, Jay de Feo, Claire Falkenstein, Nancy Grossman, Louise Nevelson, Nancy Spero*, exh. cat. (New York: Michael Rosenfeld Gallery, 2000), 7.

co-opt the facticity of the filmed image to battle, in his words, "the industrialization of thought" and "the automation of experience." Using the methods of a scientific researcher, he builds a case against the so-called progress of science itself.

Carsten Höller earned a PhD in biology, and he uses his experience as a scientist in his work as an artist, concentrating particularly on the physiological reactions of viewers. His work is often considered under the rubric of what Nicolas Bourriaud has christened "relational aesthetics," meaning artwork that is based in human relationships; but although viewer participation is key to almost all of Höller's sculptures, it is merely a vehicle through which he informally, but carefully, describes the observable elements of human perception and physiological reactions. Closer to scientific experiments than to sensual experiences, most of Höller's works are devoted to the artist's singular obsession with analyzing—chemically—the nature of human emotions. From a series of interactive sculptures designed to produce a sensation of happiness to his most recent work—a garden filled with flowers that exude pheromones capable of inducing feelings of love— Höller takes the logic of empiricism, which states that we can only know what we apprehend through our senses, to its most absurd degree. This said, the artist believes in the use value of his projects, choosing to experiment with love or goodwill instead of more unpleasant states. Less interested in showing "something I did" than in "influencing how people feel," [11] Höller embodies the empiricists' golden rule that "beyond the bare phenomenal facts … there is nothing" [12] by proffering his chemically produced ersatz emotions as interchangeable with those produced chemically in perhaps a more spontaneous fashion.

There is an element of parody in Höller's strict adherence to scientific exactitude when it comes to matters of defining something as mercurial as human emotion, as well as an impulse to hold scientific method as a formal strategy up to scrutiny. As some have argued, radical empiricism in the aesthetic realm eventually manifested itself as the formalist crusade for purity and the search for what came to be known, for a time, as "the absolute." [13] "Science," writes Louis Menand in his recent study of pragmatic philosophy and modernity, "became modern when it was conceived not as an empirical confirmation of truths derived from an independent source, divine revelation, but as simply whatever followed from the pursuit of scientific methods of inquiry. If these methods were scientific, the result must be science." "Even art," he continues, "adopted the same standards in the modern period; it became defined as the realization of the aesthetic potential of the artistic medium. Poetry was talked about as an exploration of the resources of language, painting as a manipulation of canvas and paint, figure and ground." [14]

The "absolute" in critic Clement Greenberg's famous characterization embodied the search for the most concrete and irreducible language of art, which is in and of itself meaningful without having to rely on referential or symbolic associations. No relativities, no contradictions, just the art object in its purest, most abstract state. For midcentury artists in the United States, Europe, and parts of Latin America, this more spiritual reconstitution of the more overtly political aspirations of the Russian Constructivists allowed for an aesthetic expression that was autonomous with "no known physical, visual or mathematical counterpart," [15] as Barnett Newman put it, but nonetheless engaged in the human struggle. "A shape," wrote Newman in 1947, "was a living thing, a … carrier of awesome feelings … felt before the terror of the unknowable." [16]

11 Jessica Morgan, "Interview with Carsten Höller," in *Common Wealth*, exh.cat. (London: Tate Modern, 2003), 75.

12 William James, "Pragmatism" (1907), reprinted in Russell B. Goodman, ed., *Pragmatism: A Contemporary Reader* (New York and London: Routledge, 1995), 72.

13 See Clement Greenberg, *Art and Culture: Critical Essays* (Boston: Beacon Press, 1961, 1989).

14 Menand, *Metaphysical Club*, 432.

15 Barnett Newman, "The Ideographic Picture" (1947), reprinted in Ellen H. Johnson, ed., *American Artists on Art from 1940 to 1980* (New York: Harper & Row, 1980), 17.

16 Ibid., 15.

By the early 1960s, this high-minded notion of art's autonomy gave theoretical justification for a new level of insularity, and in American easel painting in particular, the birth of an art that was purely self-reflexive. Bontecou is of the generation that came to artistic maturity during the period in New York when Abstract Expressionism had begun to share the stage with so-called nonrelational art. Her feat of skirting total nonobjectivity without resorting to narrative represents a break from the enforced abstract purity of the New York School, and the continuing evolution of her work remains a strong example of the possibilities of abstraction to go beyond the more hermetic inquiries into the nature of art.

In a cultural climate in which much art labors to slip by unnoticed amongst the most quotidian objects and activities, the autonomous art object, not to mention an abstract one, immobilized on the white wall of an art museum, hardly seems fertile ground for social engagement. However, it has been argued by philosophers from Karl Marx to Theodor Adorno to Eagleton that art's very disengagement from the vicissitudes of functionality and the minutiae of daily existence allows it to explore, in Eagleton's words, "issues ... of vital concern to humanity as a whole" as well as to raise "ultimate questions, not just pragmatic, parochial ones."[17] Perhaps in reaction both to the aestheticization of the objects of everyday life and to the resurgence of illusionism and narrativity, a new generation of abstractionists have taken up the challenge to create works of art that in their autonomy serve as statements of faith in art's ability to transcend itself.[18] In his recent book on modernity, Fredric Jameson posits that late modernists can only make art that refers to art because modernism already exists,[19] but artists such as Tomma Abts, Mark Grotjahn, and Eva Rothschild are emphatically uninterested in referencing their predecessors. With an exuberance and sense of discovery that belies any obvious affinities to past modernist, or for that matter, postmodernist experiments, their works explore notions of autonomy and the absolute as if for the first time, relishing in impure palettes, quirky geometries, and a love-hate relationship with illusionistic space.

Tomma Abts' paintings are small in scale and somber in color—tightly painted systems of interlocking parts that are not quite biomorphic or geometric. Their swooping curves and vertiginous voids seem to nod to early modernist, post-Cubist styles such as Orphism and Futurism, but they are equally concerned with the creation of space—concavity as well as convexity. Although understated to the point of being dour, Abts' paintings can still punch visual holes in the walls on which they hang, as if they were windows looking onto the surfaces of various faraway planets. They do this in a manner that recalls Picasso's and Braque's analytic Cubism—through juxtaposition of areas of color that are very close in hue. But Abts is not a fourth-generation Cubist; her pictures incorporate *passage*, but also display careful perspectival drawing. Their complex consideration of space notwithstanding, her works are not paintings *of* space, or for that matter, paintings of *objects* in space. Unlike recent abstract painting by her contemporaries, which tends to be *of* something, like a shape or a pattern, Abts' paintings are nonobjective in the most literal sense of the term; they are of nothing that can be found in the visible world.

The traditional vehicle for achieving a nonobjective profundity that supercedes painterly description is the monochrome. Mark Grotjahn's latest works are effulgent and luscious examples of the one-color strategy, although more accurately, each canvas displays a range of chromatic

17 Eagleton, *After Theory*, 98.

18 Fredric Jameson, *A Singular Modernity: Essay on the Ontology of the Present* (London and New York: Verso, 2002), 162. Jameson calls this the point of modernism.

19 Ibid., 200.

modulations on a single color theme. Fanning out like butterfly wings from a central horizontal slab that slices his composition in two, or emanating from a central point in a sunburst configuration, these slats of color cover the surface of his canvases thickly, like an opaque screen. That there is something beneath that screen is made evident by the traces of underpainting—more often than not, in a color complementary to the surface paint—that Grotjahn allows to peek out from the sides of the canvas, from the edges of the composition and sometimes, from the depths of his signature, which he scratches into a work's wet surface. But Grotjahn is less interested in the investigation of color relationships than he is in the ability of color to obliterate, to suffuse, and to impart meaning, however inchoate. Mandala-like, his paintings bear a relationship to the quasi-religious monochromes of Ad Reinhardt. There is, however, a certain lawlessness in Grotjahn's paintings, a lack of system that makes itself apparent in the wide proportional variance of his color bands and in the outsized dates and signatures that boldly embellish the pristine surface of many of his works. This surface writing, scribbled in an almost Sanskrit-like script, is an effective means for frustrating the illusion of looking *into* pictorial space and adds to the talismanic quality of the pictures.

Eva Rothschild's sculptures are pure geometric abstractions that echo the argument that Bontecou's forms have been making for the past forty years, namely, that an abstract language can be as readable and as moving as a figurative one. Monumental despite their spareness, Rothschild's elegant linear forms bear a visual similarity to Russian Constructivist mobiles and reliefs, but their size and ability to stand alone allow them to capture rather than parse space. They do this through a kind of three-dimensional outlining that creates a chapel-like area within each sculpture, an inviting space that seems energized, almost electrified, by the borders that surround it. A mandala is a shape that transcends its representation of a spiritual object to become, in its essence, spiritual. If Rothschild's sculptures seem at first glance to be straightforward geometry, one has only to look at the negative space created by her slim black lines to see that the empty air resolves itself into such associative forms as pyramids, pentagrams, and cruciforms. As in Bontecou's sculptures, the allusiveness of a Rothschild sculpture never devolves into illusion. As specific as they are, her forms refuse specific interpretation; like archetypes, they hold a world's worth of symbolic meaning and are, in Jameson's elegant terms, themselves "symbolic acts." [20]

The passionate experiments of Abts, Grotjahn, and Rothschild pledge allegiance to abstraction's transcendental value, setting the stakes as high as any postwar modernist. But is the concept of modernity, as Jameson would have it, really "back in business"?[21] The answer is a qualified no. For these artists, this element of modernity—the notion that an autonomous artwork can be a vehicle for the expression of "awesome feelings felt before the terror of the unknowable"[22]—is less an ideology than a strategy, which can be modified as need be. For other artists, modernist abstraction is a kind of character in a broader narrative, one of a number of potent symbols[23] in an eclectic language. Jim Lambie's sculptures, objects, and installations playfully find high-modernist forms in junk from the very era (the 1960s and 1970s) when *modern* was a truly mass-culture aesthetic. His relational sculptures made from beauty-shop mirrors and stereo speakers, and his optical paintings that double as dance floors, are the opposite of the absolute; these are modernist forms polluted by content and showing their dark roots in popular culture.

20 Ibid., 136.

21 Ibid., 6.

22 Newman, "Ideographic Picture," 15.

23 Jameson, *Singular Modernity*, 136.

26

But there is not a whiff of sulfur in Lambie's work, no 1980s satire of shopping, critique of waste, ironic appreciation of kitsch and cheap plastic. In fact, there is a gravity to Lambie's transformation of narrative objects into abstractions, found or not. His belief in the symbolic power of abstraction is most literally described in a series of objects he calls *Psychedelic Soul Sticks*. Made from lengths of wood the size of a walking stick that have been wrapped with hundreds of layers of shredded record albums, photos, colored ribbons, yarn, and thread, these works are conceived as shamanistic tools that contain the combined symbolic power of the music, the pictures, and the objects from which they are made.

Modernist abstraction plays a symbolic role in the work of Ugo Rondinone, Katarzyna Kozyra, Julie Mehretu, and Isa Genzken as well, but among these artists, the power of the aesthetic is treated more literally and concomitantly, with more skepticism. Ugo Rondinone's multichannel video installation *Roundelay* (2003) features a hexagonal theater built of angled walls inside of which are projected six versions of a serious-looking young man and a slightly stricken-looking young woman walking separately through the streets of Paris. Manipulated to vertiginous effect with rushing perspectives and sharp angles, the video follows the progress of these two characters as if traveling through a Cubist painting. The score, by minimalist composer Philip Glass, seems to echo off the tilting walls and compounds the spatial disorientation and mood of modernist anomie. As in other works by Rondinone, which comprise sound pieces, sculptures, drawings, and paintings as well as videos, there is a palpable sense of nostalgia in the atmosphere, a feeling of emotional and psychic loss that accompanies the very physical sensation of being set to wander in three-dimensional space.

This split attitude toward modernity—a fearfulness coupled with longing—is also evident in Katarzyna Kozyra's multichannel video installation *The Rite of Spring* (1999/2004). An homage to Stravinsky's and Nijinsky's ecstatic paean to the unbridled life force of the modern, Kozyra's life-size projections, arranged in a ritualistic circle, emphasize the music's pagan roots. However, her visual choices lend this version of the dance a mechanistic air: she filmed elderly dancers from above as they executed the choreography while lying prone on a white background. The severely circumscribed movements of the dancers curiously bring out the tremendous discipline rather than the frenzy of the music and the choreography, making them examples of control rather than release. Like marionettes, the performers seem compelled to move by some unseen hand; this effect, while not exactly cruel, is certainly discomfiting, as it serves to heighten our awareness of our own vulnerability to external forces, whether primal or mechanistic.

Modernity, heralded by cool white angularity, repetition, and of course, youthfulness, is a moment but also a condition; it is a dream of a future when everywhere is endless Paris, and a nightmare in which one boulevard dead-ends into another so that no matter how far you walk, you never reach a destination. Julie Mehretu's paintings display a kindred attitude toward what can be called institutional modernity—the theories of modernism as laid out in practice in city plans and the designs of corporate complexes, airports, and the like. In overlaying patterns culled from these and other sources, including weather maps and aerial photographs, Mehretu creates compositional symphonies on the themes of simultaneity and integrated systems. Her works, with their colorful directional lines that seem to zoom across the canvas and their vigorously drawn vortices

resembling tornados or conflagrations, have an unmistakable connection to high modernism—to Futurism's vision of speed, and to the vigorous rhythm of late Kandinsky. However, as in the works of Lambie and Rondinone, Mehretu's modernistic elements are found, her abstractions are ready-made. Modernity is the imprint of our spaces—our homes, our cities, our world. But it goes even beyond that; it is also the shape of our trajectories as we move from one place to another, as illustrated by the roaming of Rondinone's boy and girl and by Mehretu's whooshing lines.

For almost thirty years, Isa Genzken has created challenging objects, photographs, and installations, many of which take as their subject modernist architecture and its symbolism of progress, power, and aesthetics as well as its relationship to urban space and to life on a human scale. Her most recent series *Empire/Vampire*—small-scale sculptures perched on pedestals—was begun in late 2001, after the artist had witnessed the destruction of the World Trade Center in New York. No direct relationship exists between that disaster and the majority of these small tableaux, in which toys and tennis shoes, shards of mirror, and sheets of plastic are set in violent interaction; but one underlying theme of their wildly imaginative and disturbing scenarios is that of geometric form run amok, as towering slabs of mirrored glass threaten defenseless dolls lying prone amidst devastated landscapes in miniature.

Barnett Newman once wrote that "true abstraction" can only be discussed in metaphysical terms, 24 and in fact the notion of an autonomous art through which to explore the unknowable depths of human existence is closer to a religious strategy than to a pragmatic or empirical one. 25 The transition from experience to belief through the vehicle of the art object is an abiding interest in Rachel Harrison's work, one that links her photographs to her sculptures. *Untitled (Perth Amboy)* (2001) is a series of photos depicting a single window of a house in suburban New Jersey upon which an apparition of the Virgin Mary had been reported. Harrison was drawn to Perth Amboy because she wanted to record the phenomenon, to find visible proof of a mystical occurrence. What she ended up with is a chronicle of devotion, a nuanced study of how people go about believing. Each photo in the series details a particular trace: a shadow of a hand laid upon the spot where the holy image is supposed to have appeared; an outline of a family photograph pressed up against the sacred glass; the mist on that glass; the residue of hundreds of tears, handprints, and the hot breath of emotion. Although begun perhaps with the intention of making material what might otherwise have been purely metaphysical speculation, *Perth Amboy* is peculiar in that it serves neither to disprove nor to substantiate the miracle of the Virgin in the window. Movingly, it documents, in a drab suburb in Anywhere, USA, the existence of faith.

Harrison's work, to a certain degree, indicates not only that it is by looking that one can redeem oneself, but also that looking at art can lead to enlightenment. Araya Rasdjarmrearnsook's practice of reading to the dead takes this notion to an extraordinary conclusion. Motivated by the conviction that it is possible to communicate with the essence or soul of a dead person through stories, poetry, and song—in other words, through art—the artist has taken it upon herself in recent years to search out people who have died anonymously and to soothe them by reading or singing folktales and love stories to them. What may sound ghoulish when merely described becomes touching when witnessed, so evident is the artist's human compassion and Buddhist faith. Just as Harrison's *Perth Amboy* is a record of the artist's pilgrimage—her search and the evidence of what she

24 Barnett Newman, "Reply to Clement Greenberg's review in *The Nation*, December 6, 1947" (originally unpublished), in Johnson, *American Artists on Art*, 17.

25 God is a far more popular idea employed to find the ultimate foundation for human existence.

found—Rasdjarmrearnsook's videotapes, shot using a video camera on a tripod in most instances, are not the artwork, but rather a convenient device with which to document it. The pieces themselves exist both in the act of undertaking this practice and, perhaps more interesting, in the connection made between the artist and the soul of the dead person receiving the comfort of the songs and stories, both beautiful and familiar. No evidence is given for the success of this connection; its existence is a matter of faith on the part of the viewer. It is possible then, to experience this simple work on two levels: first, to watch the artist practice her belief; and second, to believe with her ourselves.

Senga Nengudi, in her recent work, embraces head-on a kind of animism and shares with Rasdjarmrearnsook the notion of art as an instrument of healing, spiritual and otherwise. In the 1970s, Nengudi became known for sculptures made out of humble objects such as nylon stockings, which she expertly transformed into elegant abstract compositions that were at once biomorphic and precisely, movingly human—in a manner that transcended the simply narrative. In recent years, she has become more interested in the creation of environments that are spiritualized and made magic by the ritual arrangement of materials. Her sand paintings, which range from small scale to room size, partake in a tradition that is shared by groups as diverse as Native American tribes of the southwestern United States and Buddhists in Southeast and East Asia. Like Rasdjarmrearnsook's singing, the ritualistic spreading and raking that go into the making of these complex and ephemeral objects are what power the spell. The motifs of Nengudi's paintings are decidedly abstract, but their forms remain strangely familiar. We stare at them as we would at an ancient handprint in a cave; we know intimately from whence it comes, but that does not mitigate the mystery and awe it inspires.

Both Rasdjarmrearnsook's and Nengudi's manner of devotion is unconventional, in fact transgressive, in its bold mixing of Eastern and Western religious traditions. Francis Alÿs' series of small paintings entitled *The Prophet* (begun in 1992) partakes in the venerable, and specific, tradition of Catholic devotional painting. Intimate in scale, like Mexican *retablos* (Alÿs has lived in Mexico for almost twenty years), a number of these works feature subjects that are overtly religious, such as one figure blessing a second, which kneels before it. In other works the motifs are more ambiguous. From the figure who folds his hands behind his back in a pose of contemplation or submission to an odd vignette of a woman walking with one of her legs in a clay urn, the iconography of these paintings identifies them as parables, but of no known religious doctrine. They share with their more readably devotional counterparts an intense, quiet, almost sacred air, but in Alÿs' works, this is created by their allusive yet nonspecific content as well as by the dense opacity of their coolly colored surfaces. Alÿs has said that these works are "little windows" onto a more spiritual plane, one that the artist may or may not believe exists. For him, it is the very possibility of its existence that is important.

Maurizio Cattelan has often tangled with religion and other modes of organization and control in his angry, funny actions (taping a gallerist to a wall in a kind of mock crucifixion) and sculptures (*La Nona Ora*, his infamous 1999 depiction of the present pope felled by a meteor). A spiritualist he is decidedly not, but his oeuvre over the past ten years has revealed him to be a believer, if not in a religious doctrine, then in an ethics, if not in good and evil, then in the notions of right and wrong, justice and injustice. Cattelan is relentless in his analysis of human cruelties,

and iconoclastic in his choice of weapons. *Him* (2001), a sculpture of
Adolf Hitler kneeling in prayer, is one of the artist's most disturbing works,
as it operates on our sensibilities on many levels. Although this version of
Hitler could by no means be construed as laudatory, Cattelan has chosen to
depict the murderous Nazi not as an otherworldly monster, but as decidedly
human, clothed in a little tweed suit and scaled to childlike proportions.
To make matters more uncomfortable still, Hitler's smallness and
vulnerability seem intended not so much on demeaning him, but on tempting
us to pity him. The statue's devotional attitude is equally shocking—
seemingly blasphemous until one remembers that in Catholicism at least,
God's fundamental promise is to forgive anyone for any sin, no matter how
grievous. *Even him?* this work seems to ask, but it does not give an answer.
For more than a decade, Cattelan has devised artworks and actions whose
main targets are structures of power—institutions, laws, and ideological
constructs such as social norms, party lines, and organized religions.
The level of controversy he has managed to create around his entire oeuvre
is a testament to the strength of visual representation to engage in the
largest and most difficult of issues. The frisson of horror—and perhaps of
outrage—engendered by the likeness of Hitler notwithstanding, *Him* is not
primarily about Nazism, or Christianity; rather, it takes a simple but
searing stab at understanding the nature of evil, not as it has been visited
upon us, but as a product of our own society. Social critic Hannah Arendt
described the Nazi killing machine as a "fury at existence as such," [26]
a hatred fueled by the desire not only to destroy human beings but to kill
the very concept of the human. *Him* does not question the fact that the
face of Hitler stands for the most unimaginable wickedness, but it does
question—and ruthlessly so—the ability of Judeo-Christian notions
of faith and redemption to adequately describe such evil, and in a larger
sense, to come to terms with the broad parameters of humanity as it is.
Cattelan's newest work, entitled *Now* (2004), is a life-size effigy of
President John F. Kennedy laid out in an open coffin. The work can
be seen as a commentary on the state of American politics today, a moment
in which our country lacks precisely the kind of internationally popular
figurehead that Kennedy represents. But like all of Cattelan's best work,
Now transcends its most obvious reading to touch on more universal concerns.
If *La Nona Ora* and *Him* question the possibility of divine intervention
to both perpetrate and save us from evil, *Now*, a contemporary martyr
depiction having no redemptive payback, doesn't question anything;
it simply states that hope—meaning the best we humans have
to offer—is dead and beyond resurrection.

As Eagleton and others have pointed out, "evil" is a loaded word,
"transfer(ring) the question from [the] mundane realm to a sinisterly
metaphysical one." [27] Works such as *Now* and *Him* retrieve the notion of evil
from the grips of the Satanic and return it to the common, human platform
of politics. Like religion, political ideology offers a set of theoretical tools to
tackle questions of human agency and well-being, social organization,
and ultimately, right and wrong. It trumpets the logic of human, rather
than divine, systems. Systems of thought fascinated Dimitrije Bašičević,
an art historian and pseudonymous artist who used the name Mangelos
when making art. Over a forty-year period, he created an oeuvre consisting
of watercolors, paintings, altered books, drawings, and a series of more
than twenty globes, many of which provided the support for manifestos
on topics as diverse as philosophy, art, and mechanization. For Mangelos,
the form of the manifesto—a declaration of ideological intent—was the

26 As quoted by Eagleton, *After Theory*, 216–17.
27 Ibid., 141.

ultimate example of "functional thinking," a concept that sprang
from an age dominated by technological systems and that replaced the
metaphorical thinking of a more naive age. Mangelos' manifestos make use
of a range of descriptive systems, from alphabets to mathematical proofs,
from scientific theories to perceptual schemata, presented as the logical
heirs to defunct metaphorical systems found in philosophy, religion, and art.
According to the artist, these latter modes of thinking—nonspecific
and unprovable—are obsolete in a contemporary society that is
automated, planned, and rational in the extreme.

Adopting the severe red, black, and white palette of the Russian
Constructivists, Mangelos made a conscious link between his work,
emanating from the postwar socialist environment of Yugoslavia, and that
of his Russian predecessors who attempted to embody the ideals of the
workers' revolution. One could argue, however, that Mangelos' reference
to Russian Constructivism is as much a parody of the movement's rigid
ideological armature as it is an homage to its idealism. Mangelos might
have proclaimed unequivocally that "there are no profound thoughts:
only functional ones,"[28] but he also wrote, in a subtle indication that social
systems produce the symbolic systems they most deserve, that "art does
not stem from a concept but from a state."[29] Since the late 1940s, Mangelos
had experimented with black monochrome *tabulae rasae* and a series
of text works called *no-stories*. From 1961 to 1966, he was a member of the
Croatian neo-Dadaist group Gorgona, which, like its counterparts in Milan,
Paris, and New York,[30] was dedicated to the promotion of neo-Duchampian
anti-art strategies. This evidence of Mangelos' ironic attitude toward
art as a system is nowhere more clearly displayed than in his series of
manifestos, the bulk of which were completed in the last decade of his life.
In contradistinction to their declarative aspect, these models of "functional
thinking" frustrate meaning rather than make it, ultimately creating a
kind of "no meaning," a neologism distinct from the term "meaningless."
No meaning implies a dissolution of received ideas, a questioning of
definitions, hierarchies, and ultimately, values. Drained of their referents,
descriptive systems—from paintings to alphabets to manifestos—
are examples of functionalism without function, of the logical
taken to the level of the absurd.

This notion of the absurd as a potent weapon against the iron fist
of rationality has its origins in postwar European literary culture, but it
continues to have currency with artists two generations removed from
Eugene Ionesco, Piero Manzoni, and Mangelos. John Bock's performance-
cum-sculpture embraces natural science, philosophy, and economic
theory as freely interpreted by a polyglot Buster Keaton. Employing
handmade props, elaborate costumes, and unimaginably intricate sets—
and armed with charts scribbled with formulae and quotations from Kant
and John Stuart Mill—Bock sallies forth to explain, in several languages,
the vast and complicated world, both physical and metaphysical.
It is a Sisyphean task, and the breakdown of his many systems, material
as well as philosophical, is inevitable. In the past, Bock has called his
performances "lectures," in reference to a German artist-shaman-
philosopher of an earlier generation, Joseph Beuys, but Bock prefers
hypnogogy to pedagogy, and the point of his performances is not to explain,
but to destroy explanation. Bock's work seduces and confounds
simultaneously, in an effort to prove and to glorify the inexplicability
of the interrelationship of man and his universe.

28 Mangelos wrote this in 1978.

29 As quoted in Branka Stipančić's essay in this book; see page 176.

30 Gorgona was in contact with a number of other groups in Europe and the United States, and published work by many European and American artists, including Jasper Johns and Piero Manzoni, in their short-lived but influential eponymous publication.

Mangelos did not discern between aesthetic, mathematical, grammatical, or political systems; he skewered them all with an equally lethal critical acuity. He is considered a practitioner of "anti-art," and it is his engagement with the larger world of systems beyond those that are applicable to the visual arts that has the deepest significance for contemporary artists similarly fascinated. Jeremy Deller, for example, is a connoisseur of the ideological symbol. Trained as an art historian, in his artistic practice he rescues the symbolic from the jaws of the quotidian, not by recontextualization, but by something akin to the art-historical practice of iconology. Mining popular culture for artifacts that range from folk music to political pamphlets, Deller interprets them by comparison to historical precedents, as in his masterful restaging of a miners' strike as a medieval battle, or by cultural origin, as in his construction of the history of the fans of the British cult band Manic Street Preachers. Like Crumb, Deller recognizes the epic in the everyday, but like Mangelos, his fascination remains not with what the evidence tells us about ourselves, but with what it tells us about the society that created it. If Crumb is obsessed with the creation of a portrait of human beings through the study of individuals, then Deller, like Mangelos, is more interested in studying the anatomy of a society as it is defined by its overarching ideas, which are made manifest in the symbolic forms it creates. This examination of representative forms that create a picture of a country, a people, or a historical event also obsesses Fernando Bryce. His drawings—made by the hundreds—transcribe, in ink-on-paper facsimiles, entire archives of written materials, from official government documents to tourist brochures. Gaining credibility by the sheer number of objects presented, his collections are meant to expose how facts are constructed, history is reported, and culture is described. But why not merely gather the actual papers, or perhaps photographs or photocopied images of them? In reproducing them by hand, Bryce physically yanks each piece of paper from the realm of facticity and replants it into that of art. Like Mangelos, Bryce uses aesthetics strategically to destroy what is presented as reportage. His drawings undermine any faith in the credibility conveyed by the printed page.

Mangelos' entire project can be interpreted as the orderly unraveling of the very concept of the ideological system. The beginning of this millennium has been marked by just such a sense of the unraveling of structures and reinterpretation of narratives, which has, in turn, sparked a revival of interest in finding newer and easier answers to ever more complex problems. The relevance of this destabilizing impetus to a moment marked by a kind of international searching for stability is unquestionable. Mangelos' pointed reference to the artistic language born of the Russian Revolution finds an updated counterpart in the strategy employed by Neo Rauch in his curious and curiously beautiful paintings. Born and educated in East Germany, Rauch, like Mangelos, experienced firsthand a society built on an ideological system that permeated every aspect of life and its representation. Achieving a mature painting style after the collapse of the Berlin wall, Rauch chose to retain elements of the Socialist Realist aesthetic—a faded industrial color palette, a heroic, almost cartoonish realism—to depict a retro-futuristic fantasy world crisscrossed by pipes, scattered with machines, and populated by automatons and monsters. Most recently, Rauch's landscapes have been emptied out, leaving lush but vacant vistas painted in somber, slightly toxic dark reds, purples, and blacks evocative of an early winter evening at an abandoned industrial site. Part of the thrill of Rauch's work lies in its ambiguous treatment of a visual language loaded with ideological baggage. Is his use of Socialist

Realist stylistic elements an attempt at nostalgic recuperation or ironic resuscitation? Could it possibly be both? An equally fascinating aspect though, lies in the nature of the world that Rauch has consistently depicted in his canvases over the past decade. Neither a parody nor an homage to the real socialist society of the early years in the German Democratic Republic, Rauch's world, populated by hybrid animals and hypertrophied humans, is one in which the trappings of social order coexist with absurdities such as Yeti-like monsters portrayed in deep discussions with white-coated technicians and laborers, who are in turn involved in the busy design of useless contraptions.

Drawing from his personal fantasies and memories, Rauch creates a kind of surrealism for a postideological age; recalling Mangelos, he also depicts a world in which the "arational reason" that is art, to quote Theodor Adorno, has grown in the all but vanquished vestiges of the "irrational rationality" of ideologically driven societies. [31] Paul Chan's *Happiness (finally) after 35,000 Years of Civilization—after Henry Darger and Charles Fourier* (2000–2003) is a giddy conflation of two arational systems: the French Utopian Charles Fourier's dream of a free-loving, gender-equal, communal society [32] and the self-taught artist and loner Henry Darger's fantasies of a garden world populated by armies of surprisingly pugnacious little girls, each of whom sports a full set of male genitalia. [33] However disparate in intention, both Fourier and Darger imagined societies completely devoid of repression and entirely directed by human drives, and this is precisely what Chan colorfully and humorously describes in his animated video. Less of a narrative than an extended vignette, his computer-generated vision of happiness features floods of little Darger girls engaged in warfare, work, and free play (sexual and antic), surrounded by a landscape in perpetual spring. In Chan's artificial state of nature, flowers bloom and children tussle toward no particular goal and under no established law. In a sense, it is the no-less-absurd mirror image of the hypertrophied rationality of Mangelos' "functional thinking"; *Happiness* is a picture of an ideology-free world.

If this discussion began with pragmatists, empiricists, spiritual travelers, ideologues, and anti-ideologues, it ends with the visionaries and fantasists. They, too, wrestle with what Kant called "noumena," that is, those elements basic to the human subject that are beyond conceptual inquiry, [34] but they do so through the language of myth. The paradigmatic function of myth is to explain origins, and with that, to justify the world and humans' existence in it—to link what we are now to the riddle of where we came from. In a sense, the mythmaker's strategy partakes of both earthly observation, including societal rules and beliefs, and spiritual searching. But it leaps into other worlds that cannot be located or described, and into a time that is neither before nor after the moment we are in now. This incommensurability is what sets the mythological apart from the merely phenomenal.

Trisha Donnelly's photographs, video works, and performances might not refer precisely to cosmogonic tales, but using a vocabulary of familiar images and gestures, they probe the notion of essences and the inchoate, or perhaps the preverbal. In her video *Rio* (1999), the eponymous song, with its catchy samba beat, provides the soundtrack as the artist describes Rio in International Sign Language, framed against a hot, beach-orange background. The Rio described in song and sign is nothing like the real Rio de Janeiro, but the work communicates the idea, or rather the *ideal*, of Rio—sensually and symbolically, with music and the three-dimensional pictographs of ISL. Donnelly's works are low-tech,

31 As quoted by Terry Eagleton, *The Ideology of the Aesthetic* (Oxford, England, and Cambridge, Mass.: Blackwell, 1990), 351.

32 François-Marie-Charles Fourier (1772–1837).

33 Henry Darger (1892–1972).

34 Kant as explained by Eagleton, *Ideology of the Aesthetic*, 75. In Kant's philosophy, the noumenal is the opposite of the phenomenological.

but her choice to use reproductive mediums such as video and photography seems peculiarly brave because she employs them to capture what is essentially still and ever in formation. *The Black Wave* (2002), a mural-size photograph that depicts a phenomenon that may or may not exist outside of folklore, is, in a way, the perfect symbol of the cosmic circle because it reads as both generative and apocalyptic. Like Rio's orange sun, or the gesture of the hand to the heart signifying love in ISL, *The Black Wave* represents the artist's effort to create a contemporary archetype—her bid to rival the drawings on the cave walls of Altamira.

Anne Chu's figurative sculptures, though different in significant ways from Donnelly's conceptual works, have an equal absorption with symbolic form. Over the past decade, Chu has been concerned with iconic images culled from a wide range of sources, including Chinese Han and Tang dynasty burial ceramics and Gothic funerary reliefs, as well as science fiction, nature guides, and folktales from around the world. Chu stated some years ago that she was interested in creating in each of her works a "fluctuation in meaning," but this is not to imply that her goal is obscurity. On the contrary, without succumbing to overt anthropological zeal, Chu traffics in archetypes, testing the hypothesis that there is a commonality in meaning among symbolic forms ranging from dragon monsters to glad-ragged tricksters/jesters/holy fools. In her recent work, the many strands of significances have merged to create a cast of über-symbols: Chinese princesses cloaked in the robes of the Virgin Mary, and knights errant, streamlined like Cycladic figures, who merge with their mounts like life-size rooks. The concept of myth, writ large, is both a source for, and a constant subject in Chu's works, and her tableaux do not so much illustrate a particular myth as participate wholeheartedly in its polyglot creation. In a similar vein, Kaoru Arima's delicate drawings on newspaper are populated by ogres, winged sylphs, animate trees, and seraphim; some are immediately identifiable as figures from European folktales and Christian myth, while others seem to refer to Japanese folktales as well as to contemporary anime. Despite the diversity of his sources, Arima is not as interested in the hybridity of the mythic vocabulary as he is in the bizarre pertinence of myth when juxtaposed with contemporary reality. Although surrounded by a cloudlike white ground, all his figures have some relationship to the text, drawings, diagrams, and photographs of their newspaper support. It is as if the daily news has been invaded by another order of being altogether, rupturing the division between linear time—that unrepeatable, easily mapped timeline of history—and sacred time, which, punctuated by myth and ritual, infinitely repeats itself.

The photographer Philip-Lorca diCorcia is best known for his ability to capture the cinematic in the everyday, turning genre subjects into freeze-frame parables through minute attention to lighting, composition, and contrast. Although his work has inspired a subgenre of photographic practice that takes the notion of the fictional setup, within a medium used to record fact, to epic proportions, diCorcia's photos over the past twenty years have been at once more modest than those of his followers and more ambitious. He has described his work as a "meditation on mortality," adding pointedly that "only a 't' separates that from morality,"[35] and the appeal of his photography seems to supercede both its formal skill and its compelling subject matter to attain a state in which, in the words of art historian Peter Galassi, "something more is at stake."[36] In his most recent series depicting women suspended acrobatically from stripper's poles, what is lurid in subject becomes, in a photographic composition, iconic.

35 A. M. Homes, "Photo-Surrealism: Philip-Lorca diCorcia's Life in Pictures," *Vanity Fair*, September 2003, 194.

36 DiCorcia as quoted in Peter Galassi, *Philip-Lorca diCorcia*, exh. cat. (New York: Museum of Modern Art, 1995), 6.

The artist has explored similar subject matter before—in the early 1990s he made a series of photographs of the hustler denizens of Santa Monica Boulevard—and like this series of a decade ago, the newer work eschews a clinical point of view in favor of a manner of presentation that emphasizes the fantastic, timeless aspect of the subject. Arranged like caryatids, the dancers—seemingly inextricable from their poles—have a look of architectural permanence that belies the fact that they have been caught in motion. Not so much glamorized by the dramatic chiaroscuro lighting that etches their forms against dark backgrounds as transformed into something symbolic, these figures glow goddesslike, echoing the archetype of Gaia—the personification of the earth—astride her axis.

To defamiliarize the everyday is to free it from its banality, to render it indescribable and to present it in "a messianic light."[37] The painter Peter Doig is a mystical type, perhaps a visionary. His choice of subject matter is deceptively simple—a suburban house, a road, or a figure in a landscape—but in his eyes and under his brush, a graffito of a rainbow over a tunnel becomes the portal to paradise; a bearded man in a canoe, a seer; a house on a lawn, the *imago mundi*, a definitive representation of the world to which no addendum or explanation need be attached. Doig achieves this by setting his work outside of time, in a kind of other place contiguous with our own that is not meant to reflect or recapitulate reality. In viewing a painting by Doig, one cannot tell whether it presents an image of past, present, or future as there are elements of all three in every work. This is achieved through painterly pyrotechnics, which include staining, dripping, and stippling as well as a palette of electric colors used in vibrating combinations. Doig seems to equate the plasticity of the painter's medium with the hallucinatory effect of psychedelics, or of magical fairy dust; paint becomes a vehicle for getting to somewhere that is not in (or of) this world. Mamma Andersson also paints landscapes and genre scenes that have the air of the supernatural, an effect encouraged by the artist's loose, washy passages in an otherwise thickly painted composition. Indeed, the notion of the canvas itself as a portal to another, more beautiful world is the subject of many of her recent paintings, which incorporate artworks by admired painters (Doig among them) as characters leaning against walls in her interiors or propped incongruously on easels in her landscapes. This bald intrusion of art into straightforward genre scenes of libraries, schoolrooms, and fields of frolicking children is frankly otherworldly; these pictures within pictures seem to give us a view of another dimension, an entire universe created by another artist's mind. Like Doig's paintings, Andersson's works portray a time that is nonlinear and simultaneous.

The conjuring of a place in time that lies somehow between the past and the future is addressed by Yang Fudong in a series of films based loosely on a third-century Chinese fable in which a group of intellectuals flees the troubled political world and, amidst the bamboo, replaces worldly concerns with pure conversation. Envisioned as a group of five films, of which the first two have been completed, the works chart the pursuit of an ideal through progressive stages from an escape into nature to a return to the reality of an urban environment to the creation of a utopian situation from the ground up. Seeing the state of the Chinese intellectual as one in which "we have to negotiate our past while imagining our present,"[38]

37 Theodor Adorno called for an art that could "displace and estrange the world, reveal it to be, with its rifts and crevices, as indigent and distorted as it will appear one day in the messianic light." From *Minima Moralia* (1951), as quoted by Eagleton in *Ideology of the Aesthetic*, 359.

38 Yang Fudong, "A Thousand Words: Yang Fudong Talks about the *Seven Intellectuals*," *Artforum* 14, no. 1 (September 2003): 183.

Yang elides historical and mythical time by casting his third-century story with contemporary-looking actors dressed in costumes from the 1930s. Shot in black and white on location in a seemingly untouched wilderness, the first film, *Seven Intellectuals in Bamboo Forest, Part 1* (2003), has a languorous pacing and a palpable, watery atmosphere that slows the action down to the kind of time experienced in memory, or perhaps, in dreams.

Yang's world, like those depicted in Doig's and Andersson's paintings, might have the quality of dreams, but it is not precisely utopian. That element of wish fulfillment present in utopian musings is more apparent in the complex fantasy worlds of Chiho Aoshima. Designed on a computer, her enormous wall murals depict toothsome, big-eyed goddesses and pallid but beautiful female zombies who float through electric-colored atmospheres resplendent with unnaturally verdant vegetation. It has been said recently that utopianism in its most contemporary form is science fiction, [39] and some of Aoshima's tableaux, with their levitating ladies of almost lunar pallor, seem to offer a vision of a future recognizable from the world of *manga* and anime. Notably though, as with many science-fiction scenarios, Aoshima's futuristic visions are also strikingly primordial, populated by Eve-like nudes, reptiles who are not quite identifiable as dinosaurs, and gigantic flowers and vines growing untamed in frightening luxuriance. A prelapsarian future and a futuristic past merge seamlessly; neither nostalgic nor predictive, this world exists parallel to our own. From that world, and from a vantage point that is decidedly feminine, Aoshima offers up a unique commentary on the origins of contemporary desire.

When Theodor Adorno wrote that "in order for a work of art to be purely and fully a work of art, it must be more than a work of art," [40] he was not implying that art in and of itself wasn't enough; rather, he meant that art was capable of bearing the burden of exploring territories traversed by philosophy, religion, political ideology, and science. [41] More than at any time since immediately after the Second World War, when Adorno published these opinions, it can be argued that the current times call for just this kind of ambition; and the thirty-eight artists in the 2004–5 *Carnegie International* have risen to this challenge. Without forsaking in toto the sensory excitement, narrative entertainment, and extreme subjectivity that have been the hallmarks of the contemporary art developed over the past ten years, particularly for the international art market and large international art exhibitions, these artists have distinguished themselves in that they have, with some risk, embarked on the more difficult task of choosing art as a meaningful vehicle through which to confront fundamentally human questions: the nature of life and death, the existence of God, the anatomy of belief. This high-stakes view of art-making may not seem extraordinary in light of the entire history of art, but it represents a subtle though important break with the art of our most recent past in that it embodies a search for meaning rather than the construction or illustration of it. The work of these artists proves that the task of investigating the unknowables is one that art can handle. Such an interrogation—sometimes sharp, sometimes gentle—of our own humanity is no less urgent for the uncertainty of its outcome.

39 Molly Nesbit, Hans-Ulrich Obrist, and Rirkrit Tiravanija, introduction to *Utopia Station,* (http://www.e-flux.com/projects/utopia/about.html).

40 Theodor Adorno, as quoted by Eagleton, *After Theory,* 160.

41 Ibid., 361.

Artists

Tomma Abts
Pawel Althamer
Francis Alÿs
Mamma Andersson
Chiho Aoshima
Kaoru Arima
Kutlug Ataman
John Bock
Lee Bontecou
Robert Breer
Fernando Bryce
Kathy Butterly
Maurizio Cattelan
Paul Chan
Anne Chu
Robert Crumb
Jeremy Deller
Philip-Lorca diCorcia
Peter Doig
Trisha Donnelly
Harun Farocki
Saul Fletcher
Isa Genzken
Mark Grotjahn
Rachel Harrison
Carsten Höller
Katarzyna Kozyra
Jim Lambie
Mangelos
Julie Mehretu
Senga Nengudi
Oliver Payne and Nick Relph
Araya Rasdjarmrearnsook
Neo Rauch
Ugo Rondinone
Eva Rothschild
Yang Fudong

Tomma Abts

Tomma Abts belongs to a generation of painters that no longer wrestles with the ontological questions of painting's "death." Rather than responding to the dominance of a particular style or ideology, these artists feel free to mine both contemporary influences and the history of painting to develop their own personal language. Abts works consistently in a 19-by-15-inch (48×38 cm) format, each picture an articulation of abstract forms and imperfect geometries that plays with basic tenets of painted spatial relationships. In an era when artists regularly borrow from the scale and the intent of cinema and outdoor advertising, and when paintings and photographs have exploded in size, Abts' decision to work small seems against the grain and entirely personal. It is also rife with historical allusions. Throughout her body of intimately scaled work, she makes multiple points of connection with early twentieth-century abstraction as well as postwar European concretism, although the paintings themselves are firmly of their own moment and without nostalgia for any particular aesthetic doctrine.

Abts paints on her own terms, approaching each canvas without an agenda or a preconception of its ultimate realization; rather, she builds up and erases layers of paint until a form crystallizes. She explores figure-ground relationships and perspectival recession in a palette of muted, sometimes dirty, and resolutely "off" colors. The final work that emerges is a refinement of the process of painting itself, evincing a synthetic modernist sensibility that privileges the totality of the canvas over the idea of a central image. The finely calibrated compositions, in the artist's own words, "have to do with holding and unfolding the space in the way that every part of the picture plane is active." The paintings are concerned as much with image as with surface, which ranges from transparent veils of color to thickly painted passages achieved through meticulous masking, painting, and overpainting. Abts' canvases are adamantly nonreferential, but the intense spatiality of the work suggests macro- and microformations in nature, from blobby cellular compositions to the radiating expanse of the cosmos. The paintings' mysterious names—*Ehme*, *Teete*, and *Emo*, for example—seem to form their own invented language, inducing associations with both the past and the future, or even some long-ago projection of possible futures. The titles could be names of far-off constellations or obscure microbiological terms, but they just as easily connote mythology or geography, or as some critics have suggested, function as onomatopoeia. Their true origin is for the most part immaterial, as the linguistic obscurity is no doubt intentional, mirroring the formal ambiguities the artist sets up. Ultimately, the paintings conspire to keep the viewer in an ambiguous place, thwarting any intent on our part to pin down or narrowly define the meaning of Abts' work.—*Elizabeth Thomas*

BORN
1967, Kiel, Germany

LIVES AND WORKS
London, England

Tomma Abts has had solo exhibitions of her paintings at Galerie Giti Nourbakhsch, Berlin (2004, 2001); The Wrong Gallery, New York (2003); Galerie Daniel Buchholz, Cologne (2003); greengrassi, London (2002, 1999); and Habitat, London (1998).

Group exhibitions include: *Künstler der Galerie*, Galerie Giti Nourbakhsch, Berlin (2003); *Kunstpreis der Böttcherstrasse in Bremen*, Kunsthalle, Bremen (2003); *Honey, I Rearranged the Collection*, greengrassi/Corvi Mora, London (2003); *Black Rainbow*, Lucky Tackle, Oakland, California (2003); *deutschemalereizweitausenddrei*, Frankfurter Kunstverein, Frankfurt am Main (2002); *Richard Hawkins and Tomma Abts, Leica Dole-Recio, Morgan Fisher, James Hayward*, Galerie Daniel Buchholz, Cologne (2002); *Ecofugal*, 7th International Istanbul Biennial (2001, catalogue); *Tomma Abts and Vincent Fecteau*, Marc Foxx Gallery, Los Angeles (2001); *Limit Less*, Galerie Krinzinger, Vienna (1999); *Fast*, 520 King Street West, Toronto (1996); and *filmcuts*, neugerriemschneider, Berlin (1995).

SELECTED BIBLIOGRAPHY

Burnett, Craig. "Tomma Abts." *Untitled* 28 (Summer 2002): 60.

McFarland, Dale. "Wallflower." *Frieze* 51 (March–April 2000): 92–93.

Myers, Terry. "Tomma Abts." In *Vitamin P: New Perspectives in Painting*. Ed. Valérie Breuvart. London: Phaidon Press, 2002.

Siegal, Katy. "Tomma Abts." *Artforum* 42, no. 5 (January 2004): 135.

Slyce, John. "Interview with Tomma Abts." *Flash Art*, no. 26 (October 2002): 68–69.

TOMMA ABTS
Ert, 2003
acrylic and oil on canvas
18 7/8 × 15 in. (48 × 38 cm)
Boros Collection, Germany;
courtesy of the artist; greengrassi, London;
and Galerie Daniel Buchholz, Cologne

TOMMA ABTS
Nomde, 2004
acrylic and oil on canvas
18 7/8 × 15 in. (48 × 38 cm)
Private collection;
courtesy of the artist; greengrassi, London;
and Galerie Daniel Buchholz, Cologne

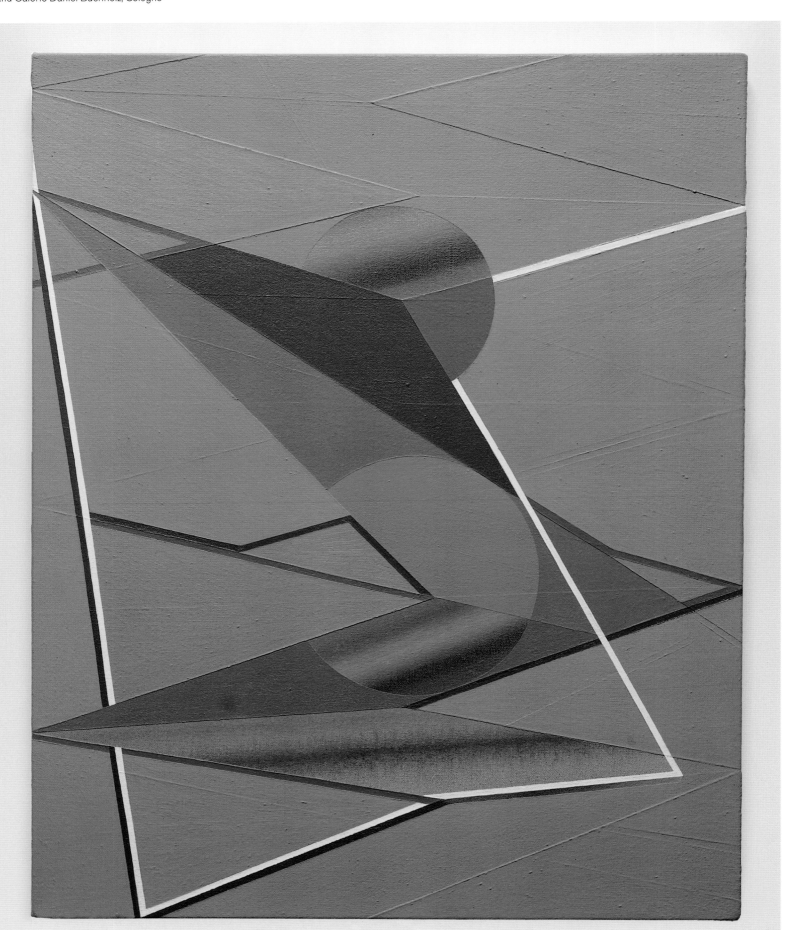

TOMMA ABTS
Zeyn, 2003
acrylic and oil on canvas
18 7/8 × 15 in. (48 × 38 cm)
Sammlung Goetz Collection, Munich;
courtesy of the artist; greengrassi, London;
and Galerie Daniel Buchholz, Cologne

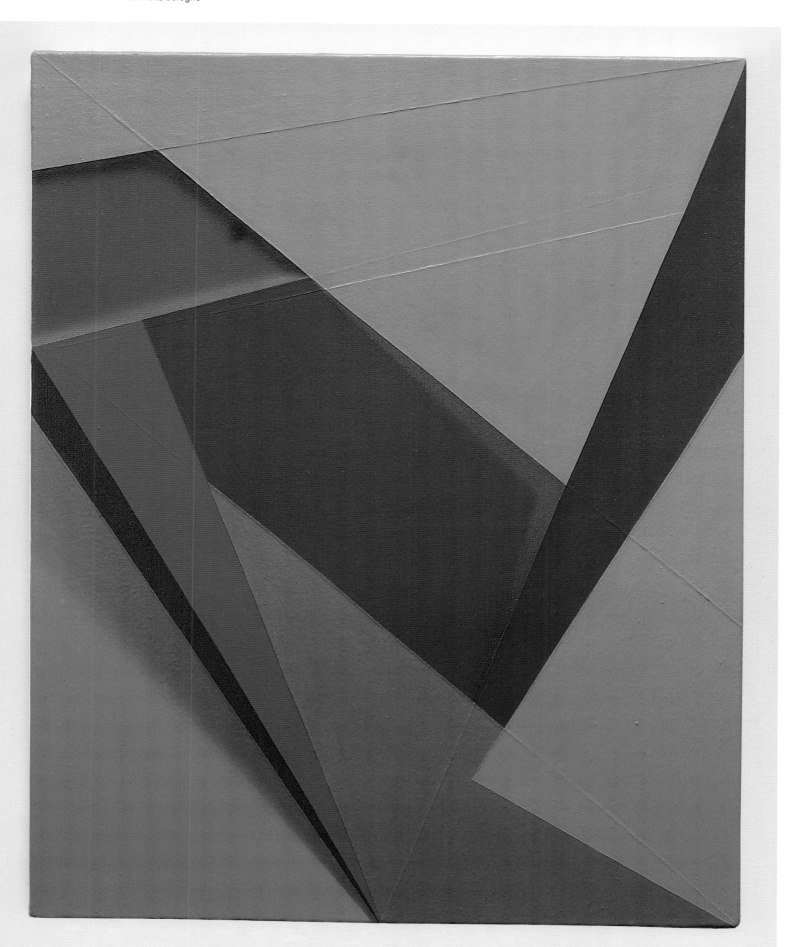

Pawel Althamer

Is Pawel Althamer the Joseph Beuys of the twenty-first century? The latter's highly influential ideas about art focused on involving society at large in artistic and creative production. Beuys' participation in politics and social service led him to become a founding member of the Green party in Germany. Althamer's approach to creative production and the role of the artist mirrors certain aspects of Beuys' actions, but his focus is on a much more narrowly defined group of people: the artist's inner circle of family and friends.

Althamer shares with Beuys a religious attitude toward his own role, as an artist, in the transformation of society. The way he looks at reality is intimate, personal, and psychological. For him, the way to change the world is by addressing our immediate surroundings. Althamer's actions—very private in nature and unlike the heroic gestures that many artists are used to producing—are reflective of his own inquiry into what it means to be here in this world: he invited an old friend, who left their native Warsaw a long time ago, to move temporarily to Chicago to perform his daily job as a house painter at the Museum of Contemporary Art for the duration of Althamer's show there in 2001; he has driven across Europe with his immediate family and close relatives, transforming leisure, tourism, and travel into a work of art; he has fired simple ashtrays in the manner of ancient Japanese pottery to produce a fund-raising multiple for the Kunstverein in Cologne. If Beuys was professing awareness of the regal individual, Althamer is searching for the true humbleness to be found in human nature.

Sleeping in a tree in the middle of winter or inviting viewers to look at his exhibition through a pair of glasses without lenses only to discover that the "show" is nothing more than a small run-down alley behind the gallery space are, for this artist, moments that create awareness of context and of its contradictions in a world constructed more and more on values of comfort and beauty. In an almost Franciscan way, reminiscent of some Arte Povera actions or artworks, Althamer forces the viewer to look into herself or himself, asserting the position that art's first context is within ourselves—our soul and mind, not yet corrupted by the speed of contemporary reality. What we see is what we *want* to see. For the now-famous but invisible action he staged for *Manifesta 3* in Ljubljana in 2000, Althamer hired professional actors to perform as "normal" bystanders a few times each day in one of the town's squares. Only after having seen a number of these performances could viewers realize that what they were seeing was not the real life of the city but a set carefully constructed and directed by the artist. The message gradually became clear: what we are looking at is important in terms of what we will make of it in our own lives, in our own private and hidden creative processes. We all are actors, Althamer seems to say, and it is up to us to figure out how we want to change the world through our daily performance called life.
— *Francesco Bonami*

BORN
1967, Warsaw, Poland

LIVES AND WORKS
Warsaw

Pawel Althamer has exhibited his work in solo exhibitions at Bonnefanten Museum, Maastricht, Netherlands (2004, catalogue); Kunstverein Düsseldorf (2003); neugerriemschneider, Berlin (2003); The Wrong Gallery, New York (2003); Center for Contemporary Art, Ujazdowski Castle, Warsaw (2002, 1998); Alexanderplatz, Berlin (2002); Kunstverein Münster, Germany (2002); Foksal Gallery Foundation, Warsaw (2001, 1996, catalogue); Museum of Contemporary Art, Chicago (2001); Kunsthalle Basel (1997, catalogue); Galeria Kronika, Bytom, Poland (1996, catalogue); and Galeria WOK, Warsaw (1994).

Group exhibitions include: *Art Focus 4*, Israel Museum, Jerusalem (2003); *Spojrzenia 2003*, Zacheta National Gallery of Art, Warsaw (2003); 50th Venice Biennale (2003, catalogue); *I Promise It's Political*, Museum Ludwig, Cologne (2002, catalogue); *Ausgeträumt...*, Secession, Vienna (2002, catalogue); *The Collective Unconsciousness*, Migros Museum für Gegenwartskunst, Zurich (2002); *Jubilee Exhibition: Neue Welt*, Frankfurter Kunstverein, Frankfurt am Main (2001, catalogue); *Vi*, Rooseum Center for Contemporary Art, Malmö, Sweden (2001, catalogue); Biennale d'art contemporain de Lyon, France (2000, catalogue); *Manifesta 3*, Ljubljana, Slovenia (2000, catalogue); *Documenta X*, Kassel, Germany (1997, catalogue); *Sonsbeek '93*, Arnhem, Netherlands (1993, catalogue); and *Magicians and Mystics*, Center for Contemporary Art, Ujazdowski Castle, Warsaw (1991, catalogue).

SELECTED BIBLIOGRAPHY

Bonami, Francesco. "Requiem for a Dream." *Flash Art* 34, no. 223 (March–April 2002): 68–69.

Cameron, Dan. "Manifesta 3." *Artforum* 39, no. 4 (December 2000): 142.

Przywara, Andrzej. *Pawel Althamer*. Exhibition catalogue. Basel: Kunsthalle Basel, 1997.

Szymczyk, Adam. "The Annotated Althamer." *Afterall* (May 2002): 14–23.

Szymczyk, Adam, and Andrzej Przywara. *Pawel Althamer*. Exhibition catalogue. Warsaw: Galeria Foksal, 1996.

PAWEL ALTHAMER
Ohne Titel (Untitled),
installation at neugerriemschneider,
Berlin, May 30 – August 16, 2003
mixed media, dimensions variable
Courtesy of the artist and
neugerriemschneider, Berlin

PAWEL ALTHAMER
stills from *Film* at *Manifesta 3,*
Ljubljana, Slovenia,
June 23 – September 24, 2000
performance
Courtesy of the artist;
Foksal Gallery Foundation, Warsaw;
and neugerriemschneider, Berlin

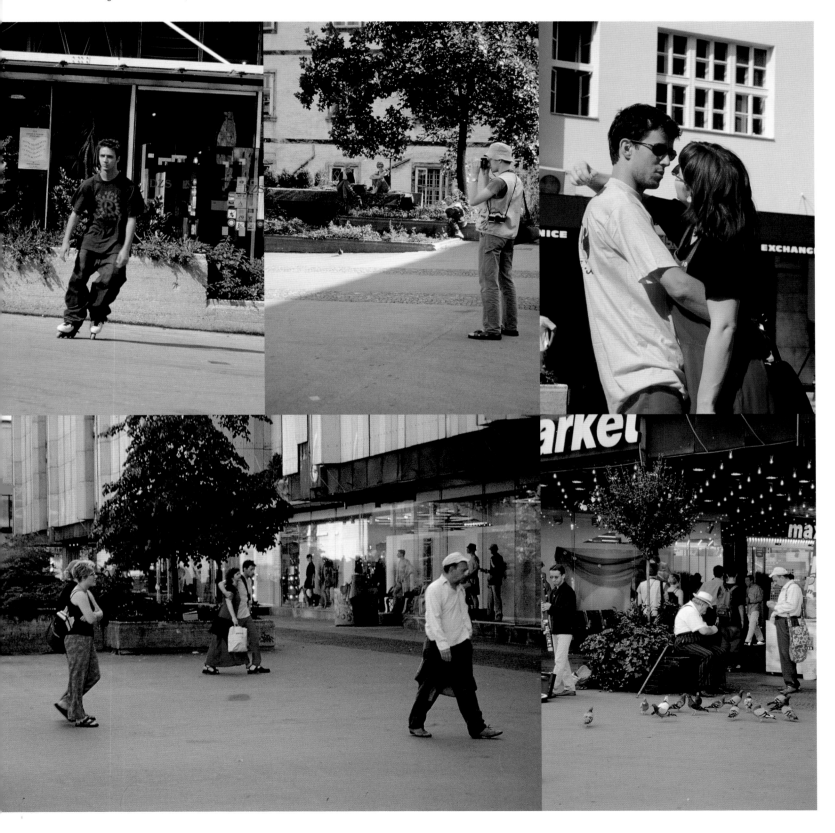

Francis Alÿs

Before language

BORN
1959, Antwerp, Belgium

LIVES AND WORKS
Mexico City, Mexico

Francis Alÿs has performed and exhibited his paintings, drawings, videos, and installations in solo shows at the Kunstmuseum Wolfsburg, Germany (2004, traveled to Nantes, France); Centro nazionale per le arti contemporanee, Rome (2002–3, traveled to Kunsthaus, Zurich, and Museo Nacional Centro de Arte Reina Sofía, Madrid, catalogue); Museum of Modern Art, New York (2002); Castello di Rivoli, Turin (2002); Lisson Gallery, London (2002); Lala Montcada de la Fundació la Caixa, Barcelona (2000, catalogue); Contemporary Art Gallery, Vancouver, British Columbia (1998); and Museo de Arte Moderno, Mexico City (1997, catalogue), among others.

Group exhibitions include: Sydney Biennial, Australia (2004, catalogue); *Made in Mexico,* Institute of Contemporary Art, Boston (2004, catalogue); *Fast Forward,* Media Art/Sammlung Goetz, ZKM/Zentrum für Kunst und Medientechnologie, Karlsruhe, Germany (2003, catalogue); *Strangers,* First ICP Triennial of Photography, International Center of Photography, New York (2003, catalogue); *Stretch,* The Power Plant, Toronto (2003); *Somewhere Better than This Place,* Contemporary Arts Center, Cincinnati, Ohio (2003, catalogue); *Edén,* La Colección Jumex, Antiguo Colegio de San Ildefonso, Mexico City (2003, catalogue); Shanghai Biennale (2002, catalogue); *Twenty Million Mexicans Can't Be Wrong,* South London Gallery, London (2002); 8th Baltic Triennial of International Art, Vilnius, Lithuania (2002, catalogue); *Moving Pictures,* Solomon R. Guggenheim Museum, New York (2002, traveled to Guggenheim Bilbao, Spain, catalogue); *Mexico City: An Exhibition about the Exchange Rates of Bodies and Values,* P.S. 1 Contemporary Art Center, Long Island City, New York (2002, traveled to Kunst-Werke, Berlin, catalogue); 6th and 7th International Istanbul Biennials (2001, 1999, catalogues); 49th Venice Biennale (2001, catalogue); *Painting at the Edge of the World,* Walker Art Center, Minneapolis (2001, catalogue); *Making Time,* UCLA Hammer Museum, Los Angeles (2001, catalogue); 7th Bienal de la Habana, Cuba (2000, catalogue); and *Mirror's Edge,* BildMuseet Umeå, Sweden (1999–2000, catalogue).

SELECTED BIBLIOGRAPHY

Alÿs, Francis, and Catherine Lampert. *Francis Alÿs.* Madrid: Turner, 2003.

Heiser, Jörg. "Walk on the Wild Side." *Frieze,* no. 69 (September 2002): 70–73.

Martin, Patricia, ed. *Edén.* Exhibition catalogue. Mexico City: La Colección Jumex, 2004.

Medina, Cuauhtémoc. "Recent Political Forms: Radical Pursuits in Mexico/Formas políticas recientes: búsquedas radicales en México/ Santiago Sierra. Francis Alÿs. Minerva Cuevas." *Trans>arts.cultures.media,* no. 8 (2000): 146–63.

Parkett, no. 69 (2003): 18–59. Special section, including essays by Kitty Scott, Saul Anton, and Robert Storr.

There are flies buzzing around in several of Francis Alÿs' paintings, punctuating a number of scenes that might otherwise seem merely visionary. In *The Prophet* (a series begun in 1992), the insects swarm around the head of a man who walks and talks to himself, as if so absorbed in his ideas that he is oblivious to any indication of mortality. Flies chase the wise and dogmatic, pestering the imperialism of speech and thought. Those flies suggest that under the encaustic veil something is fleshy and rotting. Through them Alÿs indicates that his paintings are a kind of carrion: dead residues of thought, corpses of the imagination. Or perhaps the flies are incarnations of thoughts.

Although better known for his conceptual walks and social interventions that activate the physical and utopian territory of the city, Alÿs has long used painting as a parallel endeavor. Enigmatic despite their simple figurative style, the paintings have a complex relationship to the rest of his work, offering him a means for disseminating his concepts and "sculpture ideas" to a wider audience (and sensibility). Those translations gave rise to his first social intervention: a five-year-long collaboration with commercial sign painters who copied and reinterpreted Alÿs' designs, creating images analogous to the hand-painted advertisements the artist found while wandering in Mexico City's historic center, but also reminiscent of the visual language of the Italian Renaissance. For half a decade, Alÿs' collaborators created a microtradition of painting, consisting of a genealogy of copies and variations. At the same time, this project became Alÿs' only training in the painter's craft, derived from a careful observation of sign-painting techniques.

It was not long before Alÿs' paintings took on a life of their own. He delegated to them the task of giving shape to everything he had initially tried to convey in the guise of objects, a whole series of imaginary configurations that, according to the artist, "could be perceived as if through skin, about the things the body knows, after which comes language." Painting became the projection screen for a whole catalogue of fantasies and articulations of interactions between things and the body. Object/body situations become allegorical only after we translate them into our inner senses as small violations of common sense, to the point that they sometimes resemble minor miracles, which lack, however, any moral purpose of their own.

The development of his painting practice led Alÿs to a personal division of labor. Whereas his actions are narratives that usually have a starting point in an explicit and transparent script, which later on takes the work into a chain of unexpected consequences and meanings, his paintings operate in the opposite direction: they present us with an unspeakable situation using the clearest possible iconography. Whereas his social interventions occur within the field of language, his paintings seem to happen outside of concepts. In a way, they are musings on ideas that would otherwise be only private and fleeting. We may call them "figures of thought," to avoid any pretense of psychological depth and/or the temptation of further interpretation.

If Alÿs' paintings are enigmatic, it is because they suggest a meditation on the limitations of individual will, art, and politics. In one work a shirtless young man lies on the ground next to his rifle, surrounded by flies. As with all the artist's icons, the meaning is uncertain: Does the painting depict the corpse of a guerilla soldier fallen in the pursuit of utopia or, instead, a graceful dream of action? It may well be that only the flies know. —*Cuauhtémoc Medina*

FRANCIS ALŸS
Untitled, 2001
oil on encaustic
13 3/4 × 9 7/8 in. (35 × 25 cm)
Courtesy of the artist

left
FRANCIS ALŸS
Untitled, 2001
oil and encaustic on cloth and wood
10 5/8 × 6 3/4 × 1 1/16 in. (27 × 17 × 2.7 cm)
Courtesy of the artist

right
El Soplón (The scavenger), 1995–2002
oil, encaustic, and collage on canvas on wood
9 7/8 × 7 3/4 × 2/3 in. (25 × 19.7 × 1.7 cm)
Courtesy of the artist

below
study for *El Soplón* (The scavenger), 1996
oil, graphite, and color photograph on tracing paper
9 1/2 × 11 7/8 in. (24 × 30 cm)
Courtesy of the artist

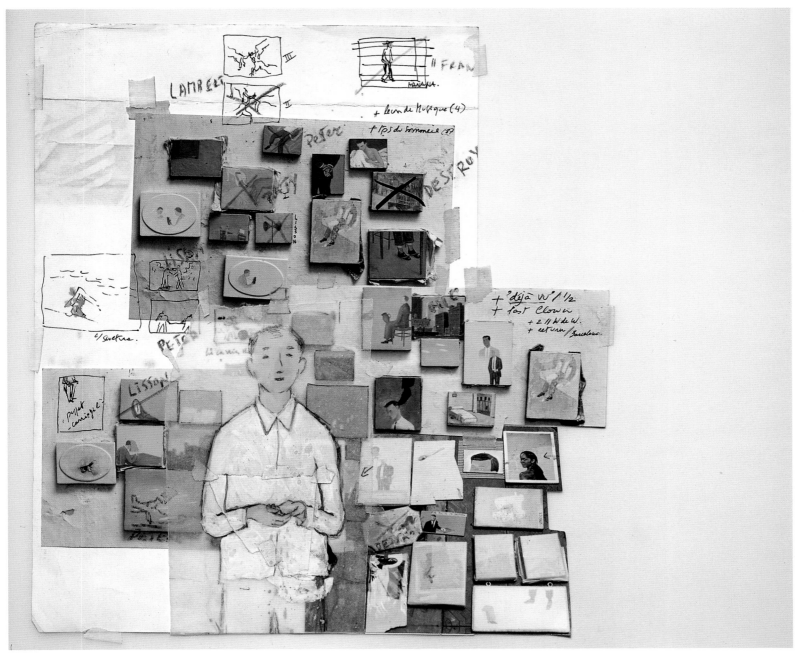

Mamma Andersson

Mamma Andersson subversively transforms the conventional space of figurative painting by invading it with signs of decay, while at the same time livening it up through her optical effects. Living rooms, bedrooms, galleries, and libraries—all markers of bourgeois pleasure and refinement—are frequented by unnatural visitations: black smoke, like an evil omen, broods over a family at a dining table, and an apparition of a landscape erupts into a waiting room. One suspects that these emanations are coming from the paintings (tokens of a civilized life) that are ever present in Andersson's pictorial space. In many of her tableaux, paintings, as objects within the scene, claim a presence equal to or stronger than human beings or furniture.

Andersson makes use of a number of techniques to create an illusory movement in her works: deliberate effacing of the edges of the canvases; adept control of color values; and uneven application of paint, leaving the surface flat but nuanced with texture reminiscent of etching or woodcut prints. Patterns come forward and walls and floors recede, causing the inversion of the fictive and the real. The reversal of significance between the living and the dead, between reality and art history, is effectively embodied in *Touched by Gods* (2003). In what appears to be a museum bookstore, people examining the books are transparent and fading, while on the floor is projected a barely intelligible scene from a counterfeit historical painting with an occult touch. The browsers seem unaware of their own disappearance or of the stalking painterly ghosts: tableaux by Edvard Munch, Luc Tuymans, and Peter Doig, niched on the shelves like icons, assert a lineage of painters with whom Andersson allies herself.

Andersson seems to be addressing the decline of bourgeois culture as a system that has long supported the fine arts, as well as the reification of painting as a symbol of useless pleasure, an inevitable result of the ossification of modernism and the postmodern relativization of taste. The "death" of an artistic sensibility is exquisitely illustrated in the elegiac canvas *Stairway to the Stars* (2002). Here, a group of anemic members of the bourgeoisie are having a picnic by the lake, oblivious to the Hopper, Monet, and Gauguin paintings mysteriously stacked together behind them like a display of commodity samples.

The disintegration of art-historical context nevertheless mobilizes Andersson's painterly universe. Her works, in which multiple planes coexist and interpenetrate, convey a dematerialization of the world, while her control of varied textures asserts the materiality of painting. Aspects of a horror film and an ornamental reworking of a painterly surface meet in *Nordic Pavilion* (2004), which shows a museum gallery in dissolution. The showcases are emptied out and fading, while two columns of color patterns, as if sucked up from previously displayed objects, prepare new formations. A ghostly outline of a gigantic baby seated on a model's stool may indicate an end of one humanist culture and the beginning of another. As in Andersson's other works, *Nordic Pavilion* captures a transitional state in which a rebirth of painting is envisioned in the middle of the chaos created by visual phenomena freed from boundaries.
— *Midori Matsui*

BORN
1962, Luleå, Sweden

LIVES AND WORKS
Stockholm, Sweden

Mamma Andersson studied at the Kungliga Konsthögskolan in Stockholm. She has exhibited her paintings in solo exhibitions at Stephen Friedman Gallery, London (2002); Galleri Magnus Karlsson, Stockholm (2002, 2000, 1997); Konstens Hus, Luleå (2001); Galleri 1, Gothenburg, Sweden (2001, 1997); Galleri Tornhuset, Luleå (1988); and Norrbottensmuseet, Luleå (1985), among others.

In 2003, Andersson was one of three representatives of the Nordic countries to participate in the 50th Venice Biennale in an exhibition at the Nordic Pavilion entitled *Devil May Care*. Other group exhibitions include: *Art Forum Berlin* with Galleri Magnus Karlsson (2002); *Blir du lonesome lille vän*, Konstnärshuset, Stockholm (2001); *Carnegie Art Award—Nordic Painting* (2000-2001, 1998-99, traveled to Stockholm, Copenhagen, Oslo, Helsinki, and Reykjavik); *X:et 100 år*, Botkyrka Konsthall, Stockholm (1999); *Aptitretare*, Konstakedemien, Stockholm (1999); *2+2*, Jönköpings läns Museum, Sweden (1997); and *Alone Together*, Liljewalchs Konsthall, Stockholm (1996).

SELECTED BIBLIOGRAPHY
Charlesworth, J.J. "Northern Exposure." *Art Review* 54 (December 2002 - January 2003): 120 - 21.

Herbert, Martin. "Mamma Andersson." *Time Out*, October 6-13, 2002, 57.

Higgie, Jennifer. "Morning Stands on Tiptop." *Frieze*, no. 68 (Summer 2002): 68-71.

Jortvelt, Anne Karin, and Andrea Kroksnes, eds. *Devil May Care: The Nordic Pavilion at the 50th Venice Biennale, 2003* (Ostfildern-Ruit, Germany: Hatje Cantz, 2003).

O'Reilly, Sally. "Mamma Andersson." *Art Monthly*, no. 262 (December 2002 - January 2003): 38 - 39.

MAMMA ANDERSSON
Traveling in the Family, 2003
oil on panel
36 1/4 × 48 1/16 in. (92 × 122 cm)
Collection of Christian Larsen, Stockholm;
courtesy of Galleri Magnus Karlsson, Stockholm;
Stephen Friedman Gallery, London;
and David Zwirner, New York

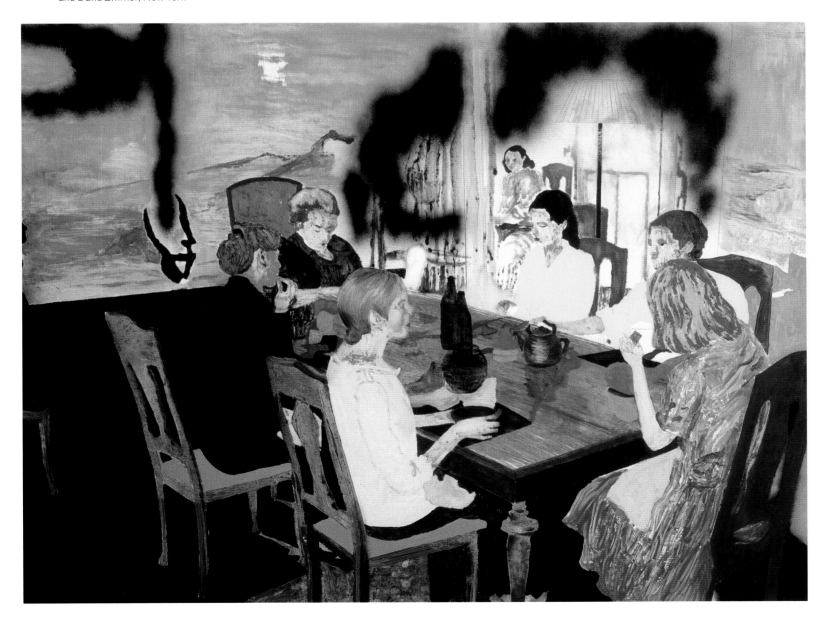

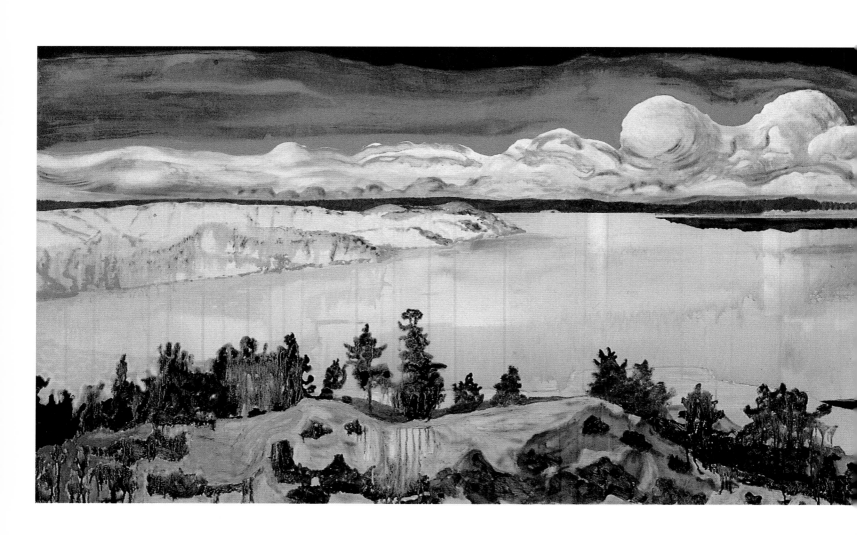

top
MAMMA ANDERSSON
Nordic Pavilion, 2004
oil on canvas
43 5/16 × 110 1/4 in. (110 × 280 cm)
Courtesy of Galleri Magnus Karlsson, Stockholm;
Stephen Friedman Gallery, London;
and David Zwirner, New York

bottom
Heimat Land, 2004
oil on canvas
31 1/2 × 110 1/4 in. (80 × 280 cm)
Collection of Jill and Dennis Roach, Los Angeles;
courtesy of Galleri Magnus Karlsson, Stockholm;
Stephen Friedman Gallery, London;
and David Zwirner, New York

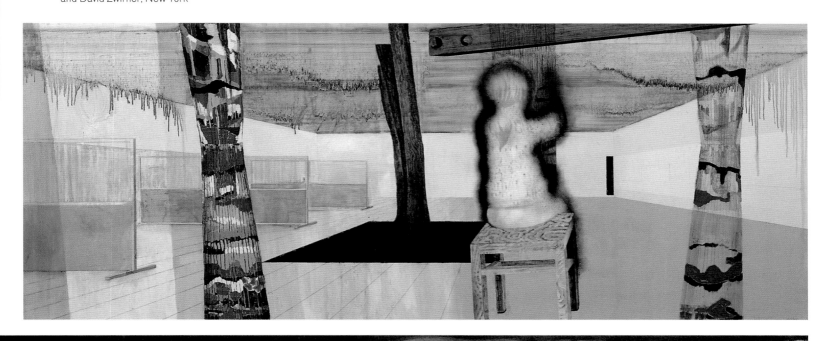

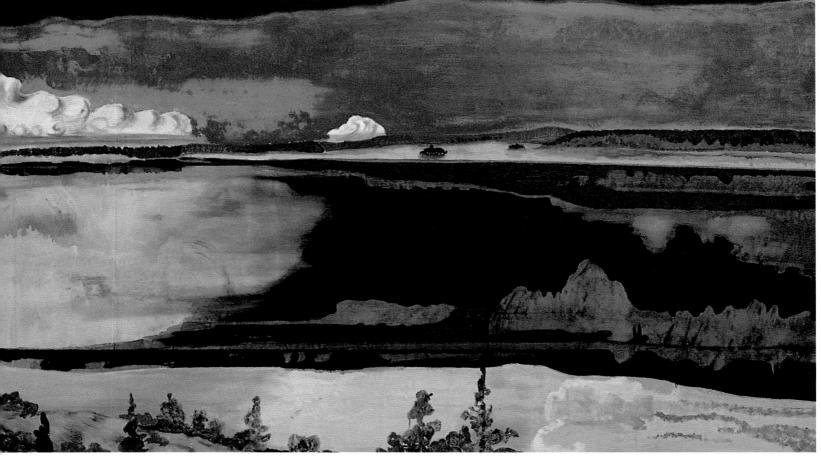

Chiho Aoshima

Chiho Aoshima's work embodies a synthetic imagination of the machine age. She creates backlit tableaux and large murals consisting of digital printouts that are drawn using Adobe Illustrator. With a mastery of computer technology, she demonstrates an effortless control of information and speeded-up image integration. In her hybrid universe, large-eyed, sinuous-limbed girls befriend reptiles, lie in the crotches of humanized trees, and grow wings or satellite antennae on their heads; in one case, a girl's gigantic head turns into a mountain. The harmonious coexistence of humans and nonhumans—with body parts blending with the landscape, creatures, and machines—indicates simultaneously a higher integration of species and a chaotic disintegration of all the boundaries between them.

The hybridization of imagery demonstrates Aoshima's creative deployment of postmodern Japanese culture. Representing the Pop sensibility of an adolescent female, who gathers details from disparate sources to realize her fantasy, Aoshima's digitized allegory could be said to fulfill the ideological mission of Superflat, which, as developed and defined by Takashi Murakami, aims to assert the "infantile" imagination of Japanese Pop as a major driving force of contemporary creativity. Aoshima modifies Japanese animation's exploitative representation of pubescent girls with the cool eroticism of her girl characters, whose unemotional engagement in violent acts inverts the nuances of cuteness. Her arcadian world of reptile-loving girls and blended imagery of interstellar travel and underwater existence, exemplified by *The Red-Eyed Tribe* (2000), poetically rewrites that of *Naucica* (1984), the vastly popular Hayao Miyazaki futuristic anime featuring an insect-loving princess who restores the arid Earth to life.

The Superflat resuscitation of traditional Japanese formal traits, including the decorative transformation of nature and composing with color fields, is exquisitely cultivated in Aoshima's tableaux. Again, in *The Red-Eyed Tribe*, the horizontal arrangement of human figures and trees accentuates the blue and white color fields of the sky and the earth, canceling out any linear perspective and directing the viewer's eye horizontally across the surface toward the edges of the canvas. The sprinkling of bright color spots over the pictorial plane creates multiple focuses, mobilizing its space, just as the red eyes of the alabaster girls resonate with the red fruits and blossoms of the trees in the periphery. In *Zombie* (2002), which depicts zombie girls rising from their graves, the ornamental application of bright color fields, such as the highly charged green grass and the gold-streaked blood-orange sky, enhances the picture's lurid apocalyptic impression.

Aoshima's projection of alternating utopian and apocalyptic visions may reflect the fascination and the anxiety aroused by imminent technological change. Aoshima recapitulates the heritage of sensorially activating pictorial surfaces and altered visions of life, touching on Maxfield Parrish's appropriation in the early twentieth century of art-nouveau allegorical tableau-vivant arrangements; Tsukioka Yoshitoshi's late ukiyo-e practice, in which ornamental bright color spots and the depiction of bloody acts of cruelty are used for erotic effect; and the fluorescent glitter of aquamarine, white, and gold characteristic of Roger Dean's illustrations for the album covers of Yes and Asia. With her own pictorial surface capturing the diffraction of a computer screen and her cyborg surrealism, Aoshima practices a new psychedelic allegory that projects the pain and the pleasure of a human nature that continually reinvents itself.—*Midori Matsui*

BORN
1974, Tokyo, Japan

LIVES AND WORKS
Tokyo

Chiho Aoshima received her BA from Hosei University. She has exhibited her computer-generated, site-specific works in solo exhibitions at Berkeley Art Museum, University of California, Berkeley (2003), and Blum & Poe, Los Angeles (2002).

Group exhibitions include: *Tokyo Girls Bravo*, Marianne Boesky Gallery, New York (2004); *Gallery Exchange*, LFL Gallery, New York (2004); *For the Record: Drawing Contemporary Life*, Vancouver Art Gallery, British Columbia (2003); Liverpool Biennial, Tate Liverpool (2002, catalogue); *Hiropon Show*, Museum of Contemporary Art, Tokyo (2001); and *Superflat*, originating at the Parco galleries in Tokyo and Nagoya (2000, traveled to the Museum of Contemporary Art, Los Angeles, Walker Art Center, Minneapolis, and Henry Art Gallery, Seattle).

SELECTED BIBLIOGRAPHY

Darling, Michael. "Plumbing the Depths of Super-flatness." *Art Journal* 61 (Spring 2001): 76–89.

Fujitsu, Ryota. "Superflat: Battle of America." *Bijutsu Techo* (Tokyo) 53 (April 2001): 179–90.

Kandel, Susan. "Oops, I Dropped My Dumplings." *Artext* 73 (May–July 2001): 40–45.

Murakami, Takashi. "A Theory of Super Flat Japanese Art." In *Superflat*. Tokyo: Madra Publishing and Takashi Murakami, 2000, 8–25, 117.

Murakami, Takashi, ed. *Tokyo Girls Bravo*. Saitama: Kaikai Kiki Corporation, 2002.

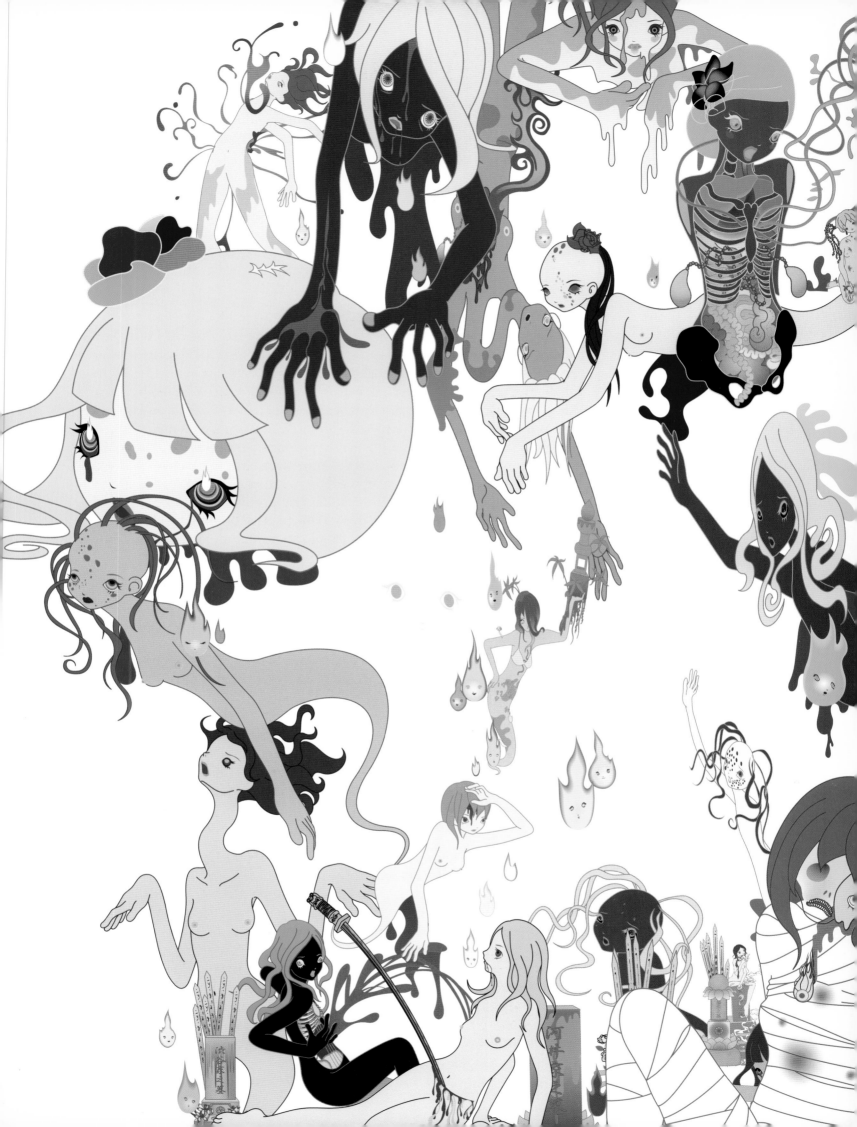

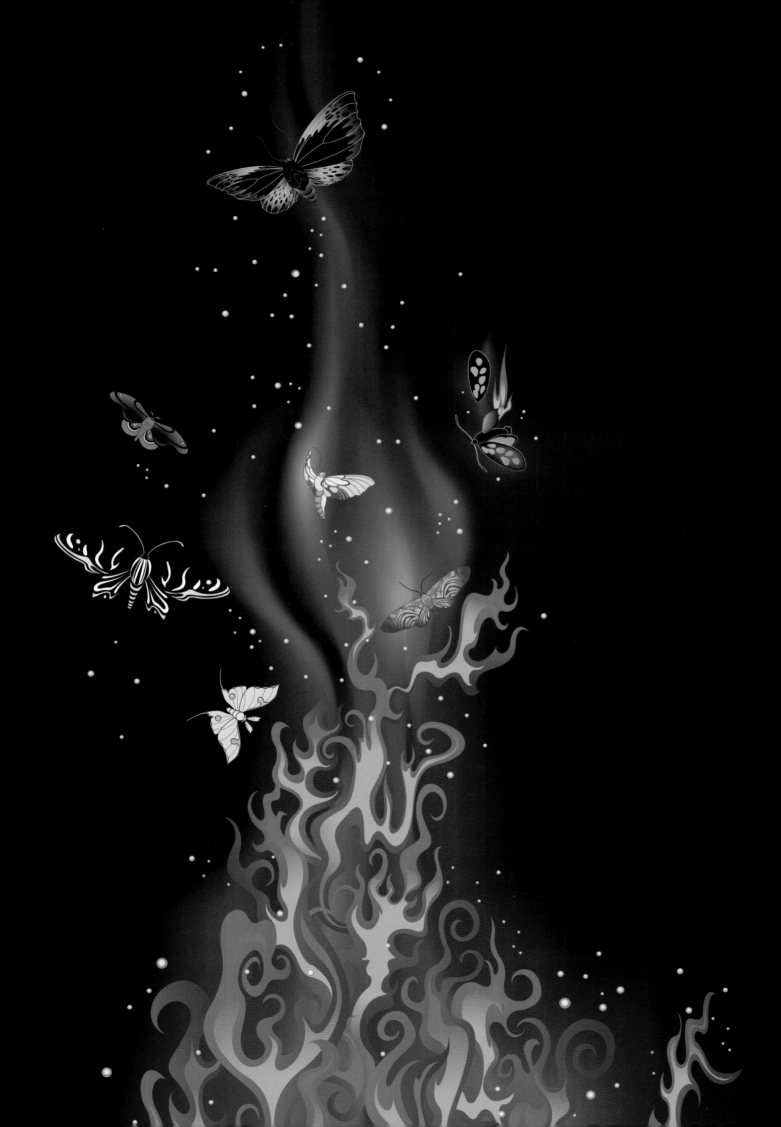

57

previous page
CHIHO AOSHIMA
Powerhouse Legion of Zombies, 2004
ink-jet print on paper
11 ft. 7 1/8 in. × 11 ft. 10 1/4 in. (353.5 × 361.3 cm)
Courtesy of the artist and Blum & Poe, Los Angeles
© 2004 Chiho Aoshima/Kaikai Kiki Co., Ltd.
All Rights Reserved.

left
Burning Moths, 2004
right
Burning Fairies, 2004
silk-dye paintings
78 1/8 × 25 1/2 in. (198.5 × 65 cm) each
Courtesy of the artist and Blum & Poe, Los Angeles
© 2004 Chiho Aoshima/Kaikai Kiki Co., Ltd.
All Rights Reserved.

Kaoru Arima

Kaoru Arima's art addresses a complex set of issues: the possibility of an interstitial existence within the contemporary constraints of informational overflow and capitalist dominance; exploration of the adolescent imagination; and reclamation of the heritage of a traditional Japanese genre, namely, drawings integrating poetry made by recluse intellectuals.

Since 1996, Arima has run Art Drug Center, an art space in an old two-story house situated in the castle town of Inuyama, on the outskirts of Nagoya, that exhibits the work of young artists. The name derives from Arima's conception of art as a spiritual remedy. The center is furnished with findings from the junkyard, and though the space is elegantly refurbished, it embodies the artist's philosophy of living modestly, making the most of available means in the hope of discovering the "hidden beauty" in life. Deeply connected to this attitude is Arima's choice of drawing as the sole means for his artistic expression. Using correction fluid to make a blank canvas out of discarded newspaper, he draws pictures accompanied by epigrammatic texts. This reuse of an everyday object of waste in the creation of fragile but condensed expressions of his thoughts recapitulates the teachings of Tea, defined by Okakura Tenshin as "a way of life based on the appreciation of beauty in the simple practice of the Everyday"; this practice is revealed through respect for unfinishedness, acceptance of one's lack of control over the arbitrary powers of life, and the aspiration to achieve a personal integration of spirit and nature.

The improvisation spurred by the modesty of his materials allows Arima to convey the undifferentiated process of his imagination. Recurrent motifs indicate an internal mythical cycle. Men, women, animals, birds, and plants intermingle with one another to produce hybrids: heads connect directly with limbs; organs give birth to new organisms. Such "grotesque" figures are the scribbler's shorthand for the nocturnal visions of Redon and Bosch, cartoonish echoes of demons adorning fourteenth-century Gothic churches and twelfth-century Japanese Buddhist temples. Arima's figuration, signaling amateurishness and exposure to popular culture, betrays an "adolescent" tendency. Androgynous figures and amphibians inhabit his graphic cosmos, incarnating a state of indeterminacy, while words enlarge its associative field. As Julia Kristeva maintains, the "adolescent"—signifying the "open psychic structure" and characterized by sexual ambiguity and an ability for self-transformation—finds its artistic counterpart in the polyphonic narrative of modernist fiction and the cartoon narrative in which the adolescent resolves his or her spiritual crises through a dramatization of desire.

Inheriting the styles and attitudes of Japanese artists ranging from the early nineteenth-century haiku poet Kobayashi Issa to the early twentieth-century painter and satirist Ogawa Usen, whose playful drawings accompanied by aphorisms reflected their Taoist worldview, Arima reinvents the marginalized genres of *giga* (drawing for one's pleasure) and *manga* as new "adolescent" vehicles. Integrating his personal engagement with his public practice, Arima provides an example of a spiritually empowered individual system with a communal connection, representing an emergent tendency among Japanese young people to question the legitimacy of materialistic competition.—*Midori Matsui*

BORN
1969, Komaki City, Japan

LIVES AND WORKS
Inuyama, Japan

Kaoru Arima received his BFA in 1990 from Nagoya Zoukei Junior College's Product Design Department. His drawings have been featured in solo exhibitions at Watari-um Museum, Tokyo (2003–4); Art Drug Center, Inuyama (2001, 1997–99); Fukugan Gallery, Osaka (2000); and Westbeth Kozuka Gallery, Nagoya (1993–96).

Group exhibitions include: *Dessins et des Autres,* Galerie Anne de Villepoix, Paris (2004); *How Latitudes Become Forms: Art in a Global Age,* Walker Art Center, Minneapolis (2003, traveled to Fondazione Sandretto Re Rebaudengo, Turin, and Contemporary Arts Museum, Houston, catalogue); *Kageki Metonymics,* Linc Real Art, San Francisco (2003); Stefan Stux Gallery, New York (2003, 2002); *Beautiful Art Life,* Art Drug Center, Inuyama (2002); *Transit,* Laforet Harajuku Kokura, Kitakyushu (2001); *Sparrow Style,* Gallery Caption, Gifu (2000); *Let's Go to the Living Room,* Watari-um Museum, Tokyo (1998–99); *Art Rape,* Art Drug Center, Inuyama (1998); *Six Artists* and *Rabbit Pen Institute,* Westbeth Kozuka Gallery, Nagoya (1997); *The Long Night,* Sloe Bull House, Iwata-senshinkan Gallery, Inuyama (1995); *New Birth,* Nagoya Municipal Gallery (1995); *Art Wave '94,* Nagoya NHK Center Building (1994); and *Wemnptemptem 143,* Canovan Gallery, Nagoya (1994).

SELECTED BIBLIOGRAPHY
Hara, Hisako. "Kaoru Arima." *Studio Voice* (Tokyo) 338 (February 2004): 85.

How Latitudes Become Forms: Art in a Global Age. Exhibition catalogue. Minneapolis: Walker Art Center, 2003, 164–67.

"Kaoru Arima: An Interview." *Bijutsu Techo* (Tokyo) 52 (April 2000): 24–27.

Matsui, Midori. "A Vehicle for an Open-Psychic Structure: Notes Toward the Definition of Drawing." *Bijutsu Techo* (Tokyo) 52 (April 2000): 63–71.

———."The Return of the Pure Self." *Studio Voice* (Tokyo) 328 (April 2003): 118–23.

KAORU ARIMA
detail of *Untitled* (June 12, 2003), 2003
graphite, colored pencil, acrylic,
and ink on newspaper
21 7/16 × 15 15/16 in. (54.5 × 40.5 cm)
Collection of Yukinari Shimono, Tokyo;
courtesy of the artist and Cellar Gallery, Nagoya

60

KAORU ARIMA
detail of *Untitled* (June 10, 2003), 2003
graphite, colored pencil, acrylic,
and ink on newspaper
22 1/16 × 13 3/8 in. (56 × 34 cm)
Collection of the artist;
courtesy of the artist and Cellar Gallery, Nagoya

KAORU ARIMA
detail of *Untitled* (June 14, 2003), 2003
graphite, colored pencil, acrylic,
and ink on newspaper
21 7/16 × 15 15/16 in. (54.5 × 40.5 cm)
Collection of Hisanao Minoura, Aichi;
courtesy of the artist and Cellar Gallery, Nagoya

Kutlug Ataman

Kutlug Ataman investigates the fugitive and intuitive construction of identity through self-presentation. Acutely aware of the power of appearance, Ataman's subjects—whose personalities or unconventional life circumstances conspire to fashion eccentric personas—broadcast, quite literally, who they are through mostly uninterrupted soliloquy. In *Never My Soul* (2001), Ceyhan Firat chronicles her personal history of singing, gender modification, and sex work, a life underscored by performance in both public and private contexts. Mediated—albeit with extreme circumspection—by the artist, whose questions are usually edited out of the work, the resulting portraits stake no claim to truth but offer only extreme subjectivity, gleaned through the personal filter of lived experience. In these autobiographies, Ataman is interested less in separating truth from fiction than in presenting the complex intertwining of the two. The goal is to capture not only the subject's story but also the process of his or her self-invention as the story unfolds.

Ataman's skill for narrative exposition was honed during years of working as a feature filmmaker, a practice he maintains concurrently with his gallery-based video installations. The flexibility and specificity of the gallery context allows him to investigate more directly the relationship between presentation and representation, between artist, subject, and audience. A four-channel projection tracks each part of *The 4 Seasons of Veronica Read* (2002), which cycles through the annual growth, decay, and hibernation of the amaryllis flowers that are the subject's consuming passion. Using a single camera and ad hoc filming situations in which Ms. Read, an avid collector of *Hippeastrum*, responds to questions from an unseen interlocutor, Ataman captures the intimacy of a life led primarily in communication with plants rather than people. An epic on the tiniest of topics, the work is a parable on loneliness and the depth of human love—even if that love is for a flower. Specific conditions of identity and personal meaning are writ large in these works—issues of passion, belonging, and transgression and how they intersect with our attempts to navigate the world through devotion to political ideology, religious doctrine, or objects of affection.

Kuba (2004), Ataman's most ambitious project to date, constructs, voice by voice, a communal portrait of an encampment of politically and socially disenfranchised individuals. A string of low-income shanties on the fringe of Istanbul, Kuba was originally settled in the 1960s as an enclave of left-wing militants. Today it is home to a wide range of people who have become, by choice or by circumstance, isolated from, even oppositional to, the larger political and social fabric of Istanbul. In Ataman's installation, forty talking heads, each on its own monitor, quite literally map the terrain of the community through the accumulation of individual stories. Ranging from criminals, drug addicts, and teenage delinquents to Islamic fundamentalists to the very poor, the motley residents of Kuba have created an alternative society in which traditional laws and established norms have been superceded by the values of freedom and individual rights. In *Kuba* Ataman explores the interdependence of personal realities, no matter how different they are. He builds a compelling portrait of a state of mind, a communal identity embodied in the form of multiple subjectivities, yet grounded in a web of community values.—*Elizabeth Thomas*

BORN
1961, Istanbul, Turkey

LIVES AND WORKS
Istanbul

Kutlug Ataman studied at the University of California, Los Angeles, where he received his MFA in 1988 and his BA in 1985. He has exhibited his films in solo exhibitions at the Serpentine Gallery, London (2003, catalogue); GEM, Museum voor Actuele Kunst, The Hague (2002); Lehmann Maupin Gallery, New York (2002); Galleri Nikolai Wallner, Copenhagen (2002); Istanbul Contemporary Arts Museum (2002); BAWAG Foundation, Vienna (2002); and Tensta Konsthall, Stockholm (2001).

Group exhibitions include: International Istanbul Biennials (2003, 2001, 1997, catalogues); *Image Stream*, Wexner Center for the Arts, Columbus, Ohio (2003, catalogue); Deste Foundation for Contemporary Art, Athens, Greece (2003); *Witness*, Barbican Art Gallery, London (2003); *Days Like These*, Tate Triennial Exhibition of Contemporary British Art, Tate Britain, London (2003); *Documenta 11*, Kassel, Germany (2002, catalogue); *Hautnah*, The Goetz Collection, Munich (2002); Bienal de São Paulo (2002, catalogue); Berlin Biennial for Contemporary Art (2001, catalogue); Museum moderner Kunst, Vienna (2000); Kunstmuseum, Bonn (1999); 48th Venice Biennale (1999, catalogue); Centre des arts contemporains, Geneva (1999); Montreal Biennial, Québec (1998); and *Manifesta 2*, Luxembourg, Belgium (1998, catalogue).

SELECTED BIBLIOGRAPHY

Anton, Saul. "A Thousand Words: Kutlug Ataman Talks about *1+1=1*." *Artforum* 41, no. 6 (February 2003): 116–17.

Honigaman, Ana Finel. "Kutlug Ataman." *Tema Celeste* 93 (September–October 2002): 91.

Kuba. Exhibition catalogue. London: Artangel, 2004.

Kutlug Ataman: A Rose Blooms in the Garden of Sorrows. Exhibition catalogue. Vienna: BAWAG Foundation, 2002.

Smith, Roberta. "Kutlug Ataman's 'Never My Soul.'" *New York Times*, July 12, 2002.

below and overleaf
KUTLUG ATAMAN
Stills from *Kuba*, 2004
40-channel video installation with tables and chairs;
color, sound
Commissioned by Artangel and
co-produced by 2004–5 *Carnegie International*,
Carnegie Museum of Art, Pittsburgh; Lehmann
Maupin Gallery, New York;
Thyssen-Bornemisza Art Contemporary (T-B A21),
Vienna; and Theater der Welt, Stuttgart

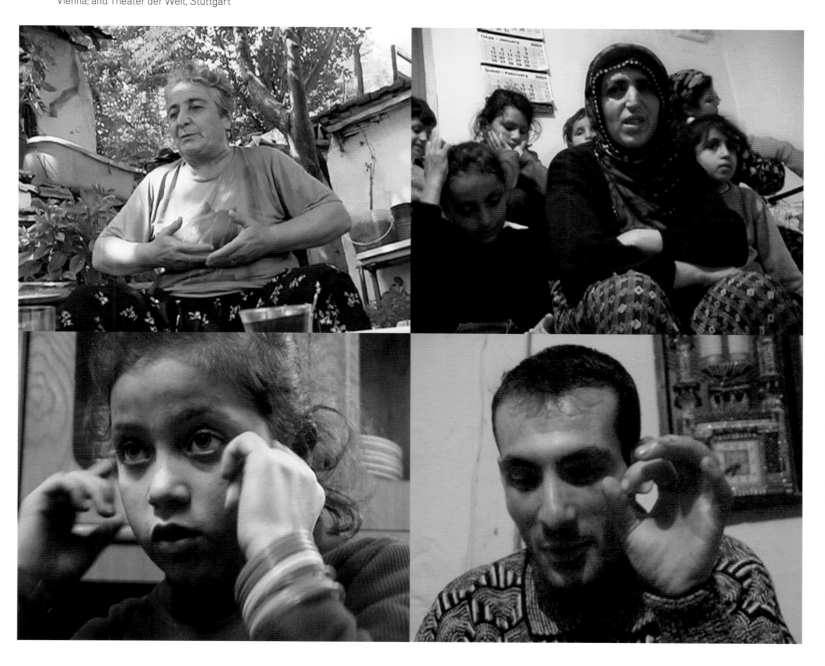

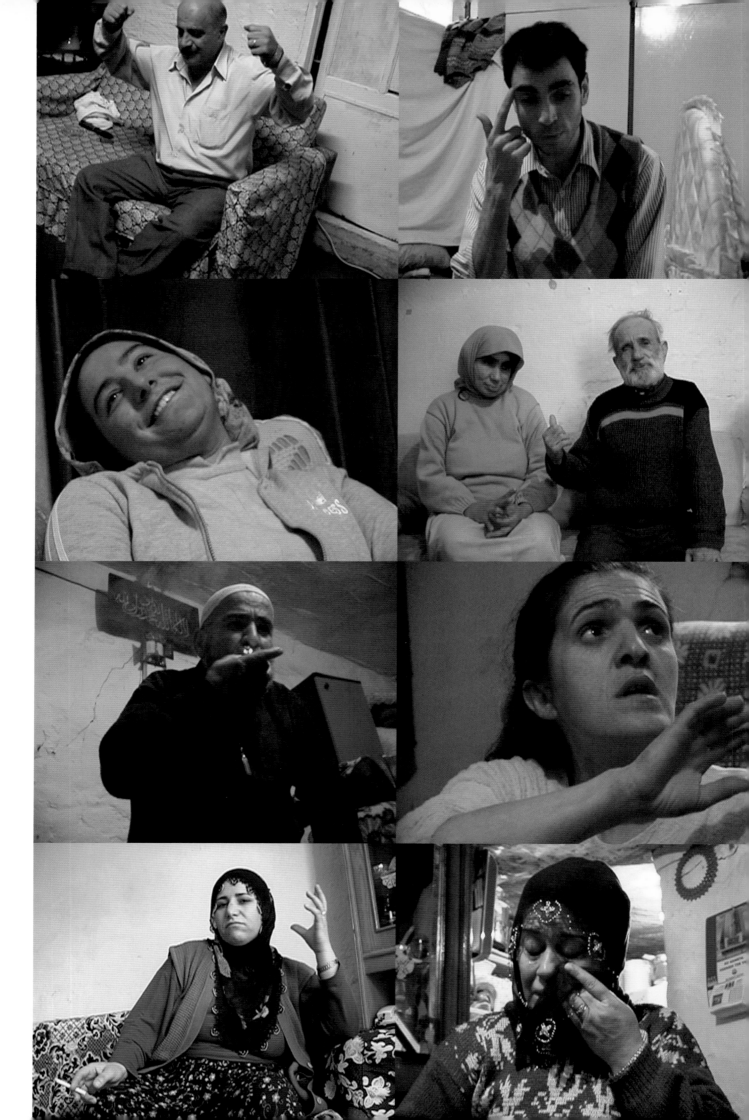

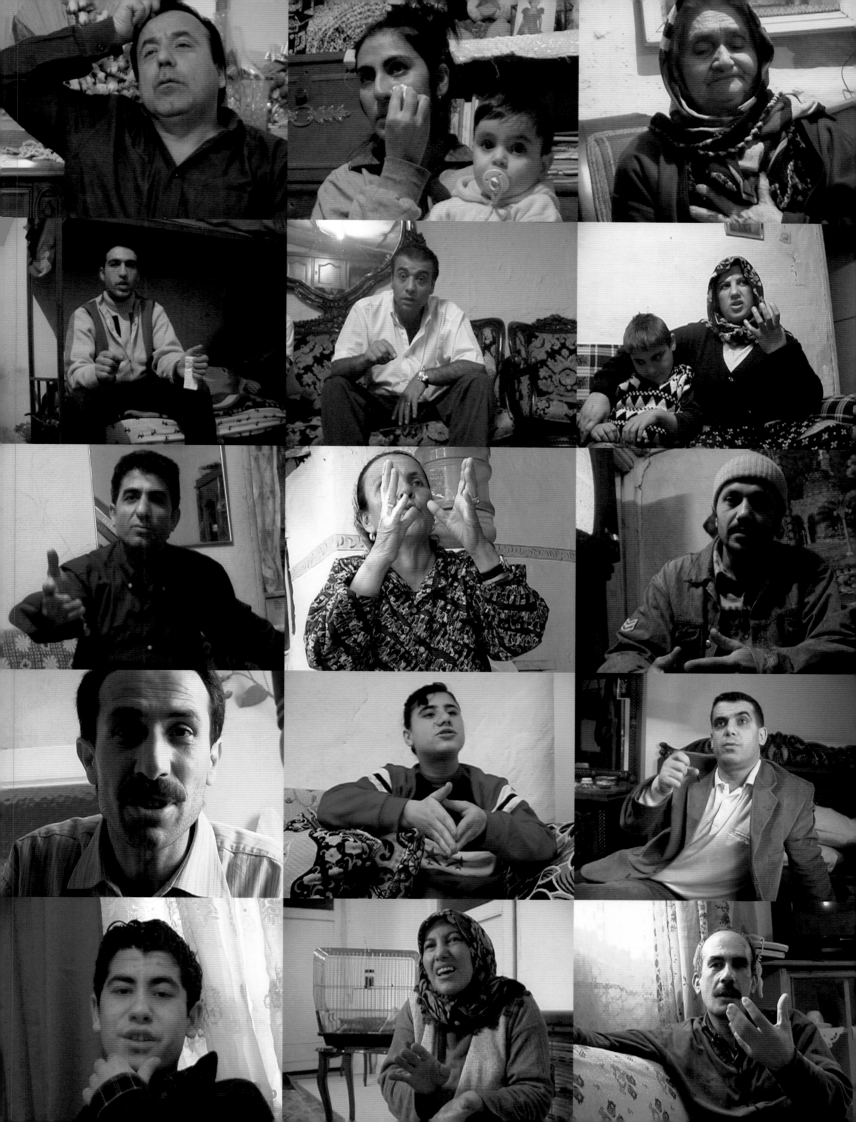

John Bock

$E=mc^2$. —Albert Einstein

BORN
1965, Gribbohm, Germany

LIVES AND WORKS
Berlin, Germany

John Bock studied at the Hochschule für Bildende Künste, Hamburg. His installations, performances, and films have been exhibited in solo shows at the Center for Contemporary Art, Kitakyushu, Japan (2004); Anton Kern Gallery, New York (2004, 2001, 1999); Arken Museum for Moderne Kunst, Ishøj, Denmark (2003); Oldenburger Kunstverein, Germany (2002); Sadie Coles HQ, London (2001); Museum of Modern Art, New York (2000); Kunstverein Bremen, Germany (2000); Klosterfelde, Berlin (1997–2000); Kunsthalle Basel (1999, catalogue); SMAK/ Stedelijk Museum voor Actuele Kunst, Ghent (1999, catalogue); Aarhus Kunstmuseum, Denmark (1999, catalogue); and Kunstkarton, Kunsthaus Hamburg (1994).

Group exhibitions include: *Sitings: Installation Art, 1969–2002*, Museum of Contemporary Art at the Geffen Contemporary, Los Angeles (2003); *Grotesque! Thirty Years of Witty Art,* Schirin Kunsthalle, Frankfurt am Main (2003, traveled to Haus der Kunst, Munich); *Extension*, Magasin 3, Stockholm Konsthall, Sweden (2002); *Hello, My Name Is…*, Carnegie Museum of Art, Pittsburgh (2002); *Documenta 11,* Kassel, Germany (2002, catalogue); *Drawings*, Regen Projects, Los Angeles (2001); *Mega Wave: Towards a New Synthesis,* Yokohama Triennial, Japan (2001, catalogue); *Children of Berlin,* P.S. 1 Center for Contemporary Art, Long Island City, New York (1999, catalogue); *German Open,* Kunstmuseum Wolfsburg, Germany (1999, catalogue); 48th Venice Biennale(1998, catalogue); and Berlin Biennial for Contemporary Art (1998, catalogue).

SELECTED BIBLIOGRAPHY

Dziewior, Yilmaz. "John Bock: The Receiver's Due." *Artext*, no. 68 (February–April 2000): 62–65.

John Bock. Exhibition catalogue. Basel: Kunsthalle Basel, 1999.

John Bock: Koppel. Exhibition catalogue. Cologne: Verlag der Buchhandlung Walther König, in association with Arken Museum for Moderne Kunst, 2004.

Jones, Ronald. "Openings: John Bock." *Artforum* 37, no. 10 (Summer 1999): 142–43.

Parkett, no. 67 (2003): 18–53. Special section, including essays by Jan Avgikos, Daniel Birnbaum, and Jens Hoffman.

The lecturer turned to his assistant and demanded that the aerosol spray of whipped-cream foam bypass the regular circular relationship between time and space. He transposed simple structures from life or living conditions into new formulations, which can either jumpstart or immediately annihilate the existence of the universe. Though lecturing was his preferred mode, he never spoke solo; there were lab assistants and Konstanze, the chambermaid of Madame Pompadour, or the local beauty and bystanders. In these events, Baroque drama, the Nouvelle Vague, Rococo chaos, and soap-operatics were misquoted. They were never elegant, more or less egalitarian, leaning more toward social sculpture, and more or less Happenings, often accompanied by beer drinking and flying cabbage heads, raw.

The lecturer, John Bock, graduated from the Hochschule für Bildende Künste, Hamburg, among colleagues who were all propelled to prominence in the recent flourishing of Germany's youthful artistic endeavors. In the footsteps of his mentor, Franz Erhard Walter, Bock has developed his own interpretation and interpolation of minimalist body art and maximal performance art (Fluxus, Happenings, Actionism), reasonably brushing up against the social sculpture of Joseph Beuys. Neither direct nor oblique, nor circumlocutory in his meandering, Bock in his lecturistic theatering brings us closer to a comprehension of Einstein's theorizing of time and space relativity, but without the death of the hare. Through the worm or rabbit hole in which we poke our heads, hands, and arms, Bock fits us prosthetically into vocabularies of the human condition. We encounter the delirium of galactic time travel. Interlocking like the collectively driven Borg society (mother-ship Earth's archenemy) of Enterprise starships, a Bock sculptural rub(r)ic can pull together a gathering of relativity tourists. In a journey comparable to presently visiting the souks of Morocco or a night market in Guangzhou straight out of a Philip K. Dick future, we are confronted and confounded by a John Bock world. We become Tourists of the Absurd—absurd because the relativity of this lecture trip cannot be deciphered through textual signs but understood only as textual body. Swim in it but don't try to drink it, at least not at the same time.

Professor Einstein was once asked about the possibility of time travel, and he confirmed that it would be possible, but not probable by virtue of the simple fact that for a person to be transported from the present to the past, the atoms of the selves present and past would collide in transit. The site of this catastrophic collision is where Bock's language lies—particles from the past flying apart, in the present, toward the future, the superexplosion of the persona attempting to bypass relativity, by means of invention. Only a poker-faced, oatmeal-encrusted facade can withstand its impact.
—*Rirkrit Tiravanija*

top
JOHN BOCK
MeechHouse, presented at *Documenta 11*,
Kassel, Germany, June 8 – September 15, 2002
Courtesy of the artist; Klosterfelde, Berlin;
and Anton Kern Gallery, New York

bottom
reziproker Break-even-point im Molloch,
presented at *Documenta 11*,
Kassel, Germany, June 8 – September 15, 2002
Courtesy of the artist; Klosterfelde, Berlin;
and Anton Kern Gallery, New York

below
JOHN BOCK
Großes Puppenspiel, presented at *Documenta 11,*
Kassel, Germany, June 8 – September 15, 2002
Courtesy of the artist; Klosterfelde, Berlin;
and Anton Kern Gallery, New York

right
*MEECHfeverlump schmears
the artwelfareelasticity (3. lecture),*
presented at the Museum of Modern Art,
New York, May 19, 2000
Courtesy of the artist; Klosterfelde, Berlin;
and Anton Kern Gallery, New York

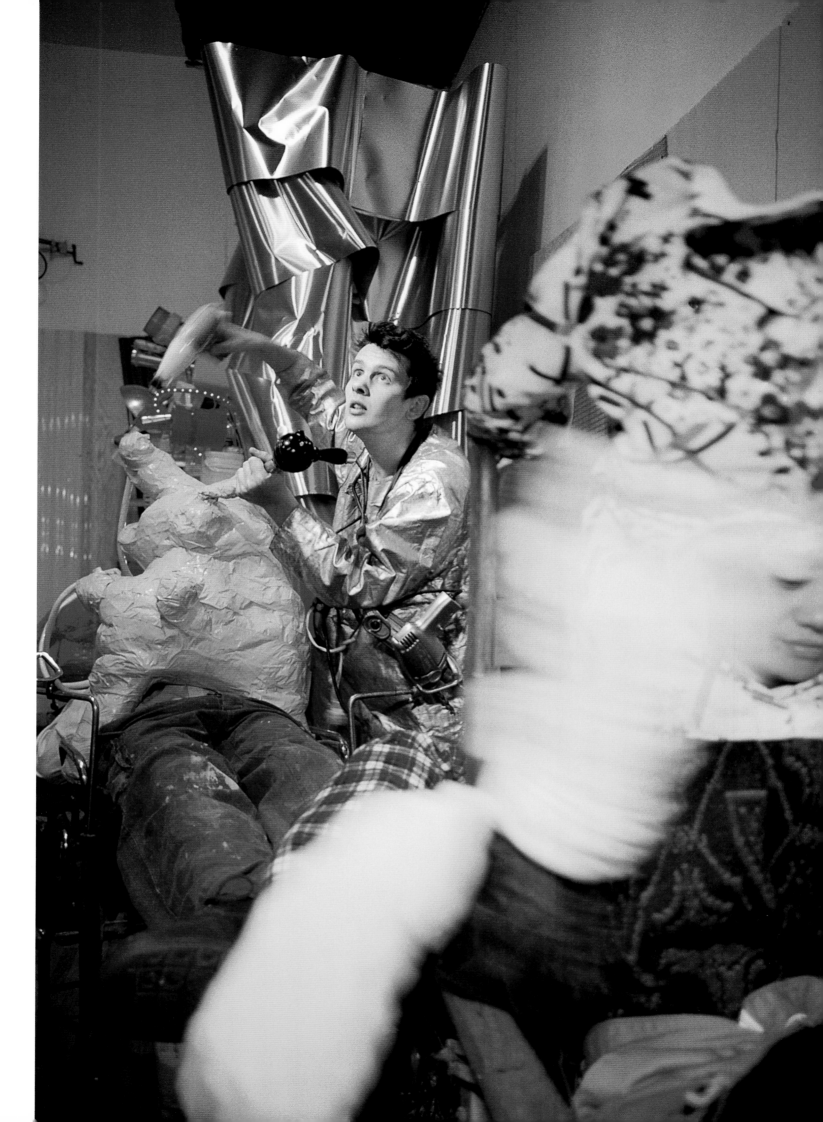

The Space of Imagination: A Contemporary Perspective on Lee Bontecou

Elizabeth A. T. Smith

BORN
1931, Providence, Rhode Island

LIVES AND WORKS
Orbisonia, Pennsylvania

Lee Bontecou studied at the Art Students League, New York. She has exhibited her sculpture, drawing, painting, and printmaking nationally and internationally since 1959, most recently in solo exhibitions at Knoedler & Co., New York (2004); UCLA Hammer Museum, Los Angeles; and the Museum of Contemporary Art, Chicago (2003–4, traveled to Museum of Modern Art, New York); Leo Castelli Gallery, New York (1999, 1971, 1966, 1962, 1960); Bonnefanten Museum, Maastricht, Netherlands (1996); Museum of Contemporary Art, Los Angeles (1993); Museum of Contemporary Art, Chicago (1972); Städtisches Museum Schloss Morsbroich, Leverkusen, Germany (1968); Museum Boijmans Van Beuningen, Rotterdam (1968); and Galerie Ileana Sonnabend, Paris (1965).

Group exhibitions include: *True Grit: Seven Female Visionaries Before Feminism,* Mills College Art Gallery, Oakland, California (2002, catalogue); *The Third Dimension,* Whitney Museum of American Art, New York (1984); *Whitney Annual* and *Whitney Sculpture Annual,* Whitney Museum of American Art, New York (1968, 1966, 1964, 1963, 1961, catalogues); *Sculpture: A Generation of Innovation,* Art Institute of Chicago (1967, catalogue); *Painting and Sculpture of a Decade: 1959–1964,* Tate Gallery, London (1964, catalogue); *Recent American Sculpture,* Jewish Museum, New York (1964); *Documenta III,* Kassel, Germany (1964, catalogue); *Americans, 1963,* Museum of Modern Art, New York (1963, catalogue); *Continuity and Change,* Wadsworth Atheneum, Hartford, Connecticut (1962, catalogue); Bienal de São Paulo (1961, catalogue); and *The Art of Assemblage,* Museum of Modern Art, New York (1961, catalogue), among many others.

Bontecou's participation in the 2004–5 *Carnegie International* is her fourth, adding to appearances in 1970, 1967, and 1961.

SELECTED BIBLIOGRAPHY

Hadler, Mona. "Lee Bontecou's 'Warnings.'" *Art Journal* 53 (Winter 1994): 56–61.

Judd, Donald. "Lee Bontecou." *Arts Magazine* 39 (April 1965): 16–21.

Smith, Elizabeth A. T., et al. *Lee Bontecou: A Retrospective.* Exhibition catalogue. Chicago: Museum of Contemporary Art; Los Angeles: UCLA Hammer Museum, in association with Harry N. Abrams, 2003. Essays by Donna De Salvo, Mona Hadler, Smith, and Robert Storr.

Solomon, Alan. *New York: The New Art Scene.* New York: Holt, Rinehart, Winston, 1967.

Sussman, Elisabeth. "Lee Bontecou: UCLA Hammer Museum." *Artforum* 42, no. 5 (January 2004): 48–49.

It has been nearly thirty years since Lee Bontecou's work has been seriously considered in the context of contemporaneous directions in art practice. Her inclusion as one of the three anchoring figures in the 2004–5 *Carnegie International,* alongside a wide range of younger artists, invites such an examination: What is the significance of her example for the current generation of emerging artists? On the heels of a recent retrospective exhibition, spanning the late 1950s to the present, accompanied by the first major publication devoted to her, it is possible now to regard Bontecou's work in its totality—as a field of continuous production over decades rather than as an isolated phenomenon of the 1960s, when her reputation was first established.[1] Her entire body of work—despite the variety of physical forms it has assumed, the range of materials employed, and its oscillation between abstraction and representation—manifests an extraordinary cohesiveness of vision and reveals a sensibility that is simultaneously optimistic and despairing about the relationship between nature and culture, between human beings and the world they occupy FIGS.1 AND 2.

Several salient qualities, inherent in Bontecou's art throughout the decades, remain highly relevant to current practice: the multiplicity of references to themes of nature, science, and technology and the way her work acknowledges and foregrounds the ambiguities and contradictions that surround these fields of inquiry; the expansiveness of vision that stems from the way she combines empirical and intuitive knowledge; and the emphatic materiality and physical presence of her sculptures, their sense of the handmade. Masterfully expressing conditions of mutability, flux, and metamorphosis, her work conveys—with authority, but without being authoritative—a keen sense of the interrelatedness of vastly different poles of human experience and endeavor. She points to nonart sources— engineering, science, the displays at New York's Museum of Natural History —and to the all-important role of the imagination as essential to the making of her art. This insistence on the imagination is also generative to how she has always approached abstraction: allowing herself to forge connections between wide-ranging objects and images from the social and natural worlds.

Never completely devoid of figural or naturalistic references, Bontecou's sculptures and drawings remain grounded in, yet transformative of, what is familiar. Her earliest sculptures of animals and birds, which hinted at the vigor and the metamorphic qualities that would animate her later work, were concerned less with realistic representation of their subjects than with manifesting what the poet Tony Towle described as "the quality of being an animal."[2] Bontecou's early welded-steel frameworks infilled with canvas and other objects and incorporating deep black voids stimulated a plethora of critical assessments and interpretations that addressed their commingling of the contradictory qualities of authority and vulnerability, anger and humor, crudeness and delicacy. The power and mystery of these objects, then as now, is undeniable.

LEE BONTECOU
Untitled, 1987
printer's ink on primed plastic paper
12 × 12 in. (30.5 × 30.5 cm)
Collection of Tony and Gail Ganz, Los Angeles
© Lee Bontecou/courtesy of
Knoedler & Co., New York

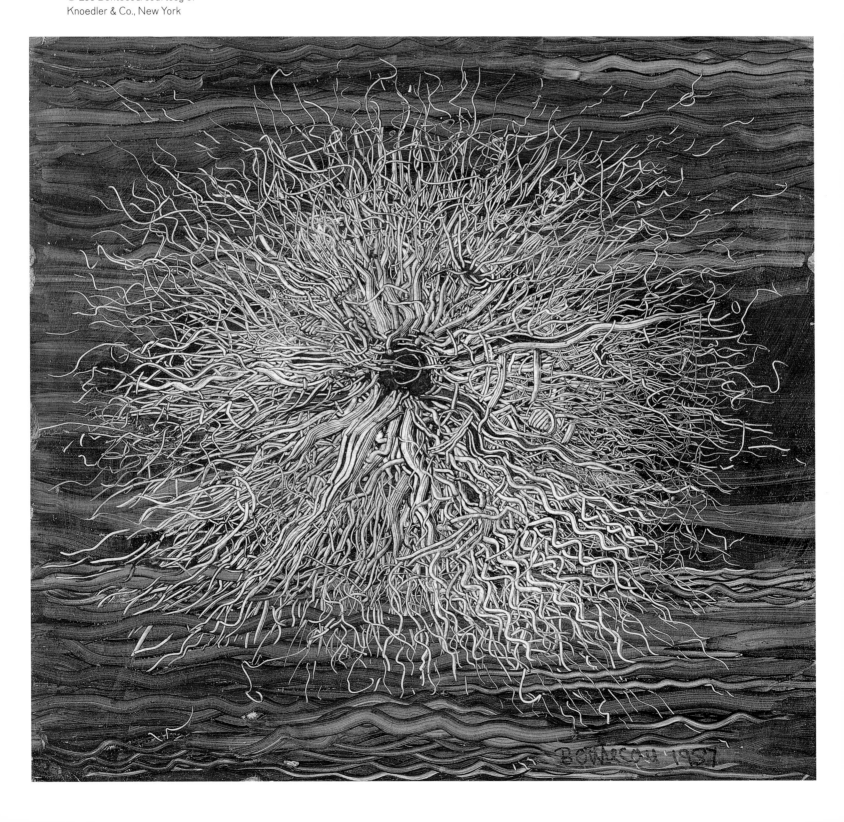

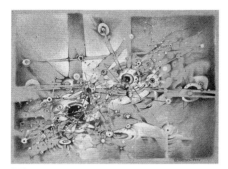

FIG.1 *Untitled*, 1987
graphite and colored pencil on paper
9 1/2 × 12 1/2 in. (24 × 31.8 cm)
Collection of Museum of Contemporary Art,
Chicago; gift of the artist in honor
of Elizabeth A. T. Smith
© Lee Bontecou/courtesy of
Knoedler & Co., New York

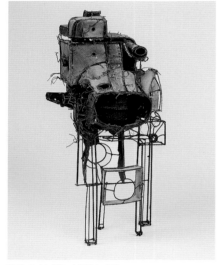

FIG.2 *Untitled*, 1958–59
welded steel and canvas
19 1/2 × 10 × 11 in. (49.5 × 25.4 × 28 cm)
Collection of the artist; courtesy of
Knoedler & Co., New York
© Lee Bontecou/courtesy of
Knoedler & Co., New York

1 *Lee Bontecou: A Retrospective* was
co-organized by the author and Ann Philbin
for the Museum of Contemporary Art, Chicago,
and the UCLA Hammer Museum, Los Angeles.
See Elizabeth A. T. Smith et al., *Lee Bontecou:
A Retrospective*, exh. cat. (Chicago: Museum
of Contemporary Art; Los Angeles: UCLA
Hammer Museum, in association with
Harry N. Abrams, 2003).

2 Tony Towle, "Two Conversations with
Lee Bontecou," *Print Collector's Newsletter* 2,
no. 2 (May–June 1971): 27.

3 Lee Bontecou, artist statement in Smith
et al., *Lee Bontecou*, 174.

4 Lee Bontecou, quoted in Mona Hadler,
"Lee Bontecou: Heart of a Conquering Darkness,"
Source: Notes in the History of Art 12,
no.1 (Fall 1992): 42.

In her later sculptures, bodily and mechanomorphic as well as cosmological allusions abound, alongside increasingly overt representations of nature, scientific phenomena, and technology—subjects that continue to be germane to contemporary art and culture.

Bontecou has acknowledged several of her contemporaries with whom she felt a close affinity during their development as young artists, specifically John Chamberlain, Tom Doyle, and William Giles.[3] But her work, from the early years to the present, clearly has reverberated with and impacted a larger spectrum of artists. Once she arrived at what would become her signature style of sculpture FIG.3, it resonated powerfully with artists of her own generation, notably Donald Judd, who wrote extensively about the work while developing his theory of specific objects, and Eva Hesse, who also commented on its impact on her own way of thinking and making. Both artists responded, in different ways, to the strength of how Bontecou's works "mentally scrape the viewer."[4] However, few writers sought to make comparisons or to draw connections between Bontecou's work and that of her contemporaries, even when it was included in group shows, emphasizing instead its singularity. As her work shifted tenor during the late 1960s toward more lyrical, ballooning objects increasingly recalling forms with biological overtones, the unique character of her vision became more and more sharply delineated. The appearance of her vacuum-formed plastic sculptures around 1969–70, which largely baffled the art world due to their seemingly abrupt departure from the previous directions of her art-making, confirmed even more strongly the opinion that Bontecou's practice stood apart from and could not be related to that of other artists at that time. It was indeed the deeply personal and self-directed character of her work that had led her along this very path; as Judd once commented, "Bontecou's reliefs are an assertion of herself, of what she feels and knows."[5] Those who visited her studio and observed her working environment quickly discerned the importance of nature and science to her thinking. One writer in the mid-1960s identified Bontecou as an "amateur biologist," shown alongside photos of animal skulls, plants, model airplanes, and fish tanks in her studio, pinpointing the artist's deep-seated interest in the realm of experience and knowledge outside the parameters of the art world and art history.[6]

Some twenty-five years later, in 1993, the first notable reexamination of Bontecou's art occurred in an exhibition that consisted of a group of sculptures and drawings spanning the 1960s at the Museum of Contemporary Art, Los Angeles. The multiplicity and fluidity of references, the emotive dualities, and the exquisite tension between abstraction and representation gripped the imaginations of numerous artists who were not previously well acquainted with her work, and reaffirmed the vigor of her vision to those who were. The haunting physicality of the sculptures and the blend of ferocity and vulnerability conveyed by their mysterious gaping voids and conjoining of hard and soft materials seemed to reverberate with the spirit of social, political, and cultural contention surrounding issues of the body— a preoccupation of numerous artists in the early 1990s. Bontecou's drawings were also a startling revelation to many. Their references to real and imagined objects and to states of transformation between them suggested an affinity with Surrealism, which was heightened by the intense, almost hallucinatory quality of the imagery and its evocation of dream states. Yet these works, too, stem from a deeply personal wellspring of feelings, ideas, and associations that defy categorization.

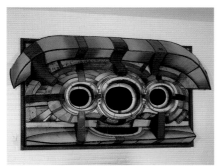

FIG.3 *Untitled*, 1962
welded steel, wood, and canvas construction
65 × 111 × 20 in. (165×282×50.8 cm)
Abrams Family Collection, New York
© Lee Bontecou/courtesy of
Knoedler & Co., New York

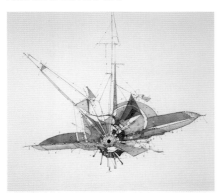

FIG.4 *Untitled*, 1996
welded steel, porcelain, wire mesh, cloth, and wire
30×32×14 in. (76.2×81.3×35.6 cm)
Collection of the artist;
courtesy of Knoedler & Co., New York
© Lee Bontecou/courtesy of
Knoedler & Co., New York

5 Donald Judd, "Lee Bontecou,"
Arts Magazine 39, no. 7 (April 1965); reprinted in
Smith et al., *Lee Bontecou*, 199.

6 Alan Solomon, *New York: The New Art Scene*
(New York: Rinehart Winston, 1967), 98–113.

7 Elisabeth Sussman, "Lee Bontecou,
UCLA Hammer Museum," *Artforum* 42, no. 5
(January 2004): 148. I am grateful to Mona Hadler
for emphasizing to me the concept of the techno-
logical sublime in relationship to Bontecou's work.

Bontecou's attention to and engagement with large issues in her work
is an important precedent for other artists seeking to communicate equally
ambitious and weighty subject matter. She is able to evoke a vast range
of concerns and readings—from the horrors of war to the mysteries of the
cosmos to conflicts between the individual and society to humans'
insidious destruction of the planet—in a way that avoids didacticism or
heavy-handedness, instead remaining open-ended and even poetic FIG. 4.
The convergence of metaphysical, apocalyptic, and quasi-scientific
elements, and their relationship to the notion of a "technological sublime,"
are crucial aspects of her practice that situate her, as Elisabeth Sussman
has commented, "as a starting point in a lineage that leads to work as
diverse as that of Sarah Sze and Roxy Paine"—a lineage that can be readily
expanded to include a much broader group of artists.7 In Bontecou's
sculptures and drawings, beauty and ugliness, the seductive and the sinister,
coexist; the ability of these objects and images, with all their polarities
and dualities, to carry meaning that is complex and contradictory resounds
with current approaches to the conjoining and transformation of familiar
imagery from nature and culture. The range of references and the
sweep of content in Bontecou's work is especially vast, encompassing,
and universal. She shares with many other artists—who also use the human
(particularly the female) body and the animal world as vehicles to
explore the ambiguities of mythology and contemporary political and
social realities—a sense of kinship in the treatment of beauty and violence,
ecstasy and horror, life force and destruction as inseparable and
interrelated elements within the natural order of things.

Bontecou's approach to abstraction has much to offer artists whose
work also is based in a transformed yet recognizable imagery. Although her
earliest sculptures in bronze and terra-cotta—of human figures, animals,
and birds—were grounded in a quasi-figurative tradition, they
were abstracted in that their forms were variously streamlined or cubistic,
with facial features absent or reworked, for example, into gaping recesses.
In her signature welded-steel and canvas works, she turned toward
a greater degree of pure abstraction based in the interplay of geometries,
at first simple and then more and more complex, and increasingly began
to infuse these works with referential imagery and allusions to world events.
The noteworthy feature of Bontecou's relationship to abstraction during
this period is that formal and compositional attributes blend seamlessly
with those referring to broader issues of content; in this manner,
she achieves an unparalleled balance and tension. Critic Christopher Miles
commented recently on the potency of Bontecou's work from the early
1960s to the time of her survey exhibition in 1972:

*It was among the toughest, most provocative, most timely and
most ahead-of-its-time work being made. At a moment when discussions
of androgyny and gender bending, cyborgism and connections between
sexuality, power, militarism and violence were barely on the cultural radar,
Bontecou was entertaining all of the above in works that laid the
groundwork for much of the minimalist, postminimalist, and feminist
art that would come in the following two decades....
Her work had amazingly broad resonance in an art world caught up
in discussions about new directions for formal abstraction, the emergence
of feminist art, and ways to bridge the gap between art and life; not to
mention a wider world in which her sculptures found a kinship among
the warheads, gun barrels and jet and rocket engines that were becoming
part of the national and global consciousness, thanks to the Space
Race, Vietnam, and the escalation of the cold war.* [8]

Grounded in Abstract Expressionism and informed by a wide-ranging
interest in non-Western and archaic forms of art as well as her overarching
fascination with science and nature, Bontecou's work posits an
alternative to the rationality and reductive premises of Minimalism and
Conceptual art. Her insistence on the role of the imagination and the primacy
of intuition to communicate meaning is perhaps her most far-reaching
contribution to the trajectory of current art practice, coupled with
an extraordinary technical prowess and commitment to experimentation.
Artist Nari Ward has commented that, in his view, "Lee's pieces become
more and more mysterious. It's about the voids and the way she's able
to articulate something unnameable, and that's what every
artist wants to do." [9]

In Bontecou we find a compelling example of an artist who has undergone
continual evolution in the direction of her work over time. A fierce dedication
to the idea of freedom has led to several notable stylistic shifts; in recent
years she has prized, above all, the ability to follow her own path without the
constraints of the art market or the strictures of critical response.
Extending the vocabulary of her sculpture from the predominantly abstract
relief format on which she had concentrated during the first part of the
1960s, Bontecou began to commingle increasingly overt references to
the technology of flight with more emphatic references to the natural world.
By the late 1960s and early 1970s, when she experimented with vacuum-
formed plastic to cast objects resembling mutated fish and plants,
she appeared to have left abstraction behind altogether—a perplexing
gesture at the time, which led one critic to comment, "She has, it seems,
been a strange naturalist all along." [10] However, from today's vantage
point, her body of vacuum-formed plastic work of circa 1970 FIG. 5
can be understood not as an abrupt or arbitrary departure from an earlier
vocabulary but rather as an evolution in a corpus of work that had begun
with naturalistic references and over the years returned to them,
allowing for the expression of the artist's thoughts about the relationship
between the individual and society, between humankind and nature,
and the coexistence of dark and hopeful attributes within the sphere of
the animate. Philip Guston likewise made a radical shift from

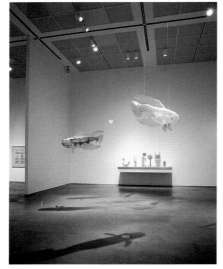

FIG. 5 installation view,
Lee Bontecou: A Retrospective,
Museum of Contemporary Art, Chicago,
February 14 – May 30, 2004
Courtesy of the Museum of Contemporary Art,
Chicago

8 Christopher Miles, "Lee Bontecou,"
Artforum 40, no. 4 (December 2001): 125.

9 Nari Ward, conversation with the author,
January 2004. Ward was a student at Brooklyn
College while Bontecou was a teacher there.

10 James Mellow, "Bontecou's Strange Fish and
Malevolent Flowers," *New York Times,* June 6, 1971.

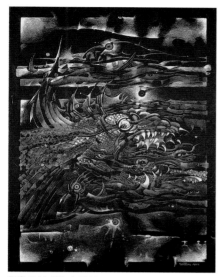

FIG.6 *Untitled*, 1999
colored pencil on paper
24 × 18 in. (61 × 45.7 cm)
Collection of the artist,
courtesy of Knoedler & Co., New York
© Lee Bontecou/courtesy of
Knoedler & Co., New York

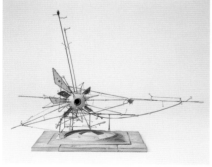

FIG.7 *Untitled*, 1993
steel, porcelain, wire mesh, and wire
12 × 15 × 9 in. (30.5 × 38 × 23 cm)
Collection of the artist;
courtesy of Knoedler & Co., New York
© Lee Bontecou/courtesy of
Knoedler & Co., New York

11 Philip Guston, "Philip Guston Talking," 1978,
reprinted in Timothy Taylor, *Philip Guston,* exh. cat.
(London: Timothy Taylor Gallery, 2004), 30.

12 Judd, "Lee Bontecou," reprinted in
Smith et al., *Lee Bontecou,* 199.

13 The delicate and even tenuous connections
between the abundant parts that compose
these objects suggest parallels with the more
contemporary sculpture and installation work of
Sarah Sze; both artists make reference to the
breadth and interconnectedness of aspects of
life, spanning the biological and the technological.

14 Lee Bontecou, in Towle interview, 26. The
concept of the worldscape in Bontecou's work
has been extensively analyzed by Mona Hadler in
"Lee Bontecou: Heart of a Conquering Dark-
ness," 38–44, and "Lee Bontecou's 'Warnings,'"
Art Journal 53, no. 4 (Winter 1994): 56–61.

abstraction to figuration in the late 1960s that was highly controversial,
producing a group of distinctive figurative paintings that shocked many in the
art world for their iconoclastic rejection of the tenets of abstract painting.
Engaging in a search for expanded and invigorated meaning in his work and
staunchly committed to the idea of experimentation and exploration,
Guston stated: "Freedom. That's the only possession an artist has—freedom
to do whatever you imagine"— a statement that echoes Bontecou's own
articulations of the necessity of artistic and personal freedom. 11

Over the past three decades, Bontecou's vision has consistently
exploded and transformed conventional definitions of abstraction. She has
moved ever more seamlessly back and forth between the poles of abstraction
and representation while developing a uniquely hybridized language of
the two modes. Rather than relying on the essential qualities perceived
by Judd in the 1960s (who, nonetheless, recognized that Bontecou's
sculptures conveyed meaning that spanned from "something as social as
war to something as private as sex, making one an aspect of the other" 12),
her more recent works manifest an additive sensibility FIGS. 6 AND 7.
Here, a multiplicity of parts are conjoined to create dazzlingly complex
objects that evoke, variously, galaxies, insects, machines, eyes, forms seen
under a microscope, aquatic life, or the strange and sinister heads
and bodies of birds. Despite the apparent complexity of these pieces,
however, they remain highly unified statements that rivet our
attention and confound, or even overload, our senses; the whole and the
parts coexist in extreme tautness. 13 A restless mutability between objects
as small as eyes or as minute as cells with those as large as airplanes
and as expansive as planetary systems locates a plethora of possible
meanings within a single object or image. A distinctive aspect of Bontecou's
work is that it defies interpretation and resists being read as social
commentary, yet at the same time is intensely and richly infused with social
content. But this content is diffuse, ambiguous, and endlessly provocative
in its suggestiveness of a diverse range of experience, endeavor,
and exploration; there is an almost primal energy that transcends style
and signification. Speaking to this issue, Bontecou has described the
nonspecific nature of much of her imagery in terms of a "worldscape,"
and once, when queried about the way in which this idea communicates
feelings about the world, she replied simply, "More like things to come,
in a positive and a negative way." 14

LEE BONTECOU
Untitled, 1962
welded iron, canvas, wire, and velvet
54 × 55 × 15 in. (137.2 × 139.7 × 38 cm)
Collection of the National Gallery of Art,
Washington, D.C.; gift of the
Collectors Committee, 2004.44.1

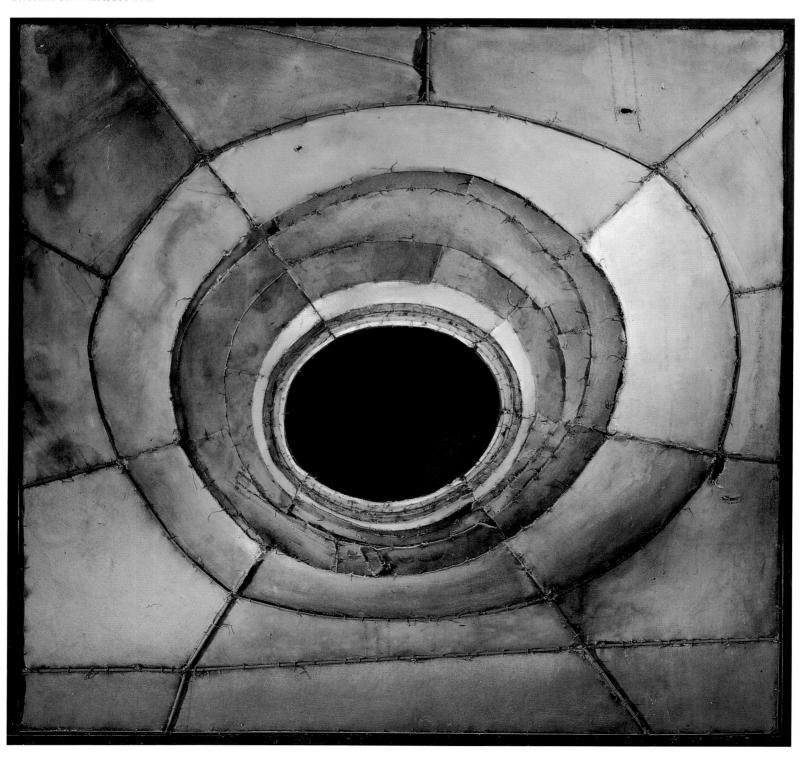

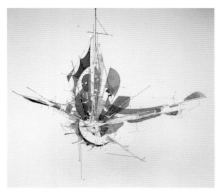

FIG.8 *Untitled*, 1996
welded steel, porcelain, wire mesh, silk, and wire
61×55×74 in. (155×139.7×188 cm)
Collection of the artist;
courtesy of Knoedler & Co., New York
© Lee Bontecou/courtesy of
Knoedler & Co., New York

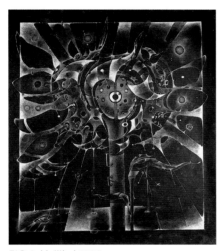

FIG.9 *Untitled*, 1996
colored pencil on black paper
30×26 in. (76.2×66 cm)
Collection of the artist;
courtesy of Knoedler & Co., New York
© Lee Bontecou/courtesy of
Knoedler & Co., New York

15 Bontecou devoted much of her time in the
1970s and 1980s to teaching at Brooklyn College
in New York, until her retirement in 1991.
Her students remember her as open, permissive,
and encouraging of individuality and experimen-
tation. Former student Patricia Cronin considers
Bontecou "a model of integrity for a way to be
an artist that was not about careerism or being
professional. She felt her job was to make the
work not the way a gallery system required but
the way she wanted to do it." Conversation with
the author, January 2004.

16 Liz Larner, in particular, as a participant
in a symposium on Bontecou's work held at the
Museum of Contemporary Art, Chicago,
February 14, 2004, commented on the profound
implications of its spatial qualities and Bontecou's
creation of an imaginary space achieved by
conflating material and image.

17 Doug Harvey, "Back from the Void:
Lee Bontecou, Thirty Years Later,"
LA Weekly, October 3, 2003.

An admired and dedicated teacher for twenty years,15
an untiring advocate for and example of creative experimentation
and freedom from the constraints of the art world system,
Bontecou is a formidable presence within current artistic practice
and discourse. A variety of younger artists have attested to the
impact on them of the astonishing object quality that has always
been a hallmark of Bontecou's work—its sculptural presence
and tactility, and the visible manifestation of the process of its
making.16 This materiality and the clear presence of the artist's
hand validate the preoccupations of many artists working today
who are keenly interested in the possibilities of process and
fresh alternatives to the emphasis on photographic, mediated,
and other technologically based art forms, which have dominated
so much recent practice and discourse. As for her drawings,
other younger artists have expressed fascination with the fluidity
with which her forms transform and hybridize restlessly
and suggestively to convey the sense of interrelated states
that animate her imagery FIGS. 8 AND 9.

Commenting on the impact of Bontecou's work and
on her example as an artist, critic Doug Harvey has observed:

*These spindly cobweb Trojan horses carry a depth charge
into the heart of the institutional art world, and its message is this:
Artists don't need any of it. Not the fame, not the glory,
not the feedback, not the community, not the validation, not the
authorization. There's the dark mystery of the void, and there
are the vessels we craft to contain or navigate it. There's the
seemingly insurmountable stupidity and greed of human nature,
and there's the will to create. And that's enough.*17

A strikingly original voice in the 1960s, an influential teacher
for a generation of students in the 1970s and 1980s, and a role model
for women artists throughout these decades, Bontecou's fierce
dedication in recent years to the making of her work above all other
concerns manifests a deep understanding of the complexities,
ambivalences, and challenges faced by all artists. She continues
to provide inspiration to those who strive to communicate
through their art with integrity and profundity and to nurture an
independent vision, apart from careerist concerns and in balance
with the rhythms of a multidimensional life.

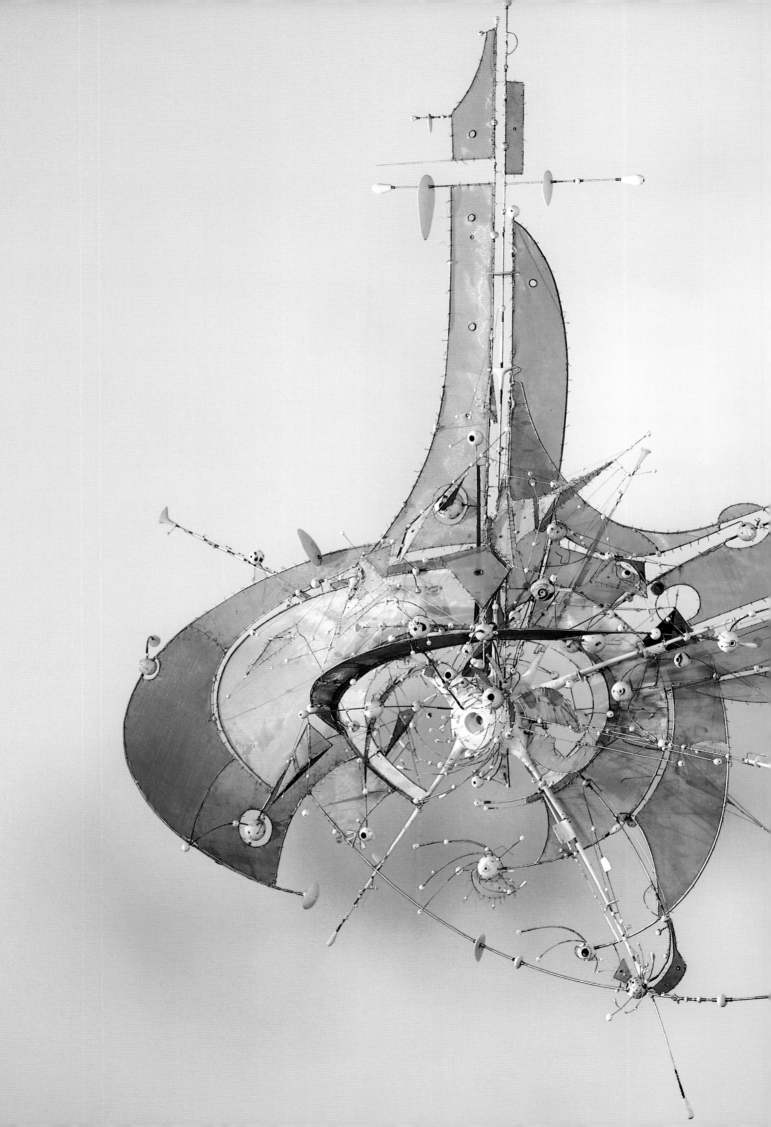

LEE BONTECOU
Untitled, ca. 1980–2001
welded steel, porcelain, wire mesh, silk, and wire
90×99×60 in. (228.6×251.5×152.4 cm)
Collection of the artist;
courtesy of Knoedler & Co., New York
© Lee Bontecou/courtesy of
Knoedler & Co., New York

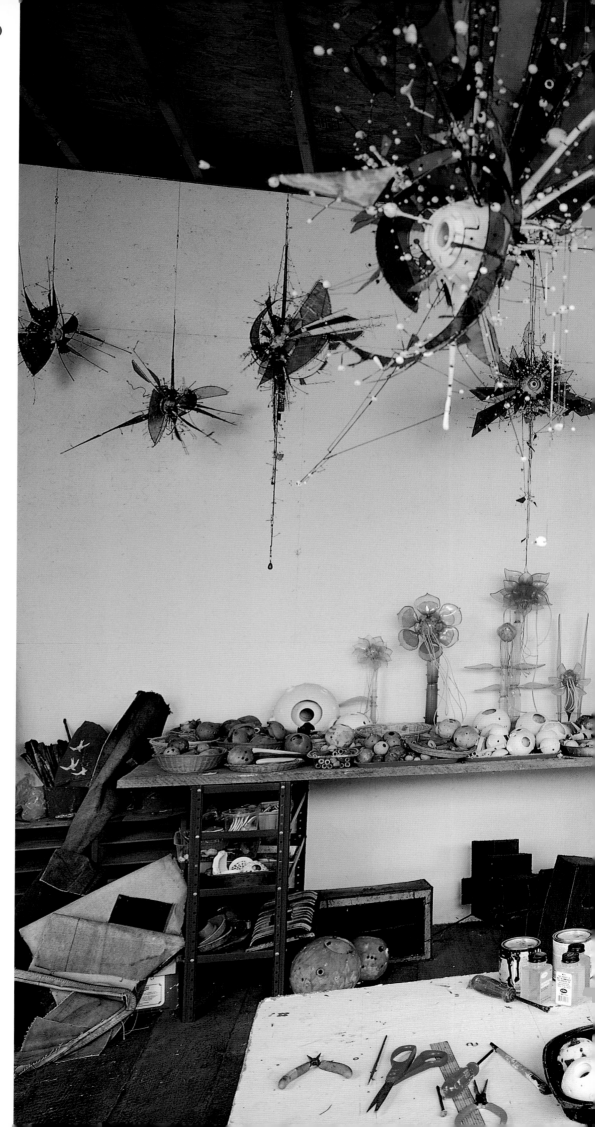

View of Lee Bontecou's
Pennsylvania studio, 2002
Courtesy of the artist
and Knoedler & Co., New York
© Lee Bontecou/courtesy
of Knoedler & Co., New York

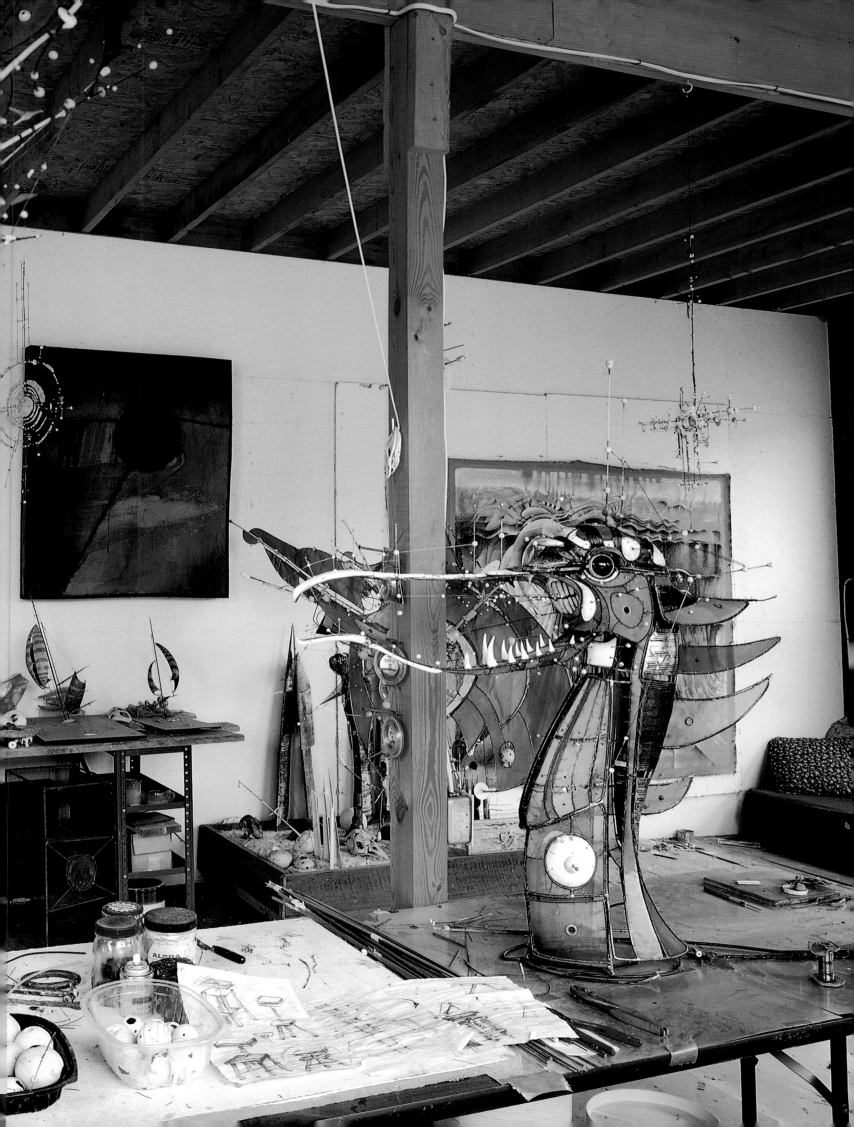

BORN
1926, Detroit, Michigan

LIVES AND WORKS
Tappan, New York

Robert Breer received his BA from Stanford University, California, in 1949. He studied painting in Paris and made his first animated film in 1952. His films have been screened all over the world and are included in major film collections in the United States and Europe. He has had, most recently, solo exhibitions at &: gb agency, Paris (2004); Musée national d'art moderne, Centre Pompidou, Paris (2001); and A/C Project Room, New York (2000).

Recent group exhibitions, festivals, and screenings include: *Beyond Geometry: Experiments in Form 1940s–1970s,* Los Angeles County Museum of Art, Los Angeles (2004, catalogue); Torino Film Festival, Turin (2004); 33rd International Film Festival, Rotterdam (2004); *Orogretto Animation 2,* Rome (2004); *Lost Property (La sculpture aujourd'hui),* Domaine Pommery, Reims, France (2004); *Stranger than Cinema,* Jeonju International Film Festival, South Korea (2004); *Mouvement de Fonds, acquisitions 2002 du Fonds National d'Art Contemporain,* Centre de la Vieille Charité, MAC, Galeries Contemporaines des Musées, Marseille (2003); *Links,* &: gb agency, Paris (2003); New York Film Festival (2003); *EAT,* Inter-Communication Center, Tokyo (2003); *What (Is) Cinema, Other than Film?* TENT, Centrum Beeldende Kunst, Rotterdam (2002); *Iconoclash,* ZKM/Zentrum für Kunst und Medientechnologie, Karlsruhe, Germany (2002); Musée cantonal des beaux-arts, Lausanne, Switzerland (2002); *Inside the Sixties: GP1.2.3,* Salon International des Galeries Pilote, Lausanne, Switzerland (2002); *Nouvelles Acquisitions,* Musée national d'art moderne, Centre Pompidou, Paris (2002); *Dessins XXL,* Le Lieu Unique, Nantes, France (2002); *Moderna Museet c/o Magasin 3,* Stockholm Konsthall (2002); *Animations,* P.S.1 Center for Contemporary Art, Long Island City, New York (2002, traveled to Kunst-Werke, Berlin); *Panopticon: Kinetic Moment,* Carnegie Museum of Art, Pittsburgh (2002); *Selection of Films,* Anthology Film Archives, New York (2002); *Useless Science,* Museum of Modern Art, New York (2000); A/C Project Room, New York (2000); *Oops,* Le Magasin Centre national d'art contemporain, Grenoble, France (1998); Musée l'espace lausannois d'art contemporain, Lausanne, Switzerland (1998).

SELECTED BIBLIOGRAPHY

Burford, Jennifer L. *Robert Breer.* Paris: Paris Expérimental/Re:Voir Vidéo, 1999. Includes videotape.

Film Culture, nos. 56–57 (Spring 1973): 39–70. Special section, including interviews by Jonas Mekas and P. Adams Sitney, and Charles Levine.

Hoberman, J. "Robert Breer's Animated World." *American Film* 5 (September 1980): 46.

Maldonado, Guitemie. "Robert Breer: &:gb agency." *Artforum* 40, no.5 (January 2002): 149–50.

Smith, Roberta. "Art in Review: Robert Breer." *New York Times,* January 7, 2000.

Robert Breer

For some fifty years, Robert Breer has been making films that flirt with the creative possibilities that lie between conventional modes of animation. Working deftly with elements of variation, repetition, rhythm, and motion, he composes animations that playfully mix drawings, photographs, and ephemera from everyday life into impressionistic visual collages. Expressive and downright delightful, his work varies in tone from kinetic explorations of abstraction to poetic meditations on life and death. He makes visible a world that can exist in the mind and the eye simultaneously, and after watching a Breer film, we see the world differently for a time—mentally inscribing, as Breer does visually, the abstract into the real, the formal into the poetic, and the impressionistic into the narrative.

While growing up, Breer drew cartoons obsessively; after the Second World War, he studied art in Paris, soaking up the energy surrounding European avant-garde abstraction. He started making films in 1952, at first by composing animations out of the forms in his abstract paintings, treating each frame as an individual and whole reality. He then pursued experiments in the mechanics of filmmaking by doing single-frame animations of completely unrelated images. Rushing by at a rate of twenty-four frames per second, images move too quickly to be resolved by the eye, resulting in works that buzz with retinal excitement but don't aspire to create any true sense of movement. Breer has said his interest was not in the illusion of movement but in signaling a shift in time and space.

An original "new media" artist, Breer has employed mechanics to great effect in machines such as rotoscopes, which physically approximate his 2-D animations. He has also made kinetic sculptures in which attention to spatial displacement is emphasized over movement. Most famously, in the early 1960s, Breer made a series of "floats," abstract volumes up to six feet tall that glided at a glacial pace, so slowly as to be imperceptible but which over time did migrate across a distance. Despite the simplicity of their movement and their stripped-down form, these floats exhibited an uncanny human quality, as playful and absurd as the realities crafted in the artist's films.

The title of his most recent work, *What Goes Up* (2003), contains within it the inevitable conclusion: "… must come down." The film cycles through several intervals framed by the drawn animations of an ascending plane, punctuated by a variety of images: photographs of the artist, his family, and familiar landscapes; abstracted drawn passages; fragments of maps; and a painting of a woman contemplating her own reflection in a mirror. The work playfully and literally illustrates the fated descent of airplanes, autumn leaves, and male genitalia. The film winds down with one autumn leaf falling atop a picture of the landscape, and finally a photograph of the artist himself, raising a glass to the camera; in this moment he toasts us and himself, and the life he has lived. The impressionistic fragments trace the passage of time: as seasons change, places are transformed, and flesh grows old. Meditating on the cycles of all things, Breer masterfully concerns himself with both physiological questions of seeing and philosophical questions of being. He offers the ultimate resolution of the desire for abstraction and purity within the messiness of reality, and for the possibility of reconciling the spontaneous with the rational.—*Elizabeth Thomas*

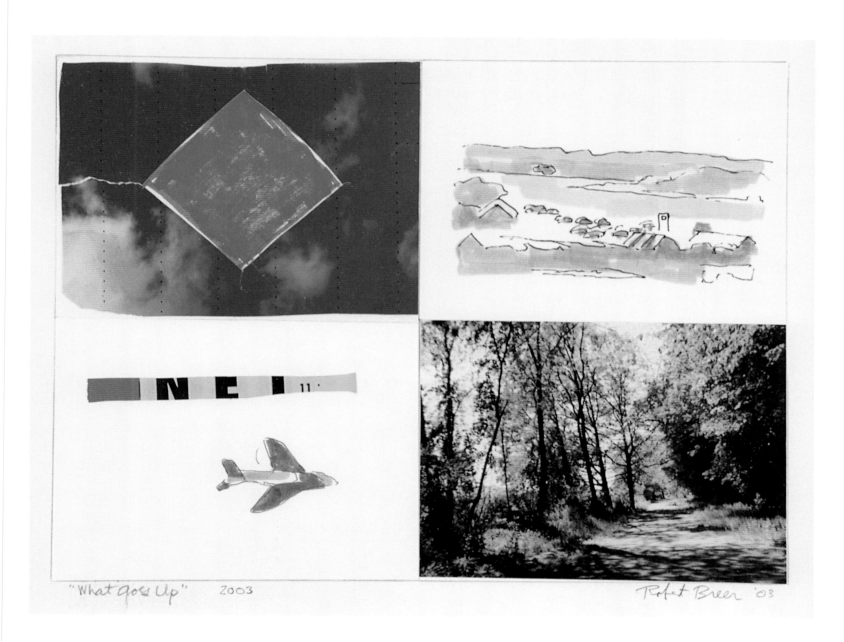

ROBERT BREER
grouped stills from *What Goes Up*, 2003
16mm film; color, sound
4:37 min.
Courtesy of the artist and &: gb agency, Paris

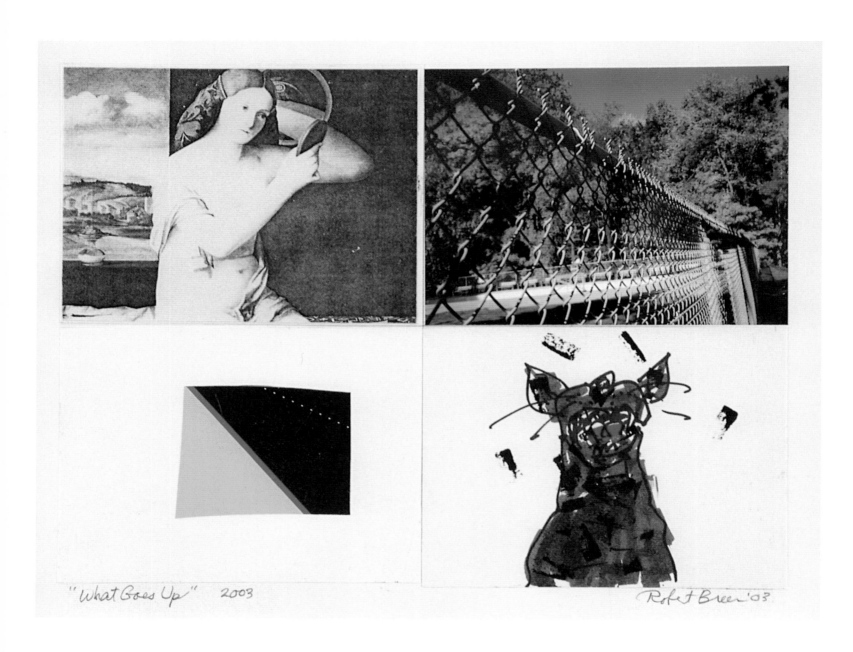

"What Goes Up" 2003

Robert Breer '03

ROBERT BREER
grouped stills from *What Goes Up,* 2003
16mm film; color, sound
4:37 min.
Courtesy of the artist and &: gb agency, Paris

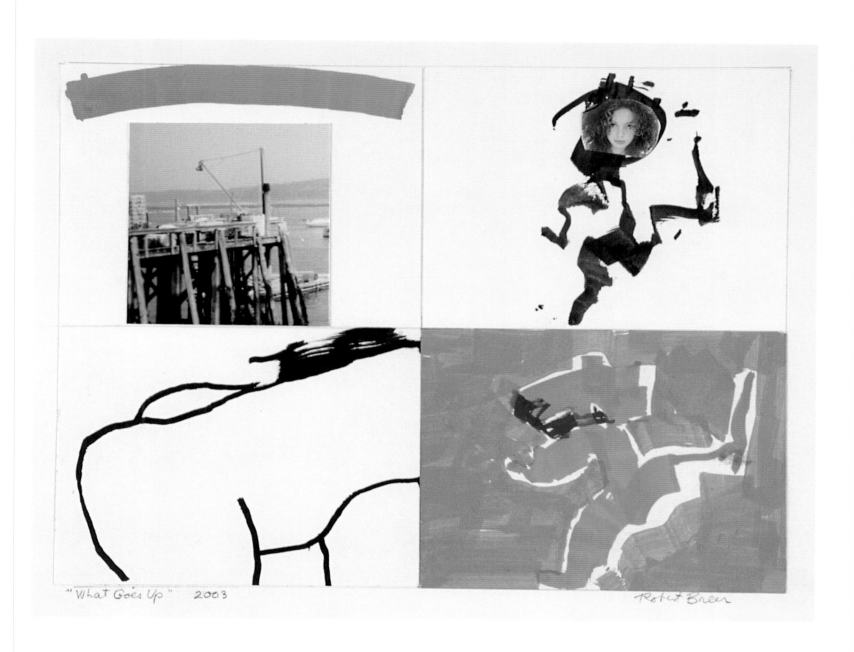

"What Goes Up" 2003 Robert Breer

Fernando Bryce

On the past as a treasure of images

BORN
1965, Lima, Peru

LIVES AND WORKS
Berlin, Germany, and Lima

Fernando Bryce studied at the École des Beaux Arts, Paris, the Université Paris VIII, and at the Universidad Católica, Lima. Solo exhibitions of his work have been presented at Raum für Aktuelle Kunst, Lucerne, Switzerland (2003); Galerie Barbara Thumm, Berlin (2002, 1998); Künstlerhaus Bethanien, Berlin (2002); Sala Luis Miró Quesada Garland, Lima (2001); Casa Museo José Carlos Mariátegui, Lima (1999); Galería Forum, Lima (1998); Galería Trilce (1996); and Galería Trapecio, Lima (1995).

In 2003, Bryce was one of two artists featured in the Latin American Pavilion at the 50th Venice Biennale. Group exhibitions include: *To Be Political, It Has to Look Nice,* apexart, New York (2003); *Present Perfect,* &: gb agency, Paris (2003); *Poetic Justice,* 8th International Istanbul Biennial (2003, catalogue); *Comportamientos Actuales del Dibujo,* Museo Patio Herreriano, Valladolid, Spain (2003); *Benjaminiana,* Centro Cultural de España, Lima (2002); *Manifesta 4,* Frankfurt am Main (2002, catalogue); Bienal Iberoamericana, Lima (2002, catalogue); Busan Biennale, South Korea (2002); *Mallki: La Exhumación Simbólica en el Arte Peruano 1980-2002,* Centro Cultural de San Marcos, Lima (2002); *Políticas de la Diferencia, Arte Iberoamericano Fin de Siglo,* Museo de Arte Latinoamericano de Buenos Aires (2001, catalogue); *Resistencias,* Casa de America, Madrid (2001, traveled to Santa Monica, California); *The Power of Narration: Mapping Stories,* Espai d'Art Contemporani de Castello, Spain (2000); *El Laberinto de la Choledad,* Museo de Arte de Lima (1999); *Realidad,* Centro Cultural Ricardo Palmo, Lima (1999); and *Viaje a la Luna,* Centro Cultural de España, Lima (1998).

SELECTED BIBLIOGRAPHY

Bryce, Fernando. "Atlas Perú: un essayo artístico de reconstrucción crítica de la Historia de Perú." In *Humbolt,* no. 139 (2003), published by Goethe Institut, Munich.

Fernando Bryce. Santa Monica, Calif.: Smart Art Press, 2001.

Fernando Bryce. Exhibition catalogue. Berlin: Verlag Thumm & Kolbe, 2003.

Políticas de la Diferencia, Arte Iberoamericano Fin de Siglo. Exhibition catalogue. Buenos Aires: Museo de Arte Latinoamericano, 2001.

Puntos Cardinales: 4 Artistas Visuales Peruanos. Exhibition catalogue. Lima: Sala Luis Miró Quesada Garland de la Municipalidad de Miraflores, 2002.

During the last decade, Fernando Bryce has produced a distinctive form of critical reflection that uses drawing as a tool to address the tragic banality of historical images, documents, and texts. Rather than focusing on the content of historical events per se, Bryce's method, which he aptly calls "mimetic analysis," obliges us to scrutinize images that circulate in the interstices of the historical narratives so as to slowly digest their political and ethical implications. Armed with pen and ink, and practicing a kind of neutral drawing reminiscent of quaint comic strips of the mid-twentieth century, Bryce revisits the way in which certain convoluted moments of the past were "packaged" under the influences of an extreme mixture of exoticism, political illusion, neocolonialism, and ideological propaganda.

Reviewing the touristic-anthropological representations of Peru and Hawaii, the propaganda wars during the Spanish Civil War, the creation of museums in the periphery made up of reproductions of famous paintings, the kitsch politics of the Fujimori dictatorship in Peru, or the fate of leftist heroes, such as Walter Benjamin or Leon Trotsky, as they appeared in vintage newspapers, magazines, photographs, archives, and all kinds of ephemera, Bryce does not intend to validate any specific account of the past, nor to clarify any particular event disputed by different historians. His aim is not to accumulate "evidence" for any one interpretation, but rather to unlock the melancholic powers of his sources. Despite the fact that some commentators have suggested his kinship with artists such as Raymond Pettibon, it would be more fitting to relate Bryce's work to Andy Warhol's images of car accidents or Gerhard Richter's paintings about the killing of members of the Bader Meinhof gang insofar as his images are equally aloof explorations of social tragedies.

Like Michel Foucault's "archeology of knowledge," Bryce's mimetic analysis aims its critical attention on the constitution of the historical record instead of on history as such. Granted, his hand-drawn transcriptions of documentation involve an attempt to rescue it from the unstoppable erosion of technological reproduction, to suggest a careful and dutiful meditation, poised against the endless flood of irrelevant images that characterizes contemporary media. In any case, Bryce focuses on fragments located outside the continuum of historical processes, bringing back—as Walter Benjamin advocated—an "image of the past that is not recognized by the present as one of its own concerns."

At the *Carnegie International,* Bryce presents a new series on the history of "Inter-American" relationships, the paternalist discourse through which the United States promoted its control of Latin America during the Cold War. Located between the progressivist rhetoric of the Alliance for Progress and the alleged threat of communist Cuba, Bryce's new series charts a significant chapter of the conservative fantasies that still shape the American imagination. — *Cuauhtémoc Medina*

¡TODOS A LOS PUESTOS DE COMBATE Y DE TRABAJO!

FIDEL CASTRO

REVOLUCION
ORGANO DEL MOVIMIENTO 26 DE JULIO

AÑO IV
5 Centavos
• La Habana, Martes, 18 de Abril del 1961
DIRECTOR: CARLOS FRANQUI • No. 727

LISTA LA U.R.S.S. Y LOS PAISES SOCIALISTAS PARA AYUDAR A CUBA

Combaten nuestras fuerzas heroicamente al enemigo *Parte de FIDEL*

Preso Boza Masvidal por conspiración

Detenido jefe de espías yanki

Hacia Cuba Lázaro Cárdenas

¡PATRIA O MUERTE ¡VENCEREMOS!

¡VIVA LA REVOLUCION!

EU. CULPABLE DE LA RUPTURA

REVOLUCION
ORGANO DEL MOVIMIENTO 26 DE JULIO

Año IV • La Habana, Jueves 3 de Enero de 1961
2ª EDICION 5 centavos • Director: CARLOS FRANQUI • No 641

VEA INFORMACION EN LA PAGINA TRES

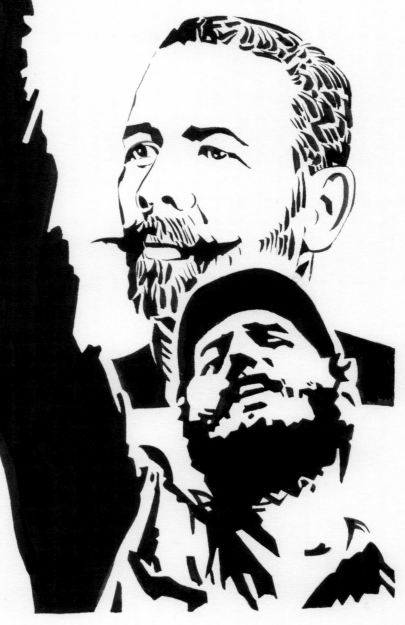

DOS GENERACIONES
Y UN SOLO IDEAL:

¡Venceremos!

previous page, left, and right
FERNANDO BRYCE
selections from *Revolución,*
from the series *Inter-American Affairs,* 2004
ink on paper; 230 drawings
8 1/4 × 11 3/4 in. (21×29.8 cm)
11 3/4 × 16 1/2 in. (30×42cm)
16 1/2 × 23 5/8 in. (42×60cm)
Courtesy of the artist
and Galerie Barbara Thumm, Berlin

Kathy Butterly

Using her undeniably impressive skill with clay and glazes,
Kathy Butterly packs tremendous sculptural and textural complexity into
tiny forms that have an effusion of decorative detail. Like her "funk"
ceramic forebears Ron Nagle and Ken Price, Butterly exploits the sensuous
and whimsical properties of vessels, creating a body of work that nods to
anthropomorphism with irreverence and wit. Her work calls forth
influences with great material specificity, but also ranges widely to suggest
the curious color of Indian miniatures, or the elemental forms of Chinese
sculpture, or the graphic brightness of cartoons.

Butterly at first concentrated on amphorae-like forms, thrown
on a potter's wheel, that echoed the curvaceousness of the female body.
Since the mid-1990s, she has worked exclusively on making cuplike vessels
that are cast rather than thrown. Working within self-imposed strictures
of scale and basic body type, Butterly has created an army of small vessels
bursting with personality and individuality. Beginning with a perfectly
symmetrical form in wet clay, the artist pokes and prods the piece until
it slumps, caves, twists, or bends into a unique shape that recalls some aspect
of a human body, or implies some interaction with it. The process
of addition then begins, as Butterly attaches elements to the surface and
a foot for the body to stand on. It can take up to nine months to complete
a work, as it requires multiple firings to achieve the delicacy and specificity
of color she's after. With great formal precision and imagination,
Butterly dresses the surface of each sculpture in a variety of ways, from
literally knitting with clay to clothe a vessel or incising patterns on the
surface to applying tiny clay beads or nubbins of texture. Color also plays
an important role, and the glazes are layered, laboriously, to produce
a rich spectrum of effects, from chalky crustiness to high gloss.
Though the vessels are typically no more than 8 inches tall and 3 inches
in diameter, Butterly exploits every square inch of surface to create works
that belie their scale in terms of energy and dynamism.

Butterly delights in pushing the limits of her chosen idiom,
revisiting the same essential form without ever repeating the unique
tenor or humor of any given piece. Abstracted and playful, Butterly's
cups have their own body parts—arms and legs, rear ends, feet—and this
expressive, sensuous materiality lifts each vessel to the level of imagined
portraiture. In fact, as the artist admits, these works are essentially
self-portraits. But Butterly's sculptures also address a larger issue of
adaptation, figuratively and literally, of the individual making his or her
way through the world. Butterly's vessels speak to the malleability of
human form—whether squeezing onto an overcrowded bus, or enacting
the complex presentation of identity through appearance and adornment.
More existentially, her forms might suggest the psychic appearance
of a being. Each object is imbued with personality through the inventive
and peculiar use of material, form, decoration, and color. Hers is an
aesthetic that celebrates delicacy and prettiness while also
acknowledging the oft-unheralded grace of all things quirky, klutzy,
and odd.—*Elizabeth Thomas*

BORN
1963, Amityville, New York

LIVES AND WORKS
New York, New York

Kathy Butterly received her MFA from the University of California at Davis in 1990 and her BFA from Moore College of Art, Philadelphia, in 1986. She has exhibited her ceramic vessels in solo exhibitions at Shoshana Wayne Gallery, Santa Monica, California (2003); Tibor de Nagy Gallery, New York (2002); Franklin Parrasch Gallery, New York (2001, 1994-99); The Clay Studio, Philadelphia (1993); and Moore College of Art, Philadelphia (1992).

Group exhibitions include: *Very Familiar: Fifty Years of Collecting Decorative Arts,* Carnegie Museum of Art, Pittsburgh (2003); 57th Scripps Ceramic Annual, Ruth Chandler Williamson Gallery, Claremont, California (2001); *Figstract Explosionism,* Bridgewater/Lustberg & Blumenfeld Gallery, New York (2001); *Defining Craft I,* American Craft Museum, New York (2000); *Pioneers and Terriers: Colenbrander, Ohr, and USA Clay Today,* Museum Het Paleis on Lange Voorhout, The Hague (1999); and *New York, NY: Clay,* Nordenfjeldske Kunstindustrimuseum, Trondheim, Norway (1995-96).

SELECTED BIBLIOGRAPHY

Adkins, Gretchen. "The Pots of Kathy Butterly." *Ceramics Art and Perception,* no. 23 (1996): 29-31.

Chambers, Karen. "Next of Kiln." *Art & Antiques* 20 (January 1997): 60-67.

Clark, Garth. "Rising Above the Polemic: Organic Abstraction in Contemporary Ceramics." *Ceramics Art and Perception,* no. 22 (1995): 3-11.

Del Vecchio, Mark. *Postmodern Ceramics.* London: Thames and Hudson, 2001.

Smith, Roberta. "Art in Review: Kathy Butterly." *New York Times,* August 4, 1995.

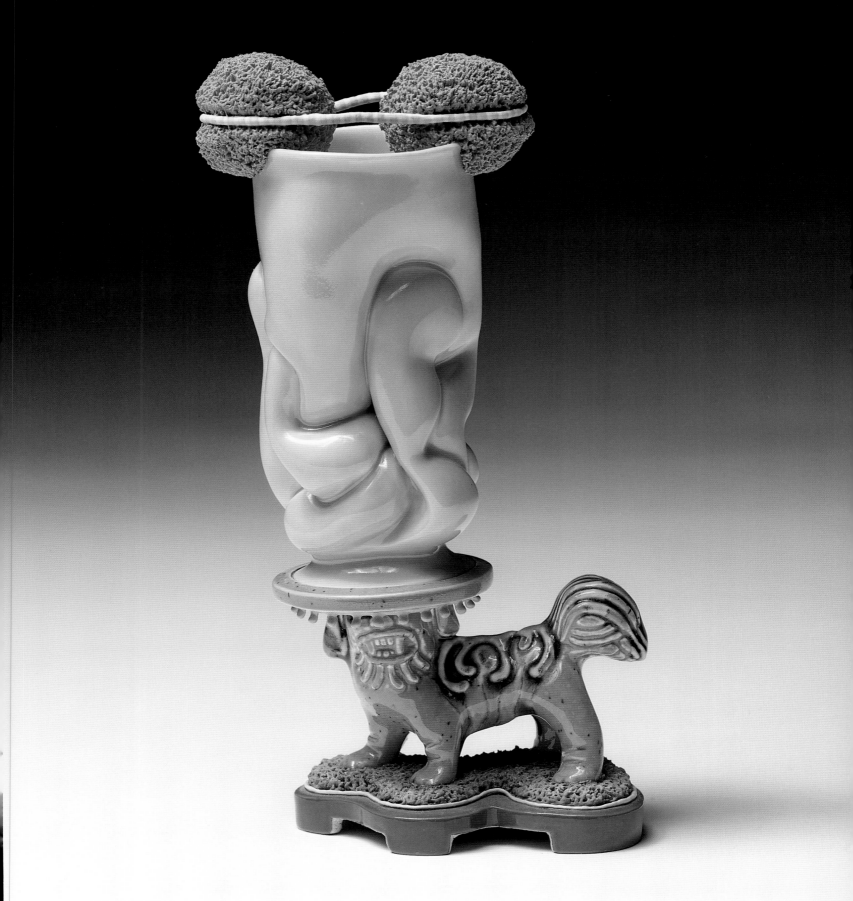

KATHY BUTTERLY
Bonnet, 2000
porcelain, earthenware, and glaze
7 5/16×2 3/16×3 1/4 in. (18.6×5.6×8.3 cm)
Collection of Elizabeth Levine, New York;
courtesy of Tibor de Nagy Gallery, New York

bottom left
KATHY BUTTERLY
Undercover, 2001
porcelain, earthenware, and glaze
6 5/8 × 3 3/4 × 3 in. (16.8 × 9.5 × 7.6 cm)
Collection of Barrie Schwartz and
Patrick Hayne, New York; courtesy of
Tibor de Nagy Gallery, New York

bottom right
Mask, 2003
porcelain, earthenware, and glaze
4 7/8 × 3 5/8 × 2 1/4 in. (12.4 × 9.2 × 5.7 cm)
Courtesy of the artist
and Tibor de Nagy Gallery, New York

right
Frosty, 1997
porcelain, slip, and glaze
4 × diam. 2 7/8 in. (10.2 × diam. 7.3 cm)
Collection of Elizabeth Levine, New York;
courtesy of Tibor de Nagy Gallery, New York

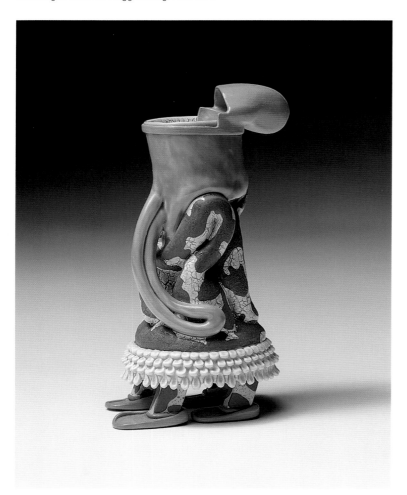

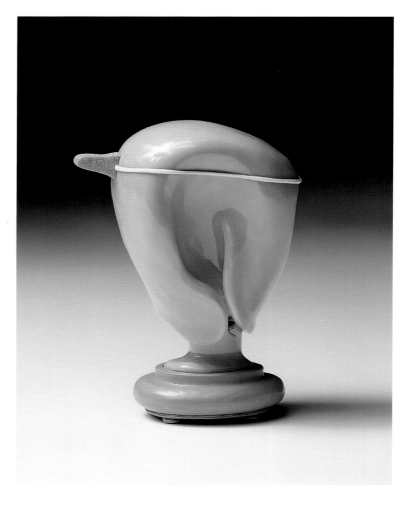

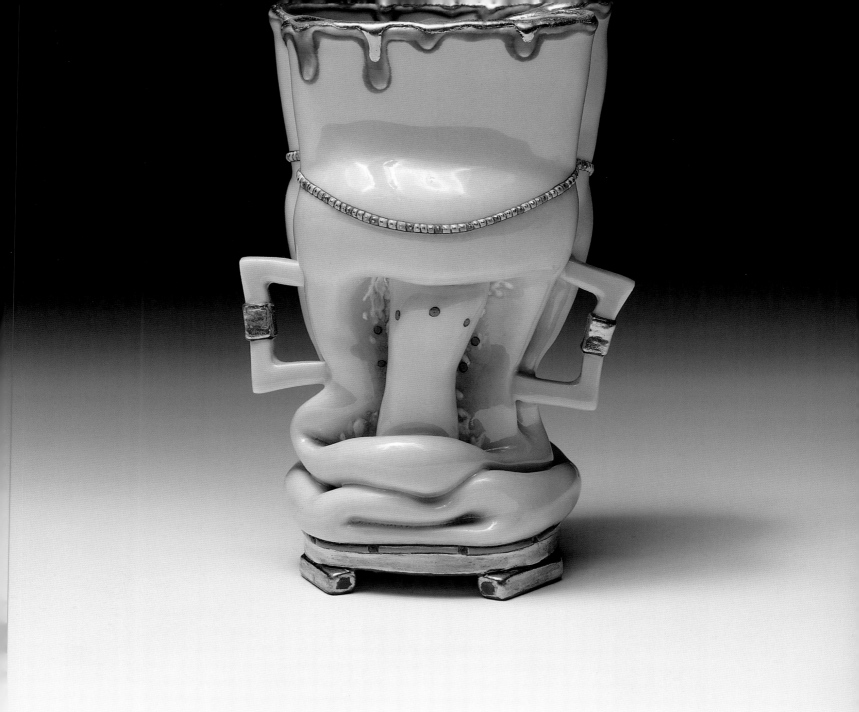

Maurizio Cattelan

BORN
1960, Padua, Italy

LIVES AND WORKS
New York, New York

Maurizio Cattelan has had solo exhibitions at ARC, Musée d'art moderne de la Ville de Paris (2004); Fondazione Trussardi, Milan (2004); Museum of Contemporary Art, Los Angeles (2003); Museum Ludwig, Cologne (2003); Marion Goodman Gallery, NewYork (2002, 2000); Museum of Contemporary Art, Chicago (2001); Museum Boijmans Van Beuningen, Rotterdam (2001); Migros Museum für Gegen-wartskunst, Zurich (2000); Musée national d'art moderne, Centre Pompidou, Paris (2000); ArtPace, San Antonio, Texas (2000); Kunsthalle Basel (1999, catalogue); Museum of Modern Art, New York (1998); Castello di Rivoli, Turin (1997); and Secession, Vienna (1997), among many others.

He has participated in five Venice Biennales (2003, 2001, 1999, 1997, 1993). Other group exhibitions include: *State of Play,* Serpentine Gallery, London (2004, catalogue); *Whitney Biennial,* Whitney Museum of American Art, New York (2004, catalogue); *Partners,* Haus der Kunst, Munich (2003); *Let's Entertain,* Walker Art Center, Minneapolis (2002, traveled to Portland Art Museum, Oregon, Musée national d'art moderne, Centre Pompidou, Paris, Museo Rufino Tamayo, Mexico City, and Miami Art Museum, Florida, catalogue); *Places in the Mind: Photographs from the Collection,* Metropolitan Museum of Art, New York (2001); *Apocalypse: Beauty and Horror in Contemporary Art,* Royal Academy of Art, London (2000, catalogue); *Age of Influence: Reflections in the Mirror of American Culture,* Museum of Contemporary Art, Chicago(2000, catalogue); *Abracadabra,* Tate Modern, London (1999, catalogue); *Manifesta 2,* Luxembourg, Belgium (1998); 6th International Istanbul Biennial (1998); *Truce: Echoes of Art in an Age of Endless Conclusions,* Site Santa Fe, New Mexico (1997, catalogue); and Kwangju Biennale, South Korea (1995).

SELECTED BIBLIOGRAPHY

Bonami, Francesco, et al. *Maurizio Cattelan.* London: Phaidon Press, 2003.

Gioni, Massimiliano. "Maurizio Cattelan, 'Him.'" *Flash Art* 34, no. 218 (May – June 2001): 114 – 17.

Maurizio Cattelan. Exhibition catalogue, Basel: Kunsthalle Basel, 1999.

Smith, Roberta. "Cattelan Uncovered." *Art Review* (International Edition) 54, no. 8 (2003): 40 – 47.

Work: Art in Progress (January – March 2004): 18 – 81. Special section, including essays by Laura Hoptman, Catherine Grenier, Hans-Ulrich Obrist, et al.

If Maurizio Cattelan were to add a tragic vision to his subversive attitude, he could aspire to be the Goya of our day. His irreverent approach toward figures of power is a humorous gesture, yet no less devastating. The pope crushed by a meteorite, two cops hung upside down, a self-portrait dressed in Beuys' felt suit—all these works reveal the true nature of the subject behind the appearance of the uniform or the holiness of the religious symbol. We are all human, no matter how we disguise ourselves in the comedy of life. Roles collapse under the weight of our humanity and the unavoidable threshold of death. We all die: the pope, the president, the policeman, the famous artist, the viewer.

Humanity is the subject of the disturbing sculpture *Him* (2001). From behind, as we approach the kneeling figure, it appears to be a small boy; but when we come around to the front, we are shocked to discover his identity: Adolf Hitler. The disconcerting impact of the work is that we are looking not at Hitler as we are used to considering him, but at a humble person captured in a moment of vision or religious illumination, like Saint Paul on his way to Damascus. Yet the figure remains Hitler, *him,* the ultimate symbol of modern evil. Cattelan perversely wants us to reflect on this image, on this subject, presented as just another person praying and representing goodness. Can evil be good even for a fragment of time? Could Hitler have experienced goodness at some point in his life, and if so, could we ever consider, even remotely, the eventuality of redemption? As much as Hitler induces hate, can we hate this harmless little person on his knees which the artist presents to us? Cattelan is in no way suggesting that we should love *him* or consider any kind of forgiveness; rather, he offers us proof that power and evil can assume the appearance of good and thereby deceive us. Using this icon of modern evil, the artist warns us about the corrupting nature of power and reminds us how history can transform the acts of a single dangerous individual into a tragedy for all humankind.

The little Hitler brings to mind Chaplin's Great Dictator, playing joyfully with the inflated world, or more recently, the images of Saddam Hussein humiliated by the banality of undergoing a physical examination by his captors. The entire world witnessed the helpless Iraqi dictator and inevitably, even if briefly, we may have also felt some compassion. In witnessing to our own humanity, we risk forgetting history and its cruelties. In the end, Cattelan's work has the strength of every good comedy: the ability to make us laugh about power, and through laughing, to understand the danger of it—its treacherous ability, even after downfall, of resurrecting and striking society again and again. It is in the awareness beyond the laugh that the best art becomes the best weapon against such danger.—*Francesco Bonami*

MAURIZIO CATTELAN
installation view, *Untitled*, 2004, Milan, May 2004
mixed media
life-size
Courtesy of Fondazione Nicola Trussardi, Milan

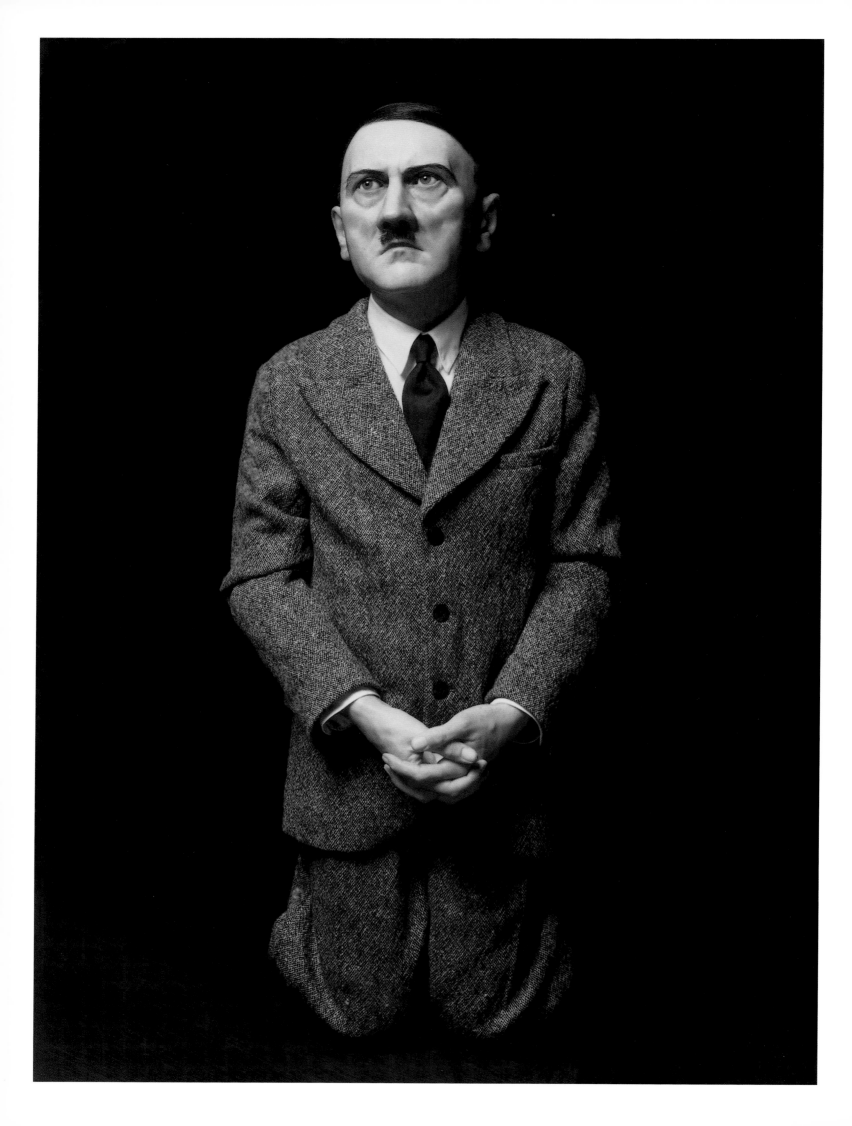

left
MAURIZIO CATTELAN
Him, 2001
wax, human hair, polyester resin, and clothes
39 3/4 × 16 1/8 × 20 13/16 in. (101 × 41 × 53 cm)
Courtesy of Marian Goodman Gallery, New York

below
installation view, *Untitled*, 2004, *State of Play*,
Serpentine Gallery, London,
February 3 – March 28, 2004

Paul Chan

For Paul Chan, art and activism inform each other; their ideologies often overlap, though the goals, limits, and consequences of each practice are clear. When working with politically motivated groups, such as Voices in the Wilderness (with which he traveled to Baghdad as part of the Iraq Peace Team in 2002–3), Chan took concrete steps toward accomplishing something practical and tangible. With art-making there is no such clarity; it is a socially impotent act, but one that is a trigger for other action. To quote Chan (paraphrasing Kafka): "Art is the axe to break up the frozen sea within us when we don't even know what questions to ask."

Happiness (finally) after 35,000 Years of Civilization—after Henry Darger and Charles Fourier (2000–2003) is an epic animated film in which Chan casts Fourier and Darger as doppelgängers in pursuit of utopia. Fourier, the nineteenth-century social theorist, envisioned a society driven by cooperative organization of labor and the indulgence of fundamental physical passions. Darger, a reclusive visionary artist of the mid-twentieth century, created an alternate universe in the form of a fabulist tale in which innocent young girls are violently oppressed. Chan inscribes Fourier's hedonistic social philosophies into Darger's vision of young hermaphrodites frolicking and playing in a bucolic landscape in which they can satisfy every desire, from defecating to munching on flowers to masturbating. Chan's allegory entreats us to question the apparatus of social controls, to consider strictures of free will and human agency, and to think for ourselves about the causes of the struggles that arise as human beings try to live alongside one another. In *Happiness*, Chan isn't modeling a workable utopia, but positing another function of utopia— as he has said, "Utopia is a proxy that stands in lieu of absolute freedom. To imagine what this looks like is… an exercise in hope."

The portraits in *Now Let Us Praise American Leftists* (2000) are created with FACES, a type of computer modeling software used to compile digital sketches of suspected criminals. Referencing issues of social responsibility inherent in James Agee and Walker Evans' New Deal–era book *Let Us Now Praise Famous Men*, Chan developed his own visual index of persons involved in political and social activism. One motivation was his desire to amend the record documented in *The Encyclopedia of the American Left*, a book that is, perhaps unsurprisingly, lacking in diversity, as it tells the story of primarily white activism through the labor history and cultural movements of the 1960s and 1970s. Chan attempts to fashion a more inclusive collective portrait of generalized types: the Black Panther, the Industrial Unionist, the May 12 Activist, the AIDS activist, among others. Mimicking the black-and-white jumpiness of an old film reel, within the parade of faces, Chan intersperses shots of highways and landscapes, stand-ins for the American "manifest destiny" embedded at the core of the varied ideological struggles of the activists. Though meant as a kind of filmic elegy, the work also provides an ironic comment on the distinctions between the stereotypical criminal and the stereotypical activist. In the FACES catalogue of physical features, Chan found few Caucasian attributes, a fact alarming for its revelation about how we visualize criminals. More important to his project, however, were the factors that made it impossible for Chan to create the ethnically representative index that might have accounted for the histories of all people who have fought injustice through protest and activism.—*Elizabeth Thomas*

BORN
1973, Hong Kong

LIVES AND WORKS
New York, New York

Paul Chan received his MFA from Bard College, Annandale-on-Hudson, New York, in 2002, and his BFA from the School of the Art Institute of Chicago in 1996. He has exhibited his videos in solo exhibitions at Greene Naftali Gallery, New York (2004), and MoMA Film at the Gramercy Theater, New York (2003).

Group exhibitions include: *Regarding Amy,* Greene Naftali Gallery, New York (2003); *pol-i-tick,* Williams College Museum of Art, Williamstown, Massachusetts (2003); *Versus,* Diverse Works, Houston, Texas (2002); and *New Media Art Now,* Location One, New York (2000). Screenings of his work have occurred at: *History Makes a Comeback,* New York Video Festival (2003); San Francisco Cinematheque, Yerba Buena Center for the Arts (2003); *Global Conflicts 11,* Next 5 Minutes International Tactical Media Festival, Amsterdam (2003); *The Angry Breed,* Pacific Film Archive, Berkeley, California (2003); *Versionfest: E-lit,* Museum of Contemporary Art, Chicago (2002); *Surviving in a Digital World,* Transmediale New Media Festival, Berlin (2001); *Selected CD ROMS,* Ars Electronica Festival, Linz, Austria (2000); *The Black Panther Omega 2000,* Walker Art Center, Minneapolis (1999); and *All Power to the People,* The Kitchen, New York (1999).

SELECTED BIBLIOGRAPHY

Horowitz, Mikhail. "Utopian Blues: Paul Chan's Digital Visions and Political Actions Are All of a Piece." *The Bardian,* Spring 2004: 26–27.

Kerr, Merrily. "Theory: Recuperating Revolt." *Flash Art,* no. 236 (May–June 2004): 106–9.

Saltz, Jerry. "Babylon Rising." *Village Voice,* September 10, 2003.

Smith, Roberta. "A Grand Finale of Group Show Fireworks." *New York Times,* July 18, 2003.

Yablonsky, Linda. "Regarding Amy." *Time Out New York,* July 10, 2003.

PAUL CHAN
still from
Now Let Us Praise American Leftists, 2000
single-channel video;
black and white, sound
3:30 min.
Courtesy of the artist
and Greene Naftali Gallery, New York

PAUL CHAN
stills from *Happiness (finally) after
35,000 Years of Civilization — after Henry
Darger and Charles Fourier*, 2000–2003
digital animation and screen; color, sound
17:20 min.
Courtesy of the artist
and Greene Naftali Gallery, New York

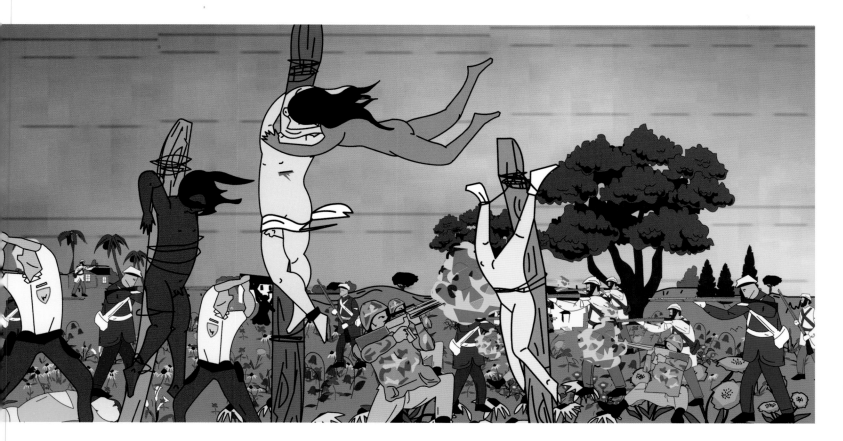

Anne Chu

Anne Chu mines the history of figuration and representation, across cultures and eras, to create sculptures that evoke ritual art, tribal crafts, storytelling, cultural performance, and mythology. Although historically specific, her sources are employed more for their capacity to trigger imagination and visual pleasure through a general allegorical impulse than for their particular references. Process is such a key element of her art-making that many of her sculptures appear almost unfinished, reflecting Chu's position that what she makes resides somewhere between a sketch and a completely polished object. The works display a forthrightness of materiality and surface, with visible joints and welded armatures, wooden elements still rough with the marks of chainsaws, and hand-embroidered and sewn costumes.

Chu installs her puppetlike figures in groupings on bases that often resemble stages, and the overall effect is one of a timeless, placeless field of players awaiting action, primed to perform enchanted stories of myth and folklore. Chu's sources span the globe and are drawn from settings as diverse as ancient China or Renaissance Europe; wooden figures based on Velásquez paintings coexist with papier-mâché bears that are derived loosely from the life-size, terra-cotta figures entombed with the third-century BCE Chinese emperor Qin Shi Haungdi. Chu's latest works, though not puppets per se, can be seen as what the anthropologist Frank Proschan has called "performing objects"—images of humans, animals, or spirits that are created, displayed, or manipulated in narrative or dramatic performance. Chu's cadre of marionette-like objects calls to mind a practice of storytelling that predates the written word. In preliterate societies, memory was the sole repository of history and knowledge, and performative storytelling was the only means of transmitting cultural values and expressing shared beliefs.

Even though such belief systems are locally specific, Chu's wide-ranging sources point to commonalities in the history of myth—the motifs and stories that are universally resonant and repeat themselves across cultures. Such archetypes as the warrior, the creator, the sage, or the healer recur throughout time and place, not necessarily through cultural transmission, but spontaneously, because their functions have relevance to life and the stories around them help us make sense of the world. The use of performing objects to personify these archetypes is nearly universal; the imbuing of inanimate objects with action, and in some belief systems, even with souls, provides a concrete connection between the material and spiritual worlds and is essential to communicating and reinforcing the artistic, cultural, and social identity of a place. Chu's work, in all its lyrical beauty and allusive power, seeks to articulate a reassuring message: that as we parse our traditions for answers about the world we live in, we find as many commonalities as differences. To paraphrase Jungian ideas, myths are the dreams of societies, and Chu's work envisions a stage on which the dreams of many might come together. —*Elizabeth Thomas*

BORN
1959, New York, New York

LIVES AND WORKS
New York

Anne Chu received her MFA from Columbia University, New York, in 1985 and her BFA from the Philadelphia College of Art in 1982. Solo exhibitions of her work have been shown at 303 Gallery, New York (2003); Christine Burgin Gallery, New York (2002); Donald Young Gallery, Chicago (2002, 1999); Victoria Miro Gallery, London (2001); Marlborough Graphics, New York (2001); Indianapolis Museum of Art, Indiana (2000); Berkeley Art Museum, University of California (2000); A/C Project Room, New York (1999, 1996); Cleveland Center for Contemporary Art, Ohio (1998); Marc Foxx Gallery, Los Angeles (1998); and Dallas Museum of Art (1998); among others.

Group exhibitions include: *Shuffling the Deck: The Collection Reconsidered*, Princeton University Art Museum, New Jersey (2003); *Drawings*, Donald Young Gallery, Chicago (2003); *Extended Painting*, Victoria Miro Gallery, London (2003); *Inside the Whale*, Clemens Gasser & Tanja Grunert, New York (2002); *Making the Making*, apexart, New York (2001); *Kiki Smith, Byron Kim, Anne Chu*, A/C Project Room, New York (1998); *Prop Fiction*, White Columns, New York (1997); *Drawings from the Mab Library*, A/C Project Room, New York (1996); Sculpture Center, New York (1993); *New Generations: New York*, Carnegie Mellon Art Gallery, Pittsburgh (1991); and *The New Eccentricity: Sculpture*, Bess Cutler Gallery, New York (1990).

SELECTED BIBLIOGRAPHY

Anne Chu. Exhibition brochure. Ohio: Cleveland Center for Contemporary Art, 1998.

Anne Chu. Exhibition brochure. Texas: Dallas Museum of Art, 1998.

Schwabsky, Barry. "Anne Chu." *Art on Paper* 2 (September–October 1997): 20–21.

Schwendener, Martha. "Anne Chu: 303 Gallery." *Artforum* 42, no. 6 (February 2004): 151.

Volk, Gregory. "Anne Chu at A/C Project Room." *Art in America* 85 (February 1997): 96.

ANNE CHU
detail of *Charming Girl,* 2003
wood, fabric, and wire
figure: 42 1/2 × 59 × 90 in. (108 × 150 × 229 cm);
pedestal: 4 × 65 1/2 × 84 in. (11 × 166 × 213 cm)
Courtesy of the artist; 303 Gallery, New York;
and Victoria Miro, London

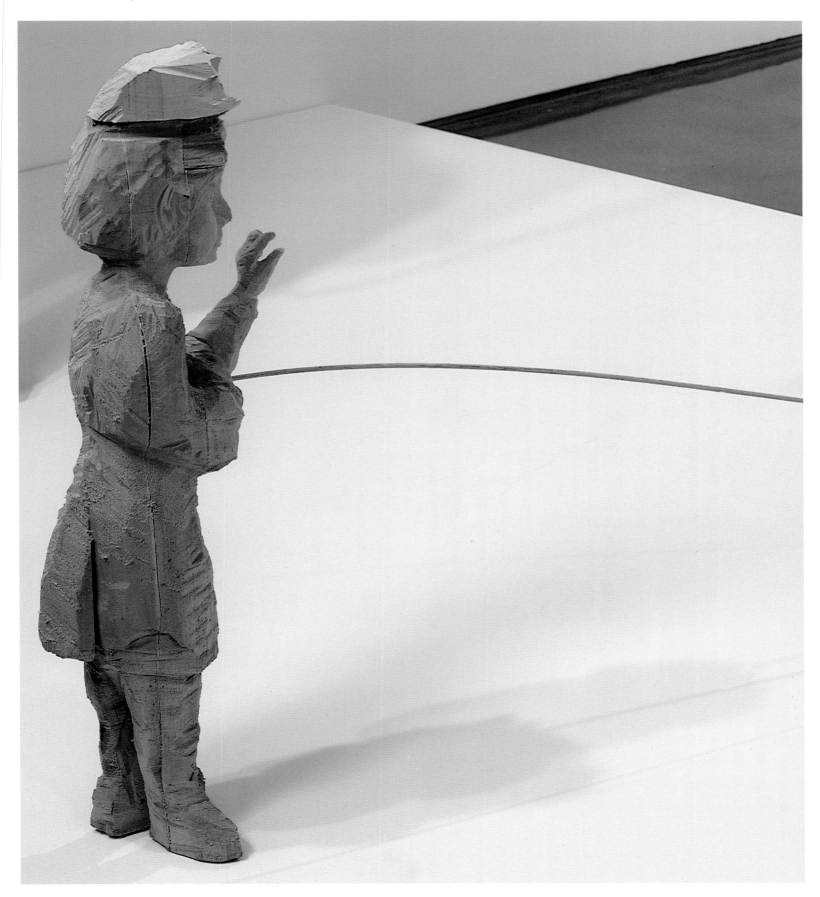

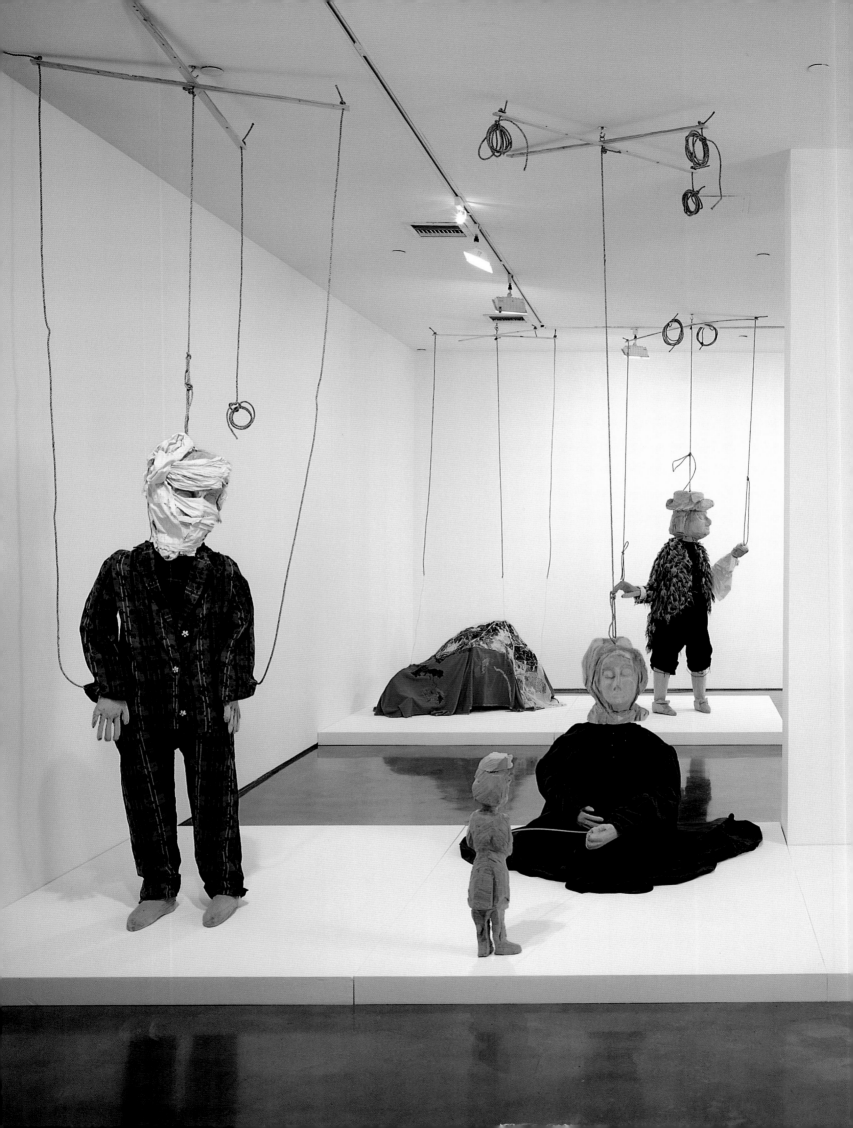

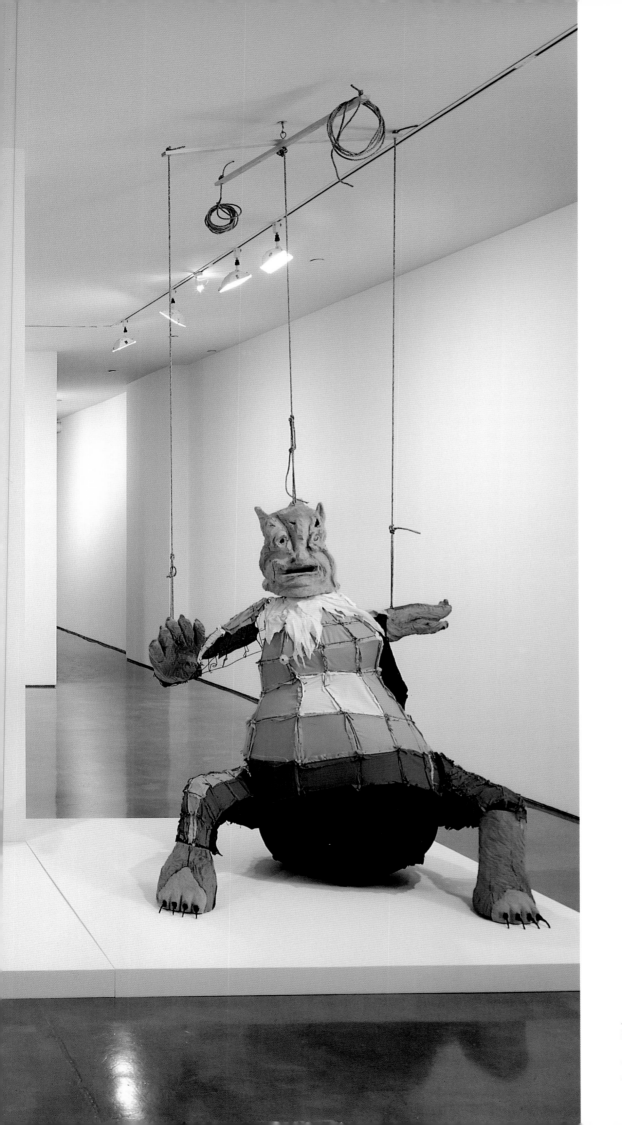

ANNE CHU
installation view, 303 Gallery, New York,
November 1 – December 23, 2003
Courtesy of the artist; 303 Gallery, New York;
and Victoria Miro, London

BORN
1943, Philadelphia, Pennsylvania

LIVES AND WORKS
Sauve, France

In addition to publishing his work internationally in comics, books, and magazines, Robert Crumb has exhibited his comics and original drawings in solo exhibitions at Ludwig Museum, Cologne (2004, catalogue); Paul Morris Gallery, New York (2002, 2000); Alexander Gallery, New York (1993); Modernism, San Francisco (1990, 1983); Gotham Book Mart, New York (1987); and La Hune, Paris (1986).

Group exhibitions include: *The Great Drawing Show,* Michael Kohn Gallery, Los Angeles (2003); Air de Paris, Paris (2002); Feigen Contemporary, New York (2002); Paul Morris Gallery, New York (2001, 2000, 1999); *100 Drawings and Photographs,* Matthew Marks Gallery, New York (2001); *Amused,* Carrie Secrist Gallery, Chicago (2001); *Self-Made Men,* DC Moore Gallery, New York (2001); *Panic,* Julie Saul Gallery, New York (2001); *Best of the Season,* Aldrich Museum of Contemporary Art, Ridgefield, Connecticut (2001); *Eye Infection,* Stedelijk Museum, Amsterdam (2001, catalogue); *Misfit Lit: Contemporary Comic Art,* Center on Contemporary Art, Seattle (1991); *R. Crumb Comix,* Duke University Museum of Art, Durham, North Carolina (1990, catalogue); *High and Low: Modern Art and Popular Culture,* Museum of Modern Art, New York (1990); *Zap to Zippy: The Impact of Underground Comix,* Cartoon Art Museum, San Francisco (1990); Psychedelic Solution, New York (1989); *Raw: Images from the Graphix Magazine That Overestimates the Taste of the American Public,* New York Institute of Technology, Old Westbury (1988); and Gotham Book Mart, New York (1987).

SELECTED BIBLIOGRAPHY

The Complete Crumb: Volumes 1–16. Seattle: Fantagraphics Books, 1987–2002.

Groth, Gary, and Robert Crumb. "R. Crumb Bares All." *Comics Journal,* no. 121 (April 1998): 48–123.

———. "Robert Crumb: On Racism, Mysogyny, Love, and Himself." *Comics Journal,* no. 180 (September 1995): 116–38.

Richter, Carl, ed. *Crumb-ology: The Works of R. Crumb, 1981–1994.* Sudbury, Mass.: Water Row Press, 1995. Supplements published in 1995 (Sudbury, Mass.: Water Row Press) and 2002 (Babylon, N.Y.: Babylonia Press).

Robert Crumb. Exhibition catalogue. Cologne: Museum Ludwig, 2004.

1 The spelling of "comix" first appeared in the mid-1960s to describe the "underground" genre of adult-themed comic books of which Crumb was a founder.

ROBERT CRUMB
Untitled (*Carnegie International* poster), 2004
ink and mixed media on paper
15 1/2 × 11 5/8 in. (39 × 30 cm)
Collection of the artist; commissioned by 2004–5 *Carnegie International,* Carnegie Museum of Art, Pittsburgh
© 2004 R. Crumb

"Remember folks, it's only lines on paper": Robert Crumb and the Art of Comics

Jean-Pierre Mercier

In the space of four decades Robert Crumb has produced an immense body of work, almost entirely in the drawing medium. He has also cultivated a passion for popular music, with a dozen or so LPs and CDs to his credit. He painted for a short time during the 1980s, and twice devoted a period of several months to sculpture, producing two pieces in painted and varnished wood. Essentially, however, his life's work has been as an illustrator and "comix" creator. [1]

The project to publish his complete works began seventeen years ago, is still in progress, and now runs to sixteen volumes. To these must be added the 1975 reprinting of the *Big Yum Yum Book* (drawn in 1962–63) and the 1980 reappearance of the fanzine *Foo,* originally self-published by Robert and Charles Crumb in 1958. The more recent publication of the complete *Sketchbook Reports* (1993), which originally appeared (or were destined to appear) in *Help!* magazine in the early 1960s, and of the massive volume *Odds & Ends* (2001), which brings together his private graphic work (posters, greeting cards, wedding and birth announcements, and various illustrations), affords us a fairly comprehensive picture of the published Crumbian oeuvre. To be utterly completist, one would have to add the eight volumes of *Sketchbooks* still slated for printing by U.S. publisher Fantagraphics, and the three-volume *Waiting for Food* (1996/2002/2003), which presents a wide selection of drawings that Crumb executed between meal courses on restaurant placemats in the south of France. The exhumation of this "private" side of Crumb's graphic work, begun in 1978 by the German publisher Zweitausendeins (seven volumes were published up to 1997), has helped alter public perceptions of the artist.

The "Happy Hippy Cartoonist" of the late 1960s, as most remember him, is revealed in the pages of these hefty tomes to be a compulsive draftsman whose published work makes up but a fraction of his creative output—the tip of the iceberg, if you will. More attentive fans know that the *Waiting for Food* material didn't really fall into the never-before-seen category. *Artistic Comics,* published in 1973 and devoted entirely to his personal sketches, and the few drawings reproduced in the seventh and final issue of the excellent magazine *Arcade* (1975) had already provided them with a glimpse into Crumb's vigorous graphomania. A careful reading of this vast corpus provides a new perspective on the initial period of Crumb's renown (indeed the peak of his popularity): the years 1967 to 1977.

Though he is viewed equally by his peers and by comics historians as the leading illustrator of the late 1960s underground, the idea of Crumb as leader is a paradox in a lot of ways. And though there is no doubt he, too, was borne along by the pervasive optimism of the hippie generation, Crumb did not share in the totality of its values—far from it. He was too inhibited, casting a mistrustful eye on the more extreme—and the more naive—expressions of the philosophy of the times. Hence one could argue that the simultaneously indulgent and ironic

gaze Crumb used to draw about that period later in his career (see the panels from *I Remember the Sixties* published in *Weirdo*, no. 4, 1981–82) was in the end not so far removed from the one he employed when he drew from the moment. The paradox of Crumb's situation at the end of the 1960s is perfectly illustrated by the success of Ralph Bakshi's animated film of Fritz the Cat's adventures. Where Crumb's Fritz was an irresolute, unrefined, and on the whole ridiculous hero, Bakshi turned him into a tough little smartass, always one step ahead of the next gag. Small wonder Crumb took the filmmaker's vision as a betrayal—and then took sweet revenge in sending Fritz to meet his maker in the memorable *Fritz the Cat Superstar*. The irony, of course, is that for so long Crumb owed much of his fame to a movie he disowned.

Crumb's ambivalence toward the hippie movement is also patently obvious in the character of Mr. Natural FIG.1, which parodies one of the obligatory figures of hippie culture, the guru. True sage, cynical manipulator, recluse, sensualist—Crumb allows his subject every ambiguity, in the process lending incomparable richness to the relationship with his disciple, Flakey Foont. Sign of the times: the latter, on the cusp of the 1980s, ends up institutionalized. He gets out at the end of the decade, to embark on adventures substantially different in tone from those of his earlier period.

In hindsight, there's no mystery as to why Crumb should have been viewed as the leading figure of the underground: at the time, among illustrators of his generation, his technical skills were without peer. He had earned his living from illustration since 1962, and had been drawing every day since the age of six. By the time *Zap Comix* propelled him to fame in 1967, his output already ran to the thousands of pages; he had experimented with a wide range of graphic techniques, all self-taught; and he had absorbed the influences of myriad past masters of American comic book and cartoon illustration.

The importance of *Mad* magazine in Crumb's initial education is well known, and there were other early influences: Walt Kelly's *Pogo*, the *Donald Duck* pages that Carl Barks drew anonymously for Walt Disney and, more fleetingly, the work of Jules Feiffer. His love for these pioneers, themselves connoisseurs of the long tradition of cartoon drawing, inevitably drew Crumb ever further backward along an arc of rediscovery. From Bud Fisher (*Mutt and Jeff*) to Milt Gross (*He Done Her Wrong*), Elzie C. Segar (*Popeye*), Gene Ahern (a supporting character in *The Squirrel Cage* was the model for Mr. Natural), Sidney Smith (*The Gumps*), George Herriman (*Krazy Kat*), Frank King (*Gasoline Alley*), Cliff Sterrett (*Polly and Her Pals*), and Harold Gray (*Little Orphan Annie*), Crumb absorbed and resuscitated an entire, forgotten world— this in a period dominated by strips featuring cerebral humor and a leaner line, best exemplified by Charles M. Schulz's *Peanuts*, Crockett Johnson's *Barnaby*, and Jack Kent's *King Aroo*.

Crumb's earliest success clearly stemmed from the fact that, formally, his work revived the best of the 1930s strips, while its content was rooted in the reality of the 1960s. A fine example of this contrast is seen in his strip *Dirty Dog* (1968), in which a character from the Disney universe is depicted as a poor, drunk, sexually frustrated loser. In addition to the staggering graphical virtuosity on display, there was plenty about this hybrid vision to appeal to and amuse readers of the time.

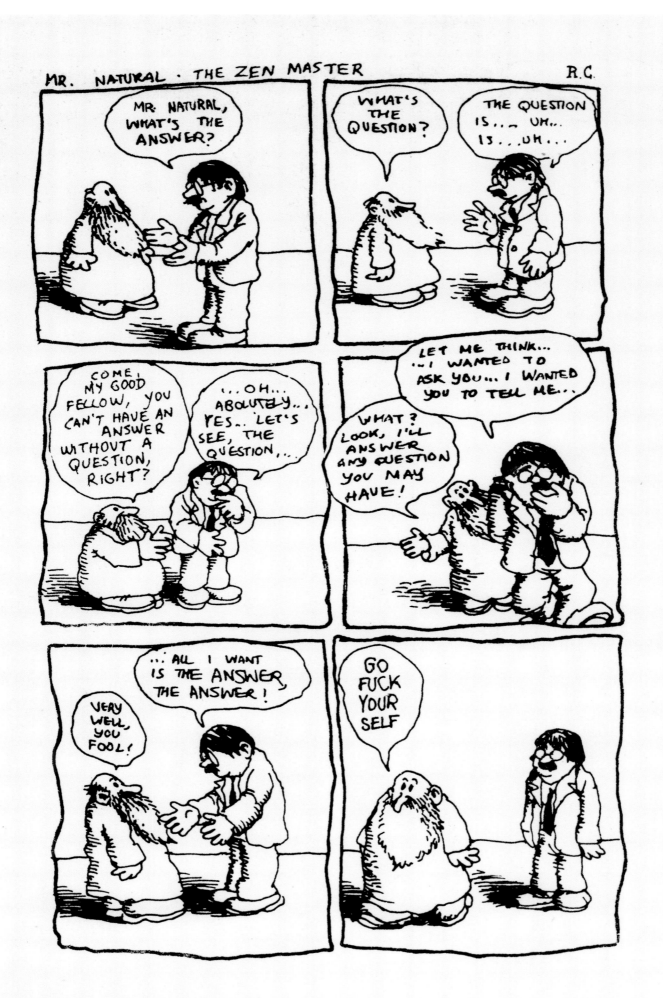

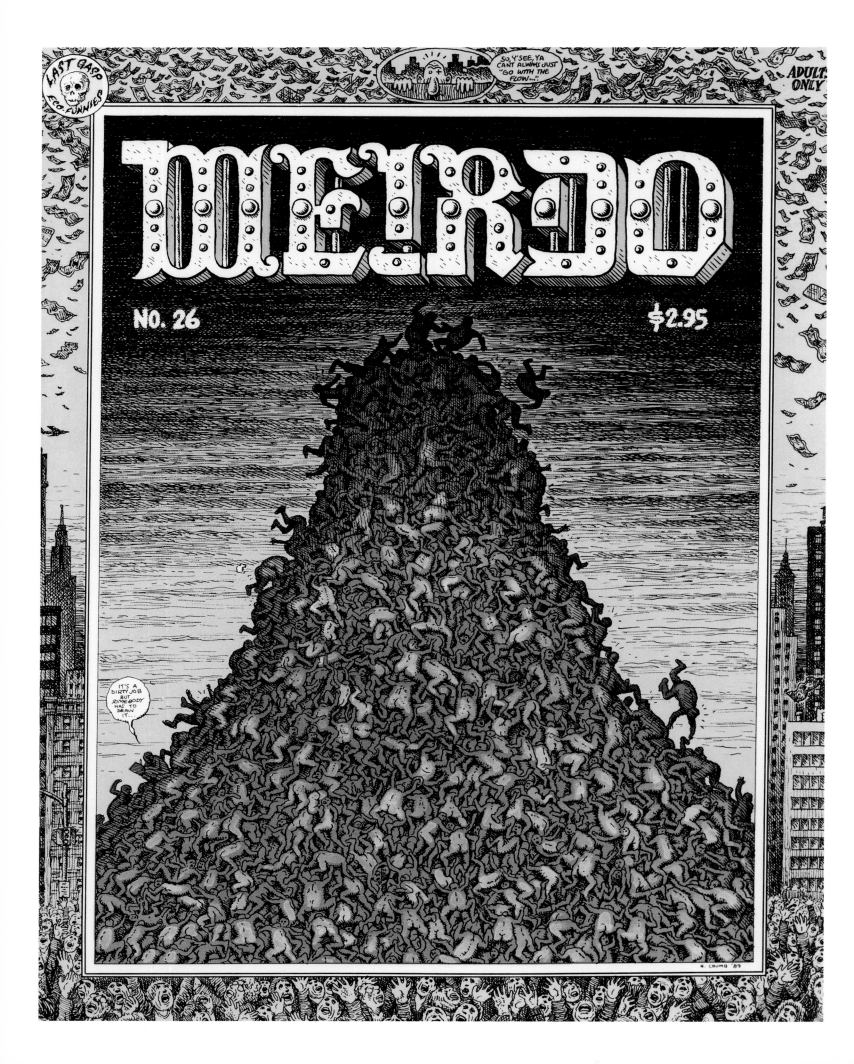

It is not merely graphic excellence that sets Crumb apart from the illustrators of his generation; he has always been unique in the way he uses the medium. Where some among his peers took to renewing the strip form by exploding its formal boundaries, Crumb adhered steadfastly to classical narrative technique. Whereas Victor Moscoso or Rick Griffin did away with frames, balloons, and even text in favor of cascading frescoes of dream imagery, and S. Clay Wilson saturated his short tales with ultraviolence-engorged images, intentionally blurring readers' comprehension of their thin narrative threads, Crumb never abandoned frames and balloons, nor the clarity of his discourse—even in the works most directly inspired by lysergic acid visions. The zenith of his experimentations came with the fourteen-page *Abstract Expressionist Super Modernistic Comics...* followed by *All Meat Comics* and *Cubist Be Bop Comics*, published within a relatively short span of time (between 1966 and 1972), which basically operate as juxtapositions of images that in terms of narrative have no direct causal link, attempting to reconstruct emotions evoked by popular music (*Cubist Be Bop Comics*), or to conjure in maximum microscopic detail the primal pleasures of the flesh and of bodily functions (*All Meat Comics*).

After absorbing the illustrational heritage of the interwar period, and once he had closed the hippie "parentheses" near the end of the 1970s, Crumb continued on his backward arc through the history of popular illustration by drawing inspiration from U.S. artists Thomas Nast and T. S. Sullivant; England's George Cruikshank (an illustrator of Dickens), Thomas Rowlandson, and James Gillray; as well as France's Gustave Doré and Honoré Daumier. It is clear that Crumb's penchants for caricature, for drawing mugs (including his own), and for the cross-hatching technique have their origins in his appreciation for these eighteenth- and nineteenth-century masters.

Crumb's taste for the know-how of the past is also evident in his joyful lettering. All of his titles are masterpieces of calligraphy, for the most part inspired by (when not directly copied from) ancient alphabets. Those seeking to truly appreciate Crumb's talent as a calligrapher need only turn to his twenty-seven *Weirdo* covers FIG. 2, which are among his most strikingly successful forays into the form.

In borrowing the notion of parentheses to describe Crumb's hippie period, which extended from 1965 to 1975, I mean first of all that stylistically these years are marked by, among other things, a simplifying and rounding off of his line, which resulted in a clarity whose impact on contemporaneous readers was phenomenal. It is striking to read the *Sketchbooks* and note how, in the space of a few weeks, the use of LSD progressively reduces Crumb's style to the iconographic archetypes of the "Big Foot" tradition. A symmetrical, gradual return to a more elaborate style, rooted in observation and pattern work, is seen beginning in 1972, when he stops using hallucinogens. This renewed taste for transcribing reality extends as far as copying photographs, specifically in his trading-card portraits of popular music legends (*Heroes of the Blues, Early Jazz Greats, Pioneers of Country Music*, and even, once he'd settled in France, *Les As du Musette*)[2] or in copying, purely for the sensual pleasure of it, photos of buxom beauties that he particularly fancies.[3] Nor is the practice of drawing from photographs exclusive to his later career: see, for example, the sketchbook portraits after German photographer August Sander, done in the late 1950s.

FIG. 2
cover of *Weirdo*, no. 26, 1989
comic book; offset lithograph on paper
10 5/8 × 8 1/4 in. (27 × 21 cm)
Courtesy of the artist
and Paul Morris Gallery, New York
© 2004 R. Crumb
© 1989 Last Gasp Eco Funnies

2 "Aces of Musette," referring to a traditional accordion-based form of French popular music.

3 See *Art & Beauty Magazine*, no. 1 (1996) and no. 2 (2002).

Thematically, too, the 1960s and 1970s can be described as parenthetical. Crumb is initially fond of *Mad* humor (*Foo* is an obvious nod to the mag founded by Harvey Kurtzman in 1952), then later allows himself to be swept up in the optimism of the era, finally arriving at the profound sense of absurdist existentialism with which he imbues the stories that bring him his initial successes. Here, too, there is little doubt that absorption of consciousness-altering substances was directly responsible for the change. Some stories—*Meatball* (1967), in particular—function as metaphorical descriptions of the potential for individual awakening and social transformation via widespread drug use. And it is notable that, with the exception of Fritz the Cat, every one of the characters that were to bring Crumb his initial fame began life on the page in 1965, during what the artist has described as "that fuzzy period," brought on by a dose of bad acid. In that space of several weeks, he invents (in spite of himself, in a way) Mr. Natural, Flakey Foont, Angelfood McSpade, The Snoid— the entire cast of characters he would direct over much of the next decade, and which would end up icons of an era. Both the impact of these first stories and their archetypal dimension doubtless owe much to the fact that Crumb, because he was incapable of fully controlling the creative process, basically let his unconscious speak. But beyond any precise significance that can be ascribed to the circumstances of their creation, the strips have retained the power to fascinate. Though he most often employs the absurd to deconstruct the inanity of social convention, Crumb also sometimes shows a moralistic bent, as when the disillusioned account of contemporary alienation in *It's Really Too Bad* (1969) FIG. 3 goes beyond mere diatribe to reach—with a remarkable sense of restraint— an existential giddiness. *Whiteman* (1967) depicts *homo americanus* as a poor sap trapped by social convention, who eventually finds his freedom in *Whiteman Meets Bigfoot* (1971) FIG. 4. In this long fable tinged with Rousseauian touches, he attains self-revelation when he meets the Yeti, the wild woman. Contrasting with these masterworks of the early period is the two-part *Lenore Goldberg and Her Girl Commandos* (1969/1970), Crumb's only contemporary attempt at a politically activist text. By the artist's own admission—though one senses a certain uneasiness— this was a very conscious effort to throw his weight behind the most highly politicized "fringe" element of his generation.

Aside from that, Crumb rarely applies an ideological schema to his reading of the world, and never reacts on the spot to the political events of his times. He cannot be considered a political illustrator, in the manner of his friend and contemporary Spain Rodriguez, a zealous advocate of a Fourth International that has yet to arrive, or even of Walt Kelly, whose sympathy with the Democrat cause is manifest in the pages of *Pogo*.

FIG. 3
It's Really Too Bad from *(Plunge into the Depths of) Despair*, 1969
comic book; offset lithograph on paper
9 3/4 × 6 3/4 in. (25 × 18 cm)
Courtesy of the artist
and Paul Morris Gallery, New York
© 2004 R. Crumb
© 1969 Last Gasp Eco Funnies

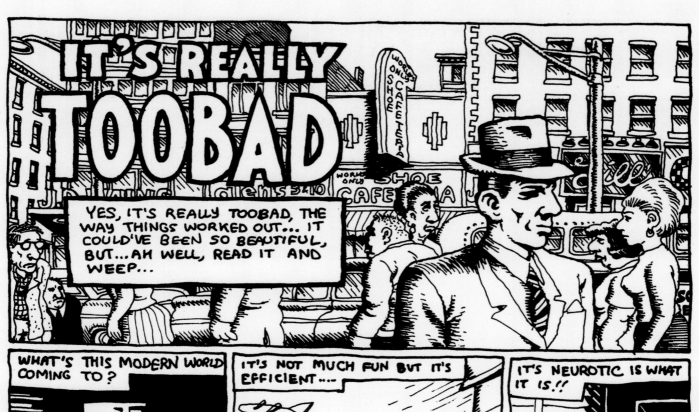

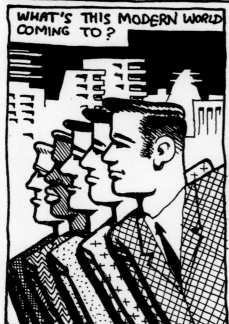

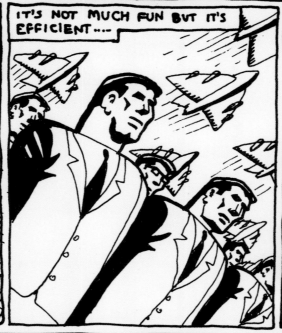

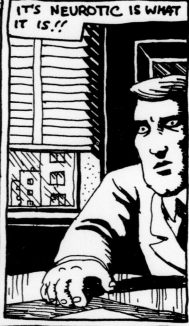

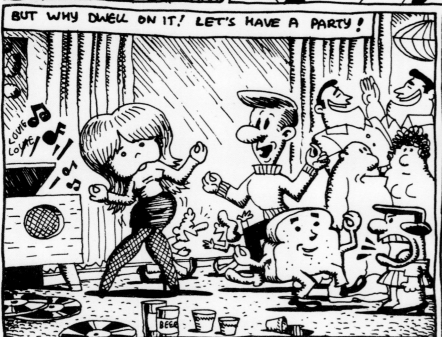

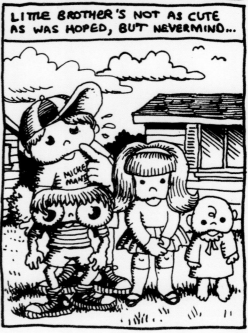

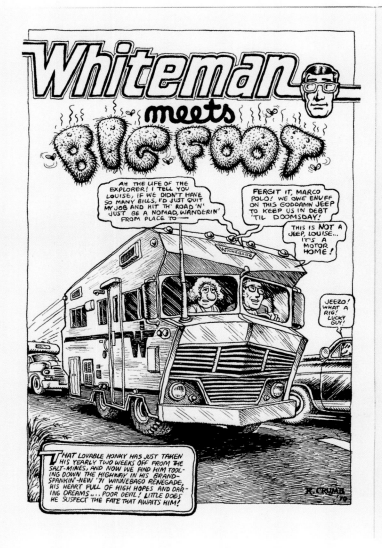

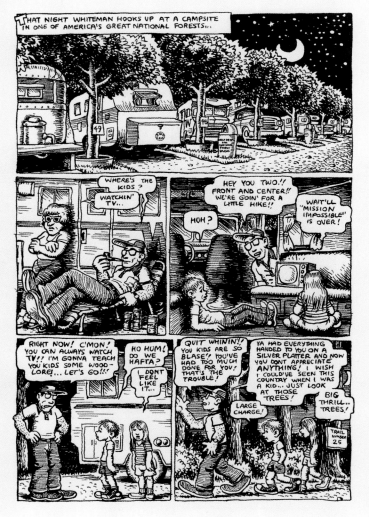

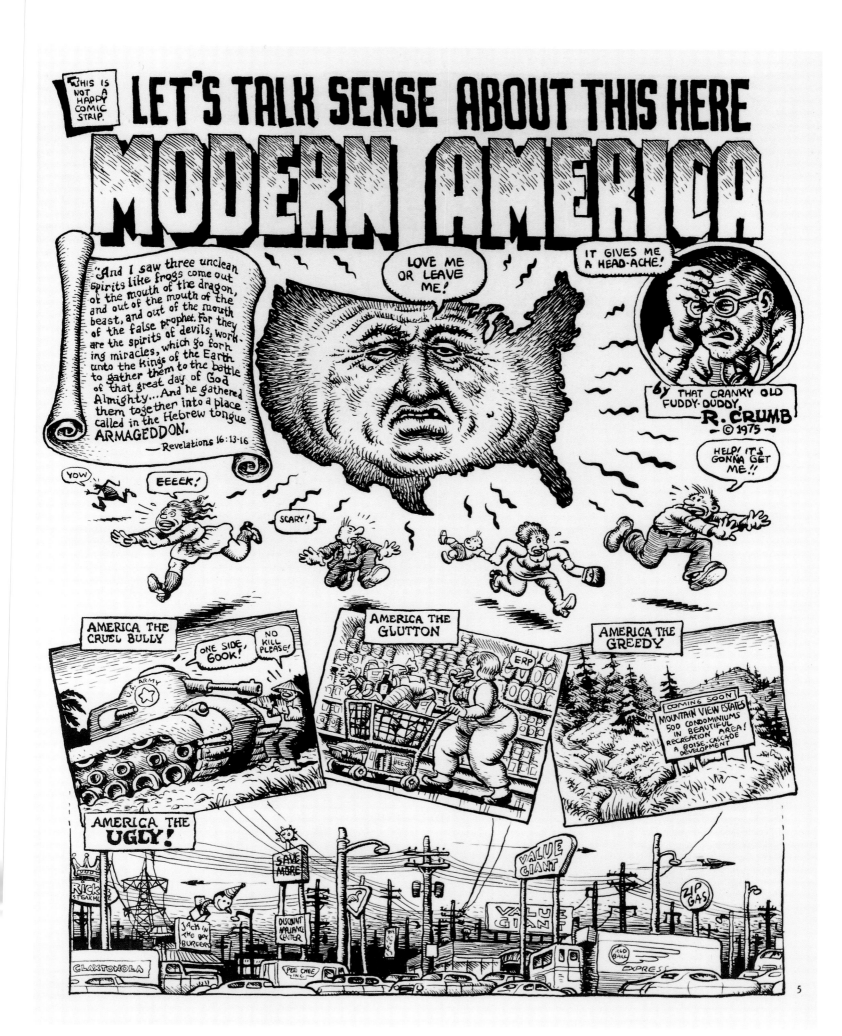

116

Here and there one detects traces of a certain fascination for the Maoist clichés still prevalent at the time (in, for example, *The R. Crumb Sucksess Story, Let's Talk Sense About This Here Modern America* FIG.5, or *Frosty the Snowman)*, but each time in a context of such caustic derision that one may well wonder just how badly the artist—who sees himself as the bourgeois decadent ripe for re-education—really wants to see the triumph of proletarian dictatorship. *Frosty the Snowman* (1975) is only superficially an ode to revolutionary armed struggle; the three heroes of this brief odyssey seem like distant cousins of *Fritz the No-Good–*era Fritz. Naive, disorganized, and scrappy, they are the antithesis of soldiers marching toward the proletarian revolution.

Published near the closing parenthesis (1975, to be exact) in *Arcade, Let's Talk Sense About This Here Modern America* is one of Crumb's major works, in that for the first time in his oeuvre, he conducts a bitter appraisal of the state of America. Nothing and no one is spared, starting with the author himself, who describes himself as unable to understand anything and signs his work, "The old crank." A few years later, Crumb cast a similarly acerbic eye on environmental activists (with whom he claims to sympathize a great deal, incidentally). When *Trash* FIG.6 appeared in the pages of *Co-Evolution Quarterly* in 1983 (though it was first published in *Weirdo* in 1982), it prompted such incendiary reactions from readers outraged by the negativity conveyed in the story that Crumb was dropped from the magazine's roster (he stopped working for the quarterly in 1984).

By the 1980s, the further adventures of Mode O'Day, now a prototypical career-obsessed yuppie female, speak to her creator's irritation at seeing an entire generation's values turned upside down. O'Day was a composite of several real people, and her exploits were usually based on factual incidents. Neurotic, narcissistic, prone to failure, she also recalls Fritz, but nothing about her adventures elicits sympathy. The gaze of creator upon creature has shifted from one of ironic affection to one of mere cruelty.

The most violent attack Crumb has yet aimed against America was to come even later: *When the Niggers Take Over America* and its companion piece *When the Goddamn Jews Take Over America*, published a decade ago in France, in the final issue of *Weirdo* (no. 28, 1993). Drawn immediately upon Crumb's return from several weeks' stay in the United States (he and his family have lived in France since the early 1990s), these eight pages ran the gamut of White American racist clichés about Blacks and Jews. They are a cold accumulation of extreme stereotypes— and so were the reactions they provoked. Crumb was bluntly taken to task by colleagues and friends, among them Art Spiegelman, Bill Griffith, and Diane Noomin—not for the substance so much as for the usefulness of such a story. Meanwhile a neo-Nazi group reprinted it in one of their publications, thrilled at the idea that the father of Fritz the Cat had taken up their cause. What Crumb was really doing—much in the manner of Lenny Bruce—was attempting to disqualify the sum total of racist clichés by fusing them into a single concentrated mass of ignominy, and implicitly betting on the potential educational power of what he was saying.

FIG.6
Trash, What Do We Throw Away?
from *Weirdo*, no.6, 1982
comic book; offset lithograph on paper
10 5/8 × 8 1/4 in. (27 × 21 cm)
Courtesy of the artist
and Paul Morris Gallery, New York
© 2004 R.Crumb
© 1982 Last Gasp Eco Funnies

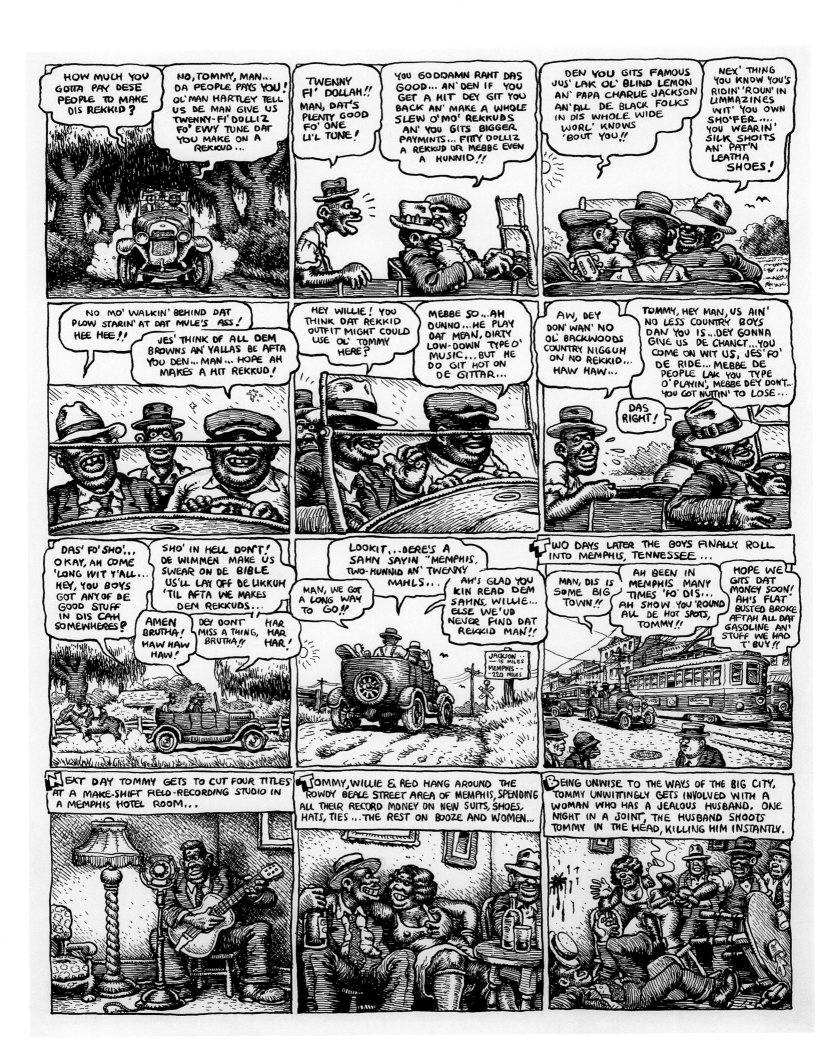

left
FIG.7
That's Life for
Arcade: The Comics Revue, no.3, 1975
ink and mixed media on paper; 5 sheets
13 3/4 × 10 1/2 in. (35 × 26.7 cm) each
Courtesy of Paul Morris Gallery, New York
© 2004 R. Crumb

following pages
FIG.8
Untitled drawings from *Sketchbook,
October 1990 to Oct '91*, 1990-91
ink and mixed media on paper
9 × 7 in. (23 × 17.8 cm) each
Collection of the artist
© 2004 R. Crumb

Crumb's disillusionment with the present (when it doesn't run to disgust) has as its corollary a deep and abiding love for the past. His aforementioned passion for the comics of the 1920s and 1930s in fact extends to all aspects of pre-industrial Americana, with a marked predilection for the popular music of the period. Crumb reused old blues titles for stories (*Dirty Dog* and *Salty Dog*) and peppered his dialogues with hackneyed 1930s quotes (not least the now-iconic "Keep on Truckin'"). Musicians Jelly Roll Morton and Charley Patton were the subject of biographies, and of course there is *That's Life* (1975) FIG.7, Crumb's retelling of the lives of the early Mississippi bluesmen, which fans point to as one of his masterworks.

That love for the past reveals even more deeply his love for popular forms of culture. Though periodically invited to exhibit his work in museums, and having had his work reprinted in deluxe editions, Crumb always returns, with pleasure, to comic books printed on cheap paper. He admires Brueghel for his prodigious technique, but also for the depictions of the peasantry that the Flemish master rarely failed to include in his canvases. Similarly, in the work of James Gillray, behind the virulent political caricatures, Crumb appreciates the lucid observations of eighteenth- and nineteenth-century British society. Crumb's *Where Has It Gone, All the Beautiful Music of Our Grandparents?* (1985) reveals a circumscribed taste for classical music, which he deems too affected, too limited. Lowbrow culture has inspired his own drawing, too: Doggo (Mode O'Day's foil), Bill Ding, and Frosty the Snowman, among other characters, are directly inspired by five-and-dime toys and figurines. Above all else, Crumb adores the freedom afforded by the less well-known realms of culture— beginning, of course, with comix.

As for the rest, Crumb is a doubter. He questions his worldview, questions his self view. He has responded to these uncertainties in the same way for the past fifty years: by drawing. He has filled dozens of sketchbooks—they are at once the crucible of his published work and the diary of his most intimate thoughts, providing glimpses into his travels, his recollections, his encounters, and his readings FIG.8. Crumb conceives of drawing as a space in which to experiment, let the unconscious mind speak, and try new graphic approaches. It is fascinating to note how obsessively certain graphic leitmotifs and *idées fixes* inhabit his sketchbooks. A few quickly dashed-off sketches can evolve into full-blown illustrations; a character who reappears persistently in these pages might become the hero of a new strip before long.

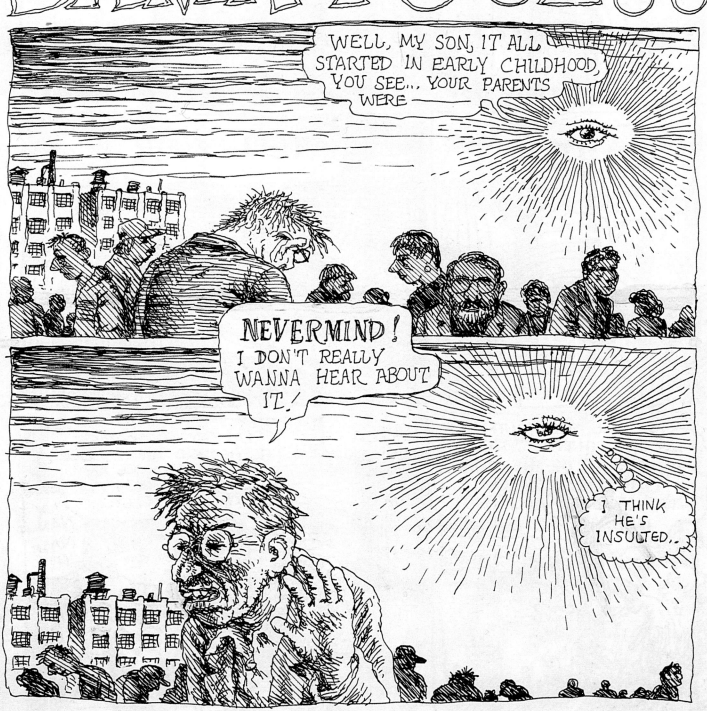

COPIED FROM A PAINTING
BY BORIS KOZJEVSKIY,
RUSSIAN ARTIST, OF
HIS DAUGHTER

WHEN
BORIS
SAW THAT I
HAD COPIED
HIS PAINTING
(OUT OF A BOOK)
HE QUICKLY,
COMPULSIVELY
WROTE HIS
SIGNATURE
HERE!

122

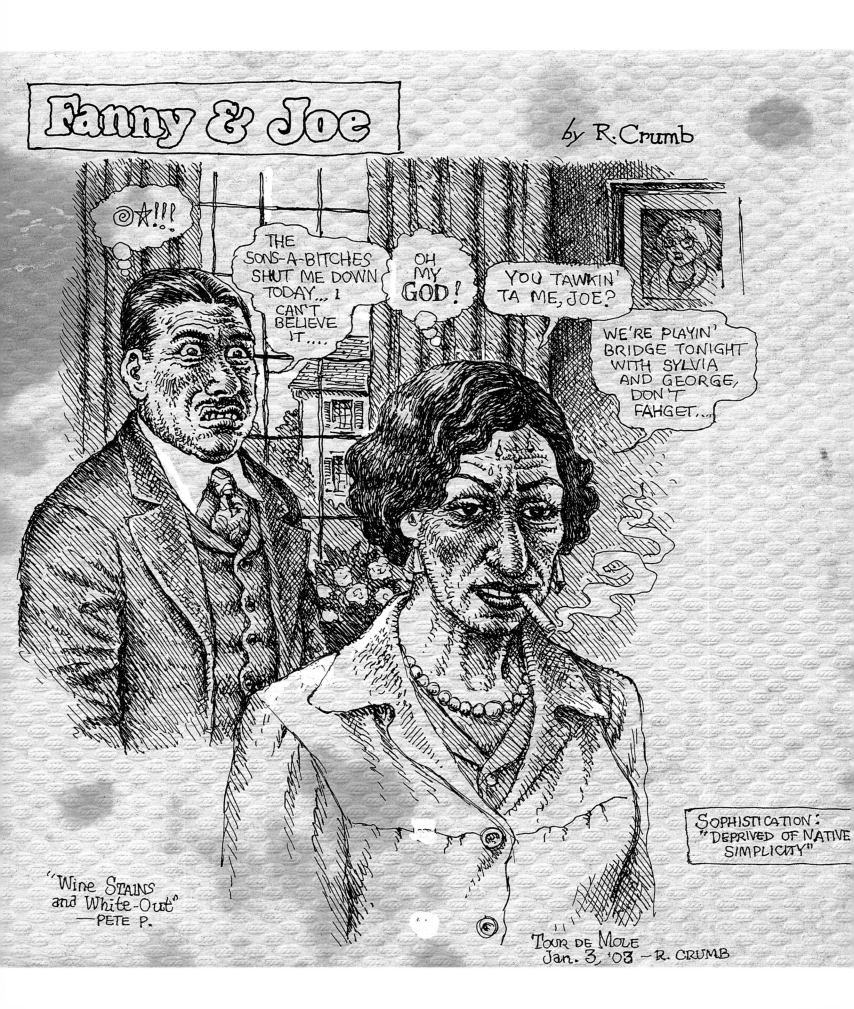

Misunderstood by his family, dogged during adolescence by feelings of profound alienation, Crumb has projected all his sweet dreams of revenge into his drawing. The full breadth of his aggressivity and angst nurtured his maturation—he has himself asserted that his life's work is built on "self-hatred." At once outlet and refuge, social connection and space for pleasure, drawing is Crumb's means of decrypting the world. Harvey Kurtzman understood this when he wrote: "Crumb really gets downright poetic with his stuff. The truest kind of art to me is the kind that really comes from deep inside your brain. You don't quite know why you're doing an idea, but you are doing it and it's effective. Crumb does a lot of that."[4]

That remark is highly applicable, of course, to any of the works that depict Crumb's sexual fantasies. With the celebrity acquired in the late 1960s, he opened the floodgates on his most private obsessions, allowing them to spill onto the page. First graphical alter egos (Eggs Ackley, The Snoid) and later Crumb himself experience "adventures" that are essentially identical in their narrative scope, not to mention their fetishistic overtones: a physically vigorous but morally submissive woman confronts a man in a one-sided combat during which she is defeated and humiliated. The violent reactions these stories have sparked from many female readers are well known; Crumb has never offered any defense beyond saying he felt an irrepressible need to draw them. To his credit, at one point these strips transcend mere repetition and delve into the reasons why such visions were given concrete expression at the tip of his pen. The two-part *My Troubles with Women* (1980) is a particularly keen and sometimes painfully honest examination of the events and traumatic experiences that caused him to deploy such virulent fantasies. They would seem to stem both from his family history—into which Terry Zwigoff's disturbing and beautiful film *Crumb* (1995) provides some astounding glimpses—and the rigid religious upbringing the artist received until his teen years. No doubt a measure of narcissism is at play in this need for self-exposure, along with the puritan instinct to confess one's turpitudes and thus know expiation. But Crumb's creative process is as much about arriving at an understanding of the self as it is about producing testimonials for others: it's about exploring the twists and turns of his mind so that "the hypocritical reader—[his] double—[his] brother"[5] will find himself at home there. As a result there is a very thin line indeed between the confessions of Crumb the comix character and some of the heroes that Crumb the creator has drawn for close to two decades. The solitude of Etoain Shrdlu in *TV Blues* (1981) and the desolation of George "Murky" Murkoid reaching out to God are no less ridiculous, no less poignant than Crumb's alter ego in *Can You Stand Alone and Face Up to the Universe* (1992) valiantly grappling with the enigmas of life, death, and what lies beyond. For there is no denying that since the early 1980s, Crumb has not shied away from asking the Big Questions about our Ultimate Purpose. And he has done so, as ever, with unremitting candor and devastating humor—echoing, nearly half a century later, the words he wrote as a young man to his friend Marty Pahls: "It is extremely difficult to express the heart and the soul in physical terms. So many things get in the way."[6] Robert Crumb is one of the rare comic book artists to have got round those obstacles in such convincing fashion.

Translated from the French by Michael Gilson

4 Quoted in Mark James Estren,
A History of Underground Comics
(San Francisco: Straight Arrow Books, 1974).

5 "Hypocrite lecteur, – mon semblable, – mon frère," Charles Baudelaire, "Au Lecteur," *Les Fleurs du mal*.

6 "Il est extrêmement difficile d'exprimer le cœur et l'âme en termes physiques. Tant de choses viennent se mettre en travers," from the French press kit for *Crumb*, dir. Terry Zwigoff.

WOKE UP IN THE MIDDLE OF THE NIGHT...

LAY THERE IN THE DARK THINKING...

...ABOUT A TEDIOUS AND IRRITATING DREAM I JUST HAD....

...ABOUT HOW YER KARMA CATCHES UP WITH YOU...

...ABOUT HOW COMPLETELY CRAZY MY LIFE HAS BECOME AND I DON'T KNOW WHAT TO DO ABOUT IT...

...ABOUT THE INFINITE NUMBER OF DREADFUL THINGS THAT ARE LURKING OUT THERE WAITING TO DRAG YOU DOWN

...ABOUT HOW TOUGH I HAVE IT...

ABOUT HOW I ALWAYS GE[...] TAK[...]

...AND OF COURSE, I PRAYED... I ASKED GOD, THE HIGHER INTELLIGENCE, THE HIGHER POWER, TO HELP ME GET THROUGH, TO GIVE ME STRENGTH, PROTECT ME, GUIDE ME.., I CAN'T DO IT ALONE....

OCT. 26TH, '90

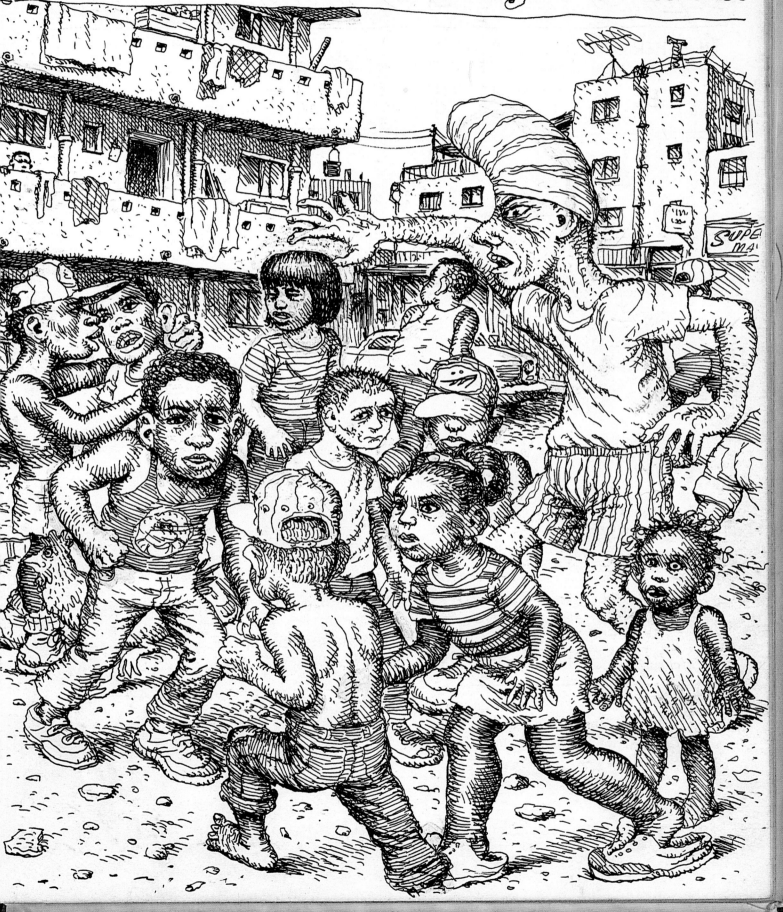

Jeremy Deller

Whatever Happened to David Bowie?
Spike Milligan Is God
Keith Moon Matters
Brian Epstein Died for You
My Mate Fancies You
I Am Human and I Need to Be Loved, Just Like Everyone Else Does
I've Seen This Happen in Other People's Lives and Now It's Happening in Mine
Happiness Is a 4x4
Life Is to Blame for Everything

BORN
1966, London, England

LIVES AND WORKS
London

Jeremy Deller studied at Sussex University
(1991–92) and the Courtauld Institute of Art,
London (1985–88). He has had numerous solo
exhibitions, including: *The Uses of Literacy,*
GBE (Modern), New York (2004); ArtPace,
San Antonio, Texas (2003); *This Is Us,* Center
for Curatorial Studies Museum, Bard College,
Annandale-on-Hudson, New York (2003);
Unconvention, Center for Visual Arts, Cardiff,
Wales (1999); and Norwich Art Gallery, England
(1997). *Acid Brass* was commissioned by the
Bluecoat Gallery, Liverpool, in 1997, and
The Battle of Ogreave, commissioned by
Artangel, London, was broadcast on Britain's
Channel 4 in 2001.

Group exhibitions include: *Manifesta 5,*
San Sebastian, Spain (2004, catalogue); *Utopia
Station,* 50th Venice Biennale (2003, catalogue);
Rock My World, CCA Wattis Institute for
Contemporary Arts, San Francisco (2002,
catalogue); *Century City: Art and Culture in the
Modern Metropolis,* Tate Modern, London (2001,
catalogue); *City Racing 1988–1998: A Partial
Account,* Institute of Contemporary Art, London
(2001); *Protest and Survive,* Whitechapel Art
Gallery, London (2000, catalogue); *Democracy!*
Royal College of Art, London (2000); *The British
Art Show 5,* Hayward Gallery, London (2000,
catalogue); and *Intelligence: New British Art
2000,* Tate Britain, London (2000, catalogue).

SELECTED BIBLIOGRAPHY

Deller, Jeremy. *After the Goldrush.*
San Francisco: CCA Wattis Institute for
Contemporary Arts, 2002.

———. *The English Civil War Part II:
Personal Accounts of the 1984–85
Miners' Strike.* London: Artangel, 2002.

———. *Life Is to Blame for Everything.*
London: Salon 3, 1999.

Hilty, Greg. "4 Real: Jeremy Deller and
the Uses of Art." *Parkett,* no. 60 (2000): 6–14.

Morton, Tom. "Mining for Gold:
Tom Morton on Jeremy Deller." *Frieze,* no. 72
(January 2003): 70–75.

For ten years, from 1992 to 2002, Jeremy Deller laid out a path for himself of discursive meandering, somewhere between that of a social organizer, a passerby, a bystander, a fellow traveler, and possibly Shane (the drifting cowboy title character played by Alan Ladd in the 1953 film). The Situationists used the activity of drifting as a discursive strategy against the daily routines of the middle class, and drifting is an apt description of Deller's daily activity, not in the sense of pointless wandering, but rather as the activity of a finely tuned consciousness. The artist's consciousness toward his daily encounters is best described as social, on both a personal and a collective level.

Most of what Deller has produced lately qualifies as ephemera—items such as posters, bumper stickers ("an unofficial constitutional right in the U.S."), maps and leaflets, guide books, T-shirts, and audio compact disks—all conceived for distribution in the most unholy grounds of popular cultural significance. Taking ephemera into the arena of actions, Deller recently conceived and orchestrated the reenactment of "the bloody battle of Orgreave," a miners' strike and confrontation with police in 1984, during the reign of Mrs. Thatcher; the reenactment, on its anniversary in 2001, was produced by Artangel, London, and directed as a docudrama film by Mike Figgis (*Leaving Las Vegas*).

In 2001–2, Deller was an artist in residence at the Capp Street Project in San Francisco, and during that year, while living in Oakland, he became acquainted with the local urban histories of the Black Panther movement. He also spent a lot of time drifting along the back roads of California's Gold Rush past, including the now-deserted Borax mines of Trona, where he bought a five-acre plot of land. As he wrote in the introduction to his related guide book, *After the Gold Rush* (2002):

I wanted to celebrate the physical and personal openness that I have encountered here through enticing the reader on a journey. This book though is really more a guide to people I've met than to places I've visited. I've always felt that what I remember most clearly from trips and holidays are the people rather than the final destination, which often becomes incidental in the end.

In the last scene of *Shane,* the gun-slinging drifter-cowboy rides off into the rising sun of a new day, his deeds done, leaving behind a faint memory and the ephemera of his passing through. A young boy calls out after him: "Shane, come back!…" Deller is no cowboy, but from his experiences during his time in California, he has a good impression of deeds needing to be done. As of this writing, he just doesn't know yet what they will be.
—*Rirkrit Tiravanija*

below
JEREMY DELLER
clockwise, from right
John 1:4:9, Job 12:8, Ecclesiastes 9:18,
and *Chronicles 1:29:15,* 2003
plastic shopping bags;
edition of 1,000 to be distributed free
18 × 14 in. (46 × 36 cm) each
Commissioned and produced for
the Frieze Art Fair, London;
courtesy of the artist; Gavin Brown's enterprise,
New York; and The Modern Institute, Glasgow

overleaf
still from *The Battle of Orgreave,* 2001
performance still
Commissioned and produced by Artangel, London;
courtesy of the artist; Gavin Brown's enterprise,
New York; and The Modern Institute, Glasgow

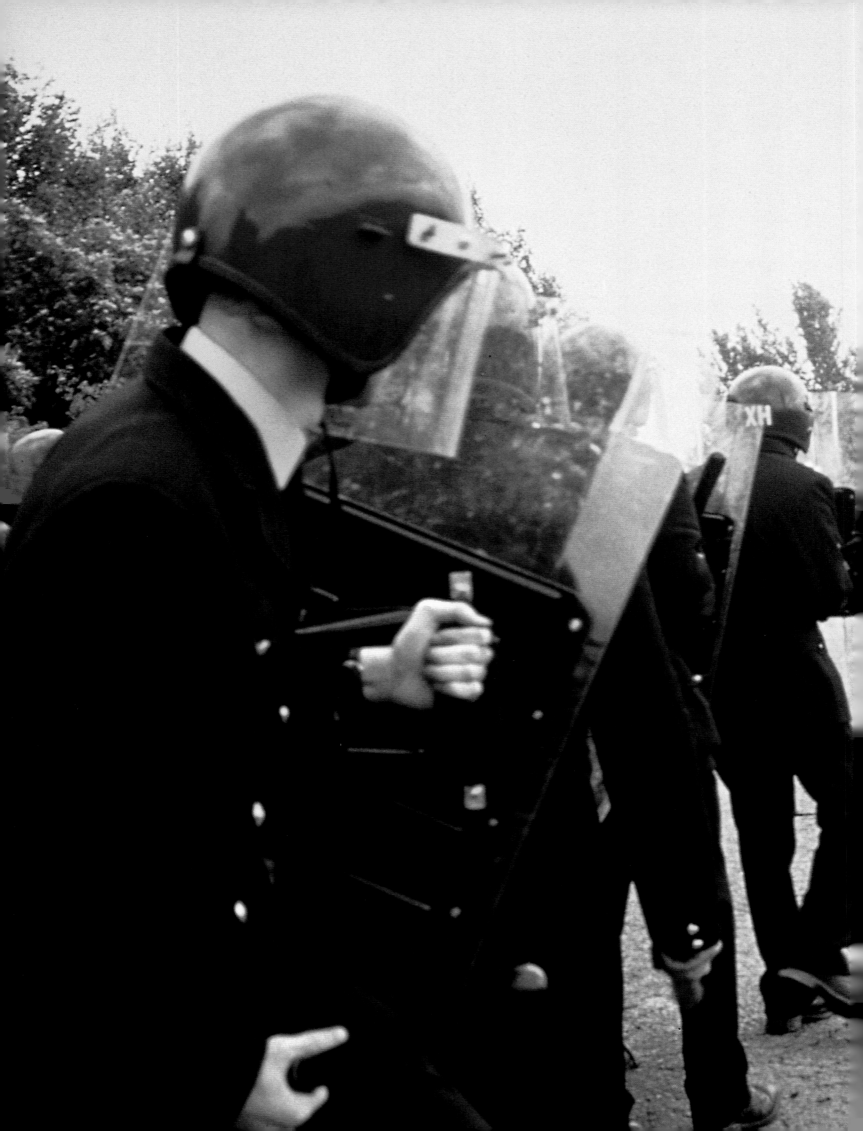

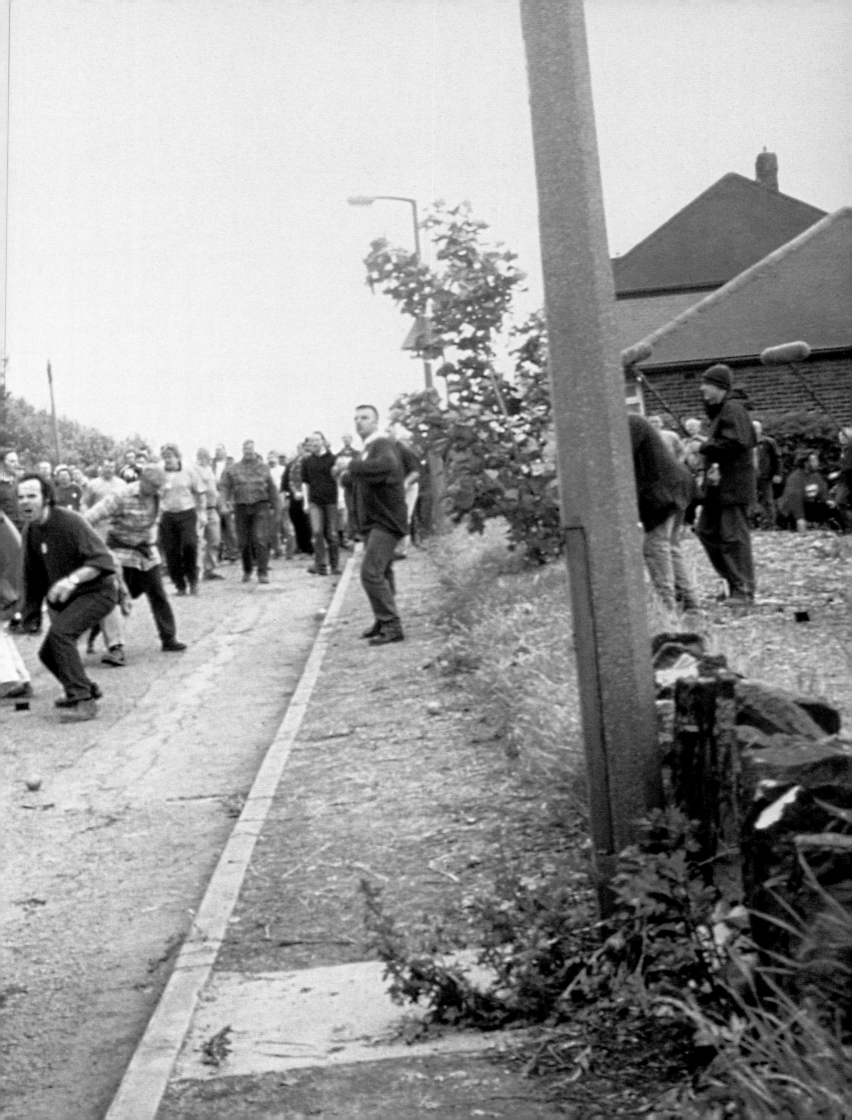

Philip-Lorca diCorcia

BORN
1951, Hartford, Connecticut

LIVES AND WORKS
New York, New York

Philip-Lorca diCorcia received his BFA in 1975 and his postgraduate certificate in 1976 from the School of the Museum of Fine Arts, Boston. He received his MFA from Yale University in 1979. He has exhibited his photographs in solo exhibitions at the Musée national d'art moderne, Centre Pompidou, Paris (2004, catalogue); PaceWildenstein, New York (2003-4, 2001, 1996-99); Whitechapel Art Gallery, London (2003-4, traveling to Centre national de la photographie, Paris, Museum Folkwang, Essen, Magasin 3, Stockholm Konsthall, Centro de Arte Visuais, Sintra, Portugal, and Fundació Telefónica, PhotoEspaña, Madrid, catalogue); Sprengel Museum, Hanover (2000); Galería OMR, Mexico City (2000); Museum of Modern Art, New York (1995, catalogue); Centre Culturel du Rocher, Lyon, France (1993); and Wooster Gardens, New York (1993).

Group exhibitions include: *Fashioning Fiction in Photography Since 1990,* Museum of Modern Art, New York (2004, catalogue); *Cruel and Tender: Photographs of the Twentieth Century,* Tate Modern, London, and Museum Ludwig, Cologne (2003, catalogue); *Uneasy Spaces,* Site Santa Fe, New Mexico (2003); *Strangers,* First ICP Triennial of Photography, International Center of Photography, New York (2003, catalogue); *Settings and Players: Theatrical Ambiguity in American Photography,* White Cube, London (2001-2); *Open City: Street Photographs Since 1950,* Museum of Modern Art, Oxford, England (2001-2, traveled to The Lowry, Salford Quays, Manchester, England, Museo de Bellas Artes de Bilbao, Spain, Hirshhorn Museum and Sculpture Garden, Smithsonian Institution, Washington, D.C., catalogue); *Quotidiana,* Castello di Rivoli, Turin (2000); *Emotions and Relations,* Hamburger Kunsthalle, Germany (1998, catalogue); Whitney Biennial, Whitney Museum of American Art, New York (1997, catalogue); *Family and Friends,* Museum of Contemporary Photography, Chicago (1997); and *Pleasures and Terrors of Domestic Comfort,* Museum of Modern Art, New York (1991, traveled to Baltimore Museum of Art, Maryland, Los Angeles County Museum of Art, Los Angeles, Contemporary Arts Center, Cincinnati, Ohio, catalogue).

SELECTED BIBLIOGRAPHY

DiCorcia, Philip-Lorca. *A Storybook Life.* Santa Fe, N.M.: Twin Palms Publishers, 2003.

Galassi, Peter. *Philip-Lorca diCorcia.* Exhibition catalogue. New York: Museum of Modern Art, 1995.

Grundberg, Andy. "Street Fare." *Artforum* 37, no. 6 (February 1999): 80-83.

Morgan, Stewart. "Deliberate Fictions." *Frieze* 31 (November-December 1996): 50-56.

Philip-Lorca diCorcia. Exhibition catalogue. Paris: Centre Pompidou, 2004.

Philip-Lorca diCorcia's photographs employ a calculated and often baroque theatricality to elevate everyday occurrences out of the realm of banality, heightening our awareness of the psychology and emotion contained in quotidian situations. His evocative and enigmatic photographs of real-life subjects, from intimates to strangers, create portals from the prosaic to the uncanny. Some of his subjects have personas that are already theatrically enlarged by their life choices, such as the Hollywood hustlers he photographed in the early 1990s or the pole dancers in his more recent work, while others are quite unassuming in their appearance. In all cases, diCorcia manipulates his subjects and scenarios to his own ends. As he has said, "Psychology is a reality for many people. I try to show this. It may not, in fact, be the actual psychology of the subject that I portray, but it is played out in the image and the projection of that psychology into the surrounding space....Their image is the outward facing front belied by the inwardly gazing eyes."

Even when based in the real world, diCorcia's scenarios appear staged, as in his street photographs taken in large urban centers such as Tokyo, New York, Berlin, and Mexico City, for which he waited in hiding to trigger the shutter and flash when an appropriate scene arose. His sensibility tweaks and dramatizes a tradition of street photography made prominent by such artists as Paul Strand, Helen Leavitt, Weegee, and Robert Frank. In their works, reality was often stranger than fiction; but in diCorcia's hands, reality becomes stranger still, as the bodies and minds of his subjects are caught in moments of complete unselfconsciousness, their internal dramas surfacing without the cover of any self-aware posturing.

DiCorcia's recent *A Storybook Life* (1977–99), comprising seventy-six images taken over the course of twenty-five years and ranging from typically staged pictures to casual snapshots, weaves a carefully selected web of images with elusive narrative associations. The title seems to suggest a personal narrative, and though the collection includes images of the artist's family and other people and places dear to him, this is not simply a memoir in the guise of a family album. It is an epic story—of love, death, place, memory, and the most fleeting moments of true emotion. The series channels the ambiguity of fantasy versus reality; the photographs record aspects of the photographer's life, but through a hyperarticulated filter—each moment of action and emotion (whether real or staged) is more dramatic, more still, more lush, more concentrated, and more lucid than could ever be registered by human memory. Fact and fiction commingle and overlap, implying a philosophical comment on the subjective nature of experience and our own capacity to manipulate the truth of our own experiences.

For the *Carnegie International,* diCorcia again avails himself of a pre-existing subcultural group and its milieu—this time the distinct world of exotic dancers. The works are shot in various locations, and most important, the dancers aren't performing for an audience but rather just for the artist himself, lending a creepy vacancy to the setting. Each image, large and sumptuously shot, captures a dancer in mid-pose as she lithely and alluringly works her body around a dancing pole. Suspended in the air, each woman's body takes on the character of statuary, as perfectly modeled as the Mannerist sculptures of Michelangelo; the contortions serve to underscore the women's athleticism and physical mastery of their craft. Far from titillating, diCorcia's powerful photographs engage with a long history of artists contemplating the human form in physical perfection and prowess.
—*Elizabeth Thomas*

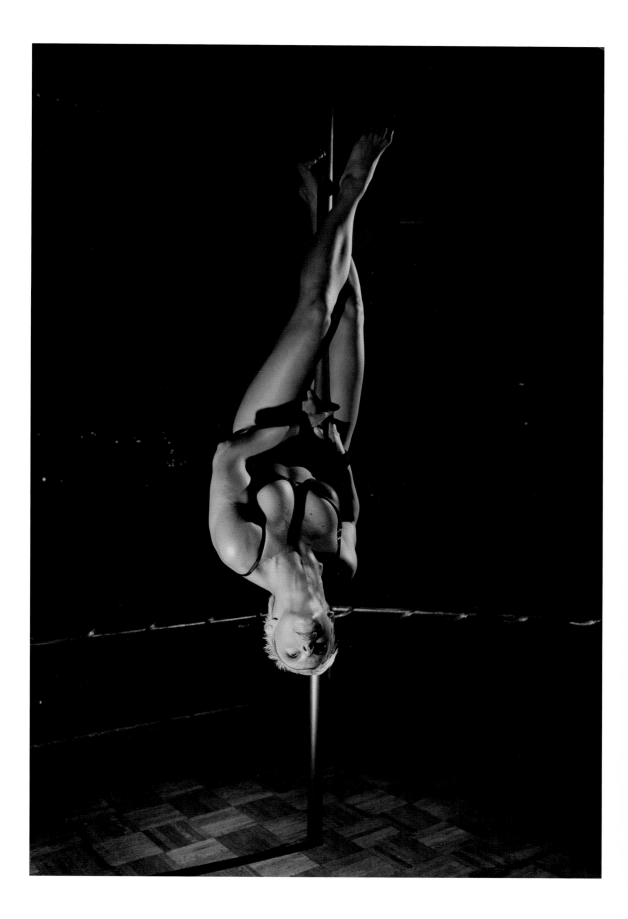

PHILIP-LORCA DICORCIA
Lynn, 2004
chromogenic color print
72 × 48 in. (183 × 122 cm)
Courtesy of the artist
and Pace MacGill, New York

overleaf left
Ruby, 2003
chromogenic color print
72 × 48 in. (183 × 122 cm)
Courtesy of the artist
and Pace MacGill, New York

overleaf right
Heema, 2004
chromogenic color print
72 × 48 in. (183 × 122 cm)
Courtesy of the artist
and Pace MacGill, New York

Peter Doig

Peter Doig's paintings instill in us an intense feeling of having encountered something real. The effect is encouraged by the perceptual play induced by the optical stimuli of his elaborately worked surfaces, and by the modification of his initial impression of a landscape with details culled from such visual sources as photographs, films, watercolors, and prints. The natural landscape, frequently alluding to the scenery of Canada where the artist grew up, is estranged by the optical effects and image collages, which mobilize its visual and psychological capacities and establish a different sense of reality than the one logically defined.

Doig exploits the techniques of early modernist figurative painting, which explored formal autonomy within the genre of landscape painting only to foreground the painted surface as a site of perceptual and psychic transmutation. Further emphasizing the autonomy of the surface, the shimmering effects of Monet's pointillism and Pollock's allover dripping are combined with the blur and flicker of a Richter or a Polke canvas in order to approximate an acid-induced hallucination. In numerous paintings, spatters of paint disguised as snowflakes, stars, or jewel-like marbles decenter the viewer's gaze, while ornamental curves of waves or a reflection on ice create moiré patterns. The sense of dissolution and reversal is enhanced by the watery washes and minute workings of texture, with creased lines and unevenly colored fields that give the works an etched look. Rivers and skies are reduced to vaporous color fields; the back of a man, to cartographic patterns. These optical tricks introduce instability into the picture: creating another material growth within a picture, they direct the viewer's attention to the continuous mutation of the surface.

Doig's pictures provide the experience of a simulacrum, defined by Gilles Deleuze as a pure surface phenomenon. An "event" of perception—psychic formation released from logical causality or individual emotion—a simulacrum realizes "the [mental] movement by which the ego opens itself to the surface and liberates the a-cosmic, impersonal, and pre-individual singularities which it has imprisoned." In his recent paintings, Doig actively engages the theme of man in nature in order to emphasize the psychological authenticity of a simulacrum. *Pelican (Stag)* (2003) presents a tropical jungle in which a man wearing a loincloth wades in a shallow river. The pictorial space is infused with signs of imminent transformation: banana leaves, rendered as stripes, suggest gigantic butterfly wings, while a luminous shaft of light pierces the indigo dusk of the jungle floor. Abstract Expressionistic brushstrokes, splashes, and washed-out painterly traces combine to create a texture similar to that of a wall on which myriad posters have been posted and then torn off, their remnants intermingling with new image fragments. This integration of multiple temporal and spatial dimensions is carried to an extreme in *Paragon* (2004). Here, the pictorial field is boldly divided into two contrasting domains: the tangerine sky adorned with pastel-colored leaves, and the milky ocean in which a long-haired man walks, immersed up to his chest. In spite of its self-reflexive references to abstract painting, *Paragon* presents a deep-mind image, a vision of a mythical emergence or a martyrdom that exists beyond personal memory. Capturing a perpetual interchange between the natural and the artificial, Doig's paintings facilitate the viewer's attainment of an altered perception of reality.
—*Midori Matsui*

BORN
1959, Edinburgh, Scotland

LIVES AND WORKS
Port of Spain, Trinidad,
and London, England

Peter Doig received his MA from Chelsea School of Art (1990), his BA from St. Martin's School of Art (1983), and also attended the Wimbledon School of Art, all in London. He has had solo exhibitions of his paintings at the Pinakothek der Moderne, Munich (2004, traveled to Kestnergesellschaft, Hannover, catalogue); Bonnefanten Museum, Maastricht, Netherlands (2003-4, catalogue); Victoria Miro Gallery, London (2002, 1998, 1996); The Morris and Helen Belkin Art Gallery, University of British Columbia, Vancouver (2001-2, traveled to National Gallery of Canada, Ottawa, and The Power Plant, Toronto, catalogue); Museum of Contemporary Art, Miami (2000); St. Louis Art Museum, Missouri (2000); Douglas Hyde Gallery, Dublin (2000); Kunsthaus Glarus, Switzerland (1999, catalogue); Gavin Brown's enterprise, New York (1999, 1996); and Whitechapel Art Gallery, London (1998, catalogue); among many others.

Recent group exhibitions include: *Painting: From Rauschenberg to Murakami, 1964-2003*, 50th Venice Biennale (2003, catalogue); *Days Like These*, Tate Triennial Exhibition of Contemporary British Art, Tate Britain, London (2003, catalogue); *Cavepainting*, Santa Monica Museum of Art, California (2002, catalogue); *Cher Peintre—Peintres figuratives depuis l'ultime Picabia*, Musée national d'art moderne, Centre Pompidou, Paris (2002, traveled to Kunsthalle, Vienna, and Schirn Kunsthalle, Frankfurt am Main, catalogue); *Twisted: Urban and Visionary Landscapes in Contemporary Painting*, Van Abbemuseum, Eindhoven, Netherlands (2000, catalogue); and *From A to B and Back Again*, Royal College of Art, London (1999).

SELECTED BIBLIOGRAPHY

Charley's Space. Exhibition catalogue. Maastricht, Netherlands: Bonnefanten Museum, 2003.

Parkett, no. 67 (2003): 54-89. Special section, including essays by Paul Bonaventura, Rudi Fuchs, and Beatrix Ruf.

Peter Doig. Exhibition catalogue. Vancouver: University of British Columbia, 2001.

Peter Doig: Metropolitain. Exhibition catalogue. Munich: Pinakothek der Moderne, 2004.

Ruf, Beatrix. *Peter Doig: Version*. Exhibition catalogue. Glarus, Switzerland: Kunsthaus Glarus, 1999.

below left
PETER DOIG
Pelican (Stag), 2003
oil on canvas
108 1/2 × 79 in. (275.6 × 200.7 cm)
Courtesy of Michael Werner Gallery,
Cologne/New York

below right
Paragon, 2004
oil on canvas
108 1/4 × 78 3/4 in. (275 × 200 cm)
Courtesy of Contemporary Fine Arts, Berlin;
Michael Werner Gallery, Cologne/New York;
Gavin Brown's enterprise, New York; and
Victoria Miro Gallery, London

overleaf
House of Pictures (Carrera), 2004
oil on canvas
78 3/4 × 118 1/2 in. (200 × 301 cm)
Promised gift of Gayle and Paul Stoffel
to the Dallas Museum of Art; courtesy of
Contemporary Fine Arts, Berlin;

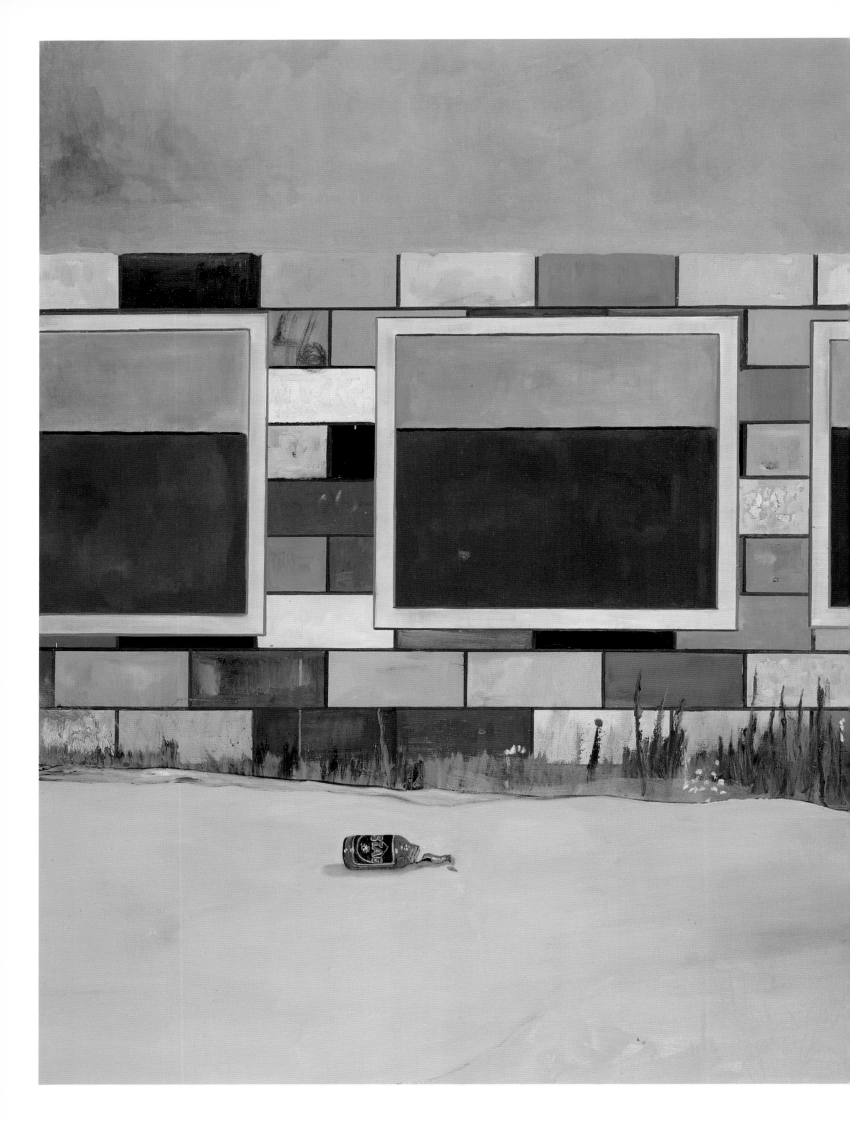

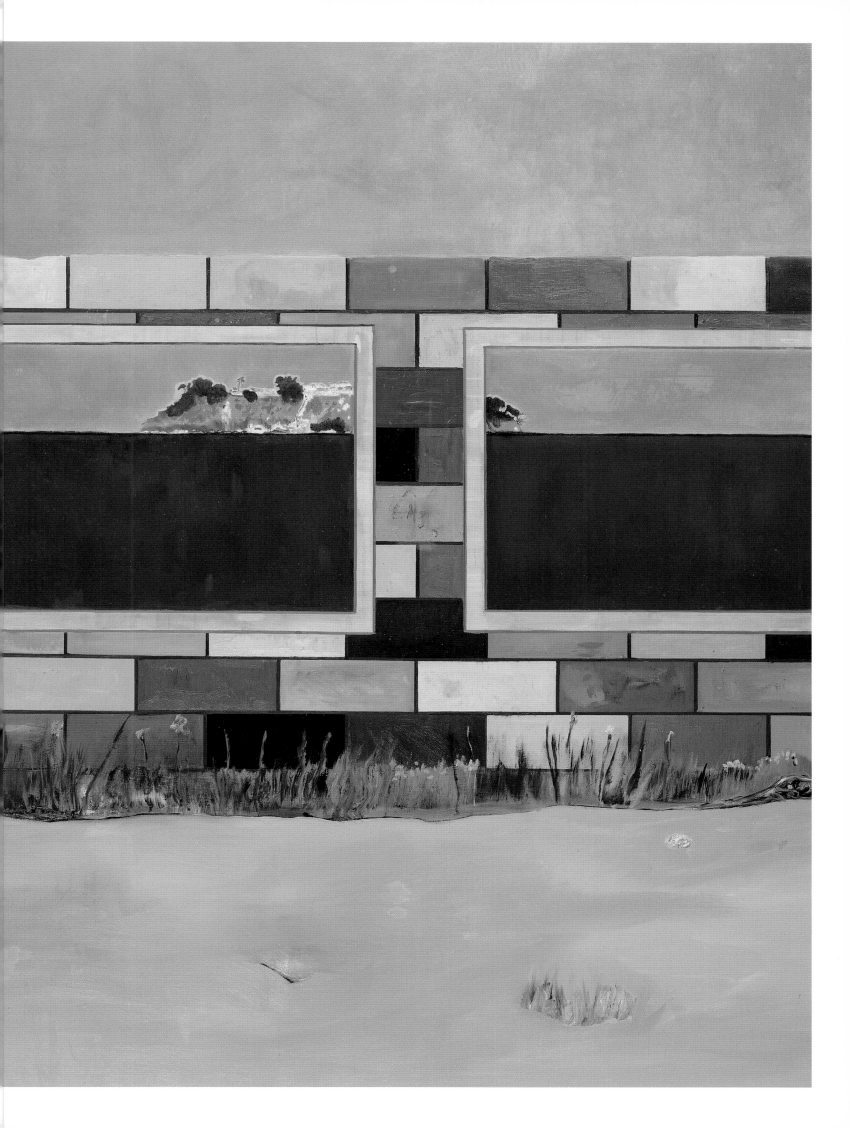

Trisha Donnelly

BORN
1974, San Francisco, California

LIVES AND WORKS
San Francisco

Trisha Donnelly received her MFA in 2000 from the Yale University School of Art and her BFA in 1995 from the University of California, Los Angeles. She has had solo exhibitions at Air de Paris, Paris, and Casey Kaplan, New York (both 2002).

Group exhibitions include: *Baja to Vancouver: The West Coast in Contemporary Art,* Seattle Art Museum (2003–4, traveled to CCA Wattis Institute for Contemporary Arts, San Francisco, Vancouver Art Gallery, British Columbia, and La Jolla Museum of Contemporary Art, California, catalogue); *Young Scene,* Secession, Vienna (2003); *Spectacular: The Art of Action,* Museum Kunst Palast, Düsseldorf (2003); *Utopia Station,* 50th Venice Biennale (2003, catalogue); *It Happened Tomorrow,* Biennale d'art contemporain de Lyon, France (2003, catalogue); *The Rebirth of Wonder,* Los Angeles Contemporary Art Exhibitions (2003); *The Lengths,* Center for Curatorial Studies Museum, Bard College, Annandale-on-Hudson, New York (2003); *A Little Bit of History Repeated,* Kunst-Werke, Berlin (2002, catalogue); *How Extraordinary That the World Exists,* CCA Wattis Institute for Contemporary Arts, San Francisco (2002, catalogue); *Moving Pictures,* Solomon R. Guggenheim Museum, New York (2002, traveled to Guggenheim Bilbao, Spain, catalogue); *The Show That Will Show That a Show Is Not Only a Show,* The Project, Los Angeles (2002); *The Dedalic Convention,* MAK Museum, Vienna (2001); *I Love Dijon,* Le Consortium, Dijon, France (2001); *Do It,* Maryland Institute College of Art, Baltimore (2001, traveled to Addison Gallery of American Art, Andover, Massachusetts, and Art Gallery of the University of Toronto, among others, catalogue); and *Echo,* Artist's Space, New York (2000).

SELECTED BIBLIOGRAPHY

Higgs, Matthew. "Trisha Donnelly." In Ralph Rugoff, ed. *Baja to Vancouver: The West Coast in Contemporary Art.* Exhibition catalogue. New York: Distributed Art Publishers, 2004, 40.

Hoffman, Jens. "Trisha Donnelly." *Flash Art* 34, no. 223 (March–April 2002): 97.

Miller, John. "Openings: Trisha Donnelly." *Artforum* 50, no. 10 (Summer 2002): 164–65.

Spectacular: The Art of Action. Exhibition catalogue. Düsseldorf: Museum Kunst Palast, 2003.

Spector, Nancy. "Trisha Donnelly." In *Cream 3.* London: Phaidon Press, 2003, 120–23.

There is an ambiguity in Trisha Donnelly's work that serves to harness our imagination. Her practice exists in a space a bit outside perceived limitations of the physical world where, for example, Napoleon's declaration of surrender, tendered by the artist herself (in what she describes as "a courteous addition to the record"), can find its proper place in the collective history of the world. Much like the story of the Golem, in which the written word "God" was powerful enough to conjure life out of an inanimate clay form, for Donnelly, language in any manifestation—spoken, written, signed, or thought—has the capacity to conjure art in its concrete form. Yet even when wielding this power, she employs the lightest touch possible; her interventions are sometimes barely visible, but they are just enough to "slip into the back of people's minds" and implant suggestions that, the artist hopes, create "exponentially different" forms in each person's imagination.

Donnelly is concerned primarily with the interrelationship of words, actions, thoughts, and images. She uses demonstrative action, written text, and spoken word to invoke images and associations in the mind's eye of the viewer, or, alternately, works backward from an image itself, encouraging viewers to construct the storyline and context for themselves. In this regard, Donnelly is an engineer of the imagination—her enterprise is filled with wonderment at the tremendous power of the human mind to formulate ideas into existence and at the same time acknowledges the limits of language, in any guise, to fully contain our ideas and thoughts.

In *Night Is Coming* (2002), the words of the title pulse in and out of view, then disappear completely as a bright afterimage punctuates the cycle of perpetual imminence. The promised action is declared, then recedes, and in the end never arrives. A blatant truism, "night is coming" is a simple statement, a reminder of the passing of time. Beyond that, the message is open and allusive (as well as elusive), and stubbornly unspecific. The experience taps into our own contingent assumptions and circumstances to furnish meaning. Do we fear or welcome the night? When will it come? Does "night" really mean the night at all, or any number of symbolic connotations? Could Donnelly be making reference to the lyrics of Sonic Youth's "The Night Is Coming On," with their whiff of suffering and fear? Or the poetry of Percy Bysshe Shelley ("The clash of the hail sweeps over the plain / Night is coming!"), which bolsters our spirits in awe of nature? Or perhaps the biblical passage of John 9:4 ("… the night cometh, when no man can work"), which encourages us to do our good works before the day ends? The associations are as varied as viewers' myriad referents.

The Black Wave (2002) is a representation of an obscure phenomenon, and like all legends, the differentiation of fact from unsubstantiated lore is largely immaterial and untraceable. By manipulating a photograph of a generic wave, Donnelly was able to create something that exists only in myth. There is no intended trickery here; rather, *The Black Wave* is an attempt at the visualization of a pure idea. It exists because the artist made it exist, because the idea is, for Donnelly, as concrete as the phenomenon itself. As she has stated, "I think there's nothing more powerful than people thinking something into existence."—*Elizabeth Thomas*

TRISHA DONNELLY
still from *Night Is Coming,* 2002
single-channel video installation, projected; color
2 min., looped
Courtesy of the artist; Casey Kaplan, New York;
and Air de Paris, Paris

NIGHT IS COMING

TRISHA DONNELLY
The Black Wave, 2002
gelatin silver print
50 × 60 in. (127 × 152.4 cm)
Courtesy of the artist
and Casey Kaplan, New York

Harun Farocki

A philosophy in motion

Since the late 1960s, when he began his career as an experimental filmmaker and critic, Harun Farocki has explored the production of images in a world increasingly dominated by the making, management, control, and evaluation of images. However, his approach differs from the postmodern exhilaration at the sublime multiplication of simulacra. A materialist at heart, Farocki examines the social process of what he describes as "the industrialization of thought": the development of technologies and artificial devices that encroach on the activity of the human mind and senses, designed, in fact, to eventually replace them, all for the sake of increased profits and social control.

With characteristic precision, Farocki approaches his subject assuming the detached principles of modern production. Mimicking the growing integration of technologies and knowledge in the modern industrial system, Farocki's filmmaking is intertwined with his historical and theoretical research and his practice as a writer. Thus, his films are characterized by a montage aesthetic akin to an intellectual assembly line that rhythmically fills our field of vision with images, thoughts, and information. Made from raw "found footage" material—derived from industrial and scientific films, cinema, and television archives—Farocki's films are articulated with fragmentary theoretical observations that are gradually assembled together in a massive display of social analysis. One could say that his cinema represents an attempt to bring immanent critique into a developed industrial phase, able to underscore the modes of production of thought in the fields of technology, propaganda, and warfare. More than representing a film genre, Farocki's movies constitute a philosophy of modernity in motion.

In his *Eye/Machine* trilogy (2001–3), Farocki charts the rise of a new technological "way of seeing"—the "operational vision" of contemporary machines that are able to "process images" without human intervention. In fact, Farocki documents the birth of an inorganic form of vision, one that has become in the end purely instrumental, inherently insensitive, bodiless, and thus devoid of aesthetic import. The new eye/machines, which came to the fore with the suicidal cameras on the so-called smart bombs of the first Gulf War in 1991, signal a further step in the process of industrial automation, whereby factories will become devoid of human workers and machines may start to assume classical managerial tasks of control, for as Farocki argues, "Machines are supposed to evaluate images made by machines." An ability gained at the cost of further reification: the eye/machines reduce "seeing" to "seeing as." Although able to classify, identify, verify, compare, and interpret images—whether "targets" in aerial views of the enemy's territory or diseases in our bodily organs— the eye/machines have virtually eliminated the ambiguous wealth of the world of perception. They have reduced the world of phenomena to a predefined and often murderous visual task. —*Cuauhtémoc Medina*

BORN
1944, Nový Jicin, Czechoslovakia

LIVES AND WORKS
Berlin, Germany

Harun Farocki studied at the Deutsche Film- und Fernsehakademie, Berlin, from 1966 to 1968. During the last thirty years, he has screened films frequently in Europe, the United States, Asia, and South America. He has shown his film and video work, most recently, in solo exhibitions at ZKM/Zentrum für Kunst und Medientechnologie, Karlsruhe, Germany (2004); Institute of Contemporary Arts, London (2003); and Art Gallery of Ontario, Toronto (2003).

Group exhibitions include: *Kino in der Reitschule*, Bern (2003); *Strangers,* First ICP Triennial of Photography, International Center of Photography, New York (2003, catalogue); Generali Foundation, Vienna (2002); Museum Boijmans Van Beuningen, Rotterdam (2001); SMAK/Stedelijk Museum voor Actuele Kunst, Ghent (2001); *Nicht Löschbares Feuer/ Werkschau,* Künstlerhaus Stuttgart (2001); *Things We Don't Understand,* Generali Foundation, Vienna (2000); *Media City Seoul 2000: City Vision,* Seoul (2000, catalogue); Galeria, Centro Cultural Belem, Lisbon (2000); *Gouvernementalitatät, Expo 2000,* Hannover, Germany (2000); *L'état des choses,* Kunst-Werke, Berlin (2000); *Joris Ivens/Chris Marker/ Harun Farocki,* steirischer herbst: Das Festival der Neuen Kunst, Graz, Austria (1998); *Documenta X,* Kassel, Germany (1997, catalogue); *Face à l'histoire,* Musée national d'art moderne, Centre Pompidou, Paris (1996, catalogue); and *Le monde après la photographie,* Musée d'art moderne, Villeneuve d'Ascq/Lille, France (1995).

SELECTED BIBLIOGRAPHY

Aurich, Rolf, and Ulrich Kriest, eds. *Der Ärger mit den Bildern—Die Filme von Harun Farocki.* Konstanz, Germany: Medien, 1998.

Elsaesser, Thomas. "Working at the Margins: Two or Three Things Not Known about Harun Farocki." *Filmbulletin,* no. 597 (October 1983): 269–70.

Gaensheimer, Susanne, and Nicholas Schafhausen, eds. *Harun Farocki: Imprint/ Writings.* New York: Lukas and Sternberg, 2001.

Jahn, Harmut. "Interview with Harun Farocki." *Spuren,* no. 2 (February–March 1979): 51–53.

Keenan, Thomas. "Light Weapons." *Documents,* nos. 1–2 (Fall–Winter 1992): 136–46.

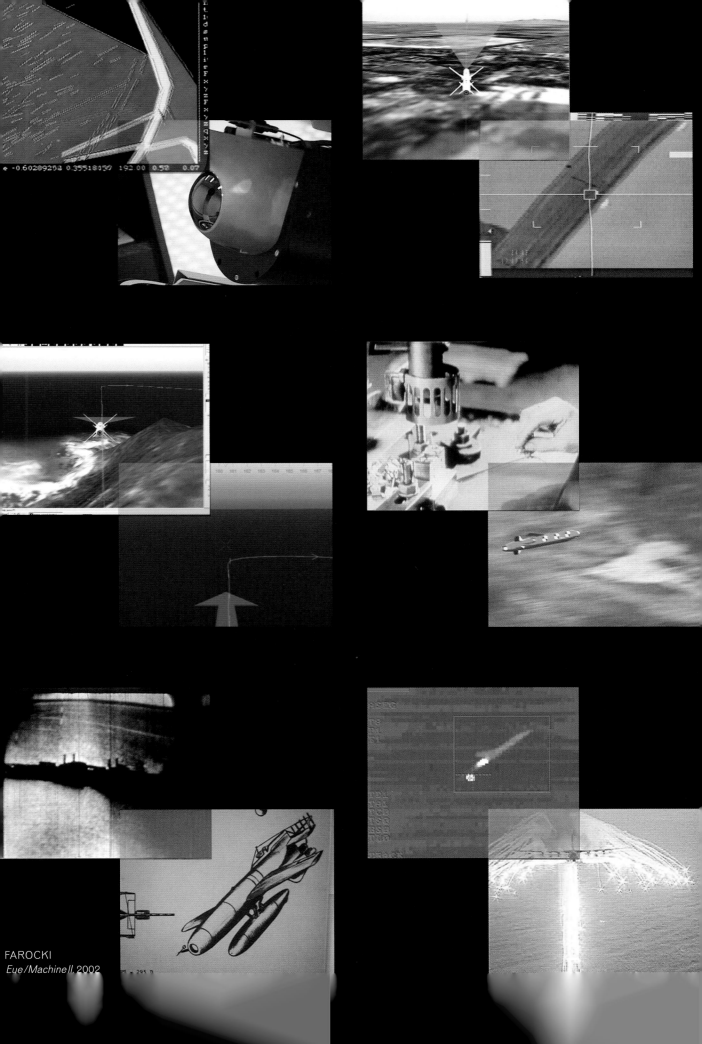

FAROCKI
Eye/Machine II, 2002

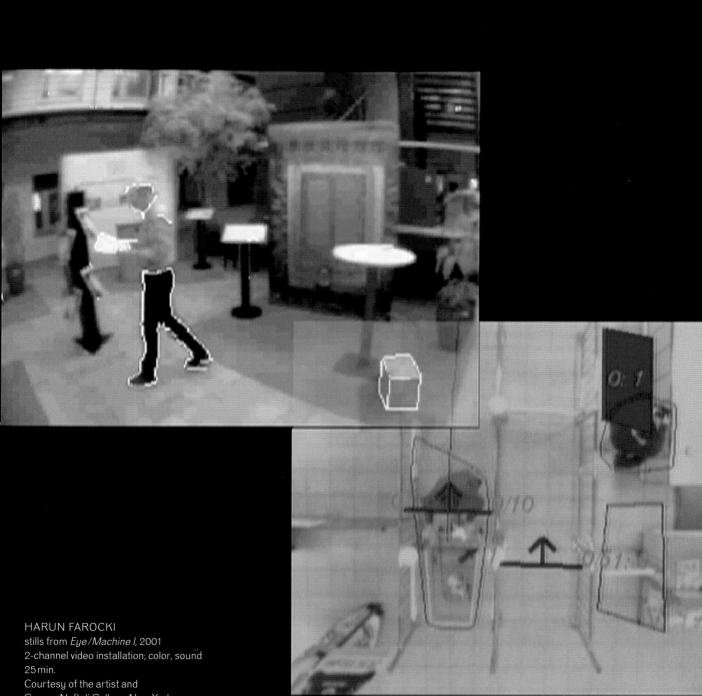

HARUN FAROCKI
stills from *Eye/Machine I*, 2001
2-channel video installation; color, sound
25 min.
Courtesy of the artist and

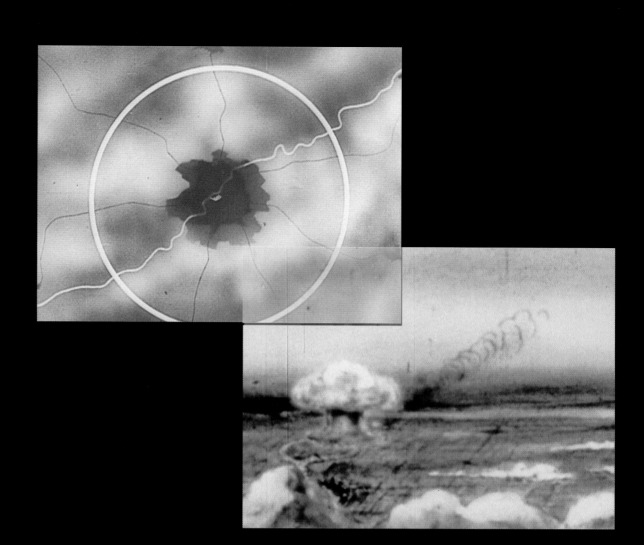

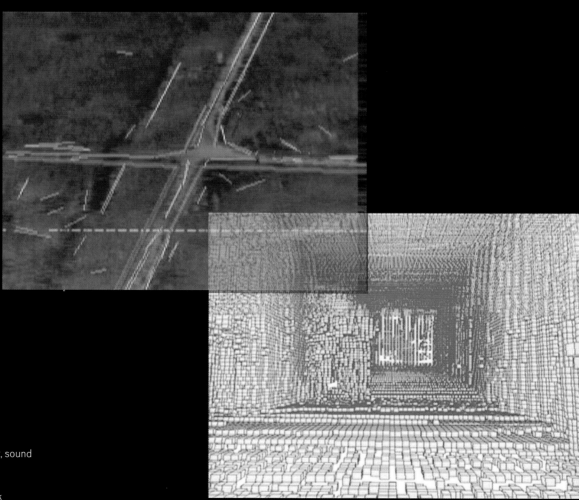

stills from *Eye/Machine III*, 2003
2-channel video installation; color, sound
18 min.
Courtesy of the artist and
Greene Naftali Gallery, New York

Saul Fletcher

Saul Fletcher's humble and tender work parses pressing issues of human existence into intimately scaled photographs brimming with psychic energy. Moody, intense, and hermetic in nature, these photographs condense emotion, psychology, circumstance, and persona in short visual passages. However, they reveal themselves easily to the viewer because of the artist's use of a time-honored vocabulary of subjects, recalling a variety of sources that includes the mysticism of memento mori paintings, the intimacy of Dutch still lifes, the incidental beauty of street photography, and the sensitivity of portraiture in the style of August Sander. Fletcher's quotidian subjects speak to the power of metaphor and allusion as tools through which we can grapple with complex issues of mortality, sexuality, spirituality, redemption, and what it means to be human.

Fletcher's entire photographic oeuvre consists of one long sequence of untitled photos, their order preconceived not as a grand, declarative narrative but as a studied compilation of moments. Within this sequence, there are distinct groupings of subjects and themes that bracket individual narrative threads, but the correspondences among interrelated narratives remain central to Fletcher's practice. The meticulously edited content is conceived and crafted by the artist as a precise mental picture before being taken as a photograph. It is as if Fletcher's subjects exist first as memories in his head, only later to be found or actualized in the realm of the physical world. In a sense, Fletcher's work seems to strive for an economy of content, seeking to convey the most psychic information possible with an absolute minimum of visual information.

Fletcher most often deals with photography as a staged act, borrowing from the conventions of still life, portraiture, or even landscape. Yet the work is intensely personal, reflecting an overwhelming orientation toward interior rather than exterior reality. He has orchestrated many images in his own home, or other personally resonant places, often using his family and himself as models, not for specific content but as evocative and convenient objects of contemplation. Even in the case of unstaged images, Fletcher does not merely present reality, he harnesses it, as if situations were willed into existence to serve his artistic purposes.

The intimate scale of these photographs condenses the intensity of the image and heightens our awareness of the very process of looking and apprehending. We are compelled to linger in his mini-dramas, drawn into the meditative poetics of banality. Even the inanimate objects—a cast-off chair, a withered bouquet of roses, a barren expanse of sky—serve to amplify the emotional tenor of the work. Rich with allusion and encouraging contemplation, Fletcher's visual poetics evince how the finely honed sensibility of one artist can reshape the world.—*Elizabeth Thomas*

BORN
1967, Barton, England

LIVES AND WORKS
London, England

Saul Fletcher has apprenticed with the prominent fashion photographers David Sims and Jürgen Teller. He has exhibited his photographs in solo exhibitions at the Anton Kern Gallery (2003, 2000, 1998); Galerie Sabine Knust, Munich (2002, 1999); the Kölner Kunstverein, Cologne (1999); and Sadie Coles HQ, London (1998).

Group exhibitions include: *Hautnah: The Goetz Collection,* Villa Stuck, Munich (2002); *Hello, My Name Is…,* Carnegie Museum of Art, Pittsburgh (2002); *Overnight to Many Cities: Travel and Tourism at Home and Away,* 303 Gallery, New York (2001); Asprey Jacques Gallery, London (2000); *Common People: British Art between Phenomenon and Reality,* Fondazione Sandretto Re Rebaudengo, Turin (1999); *Umzug,* Galerie Gebr. Lehmann, Dresden (1999); and The Photographer's Gallery, London (1996, 1995).

SELECTED BIBLIOGRAPHY
Aletti, Vince. "Portfolio." *Artforum* 40, no. 6 (February, 2002): 111–15.

Hainley, Bruce. "Fletcher." *Artforum* 35, no. 10 (Summer 1997): 137.

Heiser, Jörg. "Saul Fletcher." *Frieze* no. 35 (June–July–August 1997): 76.

Higgie, Jennifer. "Memories Can't Wait." *Frieze* 57 (March 2001): 78–81.

Saul Fletcher. Exhibition catalogue. Munich: Galerie Sabine Knust, 2002.

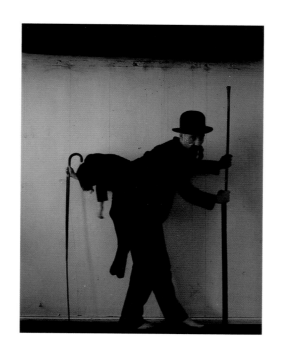

SAUL FLETCHER
Untitled #136, 2000
chromogenic color print
3 1/2 × 2 1/2 in. (8.9 × 6.4 cm)
Courtesy of the artist
and Anton Kern Gallery, New York

top
SAUL FLETCHER
Untitled #23, 1997
chromogenic color print
5 × 5 in. (12.7 × 12.7 cm)
Courtesy of the artist
and Anton Kern Gallery, New York

bottom
Untitled #155, 2004
chromogenic color print
6 1/4 × 8 in. (15.9 × 20.3 cm)
Courtesy of the artist
and Anton Kern Gallery, New York

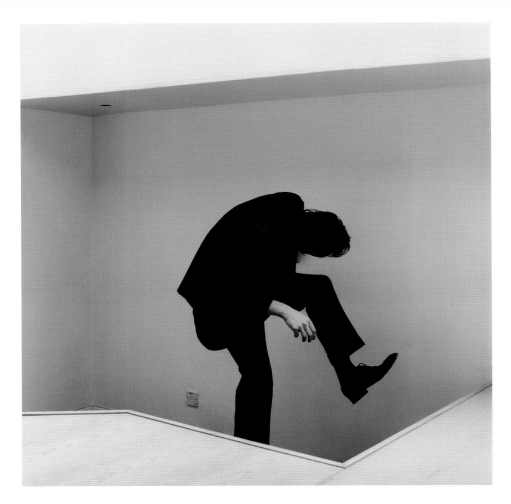

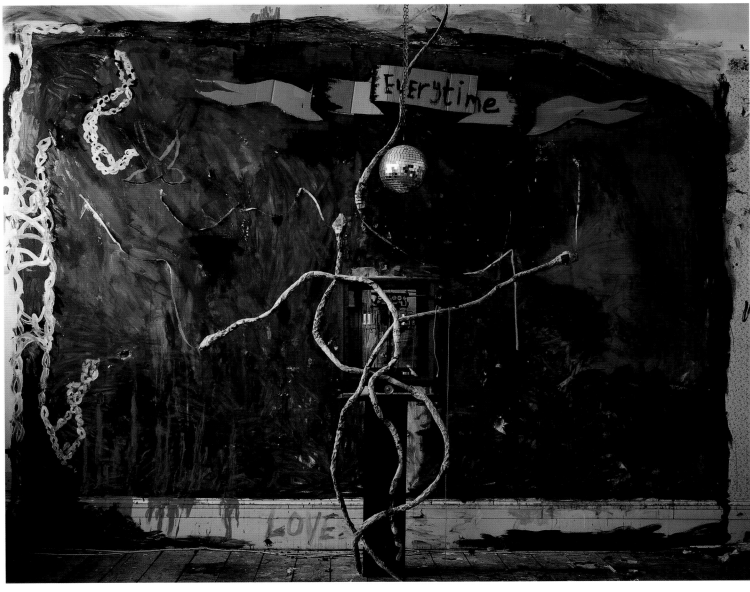

Isa Genzken

Since the mid-1970s, Isa Genzken has pursued sculpture not as a product separate from lived experience, but as an element deeply enmeshed in reality. The work obstinately confronts the social constructions that surround us and shape our everyday existence, from design, advertising, and the media to her most enduring subject, architecture and the urban environment. She targets aesthetic doctrines—from modernism to postmodernism and beyond—whose visual manifestations embody and enforce political and social ideologies. Her artistic investigations over the past three decades encompass a formal and material diversity suggestive of an intuitive rather than progressive development, as themes and formal strategies weave in and out, even seeming to contradict one another over time. Her practice extends to film and photography, painting, drawing, and collage; but it is as a sculptor that she has attained lasting prominence and influence in contemporary German art.

Genzken's early sculptures were abstract works that engaged in spatial negotiations with the environment and perceptual negotiations with the viewer. From these works, which drew on the essentialized forms and industrialized materials of Minimalism, Genzken turned increasingly to elements of architecture for her formal vocabulary. Her plaster sculptures of building fragments from the late 1980s were raw, conjuring ruins of International Style modernism, which relied heavily on concrete as a building material. More recently, she has sculpted scale models of architectural forms, especially skyscrapers, a building type that has always fascinated her. In *Fuck the Bauhaus: New Buildings for New York* (2000), Genzken thumbs her nose at the rationalism of unadorned buildings and the failed utopian ideals associated with the Bauhaus, proposing instead a proliferation of noisy antimodernist structures. The clean lines and progressive ideologies of the Bauhaus exerted a strong influence on the skylines of New York and other large commercial centers. Genzken would counter the tyranny of that modernist paradigm by populating Manhattan with absurd structural oddities, complete with fan blades, fencing, Slinkys, and other unruly appendages that transcend decoration to imply unknown functions. *New Buildings for Berlin* (2001–2) envisions a series of glass towers whose smooth surfaces and hard-edged forms are threatened by the fragility of their own construction. Genzken hints at the tenuous strength of such structures, at once delicate and monumental, signaling the fragility of the utopian dreams embodied within.

After the September 2001 attacks on the World Trade Center, the artist began a series that directly confronts the theme of architecture, power, and terror. Entitled *Empire/Vampire, Who Kills Death*, these works, much like scenes from a film, constitute self-contained stages for invented scenarios: ruins of architecture and the built environment peopled with figures trying to navigate the devastation. The materials themselves seem scavenged from the detritus of some postapocalyptic landscape; old sneakers, gnarled twists of metal, discarded clothing, and mirrored tiles form scale-model dioramas of turbulent struggles within the ruins of an industrialized society. The works play with the scale of buildings and people, engaging with elements of time and perspective to portray the moments after disaster strikes, when the familiar becomes terrifying through rupture and implosion. The twisting, gouged, crumbling forms illustrate humanity felled by the very buildings constructed to shelter it.—*Elizabeth Thomas*

BORN
1948, Bad Oldesloe, Germany

LIVES AND WORKS
Berlin, Germany

Isa Genzken studied at the Hochschule für Bildende Künste, Hamburg (1969–71), Universität der Künste, Berlin (1971–73), Universität zu Köln (1973–75), and Kunstakademie, Düsseldorf (1973–77). She has exhibited her sculpture and photography, most recently, in solo exhibitions at the Kunsthalle Zürich (2003, catalogue); neugerriemschneider, Berlin (2003); Museum Abteiberg Mönchengladbach, Germany (2002); Museum Ludwig, Cologne (2002, catalogue, 2001); Galerie Daniel Buchholz, Cologne (2001, 1998, 1996); Frankfurter Kunstverein, Frankfurt am Main (2000, catalogue); Kunstverein Braunschweig, Brunswick, Germany (2000, catalogue); A/C Project Room, New York (2000); Portikus, Frankfurt am Main (1992, catalogue); and Renaissance Society at the University of Chicago (1992).

Group exhibitions include: *Die Möglichkeit des Unmöglichen,* Frankfurter Kunstverein, Frankfurt am Main (2003, catalogue); *SEE History 2003,* Kunsthalle zu Kiel, Germany (2003); *Utopia Station,* 50th Venice Biennale (2003, catalogue); Kunstmuseum Winterthur, Switzerland (2003); *Documenta 11,* Kassel, Germany (2002, catalogue); *Wolfgang-Hahn-Preis,* Museum Ludwig, Cologne (2002); *My Head Is on Fire but My Heart Is Full of Love,* Charlottenbourg Museum, Copenhagen (2002, catalogue); *Artists Imagine Architecture,* Institute of Contemporary Art, Boston (2002, catalogue); *Ecofugal,* 7th International Istanbul Biennial (2001, catalogue); *Vom Eindruck zum Ausdruck,* Hauser Diechtorhallen, Hamburg (2001, catalogue); *Das XX Jahrhundert. Ein Jahrhundert Kunst in Deutschland,* Neue Nationalgalerie, Berlin (1999, catalogue); and *Sculpture: Projects in Münster* (1997, catalogue).

SELECTED BIBLIOGRAPHY

Isa Genzken: 1992–2003. Exhibition catalogue. Cologne: Verlag der Buchhandlung Walther König, in association with Kunsthalle Zürich, and Museum Abteiberg Mönchengladbach, Germany, 2003.

Isa Genzken: Wolfgang-Hahn-Preis 2002. Exhibition catalogue. Cologne: Gesellschaft für moderne Kunst am Museum Ludwig e.V., 2002.

Parkett, no. 69 (2004): 62–103. Special section, including essays by Jörg Heiser, Michael Krajewski, and Pamela M. Lee.

Seidel, Martin. "Isa Genzken: Stadtisches Museum Abteiberg, Mönchengladbach." *Kunstforum International* 163 (January–February 2003): 312–14.

Williams, Gregory. "Isa Genzken: Kunsthalle Zürich." *Artforum* 42, no.1 (September 2003): 234–35.

ISA GENZKEN
installation view, *Isa Genzken,* Kunsthalle Zürich,
March 22 – May 25, 2003
Courtesy of Kunsthalle Zürich
and Galerie Daniel Buchholz, Cologne

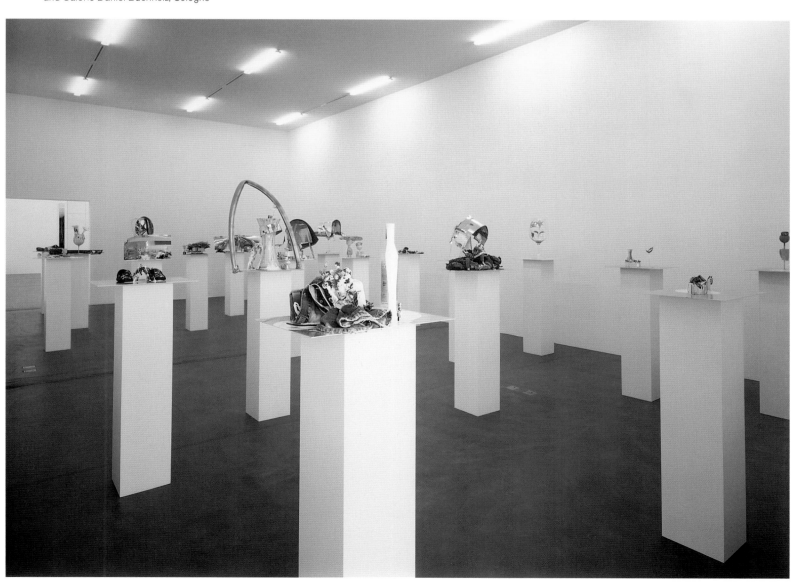

ISA GENZKEN
Empire/Vampire III, #12, 2004
metal, glass, mirror foil, lacquer,
plastic, fabric, seeds, and wood
65 3/8 × 30 5/16 × 19 11/16 in. (166 × 77 × 50 cm)
Courtesy of Galerie Daniel Buchholz, Cologne

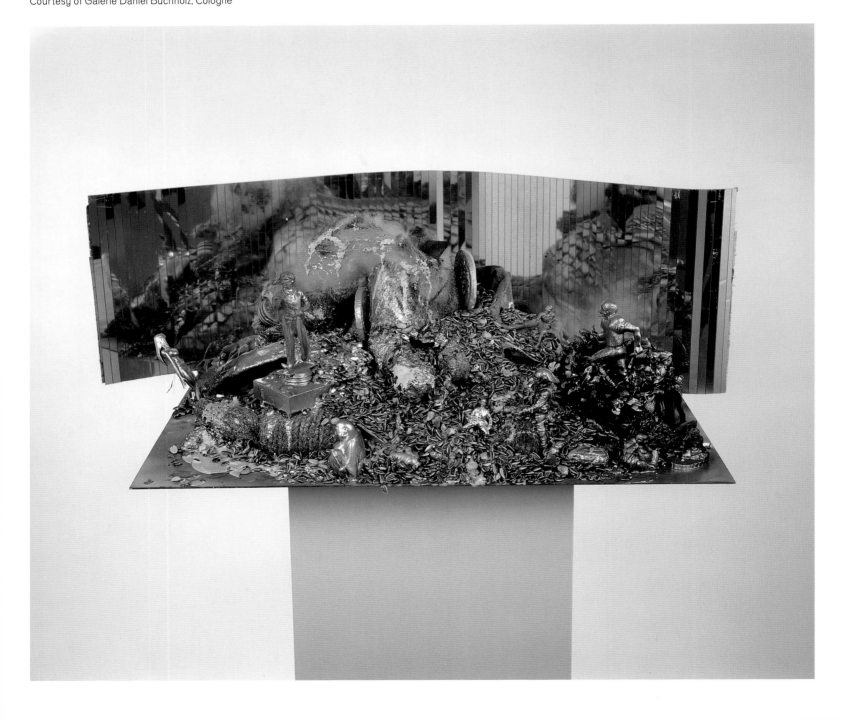

ISA GENZKEN
Empire/Vampire III, #13, 2004
metal, glass, lacquer, plastic, photographs,
mirror foil, and wood
77 15/16 × 33 1/16 × 20 1/16 in. (198 × 84 × 51 cm)
Courtesy of neugerriemschneider, Berlin

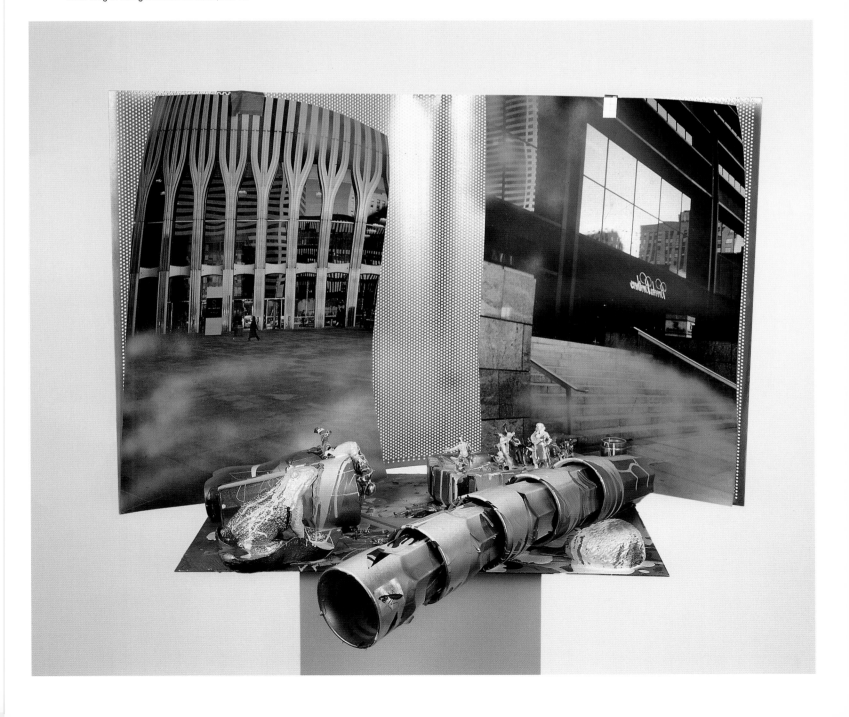

Mark Grotjahn

BORN
1968, Pasadena, California

LIVES AND WORKS
Los Angeles, California

Mark Grotjahn received his MFA from the
University of California, Berkeley, and his BFA
from the University of Colorado, Boulder.
He also studied at the Skowhegan School of
Painting and Sculpture in Maine. Grotjahn has
exhibited his paintings in solo exhibitions at
Anton Kern Gallery, New York (2003); Boom,
Oak Park, Illinois (2002); and Blum & Poe,
Los Angeles (2002, 2000, 1998).

Group exhibitions include: *On My Mind:
Recent Acquisitions from MOCA's Collection,*
Museum of Contemporary Art, Los Angeles
(2002); *Play It As It Lays,* London Institute
Gallery (2002); *Sharing Sunsets,* Museum of
Contemporary Art, Tucson, Arizona (2001);
Young and Dumb, Acme, Los Angeles (2000);
Drawings from Los Angeles, Studio Guenzani,
Milan (2000); *'00,* Barbara Gladstone, New York
(2000, catalogue); *After the Gold Rush,* Thread
Waxing Space, New York (1999); *Entropy at
Home,* Neuer Aachener Kunstverein, Aachen,
Germany (1998); *Winter Selections,* The
Drawing Center, New York (1998); *Helmut
Federle, Gunter Umberg, Mark Grotjahn, Ingo
Muller,* Anthony Meier Fine Arts, San Francisco
(1997); *Backroads* (with Doug McConnell),
Four Walls, San Francisco (1996); and *Access,*
Southern Exposure, San Francisco (1995).

SELECTED BIBLIOGRAPHY

Helfand, Glen. "Mark Grotjahn,
Brent Petersen, Paul Sietsema."
Bay Area Guardian, August 13, 1997.

Miles, Christopher. "Working Variables,
Switching Games: Mark Grotjahn." *Artext,* no. 78
(Fall 2002): 44–51.

Pagel, David. "Trying to Fit In."
Los Angeles Times, November 20, 1998.

Smith, Roberta. "Art in Review: Mark Grotjahn."
New York Times, October 24, 2003.

Trainor, James. "Rates of Exchange."
Frieze 78 (October 2002): 116–17.

overleaf left
MARK GROTJAH N
*Untitled (Black Butterfly Blue
Mark Grotjahn 2004),* 2004
oil on linen
60 × 50 in. (152 × 127 cm)
The Frank Cohen Collection;
courtesy of Anton Kern Gallery, New York

overleaf center and right
Untitled (White Butterfly MPG 03), 2003
*Untitled (Green Butterfly
Red Mark Grotjahn 04),* 2004
oil on linen
60 × 50 in. (152.4 × 127 cm) each
Courtesy of the artist; Blum & Poe, Los Angeles;
and Anton Kern Gallery, New York

Mark Grotjahn is one in the most recent array of artists to
tackle abstract painting with the same force of focus as earlier generations.
Yet his approach to painting and abstraction, like that of a number
of artists working in California today, grows out of conceptual practices.
Moving to Los Angeles in 1996, Grotjahn became intrigued by the handmade
signs he often saw in stores or restaurants, and by the proprietors who
made them. He began to copy certain signs he liked and would then present
his version to the store owners and ask to trade it for theirs, a practice in line
with conceptual appropriation strategies and one that extends art
into an arena of social exchange. As a next step, he began to copy drawings
made by his grandfather, a psychiatrist by profession but also a self-taught
artist who drew constantly, making cartoons of family life and line
drawings of plants and flowers. Soon after, Grotjahn began to reckon with
finding his own expression in his art, working with colored pencils to deter-
mine, as he put it, "a certain graphic form that I could stick with
and see how far within that system I could push it."

He developed what has been referred to as "perspective drawings,"
and from these he in turn began to make paintings. Each work has at least
two potential vanishing points, the convention of Renaissance perspective
by which a painting was structured to create the illusion of depth
and volume. Rather than setting figures or scenes within this structure,
Grotjahn uses the structure itself as his subject, ruling the chevrons
leading to each vanishing point, and then meticulously filling each one in
with a thick layer of paint. Similarly, bands that divide and mediate
between the disparate vanishing points, and the edges of the canvas itself,
are worked into the overall structure. The eye and mind meet to resolve
the experience of looking at one of these paintings, but without conclusion.
While there is an almost classical clarity to the formal organization,
the experience is alive, alert, and open—a play of perception and
understanding that remains restlessly and resiliently incapable of resolution.
This experience is further reinforced by the character of the surfaces
and the tonal modulations of color.

In the early paintings, one can detect, with scrutiny, some bit of color
at the seams and edges that betrays another surface lurking underneath
the thick face of the painting. More recently, Grotjahn has carved his
initials or name into the surfaces, playfully making explicit the fact that the
painting lies atop another plane, but also reengaging his earlier interest
in the personal lettering of sign makers. As friends and some visitors to the
artist's studio came to know, each painting began in fact with a cartoonlike
mask or face, which was ruled over and gradually obliterated. In more
recent paintings, an abstract, gestural ground precedes the geometric
structure of the final works. Grotjahn's paintings are self-conscious
constructions in which the intensity and concentration of their making
is perceptible and palpable.—*Gary Garrels*

MARK GROTJAHN
Untitled (Tequila Sunrise), 2003
oil on linen
60×50 in. (152.4×127 cm)
Private collection, Pittsburgh;
courtesy of the artist; Blum & Poe, Los Angeles;
and Anton Kern Gallery, New York

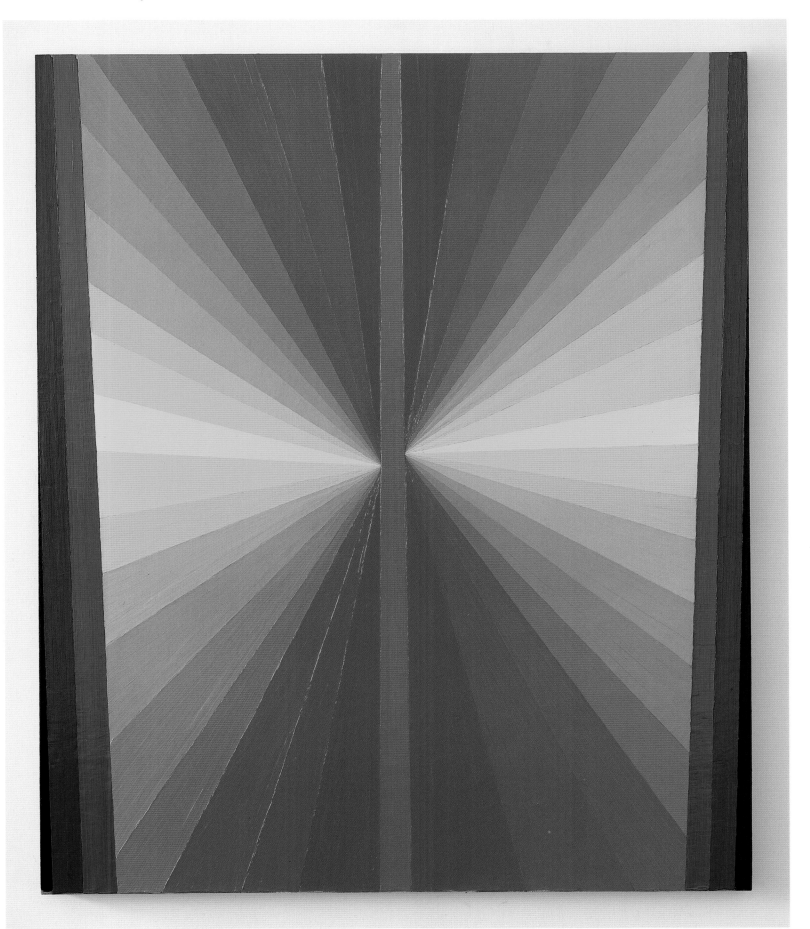

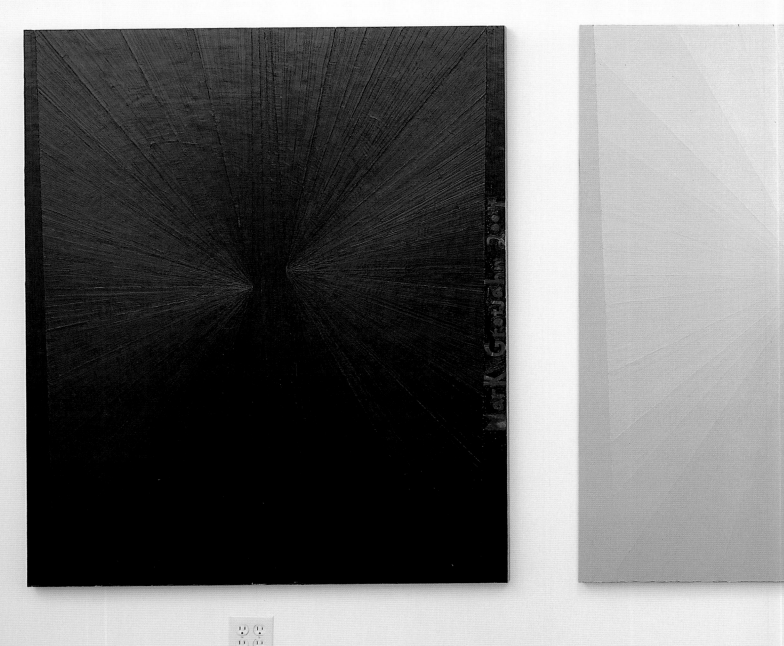

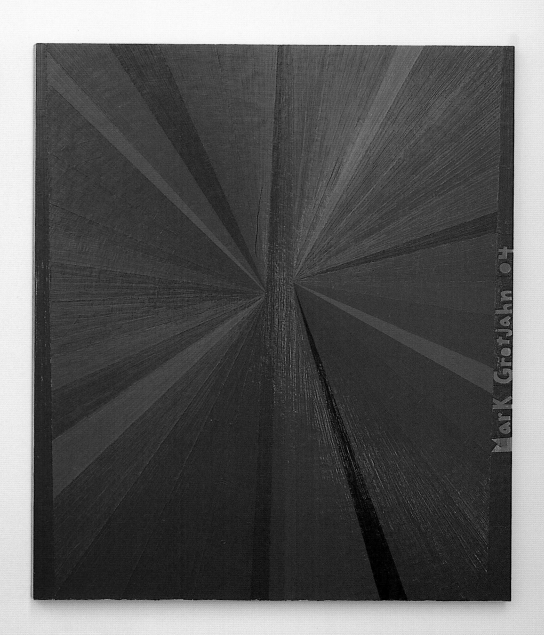

Rachel Harrison

BORN
1966, New York, New York

LIVES AND WORKS
New York

Rachel Harrison received her BA from
Wesleyan University, Middletown, Connecticut,
in 1989. She has exhibited her sculptures and
photographs in solo exhibitions at the Greene
Naftali Gallery (2004, 2003, 2001, 1999, 1997);
Camden Arts Centre, London (2004);
Milwaukee Art Museum, Wisconsin (2002,
catalogue); *Brides and Bases,* Oakville Gallery,
Toronto (2002, catalogue); *Seven Sculptures,*
Arndt & Partner, Berlin (2002); and the
Bergen Kunsthalle, Norway (2002).

Group exhibitions include: *The Structure of
Survival,* 50th Venice Biennale (2003, catalogue);
Teenage Rebel: The Bedroom Show, John
Connelly Presents, New York (2003); *Rachel
Harrison, Hirsch Perlman, Dieter Roth,
Jack Smith, Rebecca Warren,* Matthew Marks
Gallery, New York (2003); Whitney Biennial,
Whitney Museum of American Art, New York
(2002, catalogue); *Free Coke,* Greene Naftali
Gallery, New York (2000); *Answer Yes, No,
or Don't Know, Part II: Layers,* Andrew Kreps
Gallery, New York (1999); *Greater New York:
New Art in New York Now,* P.S. 1 Contemporary
Art Center, Long Island City, New York (2000,
catalogue); *New Photography 14,* Museum of
Modern Art, New York (1998); *Anne Chu, Rachel
Harrison, Donald Moffett, Jasmin Sian,*
Marc Foxx Gallery, Los Angeles (1997); *Current
Undercurrent: Working in Brooklyn* (1997);
The New God, Andrea Rosen Gallery, New York
(1997); *Sculpture Incorporating Photography,*
Feature, Inc., New York (1996); *Simply Made in
America,* Aldrich Museum of Contemporary Art,
Ridgefield, Connecticut (1992); and *Unlearning,*
142 Greene Street, New York (1991).

SELECTED BIBLIOGRAPHY

Anton, Saul, and Bruce Hainley.
"Bear Necessities: The Art of Rachel Harrison."
Artforum 41, no.3 (November 2002): 162–69.

Arning, Bill. "The Harrison Effect."
Trans>arts.cultures.media, no. 7 (1999): 168.

Currents 30: Rachel Harrison.
Exhibition catalogue. Milwaukee, Wisc.:
Milwaukee Art Museum, 2003.

Molesworth, Helen. "Rachel Harrison."
Documents 21 (Fall–Winter 2002): 49–54.

Rachel Harrison: File Notes. Exhibition catalogue.
London: Camden Arts Centre, 2004.

Rachel Harrison is concerned with the act of looking, and of comprehending (or not) the whole field of visual culture that surrounds us. She is fascinated by the semantics of images, products and their packaging, and less easily articulated concepts such as the way Pop icons and messages play upon our consciousness. This critique of imagery enters her work through photographs, which she sometimes appropriates from the steady stream of commercial and media images, and sometimes takes herself. Often grouped in discrete series, her photographs are also used individually as elements in her hybrid sculptures and installations. Combining aggressively handmade components and found objects, these three-dimensional works can take a variety of forms: autonomous objects in space, segments of constructed walls, or ungainly accretions of do-it-yourself carpentry projects. Within a single work Harrison sets up a complex relationship between the created and the found—it is unclear which was devised for which, whether the specificity of a particular photograph or porcelain figurine completes a sculpture, or whether the sculpture was in fact initiated in response to the objects.

In their ambiguity, these works are self-reflexive; they question their own status as sculptures in space and vessels for contemplation and projection. The apparent discontinuity of elements is not as abrupt as we might imagine; indeed, once we get past the intentional weirdness, there is an openness in the work that invites individual readings but also leads the viewer on a treasure hunt of sorts. We might sense echoes of form from photograph to sculpture, or word games that relate titles to small details. Harrison sets up mysteries rather than conclusions, encouraging the viewer to look actively, both physically and conceptually, and to follow her crumbs through mazes, behind walls, and into niches.

Harrison's relationship to the history of sculpture is a prickly one. Her sculptures challenge historical issues of display and connoisseurship, yet refuse to serve as demonstrable symbols or as abstract forms existing for their own sake. There is a curious interplay between the frontality of her work, emphasized, perhaps, by perfect sheetrock walls and carefully hung photographs, and what's going on behind the scenes. She is a teaser, not a trickster, setting up multipart compositions that flirt with theatricality through staging, framing, and mounting, while offering a complex critique of phenomenological theories of sculpture from the Baroque through Minimalism to the spectacle of recent site-specific art.

In the photographic series *(Untitled) Perth Amboy* (2001), Harrison taps into a found situation of faith: the Virgin of Guadalupe's appearance on a window in suburban Perth Amboy, New Jersey. Visited by an assembly line of the faithful, the apparition over time ceased to exist, replaced with an accumulation of smudgy marks bearing the traces of the multitude of hands that found something to believe in on that windowpane. In the same way that a too-bright light obliterates the object of its illumination, the thousands of fingerprints erased the very object of their reverence. *Perth Amboy* is not simply a document about the limits (or limitlessness) of faith, or the irrationality of belief, but a deeper query into the power of the human desire to believe and to deposit that belief into something tangible. In this case, seeing goes beyond believing, and more aptly, believing is seeing what we want to see, where we need to see it.—*Elizabeth Thomas*

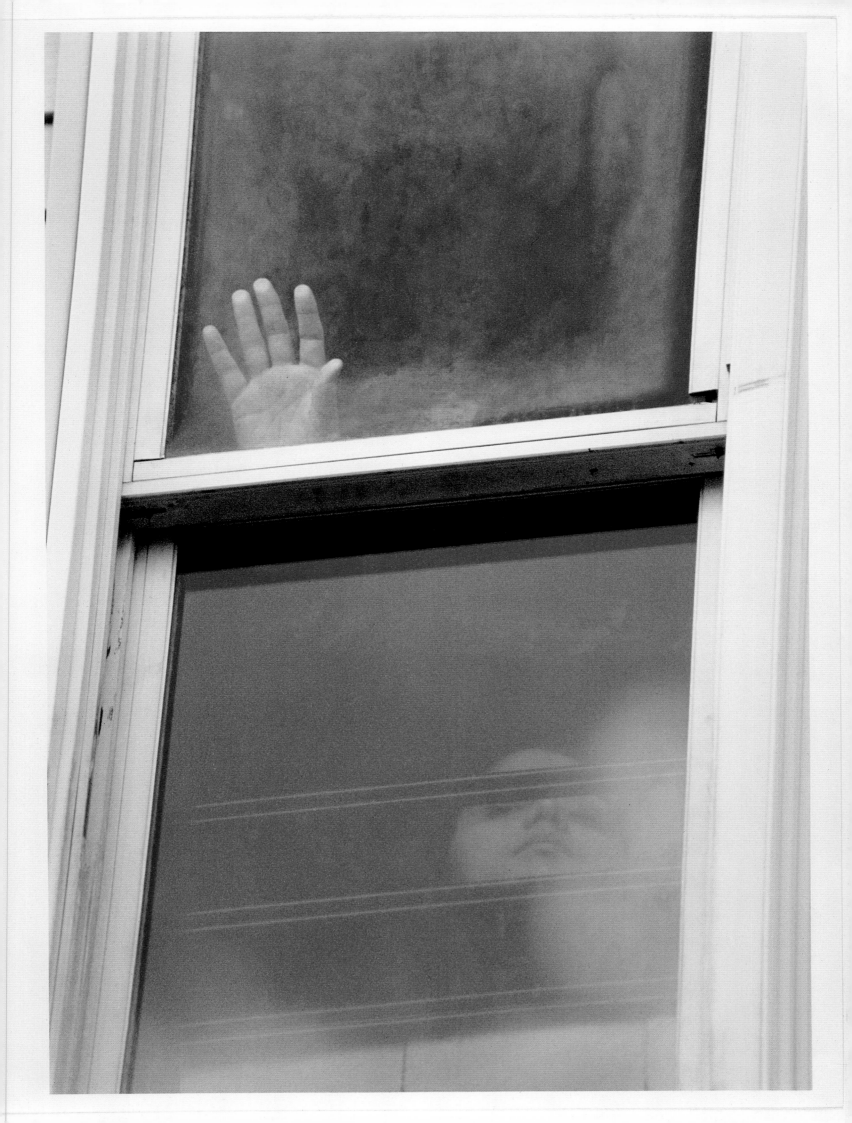

previous page
RACHEL HARRISON
(Untitled) Perth Amboy, 2001
chromogenic color print
19 3/4 × 13 3/4 in. (50 × 35 cm)
Courtesy of the artist
and Greene Naftali Gallery, New York

below and right
installation view, *Indigenous Parts 3,* 2003,
The Structure of Survival, Venice Biennale,
June 15 – November 2, 2003
mixed media
dimensions variable
Courtesy of the artist
and Greene Naftali Gallery, New York

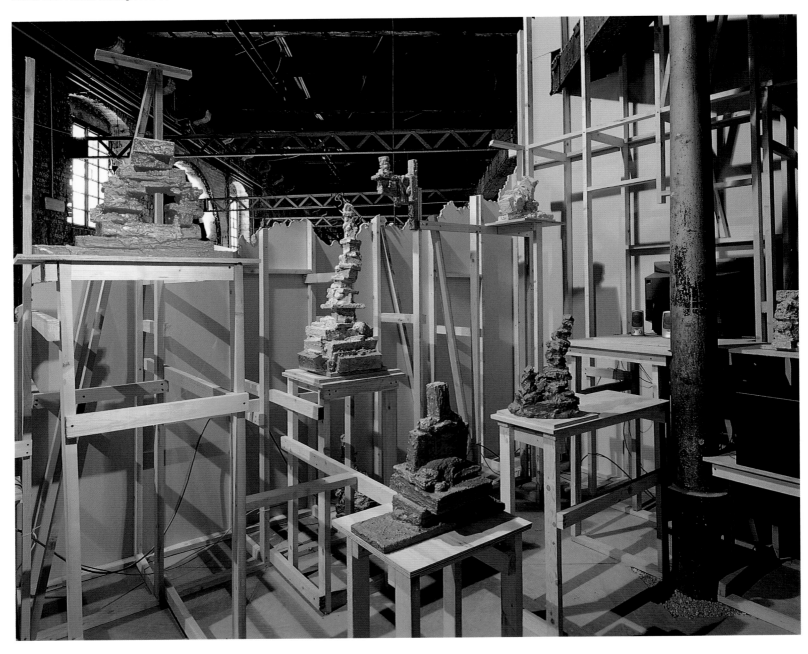

BORN
1961, Brussels, Belgium

LIVES AND WORKS
Fasta, Sweden

Carsten Höller has presented his sculptures and installations in solo exhibitions at Casey Kaplan, New York (2004, 2001); *Half-Fiction,* Institute of Contemporary Art, Boston (2003, catalogue); *One Day One Day,* Färgfabriken, Stockholm (2002); Fondazione Prada, Milan (2002, catalogue); *Light Corner,* Museum Boijmans Van Beuningen, Rotterdam (2002); Schipper & Krome, Berlin (2001, 1997, 1994); Le Magasin, Centre national d'art contemporain de Grenoble, France (2001); KIASMA Museum of Contemporary Art, Helsinki (2000); Moderna Museet, Stockholm (1999); Kunst-Werke, Berlin (1999); Camden Arts Centre, London (1998); Migros Museum für Gegenwartskunst, Zurich (1998); Kunstverein, Hamburg (1996, traveled to Kunstverein, Cologne, catalogue); and Secession, Vienna (1995).

Group exhibitions include: *Common Wealth,* Tate Modern, London (2003, catalogue); *Spectacular: The Art of Action,* Museum Kunst Palast, Düsseldorf (2003); *Den Sista Bilden,* Moderna Museet, Stockholm (2003); *It Happened Tomorrow,* Biennale d'art contemporain de Lyon, France (2003, catalogue); *Delays and Revolutions,* 50th Venice Biennale (2003, catalogue); *Spiritus,* Magasin 3, Stockholm Konsthall (2003); *Warped Space,* CCA Wattis Institute for Contemporary Arts, San Francisco (2003, catalogue); *Collections: Distorsions et Glissements de Sens,* MAC, Galeries Contemporaines des Musées, Marseille (2002, catalogue); Bienal de São Paulo (2002, catalogue); *Out of Senses,* Museum Boijmans Van Beuningen, Rotterdam (2002); *Mega Wave,* Yokohama Triennial, Japan (2002, catalogue); *Vicinato II,* neugerriemschneider, Berlin (2000); Biennale d'art contemporain de Lyon, France (2000, catalogue); Hauser Diechtorhallen, Hamburg (2000); *Dire AIDS,* Castello di Rivoli, Turin (2000); *Wall of Shame,* Museum Ludwig, Cologne (2000); *Looking for a Place:* Third International Biennial Exhibition, Site Santa Fe, New Mexico (1999, catalogue); 5th and 6th International Istanbul Biennials (1999, 1997); *Documenta X,* Kassel, Germany (1999, catalogue); *Manifesta 2,* Luxembourg, Belgium (1998, catalogue); and Kwangju Biennale, South Korea (1995).

SELECTED BIBLIOGRAPHY

Carsten Höller: Half-Fiction. Exhibition catalogue. Boston: Institute of Contemporary Art, 2003.

Celant, Germano. *Carsten Höller: Register.* Milan: Fondazione Prada, 2002.

Hoffman, Jens. "Carsten Höller: We Must Doubt!" *NU: The Nordic Art Review* 4 (2002): 130-37.

Höller, Carsten. *Glück, Skop.* Germany: Oktagon, 1996.

———. "A Thousand Words: Carsten Höller Talks about His Slides." *Artforum* 37, no. 7 (March 1999): 102-3.

Carsten Höller

After this there is no turning back …
You take the blue pill, the story ends,
you wake up in your bed and believe whatever you want to believe …
You take the red pill, you stay in wonderland and I show you
how deep the rabbit hole goes.
—Morpheus to Neo, *The Matrix*

Doubt, and perplexity, have been central aspects of Carsten Höller's investigation of the reflexive abilities of the human organism and mind. His practice is rooted firmly in his doctoral studies of insect communication through olfactory stimuli, and as a young biologist Höller slowly sniffed his own sensors toward ideas about art-making. By intention and foul play, he has turned his artworks into laboratory experiments, and we, the audience, are his test cases, his guinea piglets. Never to be misconstrued as proper science, Höller's work is better viewed as an exploration of individualistic/collective experiences/experiments. From his recent visceral lighting/lightning (strobe) cerebellum-bending sculptural installations to his compendium of elaborate environments of sculptures and architectural projections, the activation of the audience within and around the work of art transforms passive spectators into collaborating agents. He asks of us first to entrust our limbs and souls by deciding to stay on in wonderland, and then to make the leap, both a physical and a psychological summersault, into the rabbit hole he has prepared for us. Through it all, there is a constant voice in the back of our heads that questions if any of this is really happening.

As the artist has stated, "Doubt, and its semantic cousin, perplexity, which are both equally important to me, are unsightly states of mind we'd rather keep under lock and key because we associate them with uneasiness, with a failure of values." So, you already know which pill to take, but you are never certain when standing in front of a "Höller-deck" of art if it is the red or the blue you are actually given; usually, they are white. At any rate, you don't know any longer what you were supposed to be feeling after all.

But perhaps the feeling of LOVE, of a spirit freed from its confined moral codes, could be visited here, since LOVE is another state that induces emotions of both doubt and perplexity. Höller might be attempting (or tempting) something akin to LOVE when he indulges his art audience with a bowl of fine Belgian chocolate or with a greenhouse full of a plant variety, *Solandra maxima,* known to excrete pheromones. Höller revisits his olfactory past, and if the construction of LOVE can be seen as another form of communicating or communing, then the garden of pheromones can bring together revelers of art and of biology alike. And here in the garden of LOVE, in a manner similar to those male moths caught by a plume of female pheromone, we ask ourselves once again if we are falling in LOVE, or if this is just another drop of Höller's placebo of doubt and perplexity that we are swimming in. —*Rirkrit Tiravanija*

CARSTEN HÖLLER
installation view, *Sliding Doors,* 2003,
Common Wealth, Tate Modern, London,
October 22 – December 28, 2003
automatic sliding doors made of mirrored glass
86 5/8 × 181 7/8 in. (220 × 462 cm)
Courtesy of Casey Kaplan, New York

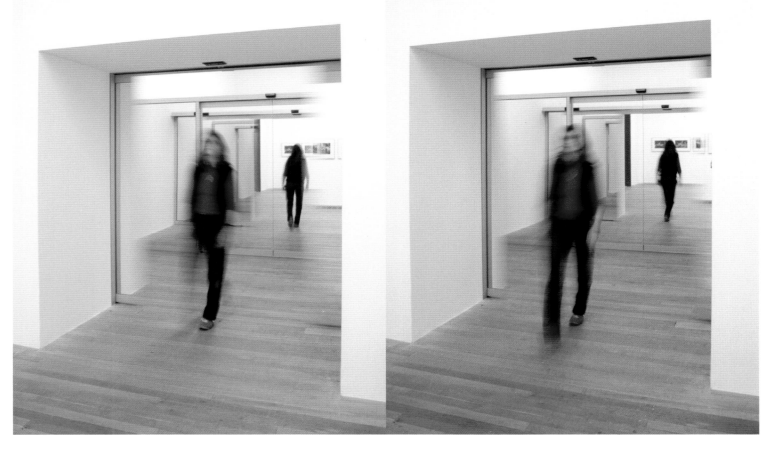

CARSTEN HÖLLER
installation view, *Light Wall,* 2001,
Instruments from the Kiruna Psycho Laboratory,
Schipper & Krome, Berlin, April 21 – May 25, 2001
incandescent 25-watt bulbs, dimmer, mixer,
electric wires, aluminium or wood construction,
sound generator, two loudspeakers (active),
and acrylic on plywood
75 1/2 × 38 1/2 in. (192 × 98 cm) each panel;
installation dimensions variable
Courtesy of Schipper & Krome, Berlin

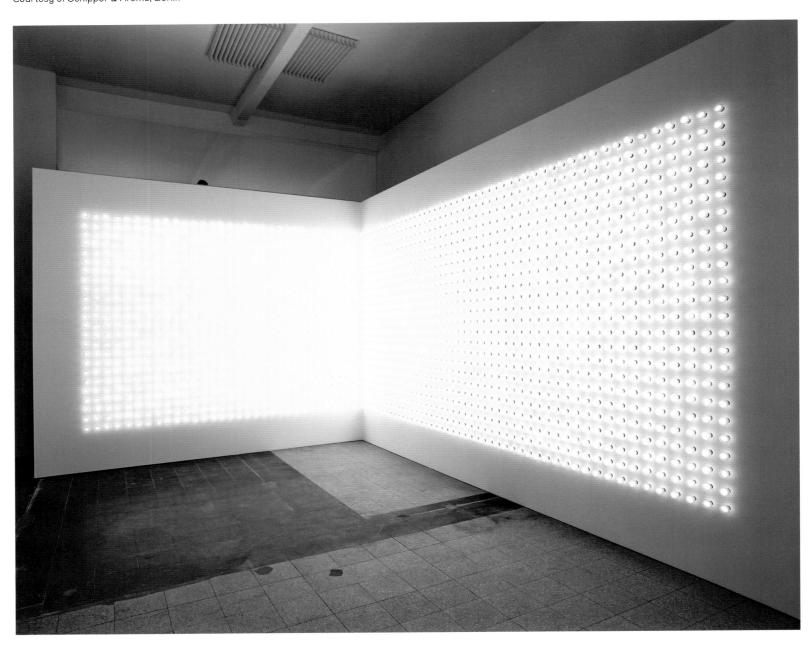

top
CARSTEN HÖLLER
plans for *Solandra Greenhouse,* 2004
Commissioned by
2004–5 *Carnegie International;*
courtesy of the artist; Casey Kaplan, New York;
and Schipper & Krome, Berlin

bottom
Solandra maxima

Katarzyna Kozyra

BORN
1963, Warsaw, Poland

LIVES AND WORKS
Warsaw, and Berlin, Germany

Katarzyna Kozyra studied at the Fine Arts Academy in Warsaw, graduating in 1993. She completed her postgraduate studies at the Hochschule für Graphik und Buchkunst, Leipzig, Germany, in 1998. Kozyra has exhibited her sculpture, performance-based work, and video work in solo exhibitions at Galleria Civica di Arte Contemporanea, Trento (2004); Museo Nacional Centro de Arte Reina Sofía, Madrid (2002, catalogue); Postmasters Gallery, New York (2002); Renaissance Society at the University of Chicago (2002, traveled to Zacheta National Gallery of Art, Warsaw); Museum of Modern Art, Oxford, England (2001); Muzej suvremene umjetnosti, Zagreb (2001, catalogue); *Dance Lesson,* Museum moderner Kunst Stiftung Ludwig, Vienna (2001); Kunsthalle Helsinki (2000, catalogue); *Bathhouse,* Center for Contemporary Art, Ujazdowski Castle, Warsaw (1997, traveled to Center of Contemporary Art, Vilnius, Lithuania, Polish Institute, Leipzig, and Zacheta National Gallery of Art, Warsaw, catalogue).

In 1999, Kozyra represented Poland at the 49th Venice Biennale. Other group exhibitions include: *Architecture of Gender,* Sculpture Center, New York (2003, catalogue); *Private Affairs,* Kunsthaus, Dresden (2002, catalogue); Bienal de São Paulo (2002, catalogue); *Collection,* Museum of Modern Art, Vienna (2001, catalogue); *The Body of Art,* First Valencia Biennial, Spain (2001, catalogue); *Masquerades,* Center for Contemporary Art, Poznan, Poland (2001, catalogue); *L'Autre moitié de l'Europe,* Galerie nationale du Jeu de Paume, Paris (2000, catalogue); *Art East Collection 2000+,* Moderna Galerija, Ljubljana, Slovenia (2000, catalogue); *La Casa il Corpo, il Cuore,* Museum moderner Kunst Stiftung Ludwig, Vienna (1999); *Fireworks,* De Appel, Amsterdam (1999); *After the Wall,* Moderna Museet, Stockholm (1999, traveled to Hamburger Bahnhof, Berlin, catalogue); and *Art from Poland, 1945-1996,* Mucsarnok, Budapest (1997, catalogue).

SELECTED BIBLIOGRAPHY

Katarzyna Kozyra. Exhibition catalogue. Helsinki: Kunsthalle Helsinki, 2000.

Katarzyna Kozyra. Exhibition catalogue. Zagreb: Muzej suvremene umjetnosti, 2001.

Katarzyna Kozyra: Laznia Męska. Exhibition catalogue. Warsaw: Centrum Sztuki Współczesnej Zamek Ujazdowski [Center for Contemporary Art, Ujazdowski Castle], 1999.

Katarzyna Kozyra: The Rite of Spring. Exhibition brochure. Chicago: Renaissance Society at the University of Chicago, 2001.

Zmijewski, Artur. "Purity, Clarity, Enthusiasm: An Interview with Katarzyna Kozyra by Artur Zmijewski." *Work: Art in Progress,* no. 8 (January-March 2004): 7-15.

Over the past decade, Katarzyna Kozyra has created uninhibited videos, performances, and photographs that delve into the role of social mores as they apply to issues of gender, aging and illness, religion, and group behavior. Her camera does not cast a gauzy haze over reality, but instead shows us the world exactly as it is, full of ethical contradictions, imperfect bodies, and existential struggle. Her works have been unsparing in their focused inquiry, beginning, just after her graduation from art school, with *Animal Pyramid* (1993), a sculpture and accompanying video examining the slaughter of animals for food that sparked a national debate on animal cruelty, censorship, and the role of the artist as a social conscience. Later works explore the fragility of her own body, photographed in the guise of Manet's famous *Olympia,* who unapologetically flaunted her sexuality. Kozyra, in the midst of a battle with cancer, likewise addresses the viewer head on, confronting issues of beauty and mortality.

Kozyra has surveyed the social constructions surrounding gender and nudity in video works she filmed surreptitiously in women's and men's bathhouses. In both *Bathhouse* (1997) and *Men's Bathhouse* (1999), she used a hidden camera to capture the most unabashed and natural expressions of behavior. In each case, the artist participated in the bathhouse rituals in order to bring the viewer as close as possible to an approximation of the experience, going so far as to appear in male drag in order to move through the male-only environment undetected. The work raises controversial issues about privacy and transgression of personal and intimate spaces, but the restrained tenor counters any possible accusations of salacious voyeurism. These gender-segregated spaces provide forums for observing men and women without the filter of gender performance as it intersects with social expectation or sexual attraction. The footage also reveals how men and women pursue these activities for different reasons; whereas the women relish the opportunity to relax, ritualistically groom, and engage in comfortable companionship with other women, the men appear more concerned with appearance, being highly attentive to their behavior as observer and the observed, but seldom touching or speaking to one another.

Kozyra's multichannel video installation *The Rite of Spring* (1999/2004) is inspired by Vaslav Nijinsky's extraordinary choreography for the composition by Igor Stravinsky, which premiered in Paris in 1913. *The Rite of Spring* celebrates a pagan sacrificial ritual, in which a virgin dances wildly to transfer her energy to the earth, an act that results in her eventual death. This transmission of energy from life to death to life again signals the cycles of rebirth in nature and in all living things. Seeing a parallel between the jerky movements in Nijinsky's choreography and puppets on a string, Kozyra re-created the work as an animation. She positioned the bodies of elderly men and women, lying prone against a white backdrop, then sequenced still image after still image to create a sense of movement, literally reanimating these less-than-agile bodies with the transfer of her own energy. *The Rite of Spring* furthers Kozyra's inquiry into social order and group dynamics by exploring the role of ritual in human interaction. Ritual reinforces social order and shared beliefs, provides a device for transitioning between stages of life (and death), and creates a framework for coming to terms with the fundamental issues and existential inquiries facing us all. —*Elizabeth Thomas*

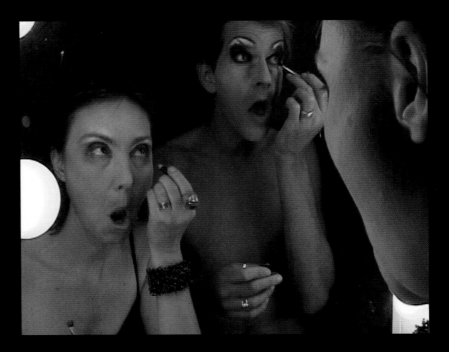

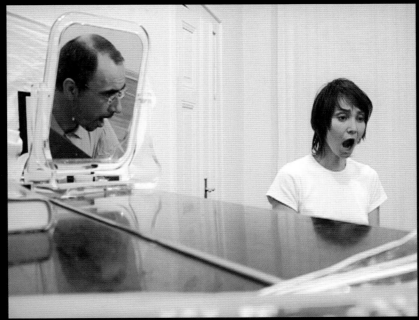

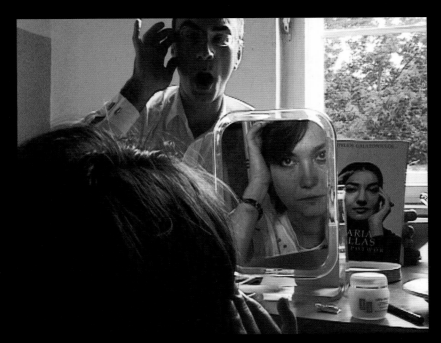

KATARZYNA KOZYRA
stills from *Non so piu cosa son, cosa faccio*
(I don't know anymore what I am,
what I'm doing), 2004
10-channel video installation; color, sound
Courtesy of the artist
and Postmasters Gallery, New York

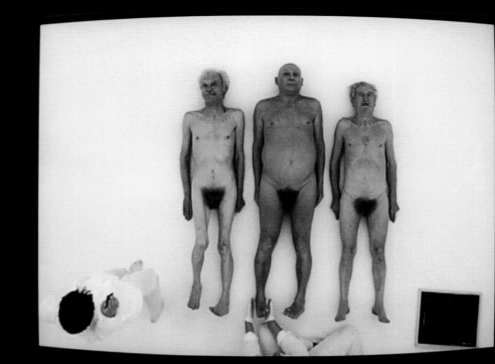

NA KOZYRA
nd installation views of
Spring, 1999
ideo installation; color, sound
of Zacheta National
Art, Warsaw;
f the artist
asters Gallery, New York

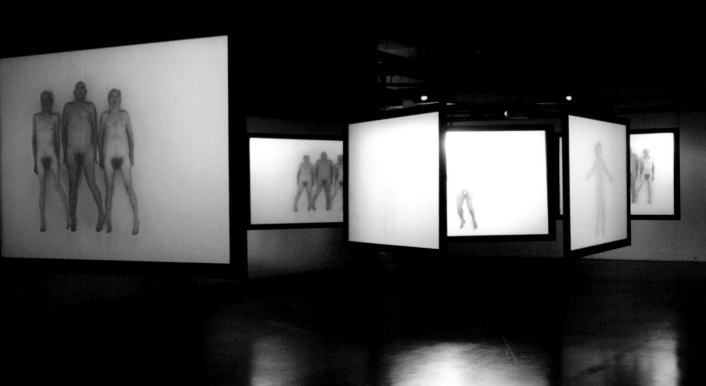

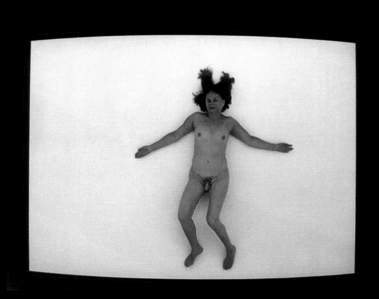

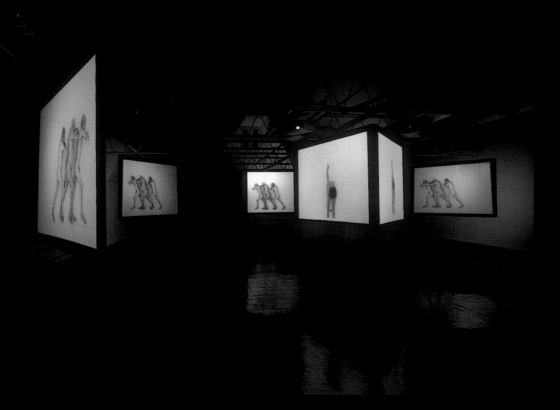

Jim Lambie

BORN
1964, Glasgow, Scotland

LIVES AND WORKS
Glasgow

Jim Lambie received his BA from the Glasgow School of Art, Scotland, in 1994. He has exhibited his work in solo exhibitions at The Modern Institute, Glasgow (2004, 2001); Anton Kern Gallery, New York (2004, 2001, 2000); Inverleith House, Edinburgh (2003); Museum of Modern Art, Oxford, England (2003, catalogue); The Breeder Projects, Athens, Greece (2002); Sadie Coles HQ, London (2002, 1999); Jack Hanley Gallery, San Francisco (2001); Konrad Fisher, Düsseldorf (2000); The Showroom Gallery, London (1999); and Transmission Gallery, Glasgow (1999, catalogue).

In 2003 Lambie was one of three artists representing Scotland in the 50th Venice Biennale. Other group exhibitions include: *The Moderns,* Castello di Rivoli, Turin (2003, catalogue); *Love Over Gold,* Gallery of Modern Art, Glasgow (2003); *Days Like These,* Tate Triennial Exhibition of Contemporary British Art, Tate Britain, London (2003, catalogue); *Hello, My Name Is...,* Carnegie Museum of Art, Pittsburgh (2002); *Early One Morning,* Whitechapel Art Gallery, London (2002, catalogue); *My Head Is on Fire but My Heart Is Full of Love,* Charlottenbourg Museum, Copenhagen (2002, catalogue); Scottish National Gallery of Modern Art, Edinburgh (2002); *Painting at the Edge of the World,* Walker Art Center, Minneapolis (2001, catalogue); *Raumkörper,* Kunsthalle Basel (2000); *What If,* Moderna Museet, Stockholm (2000, catalogue); *Creeping Revolutions,* Foksal Gallery Foundation, Warsaw (1999); *Host,* Tramway, Glasgow (1998); and *Girls High,* Fruitmarket Gallery, Glasgow (1996).

SELECTED BIBLIOGRAPHY

Days Like These: The Tate Triennial Exhibition of Contemporary Art. Exhibition catalogue. London: Tate Britain, 2003, 100–105.

Early One Morning. Exhibition catalogue. London: Whitechapel Art Gallery, 2002, 108–20.

Higgs, Matthew. *Seven Wonders of the World.* London: Bookworks, 1999.

Male Stripper. Exhibition catalogue. Oxfordshire, England: Modern Art Oxford, 2003.

Zobop. Exhibition catalogue. Glasgow: Transmission Gallery/Showroom Gallery, 1999.

The modernist practice of making assemblages from found and altered materials has a long and extraordinarily inventive history. Jim Lambie extends this history to reflect the brightness of youth-culture dreams. In the 1980s, Lambie was immersed in the Glasgow club and music scene, as both a DJ and a musician. Shifting to art, he studied in the environmental department at the Glasgow School of Art. Out of this background developed the concerns that underlie his practice as an artist: an attention to the character and qualities of the materials from which art is made, and the physical and cultural aspects of the places in which art is shown and experienced.

By the late 1990s, Lambie had his first solo exhibitions and became known for a series of floor installations, titled *Zobop*, in which bands of adhesive vinyl tape—either multicolored or black, gray, and white—were laid down following the perimeter of the architectural space. Any irregularity or interruption of the space became accentuated and exposed, the solidity of the space was dissolved, and the floor became an arena for the projection of the imagination, a sort of psychedelic dreamscape. At the same time, he began making sculptures out of ordinary objects and materials by altering, combining, or adding to them. Among the best known of these works are the *Psychedelic Soul Sticks*, sticks stuck with wadded paper and wrapped in hundreds of multicolored threads to become shamanistic objects.

In recent years, Lambie's visual vocabulary and investigation of perception and psychological states have grown more varied and complex. Turntables, speakers, records and album liners, leather and vinyl clothing, beads, buttons, and mirrors have appeared in various guises. Clearly, connections with popular music and the club scene still resonate. At the same time, however, the materials and processes of art—paint and its application, and its capacity for transformation—are equally constant preoccupations. Unifying his work is Lambie's interest in the formal qualities of surface, edge, space, and color; vertical and horizontal interplay; degrees of solidity; and relationships between objects and a room, as well as their relationships to each other and to the shifting engagement of the viewer. No less important are cultural contexts and associations. Through Lambie's choice of materials and their altered states, the dreams of youth culture are ensnared by nostalgia, memory, and ambiguities. Voyeurism and the fabrication of identity are entwined. Vulnerability and romanticism are found to lurk in the prosaic and the mundane.

One can see certain precedents in Surrealism (Man Ray and Salvador Dalí) and in British sculpture of the 1970s and 1980s (Tony Cragg and Richard Deacon). But Lambie is not tied to issues of sexuality and the unconscious mind as were the Surrealists, or to the descriptive literalism of the preceding generation in England. His works are essentially staging grounds for self-scrutiny and discovery, platforms for the imagination and for escape from the quotidian into the domain of immanent potential. —*Gary Garrels*

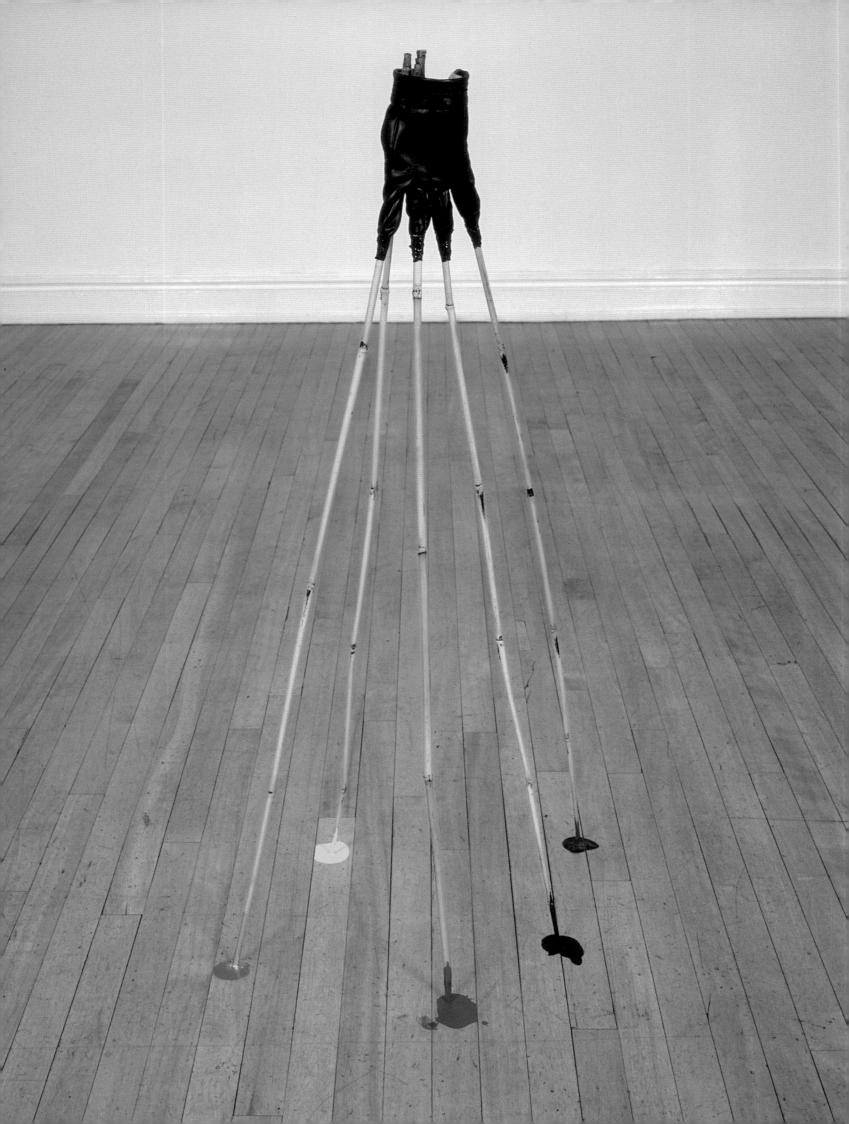

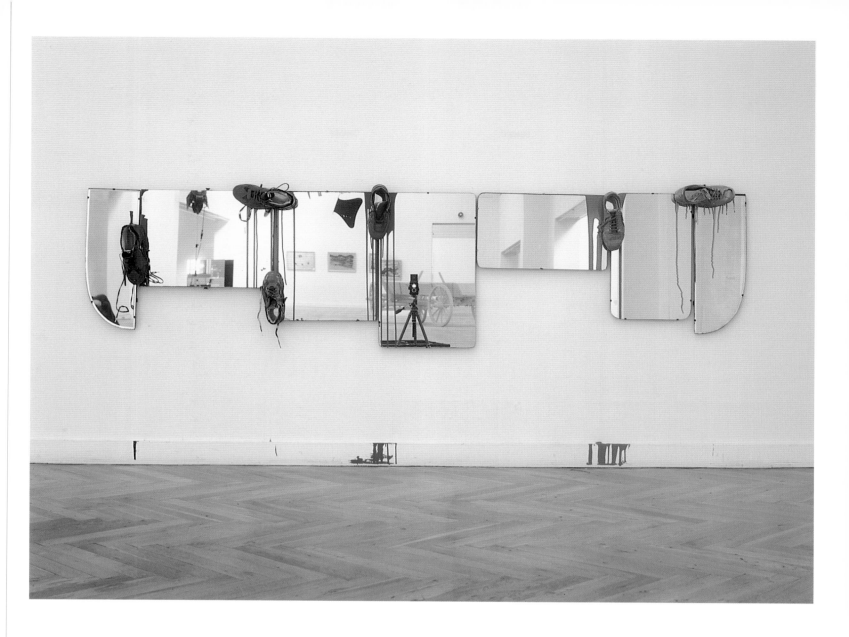

previous page
JIM LAMBIE
No Problemo, 2003
mirrors, mudrock, and paint
39 3/8 × 27 1/2 × 26 in. (100 × 70 × 66 cm)
Courtesy of The Modern Institute, Glasgow

left
Fat Burner, 2003
leather glove, bamboo cane, and enamel paint
47 1/4 × 23 1/2 in. (120 × 60 cm)
Private collection; courtesy of The Modern
Institute, Glasgow; Sadie Coles HQ, London;
and Anton Kern Gallery, New York

above
Bleached Highlights, 2002
mirrors, shoes, and enamel paint
29 1/8 × 118 1/8 × 8 in. (74 × 300 × 20.3 cm)
Private collection; courtesy of The Modern
Institute, Glasgow; Sadie Coles HQ, London;
and Anton Kern Gallery, New York

BORN

1921, Šid, Serbia/Montenegro

DIED

1987, Zagreb, Croatia

Although he began making art in the late 1940s, Mangelos (Dmitrije Bašičević) did not have a major exhibition until 1972, when he was featured in *Picasso Phenomenon* at Tribina mladih, Novi Sad, Yugoslavia. After his death, numerous exhibitions devoted to his work were presented, including: *Mangelos nos.1 to 9 1/2*, Fundação de Serralves, Museu de Arte Contemporânea, Porto (2003, traveled to Fundació Antoni Tàpies, Barcelona, Neue Galerie am Landesmuseum Joanneum, Graz, Austria, and Kunsthalle Fridericianum, Kassel, Germany, catalogue); *Les paysages des morts*, The Drawing Room, Berlin (2001); *Theses or Manifestos*, Moderna Galerija, Ljubljana, Slovenia (1999, catalogue); A/D Gallery, New York (1998); Anthony d'Offay Gallery, London (1998); *a bc*, Galeria Rainer Borgemeister, Berlin (1997); *Mangelos Books*, Center Opus Operandi, Ghent (1993); and *Mangelos*, Museum of Contemporary Art, Zagreb (1990, catalogue). Other solo exhibitions during his lifetime included Galerija Sebastian, Belgrade (1986, catalogue); Galerija Doma JNA, Zagreb (1986, catalogue); *Mangelos No. 1–9: Retrospective*, Galerija PM, Zagreb (1981); *Mangelos no. 9: Energy*, Galerija Dubrava, Zagreb (1979, catalogue); *Manifestos*, Atelier Tošo Dabac, Zagreb (1978, catalogue); and *Mangelos no. 9: Shid Theory*, Podroom, Zagreb (1978).

Group exhibitions include: *The Misfits*, Art Moscow (2002, traveled to Muzej na suvremenata umetnost, Skopje, Macedonia, catalogue); *Art East Collection 2000+*, Moderna Galerija, Ljubljana, Slovenia (2000, traveled to Orangerie Congress, Innsbruck, Austria, Umetnička Galerija: Space 2 – Cifte Aman, Skopje, Macedonia, and ZKM/Zentrum für Kunst und Medientechnologie, Karlsruhe, Germany, catalogue); *Beyond Preconceptions: The Sixties Experiment*, National Gallery, Prague (2000, traveled to Zacheta National Gallery of Art, Warsaw, Museo de Arte Moderno, Buenos Aires, Paço Imperial, Rio de Janeiro, Berkeley Art Museum, University of California, Portland Art Museum, Oregon, and Samuel P. Han Museum of Art, Gainesville, Florida, catalogue); *Aspects/Positions: Fifty Years of Art in Central Europe, 1949 – 1999*, Museum moderner Kunst Stiftung Ludwig, Vienna (1999, traveled to Fundació Joan Miró, Barcelona, and City Gallery, Southampton, England, catalogue); 47th Venice Biennale (1997, catalogue); *Galerija PM 1981–1989*, Zagreb (1989); *Gorgona (…Jevšovar, Knifer…)*, FRAC, Dijon, France (1989, catalogue); *Anti-Museum: NoArt*, Galerija Dioklecijan, Split, Croatia (1985); *Innovations in Croatian Art in the 1970s*, Galerija suvremene umjetnosti, Zagreb (1982, traveled to Muzej savremene umetnosti, Belgrade, and Collegium Artisticum, Sarajevo, catalogue); *Beyond Aesthetic*, Galerija studentskog centra, Zagreb (1981); *Gorgona*, Galerija suvremene umjetnosti, Zagreb (1977, traveled to Museum Abteiberg Mönchengladbach, Germany, catalogue); *Permanent Art and Visual Poetry*, Galerija 212, Belgrade (1971, 1968); *Tyepoetrv*, Galerija studentskog centra, Zagreb (1969).

Thinking Is a Form of Energy: Mangelos

Branka Stipančić

In his work *Relations manifesto*, Mangelos divided a globe into black and white hemispheres. The black one is inscribed with the text "les paysages de la mort" (Landscapes of death), the white with "functional thinking." *Relations manifesto* harnesses two distinct phases of the artist's career: the early stage characterized by a vague, intuitive sense of the world as represented in his *Paysages de la mort*, and the late stage when he formulated his theory on art and civilization with the fundamental concept of functional thinking. The work, juxtaposing these two artistic standpoints, is paradigmatic because it symbolizes the artist's shift from one pole of the instinct/intelligence axis to the other as Mangelos developed and refined his philosophical position of "no-art." *Relations manifesto* is signed Mangelos no. 4 / Mangelos no. 8, following the artist's Shid theory for dating his works, which assigns the first part to the 1942–49 period and the second to 1970–77.[1]

Art historian Dimitrije Bašičević lived in Zagreb, Croatia, in the former Yugoslavia, as a respected art critic and museum curator. Concurrently and less publicly, he was an artist who signed his works with the pseudonym Mangelos. Although he was a member of Gorgona, a Zagreb-based group of artists and art historians that from 1959 to 1966 acted on the principles of "anti-art," little was known of his artwork until the late 1960s when, encouraged by the younger generation of conceptual artists and critics, he began gradually to exhibit it.

It is difficult to pinpoint when and why Mangelos' project of no-art came into being. Referring in his writings to his early works, Mangelos described how as a boy, during the Second World War, whenever a relative or friend died he would ink a black rectangle in his exercise book, between homework and first attempts at poetry. In this way, he spontaneously recorded his feelings of fear and impotence more deeply and compellingly than if he had tried to express them in words. Death was there without any stylistic distancing, a blot of paint signifying absence. He titled the black "graves" he painted on paper and on geographic maps after the war *Paysages de la mort* and *Paysages de la guerre* (Landscapes of war) FIG.1.

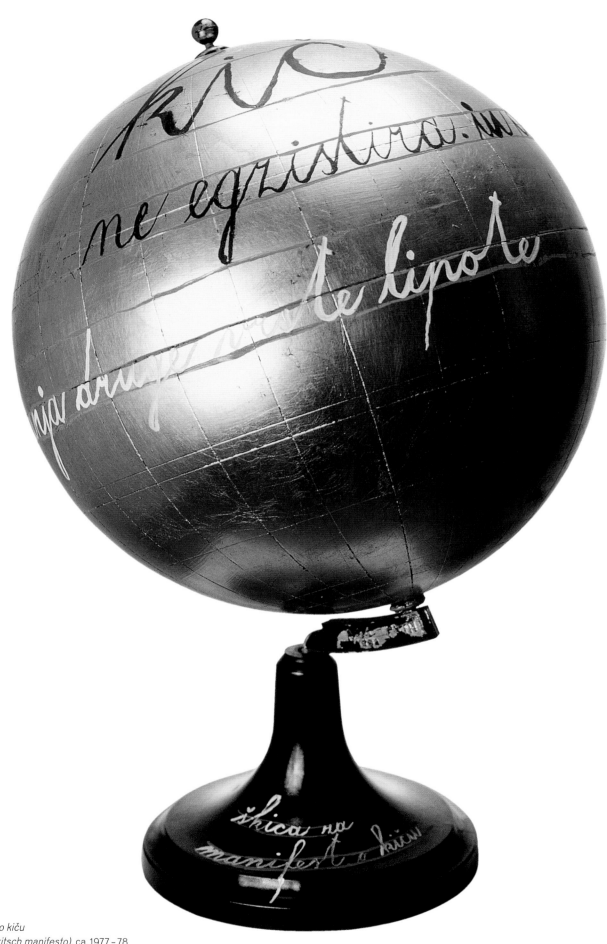

MANGELOS
Skica za manifest o kiču
(A sketch for the kitsch manifesto), ca. 1977 – 78
gold leaf and acrylic on globe
made from plastic and metal
14 15/16 × diam. 10 1/4 in. (38 × diam. 26 cm)
Collection of Mrs. Zdravka Bašičević, Zagreb;
courtesy of Fundação de Serralves, Porto

SELECTED BIBLIOGRAPHY

Dimitrijević, Nena. "Gorgona: Art as a Way of Existence." In Laura Hoptman and Tomáš Pospiszyl, eds. *Primary Documents: A Sourcebook for Eastern and Central European Art since the 1950s.* New York: Museum of Modern Art, 2002, 124–40.

Irwin, ed. "East Art Map—A (Re)-Construction of the History of Art in Eastern Europe." *New Moment Magazine* (Ljubljana) 20 (2002): 28.

Stilinović, Mladen. "Interview with Dimitri Bašičević Mangelos." In *Mangelos.* Zagreb: Galerija Doma JNA, 1986. Reprinted in *Moment* (Belgrade), nos. 6–7 (1986): 21–24.

Stipančić, Branka. *Mangelos nos. 1 to 9 1/2.* Exhibition catalogue. Porto, Portugal: Fundação Serralves, 2003.

Stipančić, Branka, ed. *Riječi i slike/Words and Images.* Zagreb: Soros Center for Contemporary Art, 1995.

1 The *Shid manifesto* (1978)—whose title is a variation on the name of the artist's hometown village of Šid in the former Yugoslavia (today Serbia and Montenegro)—provides the key for accurate dating of Mangelos' works. Because he rarely signed or dated his works, except for the painted booklets, the chronology of his other works may be determined provisionally according to his personal "metamorphoses" as outlined in this manifesto. In it, Mangelos refers to a bio-psychological theory he heard about at school when he was a child that claimed the cells in the human organism are completely renewed every seven years, and therefore each human being possesses several completely different personalities. Mangelos used it to explain the differences between early and late works by famous persons who often seemed to radically change attitudes over time: two Marxes, three Van Goghs, several Picassos, two Rimbauds—and nine and a half Mangeloses.

When he began to exhibit more frequently in the 1970s, he grouped his works according to subject matter and ascribed them to individual Mangeloses: no. 4, no. 5, no. 6, and so on, projecting them into the future and counting all nine and a half of them to his death in 1987, which he accurately predicted. *Shid manifesto* was published in the catalogue *Shid theory* (Zagreb: Podrum, 1978), nine years before the artist's death. To the year of his death he added the place: "les champs du dernier goulag" (referring to Soviet concentration camps, a metaphor for hell).

2 Dimitrije Bašičević Mangelos, "Introduction to no-art," 1979, published in *Quorum* (Zagreb), no. 1 (1989): 188. It must be noted that Mangelos tended to avoid capital letters in general. All translations into English are by Maja Šoljan.

3 Mića [Dimitrije] Bašičević, "Between Pythagoras and Exat," in *Exat 51,* ed. Ješa Denegri and Želimir Koščević (Zagreb: Galerija Nova, 1979), 291.

the war triumphed in the remnants of what might be termed a series with a paltry period or a group of black paintings. paysages de la guerre. after them came simply paysages that in "professional" terms could be called "pure landscapes" and then "assorted landscapes." if art does not stem from a concept but from a state, then the state in which metamorphoses of death were created could be seen as a certain loosening of the pressure from the triumph of war. from the emptiness of despair something like thoughts began to emerge. 2

From the painted black surfaces of the *Paysages de la mort* and *Paysages de la guerre*—which functioned as tabulae rasae—Mangelos then turned to the school slate. Like a schoolboy, he penned letterforms, entire alphabets in various fonts—Greek, Latin, Glagolitic, Cyrillic, Gothic, Runic—in books and exercise books, on pages coated in black or white tempera FIG. 2. At the same time, as if cramming for a geometry exam, he covered page after page with squares and triangles and titled each of them *Pythagoras*. Both letterforms and *Pythagoras* in Mangelos' oeuvre are rational elements that he matched against the irrational elements of the senses that tend to be favored by art. Alphabets, like geometric forms, are systematic, defined sets of signs, and the clear and functional thought of the ancient Greek philosopher appealed to Mangelos as a theoretical and practical achievement beyond dispute. In the artist's view, if we want to put the torment of war behind us—to start from scratch, from a clean slate—we might as well start with something solid and reliable, something built into the foundation of science:

FIG. 1 *Paysage de la guerre*, m. 4, 1942–44
tempera on printed paper
9 1/16 × 12 5/8 in. (23 × 32 cm)
Collection of Mrs. Zdravka Bašičević, Zagreb;
courtesy Fundação de Serralves, Porto

FIG. 2 *Alfabet (gl.)* (Alphabet [gl.]), 1952
tempera on printed paper,
staple-bound in cardboard cover
24 sheets, 8 9/16 x 6 in.
(21.8 × 15.2 cm) each
Collection of Mrs. Zdravka Bašičević, Zagreb;
courtesy of Fundação de Serralves, Porto

4 The members of the Gorgona group were:
painters Josip Vaništa, Julije Knifer,
Marijan Jevšovar, and Đuro Seder; art historians
Radoslav Putar, Matko Meštrovic, and Dimitrije
Bašičević Mangelos; sculptor Ivan Kozarić; and
architect Miljenko Horvat. For more on Gorgona,
see Nena Dimitrijević, "Gorgona: Art as a Way
of Existence," first published in the catalogue
Gorgona (Zagreb: Galerija suvremene umjetnosti
[Gallery of contemporary art], 1977); reprinted in
*Primary Documents: A Sourcebook for Eastern
and Central European Art since the 1950s*, ed.
Laura Hoptman and Tomáš Pospiszyl (New York:
Museum of Modern Art, 2002), 124–40.

*why pythagoras. / because of clarity and brevity. of pythagoras. /
the square on the hypotenuse is equal to the sum of the squares on the other
two sides. / nothing more. no introductions or elaboration of the idea. /
no footnotes and no explanations. / we were taught that only an elaborated
thought is valid. / experience on the contrary shows that it is not
necessarily so. / thought is always brief. in its formulation. / and simple as
the phenomenon itself. and phenomena. / are undoubtedly always simple. /
the quote from pythagoras / may be the first functional thought ever. /
that refers to an abstract phenomenon.*3

Both Mangelos the artist and Bašičević the art theoretician preferred thinking over feeling. Increasingly skeptical of modern art, although he still endorsed it in his critical texts, Mangelos wrote in his booklet *Documents d'un expériment* (Documents of an experiment, 1954), a blacked-out catalogue about the first postwar Croatian abstract artists group, Exat 51, "exat feels the world while pythagoras thought about it." Having chosen thought as the dominant force in his practice of no-art, Mangelos focused on words as his primary tool, as they were the most direct symbolic representation of thought.

Mangelos wanted to be a man for new times, to discard all that no longer functioned under the changed circumstances of the latter half of the twentieth century. His move toward no-art was in part a means to distance himself from traditional art disciplines. In this vein, he produced the series *Négation de la peinture* (Negation of painting) to mark the death of painting in which he crossed and blotted out reproductions from both the older and more recent history of art, negating through his conceptual act the very idea of painting. Like his Gorgona colleagues,4 for whom rigid modernism was not enough of a challenge, Mangelos sought his own anti-art position. In the early 1960s, Gorgona attempted to radicalize the very concept of art and artistic behavior.

178

Theirs was an art of the everyday, apolitical and Zen-influenced. It borrowed the spirit of freedom, play, and humor from Dadaism, an interest in the real world and a poetic approach from Fluxus. The emphasis was on experience rather than on the artwork, and the linguistic nature of art was stressed. Today their utopian, "neo-avant-garde" projects could in many ways be described as presaging conceptual works of the late 1960s FIG.3. The members of Gorgona did not work in isolation; they had contacts with international artists such as Dieter Roth, Piero Manzoni, and the playwright Harold Pinter, who collaborated with Josip Vaništa on the anti-magazine *Gorgona* (1961–66). *Gorgona* had wide international distribution; American audiences could find it in the library of the Museum of Modern Art in New York as early as 1968.

During the Gorgona period and later, Mangelos used the written idiom as the predominant means for expressing his position. One recurrent surface, in addition to school slates, exercise books, and book pages, was the globe. In ancient cultures the sphere, the ultimate symmetric shape implying circular motion, stands for perfection and the wholeness of the world. On the other hand, the globe may symbolize the unlimited and absolute power of a single entity or person. This latter aspect apparently prompted Mangelos to produce his first globe, *Paysage of Al Capone* (1952). Against a black-painted landscape of the world, he multiplied and varied the letters of the notorious mobster's name (a stand-in for a local potentate, a politically influential artist with whom Mangelos was in conflict) as a metaphor of his opposition. For Mangelos, *Paysage of Al Capone* was particularly important because it was the first work to register his defiance of society, now no longer only as Dimitrije Bašičević the art historian, whose critical texts and curated exhibitions questioned the ideas and tastes of the ruling cultural policy; nor only as Mangelos the artist, who drew his landscapes of death and *Tabulae Rasae* conveying states and alphabets; but also as Mangelos the no-artist, who formulated his message with words on an object.

During the 1950s and early 1960s, Mangelos embarked on an extensive revision of elementary and philosophical concepts. In the series of drawings *Abfälle* (Junk), made in 1961–63, he scrapped those concepts he considered obsolete: intuition, love, hope, faith, friendship, and others inherited from the old, metaphorical way of thinking. As he asserted, "mental states are undoubtedly facts, but they belong to a civilization which I dare say is dead and gone," 5 and he proffered an alternative to such subjectivity in a series of drawings with a single word related to concrete concepts (such as hand, table, etc.), which he called *Noun-facts*.

Existentialist philosophy, already an underlying element in his early works, seems to have provided a new momentum and redirected his work at this time. The note *Philosophie d'absurdité* (from *Les exercices*, begun in 1961)—which claims that "with the absurd on the philosophical level / the question of meaning in general / has been addressed for the first time / in a first (accidental) attack on the way of thinking"—indicates that Mangelos, a skeptical intellectual, not only explored new modes of thought but questioned the very act of thinking itself.

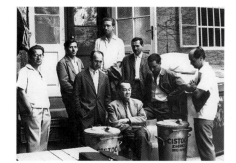

FIG.3 Members and friends of Gorgona group in the courtyard of the Gallery of Contemporary Art, Zagreb, 1961
Left to right: Dimitrije Bašičević Mangelos, Josip Vaništa, Ðuro Seder, Julije Knifer, Radoslav Putar, Matko Meštrović, Slobodan Vuličević, Ivo Steiner (seated); courtesy of Branka Stipančić

5 Mangelos in an unpublished note, in the archive of Zdravka Bašičević, Zagreb.

In *Les exercices* and also in the *Antisketches* (begun in 1963), he fills page after page with his rejection of prevailing attitudes—everything from Being, the Absolute, form, and meaning to history, evolution, truth, and aesthetics—as well as with various declarations: "pas plus les problems de la form" (There are no problems of form anymore); "aesthetics are nothing but conventions"; "super-categories are matter, energy, memory." In the process of negation and affirmation Mangelos clashed with many thinkers—Spinoza, Hegel, Heidegger, Marx, Marcuse, and others—going so far as to ridicule all authority, scoffing at Hegel in particular because his logic was not functional.[6]

Mangelos was interested in art as meaning rather than substance, but he presented that meaning in a startlingly material way: as disciplined as an ancient scribe, working in calligraphy with the thinnest of brushes. The slow working in tempera on painted-over pages of printed books; the careful plotting of space and the fine composition of sentences; the equilibrium of only four colors—black, red, white, and rarely, gold; the tactile quality of paper and the corporeal feel of books themselves all provide Mangelos' works with an aura of precious objects. The text bears the meaning yet the visual quality is undeniable FIG.4.

In the mid-1960s Dimitrije Bašičević, theoretician and curator at the Gallery of Contemporary Art and one of the organizers of the international *New Tendencies* exhibitions and symposia held in Zagreb between 1961 and 1973, analyzed the new role of artists and art in society and arrived at the conclusion that man's attitude toward matter, toward the "material," was crucial. It is from that relation that history evolved, and in which he discerned two distinct stages in the history of art: "If technology contributed to the destruction of one art (instinctive one), it also contributed to the creation of a new one. Functional."[7] This is the idea on which Mangelos would base the majority of his many no-art manifestos of the 1970s: *Manifesto of manifestos*, *Manifesto on society devoid of art*, *Altamira manifesto*, *Moscow manifesto*, *Shid manifesto*, *Manifesto on memory*, *Manifesto on subconsciousness*, *Manifesto on photography*, and others.[8]

In many of the manifestos he expounded his theories on the evolution of society and the nonevolution of art, or the crisis and death of art, which he ascribed to the gap between two civilizations: *manual* and *machine*, the former based on naive and metaphorical thinking, and the latter on "functional thinking." Mangelos claimed that technology triggered changes which in turn canceled out many of the disciplines associated with the old way of thinking—above all philosophy and art. To illustrate his point, in his *Altamira manifesto*, he wittily aligns the hypothetical caveman from Altamira with Picasso, placing them both at the same anachronistic level of manual civilization. Self-referentially, Mangelos applied the same analogy to his no-art and to the work of his colleagues from Gorgona. He addressed them in his *Moscow manifesto* just before the opening of the Gorgona exhibition in Zagreb in 1977:

FIG.4 *Jahrensbuch*, begun in 1970
tempera on printed paper,
perfect-bound in plastic-covered cardboard
76 sheets, 11 1/4 × 8 1/4 in.
(28.6 × 21 cm) each
Collection of Mrs. Zdravka Bašičević, Zagreb;
courtesy of Fundação de Serralves, Porto

6 See, for example, his artwork *There are no two logics / hegel thinks the same as his shoemaker*, Mangelos no. 7 (1964–70); and his statement "otherbeing / has not comrade hegel with his anderssein / turned the entire philosophy / from the course of science / to the course of theology," from *Les Exercices*, begun in 1961.

7 Mića [Dimitrije] Bašičević, "Actuality of Functional Art," in *New Tendencies 3*, exh. cat. (Zagreb: Galerija suvremene umjetnosti [Gallery of contemporary art], 1965), 63–64.

8 See the catalogue *Mangelos: Manifestos*, accompanying his exhibition at Atelier Tošo Dabac, Zagreb, 1978. Mangelos wrote many of his manifestos by hand, on pages torn from newspapers and magazines, on painted-over brochures, wooden panels, and school globes. He also typed a series of manifestos on a typewriter and printed them in silkscreen onto wood panels and paper.

meine libe muzikanten gorgonauts / we are preparing for our / posthumous exhibition but ART IS DEAD and so is the old / naive way of thinking. there are no / profound thoughts only functional ones.... art lost its social function with the advent of the machine. / remaining on the level of manual / production art according to marx and contra marx still functions only as / a prop of history. in museums.... / the world has changed while art is stuck at the beginning of the nineteenth century. despite its efforts in two directions. / to impose itself on society / as an avant-garde and to adapt to the machine civilization / the time of gorgonauting is over. / and the epoch of the naive way of thinking too. / the revolution of / consciousness is taking place. a functional one.

"For painting to be neither prehistoric nor historic, but contemporary," wrote Mangelos in his (unpublished) notes, "it can be formed only by a symbol that is not ambiguous, i.e., by thinking—speech-thinking and functional thinking." Like conceptual artists who focused on mental operations and introduced word language as a constituent element in what had previously been exclusively *visual* art, Mangelos wrote his manifestos in the hybrid form of theory and art of the 1970s, although his work was different visually from that of the conceptual artists. Various theories and ideas inspired him to produce works that establish a perpetual dialogue with thinkers of the past and the present, as well as with contemporary viewers FIG.5. And the successful works invariably belong to the world of communication and relationships. This type of "relational aesthetic," according to critic Nicolas Bourriaud, "always strives for more than mere existence in space, it is open for dialogue and debate, a form of interhuman communication that Marcel Duchamp called the 'art coefficient' and which represents a process in time, taking place here and now."9

Mangelos drew from literature, philosophy, psychology, sociology, biology, physics, and other disciplines of the humanities and sciences. He saw himself as a philosopher, above all as a skeptic who attempted to construct his own thought edifice. He did this by probing both Descartes' and Kant's notions of doubt, by dismissing intuition as the highest form of self-knowledge as proposed by Spinoza, and by negating art itself, going even further than the doubts about art and aesthetics raised by Hegel and Heidegger. He had respect for Marshall McLuhan and his ideas about a revolution in communications, for Walter Benjamin and his writings on the work of art in the age of mechanical reproduction, as well as for contemporary theoreticians of conceptual art such as Joseph Kosuth and Catharine Millet. He learned about aggression, instinct, and the need to revise history from Konrad Lorenz, about the theory of energy from Werner Heisenberg. Mangelos applied to his main subjects—death and thinking—the idea, borrowed from physics, that energy, as the basic form of matter, cannot be destroyed but rather converts from one form into another. In *Manifesto on thinking no.1*, he stated that "thinking is a form of energy," and in *Le manifeste sur la mort* (Manifesto on death) that "il n'y a pas de mort, il s'agit d'une autre forme de la vie" (There is no death, only another form of life) FIG.6.

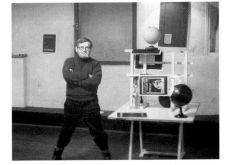

FIG.5 Mangelos at the exhibition *Shid-theory*, Podroom, Zagreb, 1978
Courtesy of Branka Stipančić

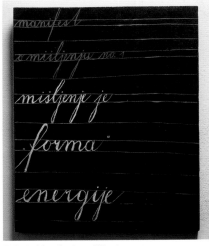

FIG.6 *Manifest o mišljenju no.1* (Manifesto on thinking no.1), ca. 1977–78
acrylic on wood panel
17 3/8 × 13 3/4 in. (44 × 35 cm)
Collection of Mrs. Zdravka Bašičević, Zagreb; courtesy of Fundação de Serralves, Porto

9 Nicolas Bourriaud, *Esthétique relationnelle* (Dijon: Presses du réel, 2001). Quoted from *Relaciona estetika* (Belgrade: Centar za savremenu umetnost, 2002), 18.

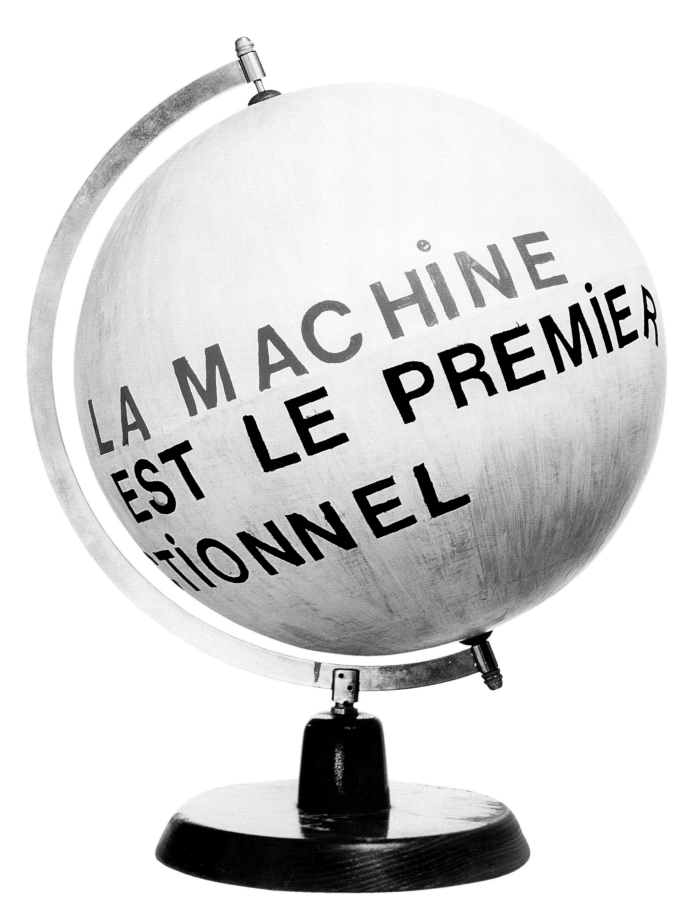

MANGELOS
Le manifeste sur la machine, ca. 1977–78
acrylic and plastic letters on globe
made from wood, metal, and paper
18 1/8 × diam. 14 3/16 (46 × diam. 36 cm)
Collection of Mrs. Zdravka Bašičević, Zagreb;
courtesy of Fundação de Serralves, Porto

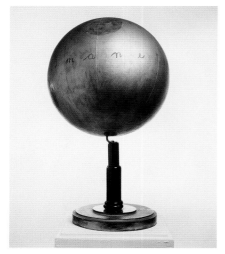

FIG. 7 *Mane tekel fares*, 1987
acrylic and tempera on globe made from wood,
metal, paper, and plastic
22 13/16 × diam. 13 3/4 in. (58 × diam. 35 cm)
Collection of Dr. Ljubomir Radovančević, Zagreb;
courtesy of Fundação de Serralves, Porto

right
FIG. 8 *Rimbaud no. 1 (1854–1874)*,
ca. 1977–78
acrylic on globe made from wood,
metal, and paper
11 7/16 × diam. 8 11/16 in. (29 × diam. 22 cm)
Collection of Mladen Stilinović, Zagreb;
courtesy of Fundação de Serralves, Porto

far right
FIG. 9 *Rimbaud no. 2 (1874–1891)*,
m.8, 1971–77
acrylic on globe made from wood,
paper, and metal
11 7/16 × diam. 8 11/16 in. (29 × diam. 22 cm)
Collection of Mrs. Zdravka Bašičević, Zagreb;
courtesy of Fundação de Serralves, Porto

10 *Manifesto on the machine no. 2*, ca. 1977–78.

11 Being=nothing / otherbeing=othernothing.
Hegel globe, ca. 1977–78. In his notes Mangelos
criticizes Hegelian logic, claiming that the
opposite of nothing, *nichts,* is something, *etwas,*
and not *sein;* that the concept of *anderssein*
devalues the concept of *sein;* and that Hegel
destroyed the concept of being by introducing
otherbeing.

12 *Sketch for the manifesto on kitsch*,
ca. 1977–78.

13 *Energy,* 1978. One of Mangelos' exhibitions,
titled *Energy* (Galerija Dubrava, Zagreb, 1979),
consisted of a single word written in various
languages on panels and globes. His last
exhibition, *Mangelos No. 1–9: Retrospective*
(Galerija PM [Expanded Media Gallery],
Zagreb, 1981), also displayed a single word.
Mangelos brought a school slate on which he
had written in chalk: "no-art."

14 Daniel 5:26–28 (King James Version).

Mangelos was often playfully ironic in the formulation of his manifestos,
creating a contrast between the pretentiousness of the message and
the banality of the sentence. He wrote in a variety of foreign languages and
occasionally combined them to underscore some of his theories or to make
puns. Aware that his writing by no means reflected the precise, functional
thinking he advocated, he tried to condense his information and present
it as clearly and concisely as possible, in a super-Wittgensteinian manner.
The brief manifestos written on globes appear to be conclusions of some of
his theories ("the first machine is the first model of functional thinking"10;
"sein=nichts / anderssein=andernichts"11; "kitsch does not exist in der
kunst / kitsch is merely an instrument of negation of the value of feeling for
another kind of beauty"12) or a summing up of his manifestos in a single
important word such as *energy*, which he spelled out in various fonts.13

Two globes reflecting the Shid theory portray two personalities of the
French poet Arthur Rimbaud: *Rimbaud no. 1 (1854–1874)*, who managed to
loosen poetic restrictions; and *Rimbaud no. 2 (1874–1891)*, who abandoned
everything and became a solitary wanderer in Africa FIGS. 8 AND 9. The latter
bears the inscription, "Où sont les neiges lanjski," an expression of fear
and resignation in a polyglot variation on François Villon's elegiac refrain
"Mais où sont les neiges d'antan" (Where are the snows of yesteryear),
and a white-on-red shape that resembles a snowy hill, the singular figurative
element in the artist's entire oeuvre. On occasion Mangelos incorporated
shapes from a geometric vocabulary: a square and a triangle to clarify
the Pythagorean theorem; a cross to negate painting; a graph to denote flow;
or a circle to represent the world. Red and black circles appeared on the
globe *Mane tekel fares* from 1987, the last work Mangelos made, at the
prompting of a physician, when he was already very ill and not working FIG. 7.
Several months before his death, he wrote on the golden globe:
"mane, tekel, fares" in a variation on *mene, tekel, peres* (numbered,
weighed, divided). The handwriting on the wall that foretold
the downfall of a Babylonian king in the biblical story means: "God hath
numbered thy kingdom, and finished it; thou art weighed in the balances,
and art found wanting; thy kingdom is divided."14 In his last work
Mangelos seems to convey a message to himself and again foretells his death.
And death, claimed Mangelos, does not really exist; like thinking,
it is just another form of energy.

Translated from the Croatian by Maja Šoljan

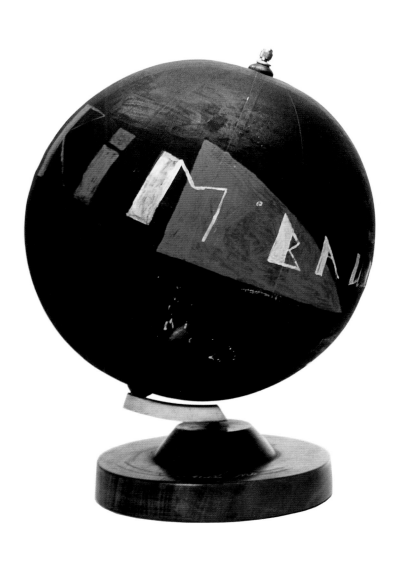
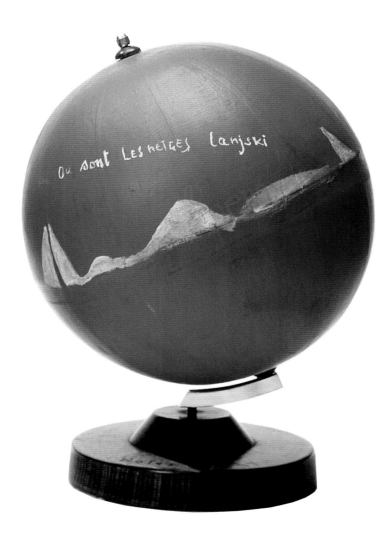

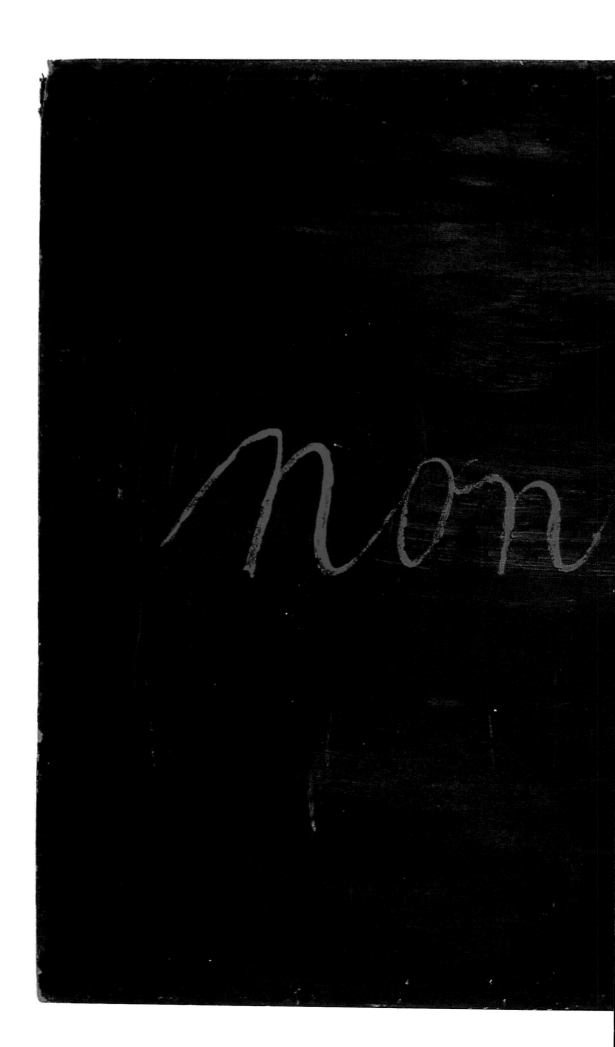

right
MANGELOS
Non Credo, m.6, 1957–63
tempera on cardboard
18 1/8 × 26 5/8 in. (46 × 67.6 cm)
Collection of Mrs. Zdravka Bašičević, Zagreb;
courtesy of Fundação de Serralves, Porto

following pages
Dilema-manifest (Dilemma-manifesto), 1978
tempera on printed paper
10 7/8 × 16 3/4 in. (27.6 × 42.6 cm)
Collection of Mrs. Zdravka Bašičević, Zagreb;
courtesy of Fundação de Serralves, Porto

credo

solange das denken

von emotionen

bestimmt ist

dieses denken

wird bleibt naiv.

DER SPIEGEL

C 7007 CX

Nr. 16
32. Jahrgang · DM 3,—
17. April 1978

dilemma-manifest progress oder

gleichgewicht

Die Computer-Revolution
Fortschritt macht
arbeitslos nodilemma

Julie Mehretu

Julie Mehretu's paintings dance knowingly around the history of the medium and attendant ideologies rooted in both abstraction and representation. At the same time, they engage in an interplay with the social concerns of power, history, and globalization. Her stated interest in the "multifaceted layers of place, space, and time that impact the formation of personal and communal identity" is quite literally embodied in the physical composition of her pictures with their strata of diagrams, visual notation, and abstract graphic forms. Her unmistakable style and palette mine a confluence of visual sources, from maps and newspaper photographs to tattoos and graffiti, with each image carefully emphasizing its cultural context. Much has been made of the artist's peripatetic upbringing—with time spent living in locales as far flung as Addis Ababa, Ethiopia, and Kalamazoo, Michigan—as it would appear to echo her works' fractured logic of mapping and the itinerancy of her source material. Within a "stratified tectonic geology," as she characterizes it, Mehretu overlays the chaotic psychic and social energy of a place onto its regimented physical order. In many works, she nods to historical aesthetic systems having their own distinct agendas: the Futurists' uneasy embrace of the machine age, the Situationists' "psychogeographic" mappings of cities, and the utopian abstractions of Wassily Kandinsky.

Transcending: The New International (2003) traces the promise of and subsequent disillusionment with the ideals of utopian modernism. On the first layer, Mehretu renders an aerial map of the economic and political capitals of Africa. Subsequent layers derive from urban plans for postcolonial Africa, in which International Style buildings symbolize the modern construction of a "new" Africa. Elements taken from photographs of African cityscapes bring the chaotic reality of urban planning into the mix, clashing significantly with the drawn perfection of the "plan." The abstract marks on the surface serve as "characters," representing individual social agency within the totalizing space of the picture. By inserting movement and social patterns within the static mapping of structural engineering, Mehretu inscribes a coded abstract language onto a figurative and representational world.

Other works are intended to play off one another, as in the case of *Dispersion* and *Renegade Delirium* (both 2002). *Renegade Delirium*'s composition swarms around a central core, held together by the centrifugal force of its own frenetic energy. The more rational (primarily orthogonal) base layer contrasts with the effusion of colored planes that mark the surface. The compositional commotion recalls the intense sensory realities of cities— the smelly, crowded, noisy spaces and the straining of people against the order imposed on them by the grid of standard urban planning. Interspersed with these abstract passages are signals of disaster—licking flames, billowing smoke, and menacing cloudlike formations. The sense of foreboding is palpable. *Dispersion* is the second part of the equation, the follow-up to implosion. The elements in this work crowd toward and escape from the confines of the canvas, leaving the center of the composition empty. This void represents a world torn apart, as Mehretu's "characters" struggle to re-situate themselves into some peaceful coexistence. Though grounded in the built environment, Mehretu's canvases operate as enveloping alternate realities in which epic struggles play out between movement and stasis, freedom and control, chaos and order, and individual action and collective power. —*Elizabeth Thomas*

BORN
1970, Addis Ababa, Ethiopia

LIVES AND WORKS
New York, New York

Julie Mehretu studied at the University Cheik Anta Dop, Dakar, Senegal, and received her BFA from Kalamazoo College, Michigan, in 1992 and her MFA from the Rhode Island School of Design in 1997. She has presented her paintings in solo exhibitions at the Berkeley Art Museum, University of California (2004); Walker Art Center, Minneapolis (2003, traveled to Palm Beach Institute of Contemporary Art, Lake Worth, Florida, Albright-Knox Art Gallery, Buffalo, New York, and CalArts Gallery at REDCAT, Los Angeles, catalogue); White Cube, London (2002); ArtPace, San Antonio, Texas (2001); The Project, New York (2001); and Project Row Houses, Houston, Texas (1999).

Group exhibitions include: *Metascape,* Cleveland Museum of Art, Ohio (2003); *Ethiopian Passages: Dialogues in the Diaspora,* National Museum for African Art, Smithsonian Institution, Washington, D.C. (2003); *Splat, Boom, Pow! The Influence of Comics in Contemporary Art, 1970–2000,* Contemporary Arts Museum, Houston, Texas (2003, catalogue); *GPS,* Palais du Tokyo, Paris (2003); *The Moderns,* Castello di Rivoli, Turin (2003, catalogue); *Poetic Justice,* 8th International Istanbul Biennial (2003, catalogue); *Centre of Attraction,* 8th Baltic Triennial of International Art, Vilnius, Lithuania (2002, catalogue); *Drawing Now: Eight Propositions,* Museum of Modern Art, New York (2002, catalogue); *Freestyle,* Studio Museum in Harlem, New York (2001, catalogue); *Painting at the Edge of the World,* Walker Art Center, Minneapolis (2001, catalogue); *Urgent Painting,* Musée d'art moderne de la Ville de Paris (2001, catalogue); *Translations,* Center for Curatorial Studies, Bard College, Annandale-on-Hudson, New York (2000); *Greater New York: New Art in New York Now,* P.S. 1 Contemporary Art Center, Long Island City, New York (2000, catalogue); *Five Continents and One City,* Museo de la Ciudad de Mexico, Mexico City (2000); *Selections Fall 2000,* The Drawing Center, New York (2000); and *Texas Draws,* Contemporary Arts Museum, Houston, Texas (1999).

SELECTED BIBLIOGRAPHY

Cotter, Holland. "Glenn Brown, Julie Mehretu, Peter Rostovsky." *New York Times,* June 23, 2000.

Firstenberg, Lauri. "Painting Platforms in NY." *Flash Art* 35, no. 227 (November–December 2002): 70–75.

Hoptman, Laura. "Crosstown Traffic." *Frieze* 54 (September 2000): 104–7.

Julie Mehretu: Drawing Into Painting. Exhibition catalogue. Minneapolis: Walker Art Center, 2003.

Sirmans, Franklin. "Mapping a New, and Urgent, History of the World." *New York Times,* December 9, 2001.

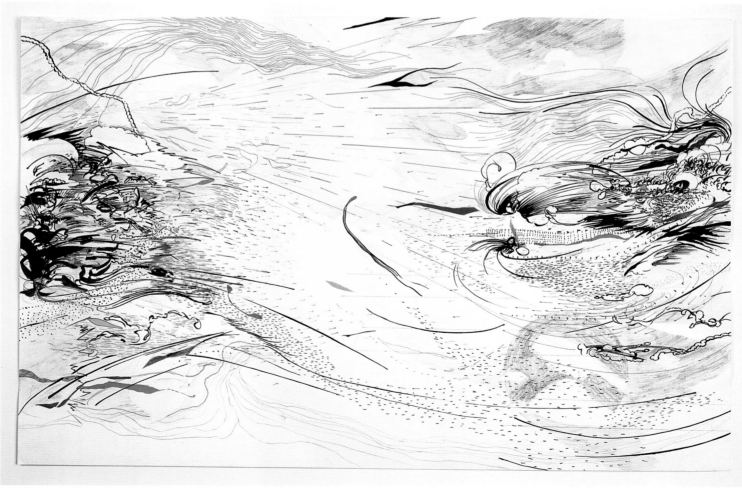

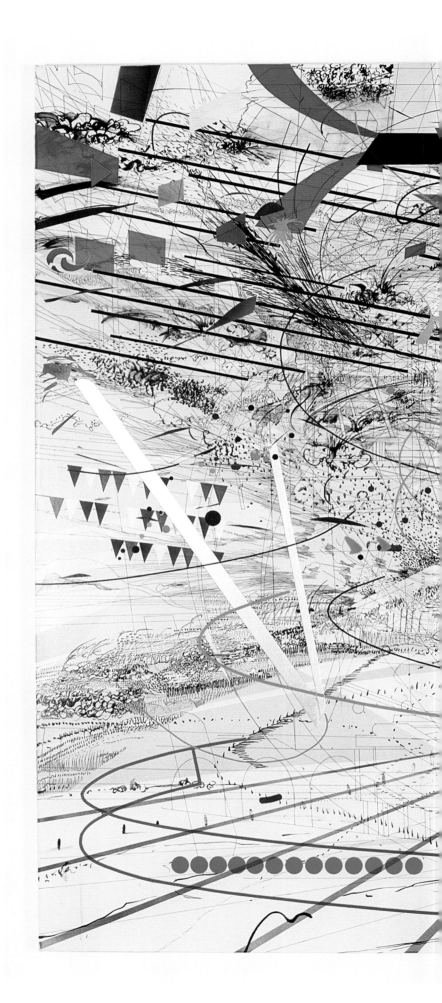

previous page top
JULIE MEHRETU
drawings (new constructions) #1, 2003
graphite, colored pencil, ink, and acrylic on paper
26 × 40 in. (66 × 101.5 cm)
Courtesy of carlier/gebauer, Berlin

previous page bottom
drawings (new constructions) #3, 2003
graphite, colored pencil, ink, and acrylic on paper
26 × 40 in. (66 × 101.5 cm)
Courtesy of carlier/gebauer, Berlin

Congress, 2003
ink and acrylic on canvas
71 × 106 in. (180 × 269 cm)
Courtesy of carlier/gebauer, Berlin

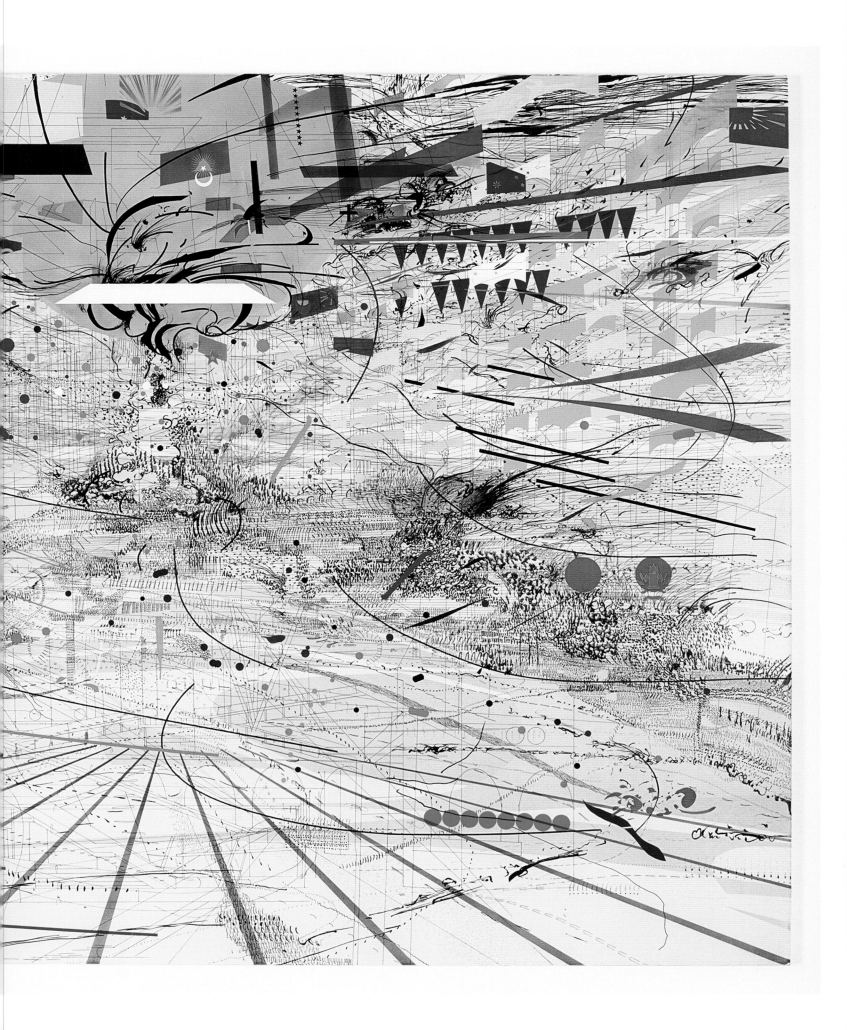

Senga Nengudi

BORN
1943, Chicago, Illinois

LIVES AND WORKS
Colorado Springs, Colorado

Senga Nengudi received her MA (1971) and her BA (1966) from California State University, Los Angeles; she also studied at Waseda University in Tokyo (1966–67). She has presented solo exhibitions or performances at the Thomas Erben Gallery, New York (2003, 1997, 1996); Wooten Studio/Gallery, Colorado Springs (2002); Colorado Springs Fine Arts Center (2001); Just Above Midtown Gallery, New York (1998, 1977); Banff Centre for the Arts, Alberta, Canada (1996); and California State University, Los Angeles (1977).

Group exhibitions include: *Kerry James Marshall: One True Thing, Meditations on Black Aesthetics,* Museum of Contemporary Art, Chicago (2003, catalogue); *Parallels and Intersections: Art/Women/California, 1950–2000,* San Jose Museum of Art, California (2001, catalogue); *A Love Supreme,* La Criée—Centre d'art contemporain, Rennes, France (2001); *Sixteen Pieces: The Influence of Yoruba on Contemporary Artists,* Brickhouse, London (2000); *Out of Action: Between Performance and the Object, 1949–1979,* Museum of Contemporary Art, Los Angeles (1998, catalogue); *Resonances,* Galerie Art'O, Paris (1997); *Incandescent,* Louisiana Museum for Moderne Kunst, Humlebaek, Denmark (1996, catalogue); *Artists Space—Twenty-fifth Anniversary Show,* New York (1993); *Shaping the Spirit: The African-American Art of Charles Abramson, Senga Nengudi, and James Phillips,* CAPP Street Project, San Francisco (1990); *Art as a Verb: The Evolving Continuum,* Studio Museum in Harlem, New York, and Maryland Institute College of Art, Baltimore (1989, catalogue); *Dialectics of Isolation: An Exhibition of Third-World Women Artists of the United States,* A.I.R. Gallery, New York (1980); and *Afro-American Art in the Twentieth Century: Three Episodes,* Bronx Museum of the Arts, New York (1980).

SELECTED BIBLIOGRAPHY

Dailey, Meghan. "Senga Nengudi: Thomas Erben Gallery." *Artforum* 42, no. 3 (November 2003): 191–92.

Green, Marni. "Senga Nengudi." *Eye Level: A Quarterly Journal of Contemporary Visual Culture* (Winter 2000): 20.

Odita, Odili Donald. "Senga Nengudi." *Flash Art* 195 (Summer 1997): 123.

———. "The Unseen, Inside Out: The Life of Senga Nengudi." *NKA: Journal of Contemporary Art* 6–7 (1997): 24–27.

Reid, Calvin. "Wet Night, Early Dawn, Scat-Chant, Pilgrim's Song." *Art in America* 85 (February 1997): 100–101.

For some thirty years, Senga Nengudi's performances and performance-based sculptures and installations have explored aspects of the human body in relation to ritual, philosophy, and spirituality. An important figure in the African-American avant-garde of the 1960s and 1970s, she helped establish a funk aesthetic that brought traditional African forms into the mix of Western modernism. Nengudi has drawn from a broad range of influences: traditional incarnations of spirituality from across the globe; her training in dance and movement; and radical performance practices such as Allan Kaprow's Happenings and the actions of the Gutai group in Japan (where she studied for a short time). With an interest in both process and performance, Nengudi has developed a unique formal language of movement and improvisation, working with a litany of materials from such earthy elements as water, sand, and dirt to the detritus of everyday life, including packing peanuts, pantyhose, and masking tape.

Nengudi is unconstrained by any attachment to material permanence. As she has said, "Individual acts of art do not have to depend on permanence of the materials, only the permanence of the soul." Within that framework, she has honed an artistic attitude borne of malleability and transience; her sculptures and performative installations, realized through an intuitive-experimental approach, allow process to determine form and shape. Manipulating the fluidity and pliability of her chosen materials—water-filled vinyl bags, mud, and sand, for example—Nengudi negotiates balance: between chance and intention, spirit and form, concept and execution, and the part and the whole.

Her *R.S.V.P.,* or *répondez s'il vous plaît,* series of the late 1970s literally implores viewers to interact with or respond to an invented landscape of corporeally suggestive forms made from used "nude" pantyhose—perverse nylon approximations of the color of flesh, from light beige to dark brown. Nengudi first worked with pantyhose as a material in her dance performances of the 1970s, testing its elasticity by using movement and parts of her own body to push and pull the nylon mesh. In the sculptures, the artist stretches, twists, and knots the stockings, coaxing form out of them by manipulating volume and tension, creating pendulous sacs or tautly outstretched limbs. These bulging, stretching, anthropomorphized abstractions suggest the resilience of the human body; like molted snake skins, they retain the "residue" of the body and the "energy" of the wearer, along with the implied fragility, sensuality, and viscerality of flesh itself.

Nengudi's quirky, entirely personal fetishism winks at traditional artifacts and reveals the artist's sly but sincere humor. In her investigation of the commonality of forms and archetypes related to the landscape and the body, she samples liberally from African, Afro-Hispanic, Native American, and Asian sources, and her sculptures often evoke relics or remnants of performative ritual. Her recent sand paintings refer even more directly to such practices, from contemplative Tibetan mandalas to ameliorative Navajo sand paintings to narrative Australian Aboriginal ground paintings. These new works channel the spiritual significance of Nengudi's own inventions: the floor-based designs embody the earth itself; the creative process enacts a form of meditation; and the material ephemerality suggests a metaphor for the impermanence of life itself. —*Elizabeth Thomas*

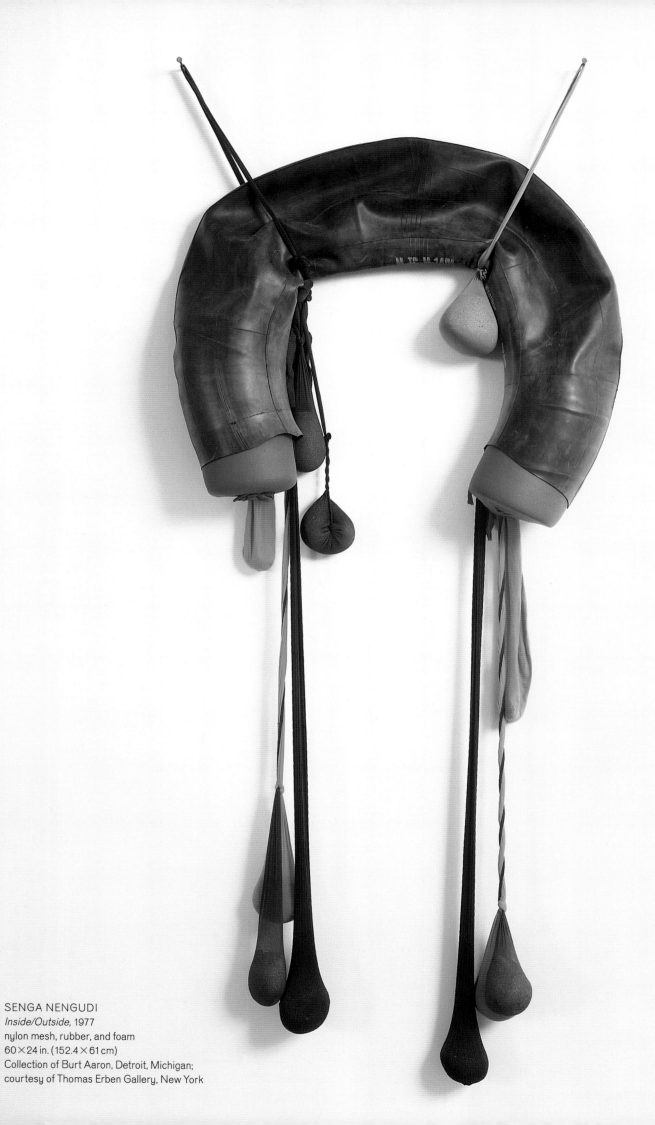

SENGA NENGUDI
Inside/Outside, 1977
nylon mesh, rubber, and foam
60 × 24 in. (152.4 × 61 cm)
Collection of Burt Aaron, Detroit, Michigan;
courtesy of Thomas Erben Gallery, New York

below
SENGA NENGUDI
installation view, *Répondez s'il vous plaît,*
Nylon Mesh Pieces, 1975–77,
Thomas Erben Gallery, New York,
September 4 – October 18, 2003
Courtesy of the artist
and Thomas Erben Gallery, New York

right
R.S.V.P. V, 1976
nylon mesh and sand
48 × 12 in. (122 × 30.5 cm)
Courtesy of the artist
and Thomas Erben Gallery, New York

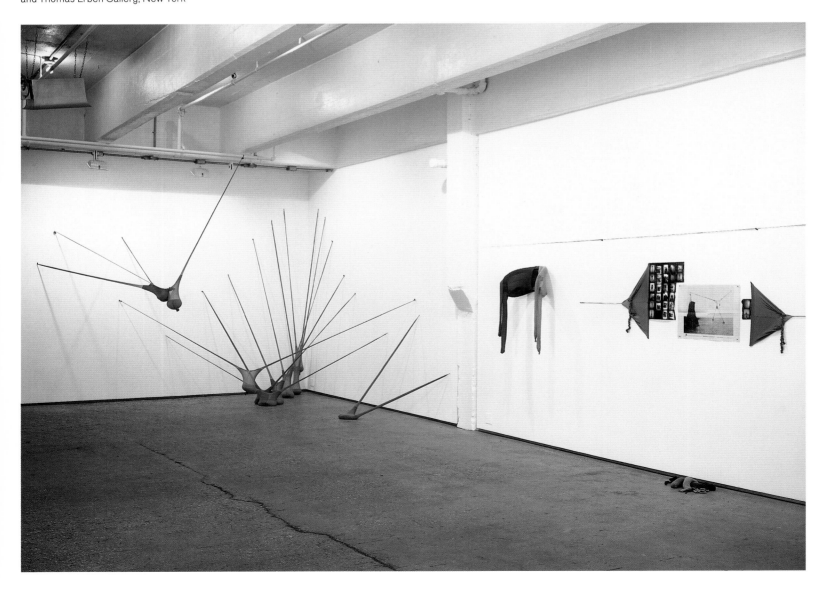

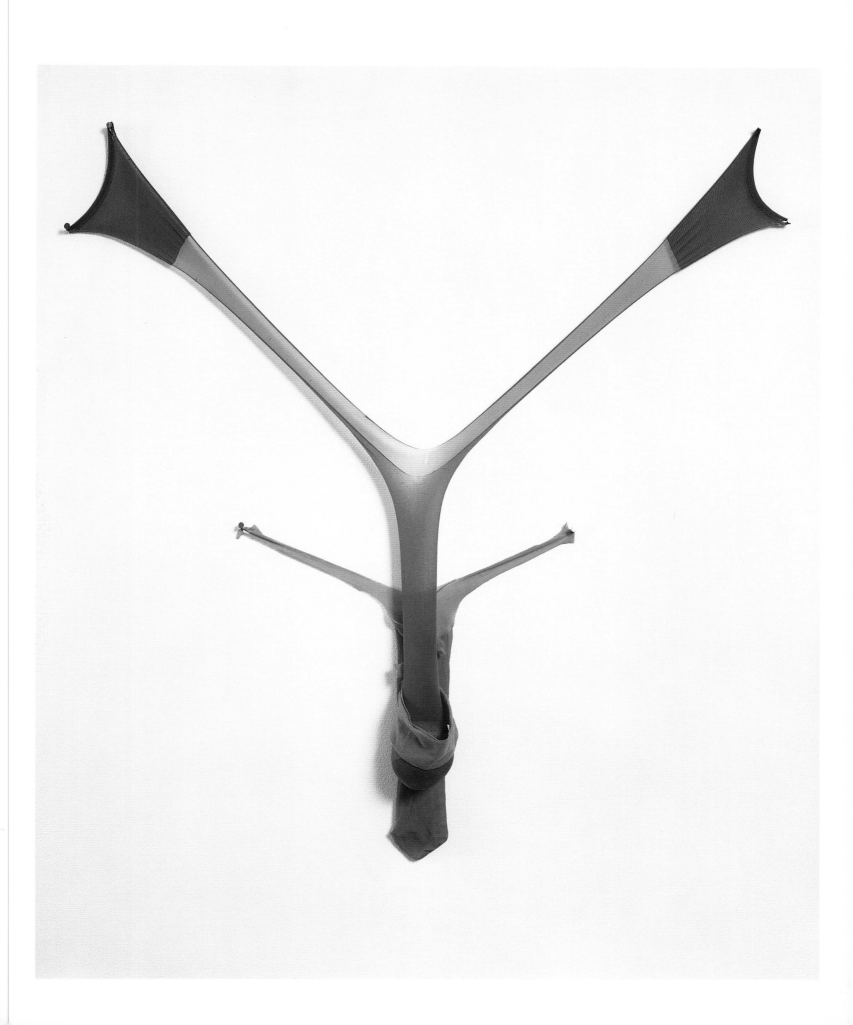

Oliver Payne and Nick Relph

Raw cane sugar

OLIVER PAYNE
BORN
1977, London, England

NICK RELPH
BORN
1979, London, England

LIVE AND WORK
London and New York

Oliver Payne failed at Kingston University of Fine Art in 2000 and Nick Relph was expelled from Kingston University of Fine Art, London, in the same year. Payne and Relph had a solo exhibition at the Knoxville Museum of Art, Knoxville, Tennessee (2003, catalogue). They have exhibited their short films in the 50th Venice Biennale (2003, catalogue), where they were voted Best Artist Under the Age of 35; *Days Like These,* Tate Triennial Exhibition of Contemporary British Art, Tate Britain, London (2003, catalogue); *Mixtape,* CCA Wattis Institute for Contemporary Arts, San Francisco (2003); *Body Matters,* Museum of Contemporary Art, Oslo (2003); *Electric Earth: Film and Video from Britain,* Na Solyanke Gallery, Moscow (2003–4, traveled throughout Russia, Lithuania, Turkey, Yugoslavia, and South America, catalogue); *Non-Places,* Frankfurter Kunstverein, Frankfurt am Main (2002); *Shoot the Singer: Music on Video,* Institute of Contemporary Art, Philadelphia (2002); *Videodrome II,* New Museum of Contemporary Art, New York (2002); Gavin Brown's enterprise, New York (2002); *Pandaemonium Festival,* Lux Centre, London (2001); *Sound and Vision,* Institute of Contemporary Arts, London (2001); *Fig. 1,* Whitechapel Art Gallery, London (2001); and *The Giant Rock 'n' Roll Swindle,* Chamber of Pop Culture, London (1999).

SELECTED BIBLIOGRAPHY

Electric Earth: Film and Video from Britain. Exhibition catalogue.
London: British Council, 2003.

Higgs, Matthew. "First Take."
Artforum 39, no. 5 (January 2001): 125.

———."Oliver Payne and Nick Relph."
In *Fig.1.* Exhibition catalogue. London:
Whitechapel Art Gallery, 2001.

Suburban: Oliver Payne and Nick Relph.
Exhibition catalogue. Knoxville, Tenn.:
Knoxville Museum of Art, 2003.

Wilson, Michael. "A Thousand Words:
Oliver Payne and Nick Relph
Talk about *Mixtape,* 2002." *Artforum* 41, no.1
(September 2002): 178-79.

Located at the crossroads of social documentary film, video clip, and visual diary, Oliver Payne and Nick Relph's videos are the expression of an urban sensibility that combines social radicalism, the pursuit of pleasure and beauty, and a fondness for cultural paradoxes. In just a few years, the London-based duo has developed an engaged view of contemporary culture that, in a manner different from their British predecessors, combines raw, immmediate excitement with a complex social and political awareness. In fact, in the artists' own words, their images are "a 'fuck you' to corporate intervention in youth culture, whether it's hardcore, punk rock, skateboarding, graffiti, whatever," and a celebration of "the other [side] to that: the pure, raw cane sugar."

Payne and Relph's travelogues/manifestos in the trilogy *The Essential Selection (Driftwood, House & Garage,* and *Jungle,* 1999–2001)* offer an extraordinary portrait of Britain at the turn of the century: an overview of its urban stories, fantasy and fiction, as seen from the position of the desires brewing in the suburbs. The three films, though different in kind, are meant to be seen as a unity that encompasses a variety of social and cultural settings: the vexed creativity of the suburbs where teenagers constantly reinvent new ways of wasting and using time beyond the reach of any form of canned entertainment; the neogothic subcultures of the countryside, dominated by UFO stories, spooky cults, and the battle between hunters and animal rights activists; and the face of contemporary London resulting from the perpetual friction between the administrative dreams of the establishment and the creativity of its social, ethical, and cultural margins.

In *Driftwood,* the cornerstone of the series, London becomes (again) the crossroads of personal epics and social histories, framed by the narrative of the emergence of spaces of cultural experimentation and dissidence, and the (failed) erection of structures of urban control. It is a history that spans from the rivalry between the "scruffs of Soho and the toffs of Mayfair," divided by the *cordon sanitaire* of Regent Street as built by John Nash, to the turf war between the skateboarders occupying the South Bank and the obstacles to them that city government architects erected in the 1980s in the guise of devices for the blind. *Driftwood* is, in fact, a social epic of how class and style wars produce both the imaginary and the physical structures and textures of a city. It is a highly personal account of a place created by the reluctant interaction of its extremes, for as Payne and Relph argue in *Driftwood,* "London doesn't love the latent or the lurking, has neither time, nor taste, nor sense for anything less discernible than the red flag in front of the steamroller. It wants cash over the counter and letters ten feet high." —*Cuauhtémoc Medina*

right and overleaf
OLIVER PAYNE AND NICK RELPH
stills from *Driftwood,* 1999
single-channel video; color, sound
25 min.
Courtesy of the artists
and Gavin Brown's enterprise, New York

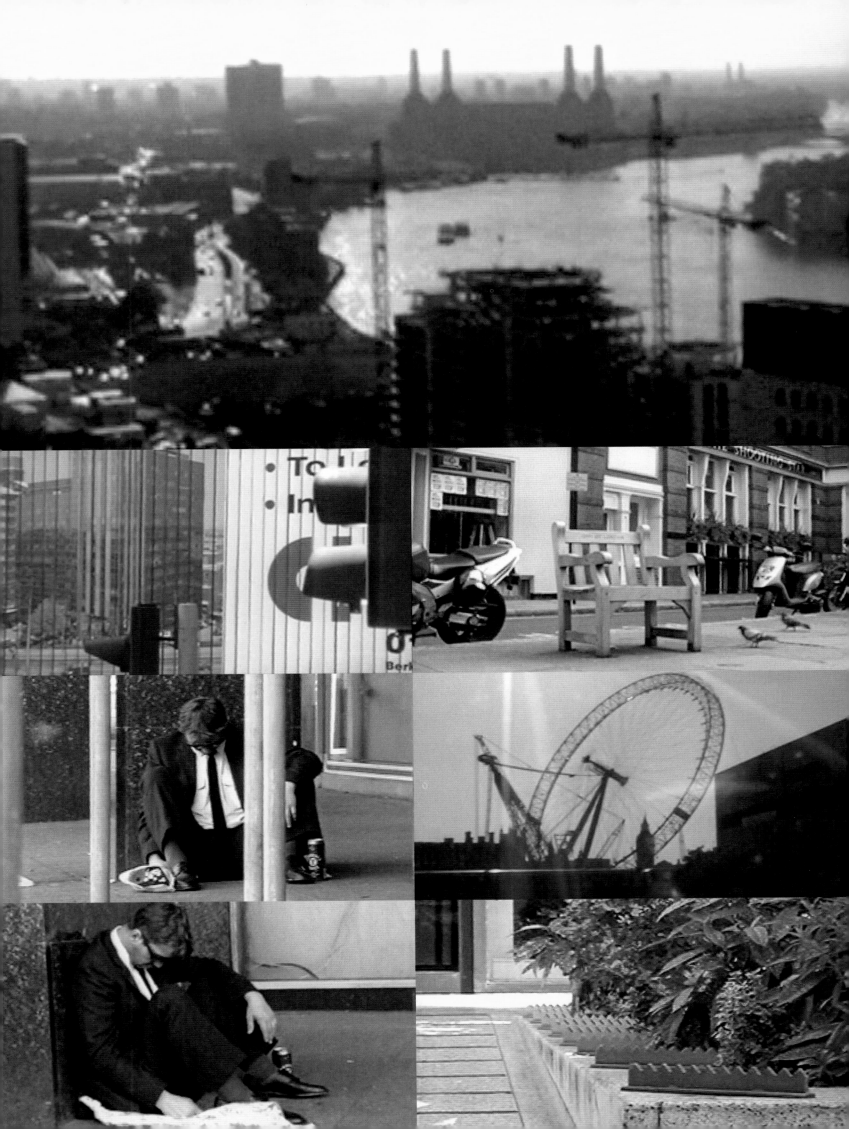

Araya Rasdjarmrearnsook

There is not one person, indeed not one living being,
that has not returned from death. In fact, we all have died many deaths,
before we came into this incarnation. And what we call birth is merely
the reverse side of death, like one of the two sides of a coin, or like a door
which we call "entrance" from the outside and "exit" from inside a room.
—*Tibetan Book of the Dead*

BORN
1957, Trad, Thailand

LIVES AND WORKS
Chiang Mai, Thailand

Araya Rasdjarmrearnsook received her MFA
from Silpakorn University, Bangkok, in 1986. She
has exhibited her sculptures and performance-
related videos and photographs in solo exhibitions,
including: *Lament,* Testa Konsthall, Stockholm
(2003, catalogue); *At Nightfall Candles Are
Lighted,* Chulalongkorn University Art Gallery,
Bangkok (2000); *Lament of Desire,* ArtPace,
San Antonio, Texas, and the Faculty of Fine
Art Gallery, Chiang Mai, Thailand (1998–99);
Printmaking and Drawing, Atelier Forsthaus,
Gifhorn, Germany (1990, 1991); and *Small
Graphic,* Goethe Institute, Bangkok (1987).
She has had numerous solo exhibitions at
National Gallery, Bangkok, including: *Why Is
It Poetry Rather Than Awareness?* (2002,
catalogue); *Lustful Attachment* (1995); *Water
Is Never Still* (1994); *Stories in Room* (1992);
and *Graphic Notes* (1987).

Group exhibitions include: *Poetic Justice,*
8th International Istanbul Biennial (2003,
catalogue); *Time after Time,* Yerba Buena Center
for the Arts, San Francisco (2003); *EV+A 2002,*
Limerick, Ireland (2002); *Small World,* Silpakorn
University Art Gallery, Bangkok (2002);
Unfolding Perspectives, ARS 01, KIASMA
Museum of Contemporary Art, Helsinki (2001);
Deserted and Embraced, Railway Hotel, Chiang
Mai, and the Goethe Institut, Bangkok (1997–98);
10th Sydney Biennial (1996, catalogue); *Thai
Tensions,* Chulalongkorn University Art Gallery,
Bangkok (1995); National Gallery, Bangkok
(1995, 1993, 1992); 1st Johannesburg Biennial,
South Africa (1995, catalogue); *Visions of
Happiness,* Tokyo (1995); 1st Asia-Pacific
Triennial, Brisbane, Australia (1993, catalogue);
20th International Biennial Exhibition of Graphic
Art, Ljubljana (Slovenia) (1993); 3rd International
Print Biennial, Seoul (1981); and 14th International
Biennial Exhibition of Graphic Art, Ljubljana
(Slovenia) (1981).

SELECTED BIBLIOGRAPHY

Cooke, Lynne. "New York: Contemporary
Art in Asia." *Burlington Magazine* 139
(March 1997): 223–24.

Heartney, Eleanor. "Asia Now."
Art in America 35 (February 1997): 70–75.

Poshyanade, Apinan. "Araya Rasdjarmrearnsook."
Art Asia Pacific 3, no. 3 (1995).

Rasdjarmrearnsook, Araya. *Lament.*
Bangkok: Amarin Printing and Publishing
Public Company Limited, 1999.

———. *Why Is It Poetry Rather Than Awareness?*
Bangkok: Amarin Printing and Publishing Public
Company Limited, 2000–2002.

It is true I cannot speak forthrightly about death, having never
been dead, at least not in the present life. Buddhists often speak about
the cycles of death and life, as a part of our daily living and dying.
The merits of our present have a lot to do with our return in the next
and other lives, though it would be better never to return—the ideal of
Nirvana. Along the strata of this ascending idealism, practitioners are
supposed to on the one hand accept their fate (this extends from Hindu
Brahman roots), and on the other hand improve present conditions through
the practice of living. The notion of "letting go," of existing without the
desires of the object world, is antithetical to this practice of being in the world.
The act of giving, or giving up, material accumulations, though understood
in the occident as a form of exchange, in Buddhism is considered part of
a long-term depository of merits. But one can only do what is
within reasonable reach of one's own life.

Araya Rasdjarmrearnsook was educated and trained as a printmaker
at Silpakorn University (the representational art school) in Bangkok. In her
early sculptures and installations, she gave representation to an idea not
common in the context of art-making in Thailand, that of the desiring Thai
female. Even in the present century, women are treated differently,
especially in a place like Thailand. Rasdjarmrearnsook recognizes that
a woman's sense of place and existence is inherently different from that of a
man in Thai/Buddhist culture and society. The specific content and context—
the spice—of her work are aimed first and foremost at her own people.
Her representations are intended to confront and confound, to cause people
to reconsider and contemplate the existence and representational
modes of femaleness and femininity.

As if it were not difficult enough being a Thai woman artist,
Rasdjarmrearnsook also has to deal with the fact that the making of objects
would directly contradict the dictates of her practice of Buddhism. But can
one avoid being representational if an image or an object is not actually made?
In *Reading Inaow for Female Corpse* (2001), Rasdjarmrearnsook reads
aloud to "images" of a person long without life, without light. The dance-
drama *Inaow*, written by King Rama I and retold by King Rama II, is a story
of female desires, adapted from Javanese into Thai. It is read by the artist,
recorded, and represented as an ephemerally projected image. On the
white surface of cultural walls, Rasdjarmrearnsook's intersection of her life
and spiritual practices is beamed into representation—raising questions
of morality, ethics, judgments and values, maleness, femaleness, life and
lifelessness, lack, loss and loneliness, the warm and the cold air that breezes
past us full of desires, the desire to understand which side of the door
we are standing on. Like the old Tibetan adage about the passage between
birth and rebirth (never death), it depends on how we approach such a
passage, such a door: We must ask ourselves as we pass through,
have I just entered or exited? —*Rirkrit Tiravanija*

below and overleaf
ARAYA RASDJARMREARNSOOK
stills from *Reading Inaow for Female Corpse*, 2001
single-channel video; color, sound
5:54 min.
Courtesy of the artist

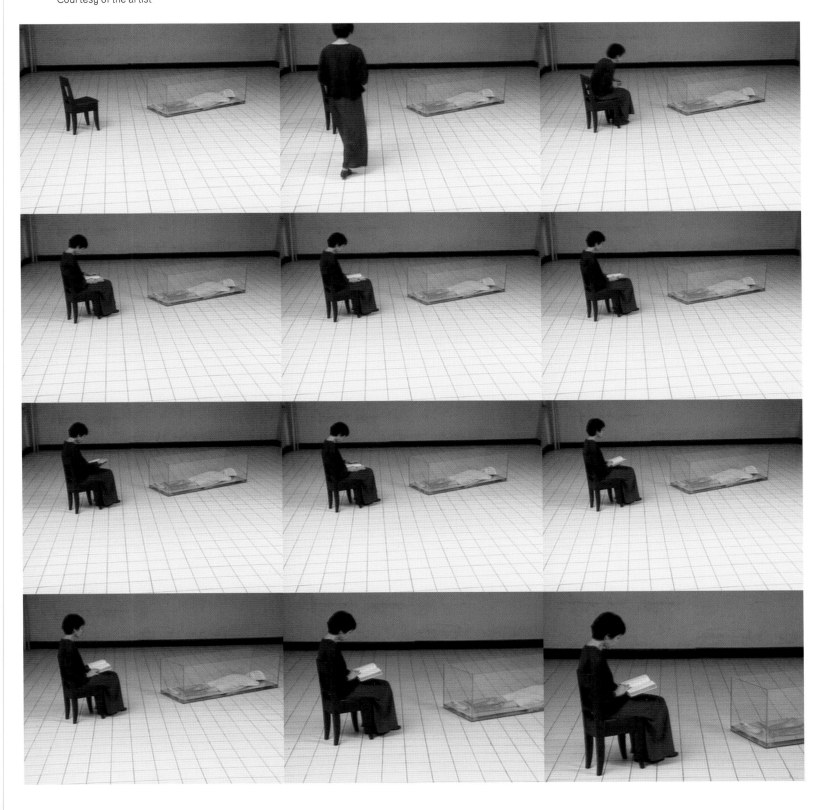

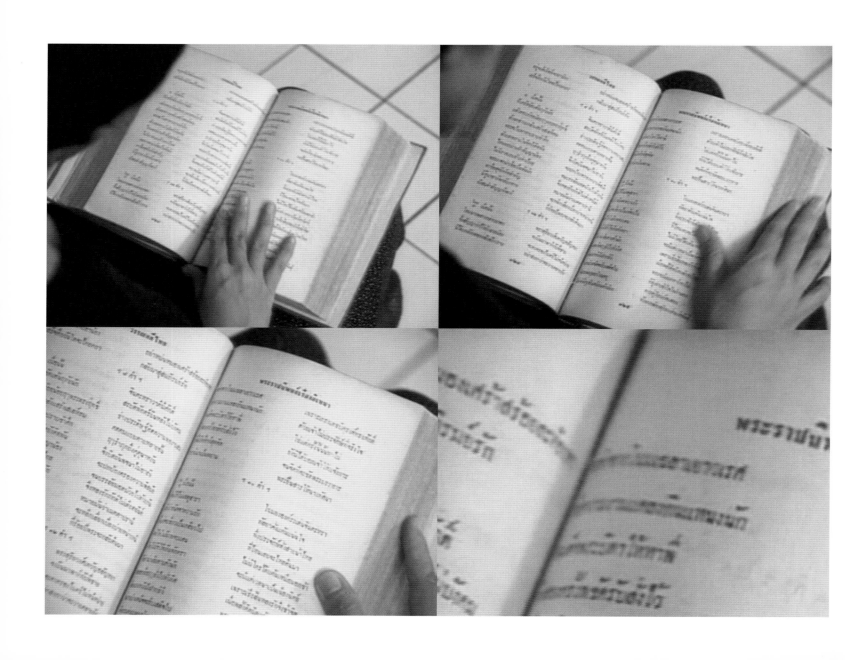

Neo Rauch

Neo Rauch studied at the Hochschule für Grafik and Buchkunst (1981–86); was a graduate student there of Bernhard Heisig, one of the most prominent artists in East Germany at the time (1986–90); and then taught as an assistant lecturer (1993–98). All of this is to say that Rauch had a thorough and rigorous academic education in art and was successful within the confines of the communist system, including membership in the official artists' union. Since the early 1990s, he has had a studio within a vast, derelict former cotton-spinning factory in Leipzig, but his work has escaped its roots to confront a more general situation of the Western imagination.

For the first years of the 1990s, Rauch made large-scale dark, muted paintings on paper of rather shadowy figures in obscure landscapes juxtaposed with a single large word. By the mid-1990s, his work had matured into an assured and almost feverishly inventive production. The palette brightened, the contours of the figures sharpened, and their interactions, although highly ambiguous, became enigmatic mise-en-scènes in which space and scale cannot readily be reconciled. Often a single word is present, but now as a diminutive sidebar, enmeshed within the overall composition. The colors, although bright, are chalky, and the surfaces dry. The figures are stiff and the scenes frozen, so that despite indications of activity and work, a torpor and lack of life pervade the pictures. Like apparitions, these figures remain aloof, enigmatic, uneasy, and even somewhat ominous. Much has been observed about Rauch's relationship to a particular East German sensibility, but the scenes he depicts are generalized enough to apply to a generic Western milieu at midcentury, in which the achievements of industry and architecture are visible, and work and study take precedence over leisure. His most recent paintings have taken a turn back in history, more evocative perhaps of nineteenth-century Romanticism, to a world less conquered by industrialism.

Rauch's work, which achieved its mature identity just after the collapse of communism, shows a clear debt to Socialist Realism. But his focus encompasses a broader state of affairs in the West, a broader malaise in which we no longer have the capacity to envision a future beyond our own time, and in which the past is equally lost to us, and nostalgia no longer comforts. In Rauch's paintings, experiments seem to have gone bad, the atmosphere and the environment look acrid and poisoned; here, nature is capable of mutating forms of life more in character with science fiction than paradise. Still, the grandeur, solidity, and strength of Rauch's characters, and the elegance and beauty of the paintings themselves, convey a different impression of accomplishment, control, and creative potential.

These works manage to capture a complex sense of a reality that is both bleak and hopeful, earnest and absurd, frozen and dynamic, beyond our control and palpable. Like dreams, Rauch's paintings have a vividness and a connection to experience that makes us think that, with enough scrutiny, some truth can be gleaned from them. But in the end they remain parallel and self-contained, mirrors of our world into which we may gaze but not enter, somehow linked to day-to-day reality but incommensurate with it.—*Gary Garrels*

BORN
1960, Leipzig, Germany

LIVES AND WORKS
Leipzig

Neo Rauch studied at the Hochschule für Grafik und Buchkunst, Leipzig, from 1981 to 1986. He has exhibited his paintings in solo exhibitions, including: The Albertina, Vienna (2004); St. Louis Art Museum, Missouri (2003); David Zwirner Gallery, New York (2002, 2000); Galerie EIGEN+ ART, Berlin (2002, 1998, 1995); Bonnefanten Museum, Maastricht, Netherlands (2002); *Randgebiet*, Galerie für Zeitgenössische Kunst, Leipzig (2001, traveled to Haus der Kunst, Munich, and Kunsthalle Zurich); Neues Museum Weserburg, Bremen, Germany (2001, traveled to Douglas Hyde Gallery, Dublin); Deutsche Guggenheim, Berlin (2001); Galerie EIGEN+ART, Leipzig (2000, 1997, 1993); Museum der Bildenden Künste, Leipzig (1997, catalogue); and Goethe House, New York (1995).

Group exhibitions include: *For the Record: Drawing Contemporary Life,* Vancouver Art Gallery, British Columbia (2003, catalogue); *Drawing Now: Eight Propositions,* Museum of Modern Art, New York (2002, catalogue); *Cher peintre: peintres figuratives depuis l'ultime Picabia,* Musée national d'art moderne, Centre Pompidou, Paris (2002, traveled to Kunsthalle, Vienna, and Schrin Kunsthalle, Frankfurt am Main, catalogue); 49th Venice Biennale (2001, catalogue); *The Mystery of Painting,* Sammlung Goetz, Munich (2001, catalogue); *After the Wall,* Moderna Museet, Stockholm (1999, catalogue); *Children of Berlin,* P.S.1 Contemporary Art Center, Long Island City, New York (1999, catalogue); *German Open,* Kunstmuseum Wolfsburg, Germany (1999, catalogue); *The Golden Age,* Institute of Contemporary Art, London (1999); *Lust und Last,* Germanisches Nationalmuseum, Nuremberg (1997, traveled to Museum der Bildenden Künste, Leipzig); *Need for Speed,* Grazer Kunstverein, Graz, Austria (1997); and *Der Blick ins 21ste,* Kunstverein Düsseldorf (1996).

SELECTED BIBLIOGRAPHY

Gingeras, Alison M. "Neo Rauch: A Peristaltic Filtration System in the River of Time." *Flash Art* 35, no. 227 (November–December 2002): 62–69.

Neo Rauch. Exhibition catalogue. Maastricht, Netherlands: Bonnefanten Museum; Ostfildern-Ruit, Germany: Hatje Cantz, 2002.

Neo Rauch: Paintings and Drawings. Exhibition catalogue. Berlin: Deutsche Guggenheim, 2001.

Neo Rauch: Randgebiet. Exhibition catalogue. Leipzig: Galerie für zeitgenössische Kunst, 2000.

Tuymans, Luc. "What the Painters Say." *Art Press* (July–August 2002): 37–46.

NEO RAUCH
Sekte, 2004
oil on canvas
98 7/16 × 82 11/16 in. (250 × 210 cm)
Courtesy of Galerie EIGEN + ART, Leipzig/Berlin,
and David Zwirner, New York

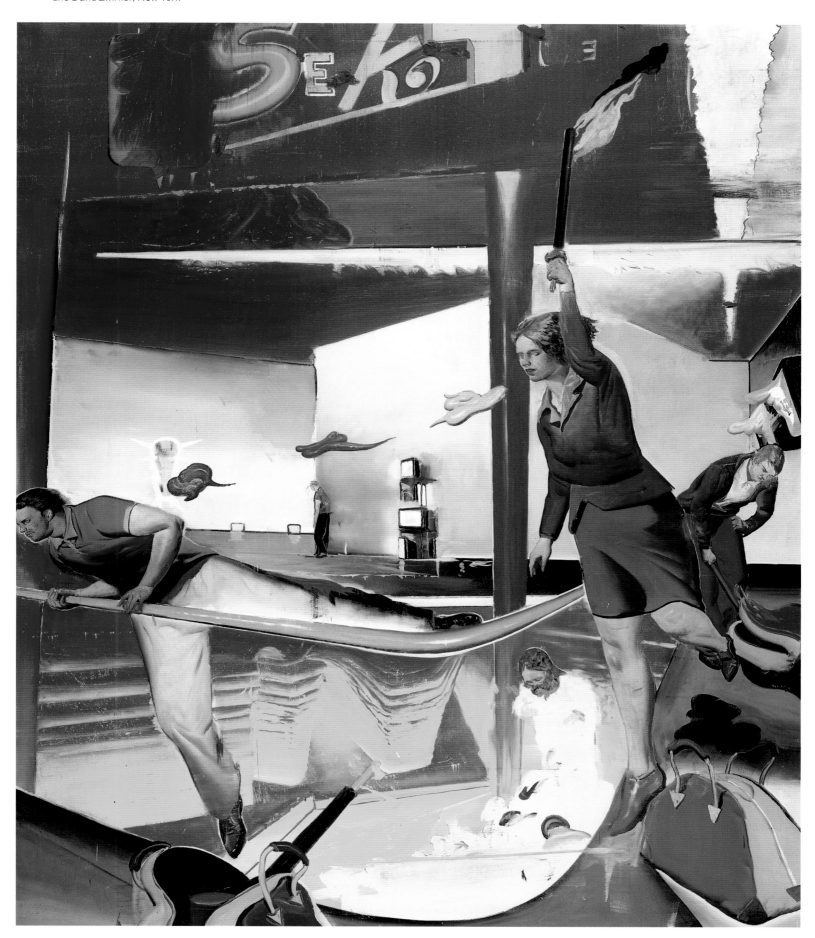

NEO RAUCH
Grotte, 2004
oil on canvas
98 7/16 × 82 11/16 in. (250 × 210 cm)
Courtesy of Galerie EIGEN + ART, Leipzig/Berlin,
and David Zwirner, New York

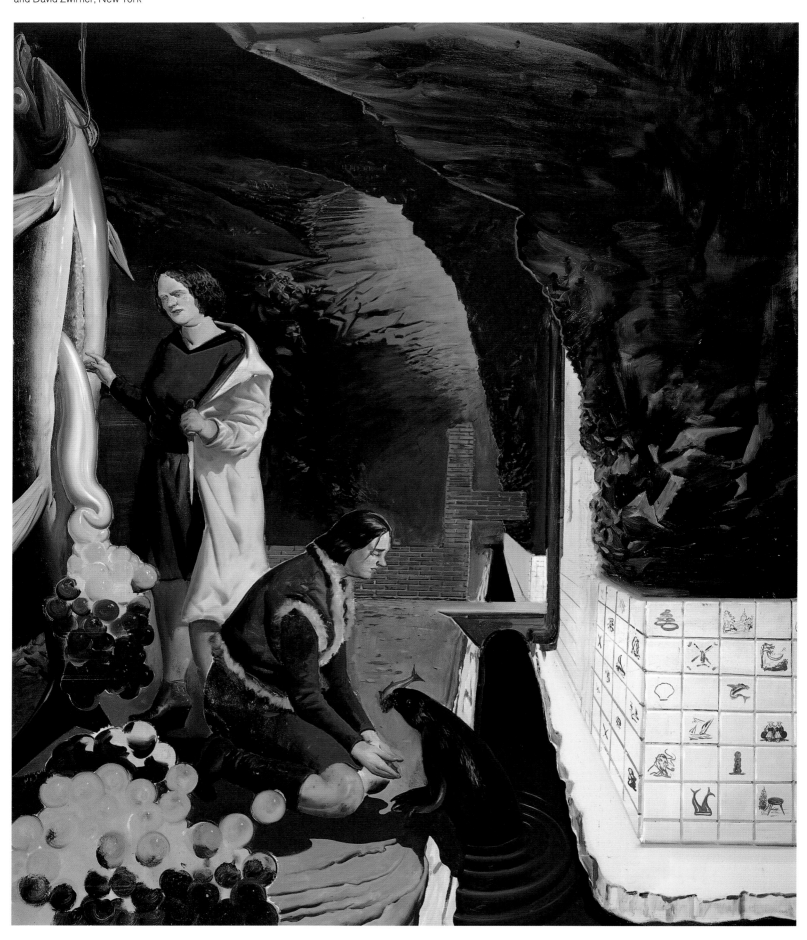

Zoll, 2004
oil on canvas
82 11/16 × 157 1/2 in. (210 × 400 cm)
Courtesy of Galerie EIGEN + ART, Leipzig/Berlin,
and David Zwirner, New York

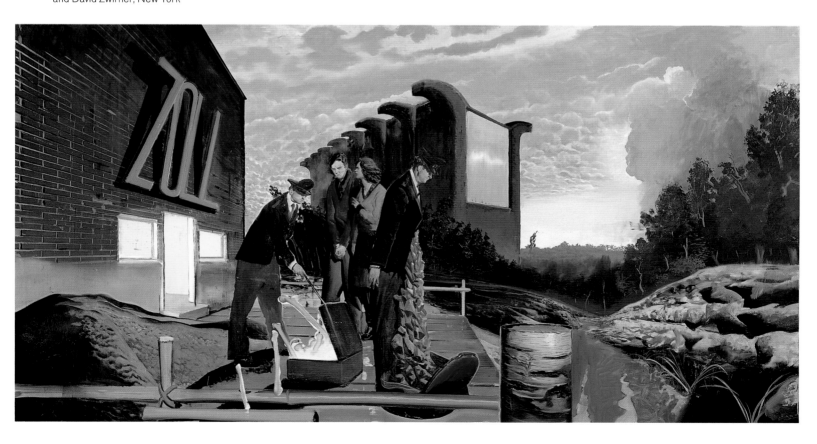

BORN
1963, Brunnen, Switzerland

LIVES AND WORKS
New York, New York, and Zurich, Switzerland

Ugo Rondinone studied at the Hochschule
für angewandte Kunst, Vienna (1986–90).
Solo exhibitions of his work include: *Moonrise,*
Galerie Hauser, Wirth, and Presenhuber, Zurich
(2003, 1999); *Our Magic Hour,* Museum of
Contemporary Art, Sydney (2003, catalogue);
Roundelay, Musée national d'art moderne,
Centre Pompidou, Paris (2003, catalogue);
Cigarette Sandwich, Sadie Coles HQ, London
(2002); *No How On,* Kunsthalle, Vienna (2002,
catalogue); *A Horse with No Name,* Matthew
Marks Gallery, New York (2002, 2000);
Le Consortium, Dijon, France (2002); *Guided
by Voices,* Kunsthaus Glarus, Switzerland (1999);
Where Do We Go from Here? Le Consortium,
Dijon, France (1997, catalogue); *Heyday,* Centre
des arts contemporains, Geneva (1996); and
Dog Days Are Over, Migros Museum für
Gegenwartskunst, Zurich (1996, catalogue).

Group exhibitions include: Biennale d'art
contemporain de Lyon, France (2003, catalogue);
Self/In Material Conscience, Fondazione
Sandretto Re Rebaudengo, Turin (2002);
The House of Fiction, Sammlung Hauser & Wirth,
St. Gallen, Switzerland (2002); *Drawing Now:
Eight Propositions,* Museum of Modern Art,
New York (2002, catalogue); *Let's Entertain,*
Walker Art Center, Minneapolis (2002, traveled
to Portland Art Museum, Oregon, Musée
national d'art moderne, Centre Pompidou, Paris,
Museo Rufino Tamayo, Mexico City, and Miami
Art Museum, Florida, catalogue); Liverpool
Biennial, England (2001, catalogue); *Under the
Same Sky,* KIASMA Museum of Contemporary
Art, Helsinki (2000); *The Passion and the Wave,*
6th International Istanbul Biennial (1999,
catalogue); *Trouble Spot: Painting,* Museum van
Hedendaagse Kunst, Antwerp, Belgium (1999,
catalogue); Berlin Biennial for Contemporary Art
(1998, catalogue); Bienal de São Paulo (1996,
catalogue); and *Migrateurs,* ARC, Musée d'art
moderne de la Ville de Paris (1995).

SELECTED BIBLIOGRAPHY

Heyday. Exhibition catalogue. Geneva:
Centre des arts contemporains, 1996.

Parkett 52 (1998): 104–43.
Special section, including essays by Francesco
Bonami, Laura Hoptman, and Jan Verwoert.

Storer, Russell. *Ugo Rondinone: Our Magic Hour.*
Sydney, Australia: Museum of Contemporary
Art, 2003.

Ugo Rondinone. Exhibition catalogue.
Vienna: Kunsthalle Wien, 2002.

Where Do We Go from Here? Exhibition
catalogue. Dijon, France: Le Consortium, 1997.

right and overleaf
UGO RONDINONE
installation views of
and stills from *Roundelay,* 2003
6-channel video installation projected
on six walls that form a hexagon; color, sound
8:54 min., looped
Courtesy of the artist; Eva Presenhuber, Zurich;
and Matthew Marks Gallery, New York;
and Galerie Almine Rech, Paris

Ugo Rondinone

Long before the art world entered into a neo-Romantic and gothic
mood, Ugo Rondinone built his own visual language based on existential
loneliness and fictional memories. His self-portraits are reminiscent
of another uncanny Swiss artist, the conceptualist Urs Luthi, and like him,
Rondinone delves into the very identity of his soul, out of which his spaces,
sounds, and figures emerge. Melancholia is a very solid matter from which
his fantasies are made. Neon signs, target paintings, fake wood, sleeping
clowns—all are elements that impart a sort of archetypal iconography
that haunts the blurred realm of dreams and hallucinations.

Like many artists of his generation, Rondinone is inspired and
influenced by movies and rock music, and threads from these fields weave
throughout his work. The Italian film director Federico Fellini might
be the first name to come to mind when we immerse ourselves in Rondinone's
environment. His characters have the same attitude as those in Fellini's
early masterpiece *I Vitelloni* (The loafers, 1953), facing life with laziness
and a self-defeating mood. Indeed, Rondinone's entire body of work could
be said to follow the path of Fellini's coming of age as a director, mixing a
surrealist imagination with childhood memories and metaphysical spaces.

The sleeping clown, representing the ultimate sad loser, is a cornerstone
of Rondinone's message. Lying prone in mirrored spaces, these clowns,
with their lifelike appearance, do not function as deceiving elements,
like Duane Hanson's figures, but rather as bodies abandoned by their souls,
yet not dead. Asleep, they wait to die, or to be reawakened to a reality in
which they perform, again and again, but without feelings. The laughs
they are supposed to extort from the audience are nothing but the echoes
of the tragic scream they produce out of their humiliation.

Rondinone's reflections on underground and seedy culture make a strong
case for a kind of art that does not seek to celebrate greatness but instead
strives to meditate on the limitations and false starts of any individual.
Like Fellini's films, Rondinone's art allows the people he is representing,
describing, or narrating to accept their downfall and still remain in
awe of the complexity that lies in the banality of life—its signs, and its
overlooked landscapes blessed by a lesser god. —*Francesco Bonami*

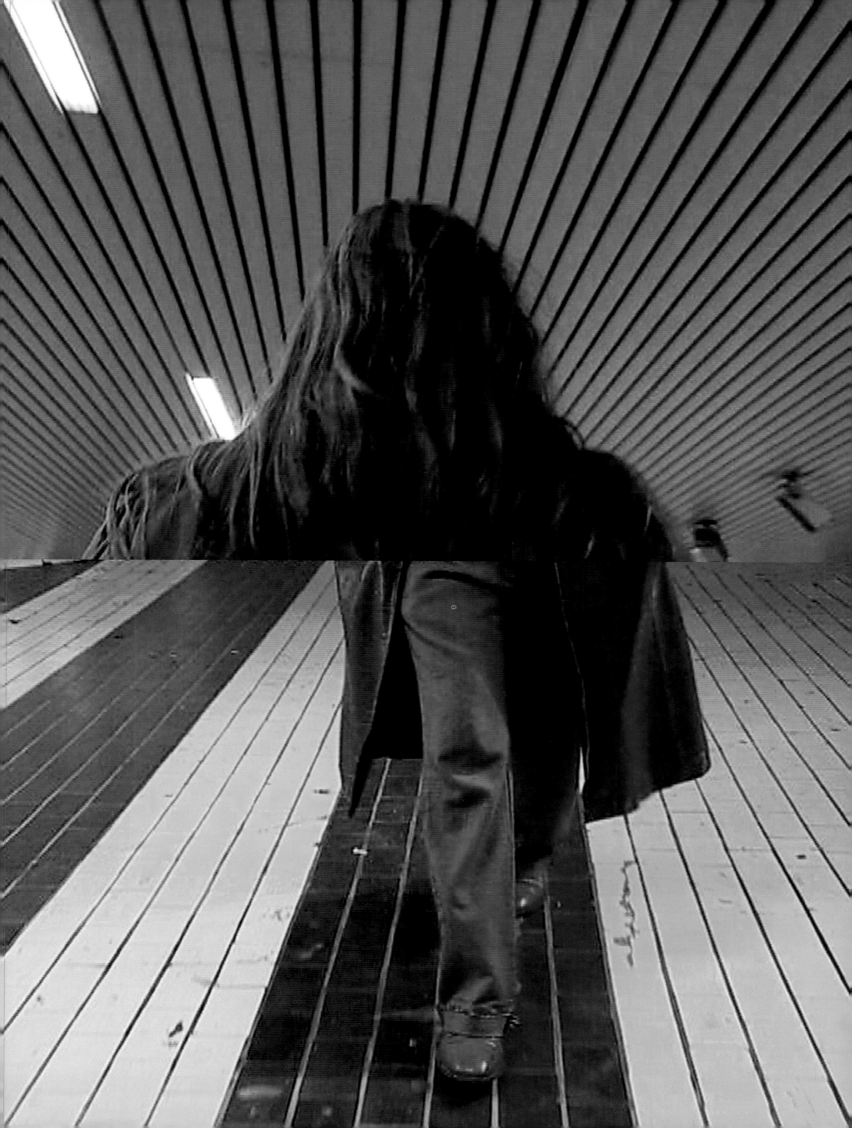

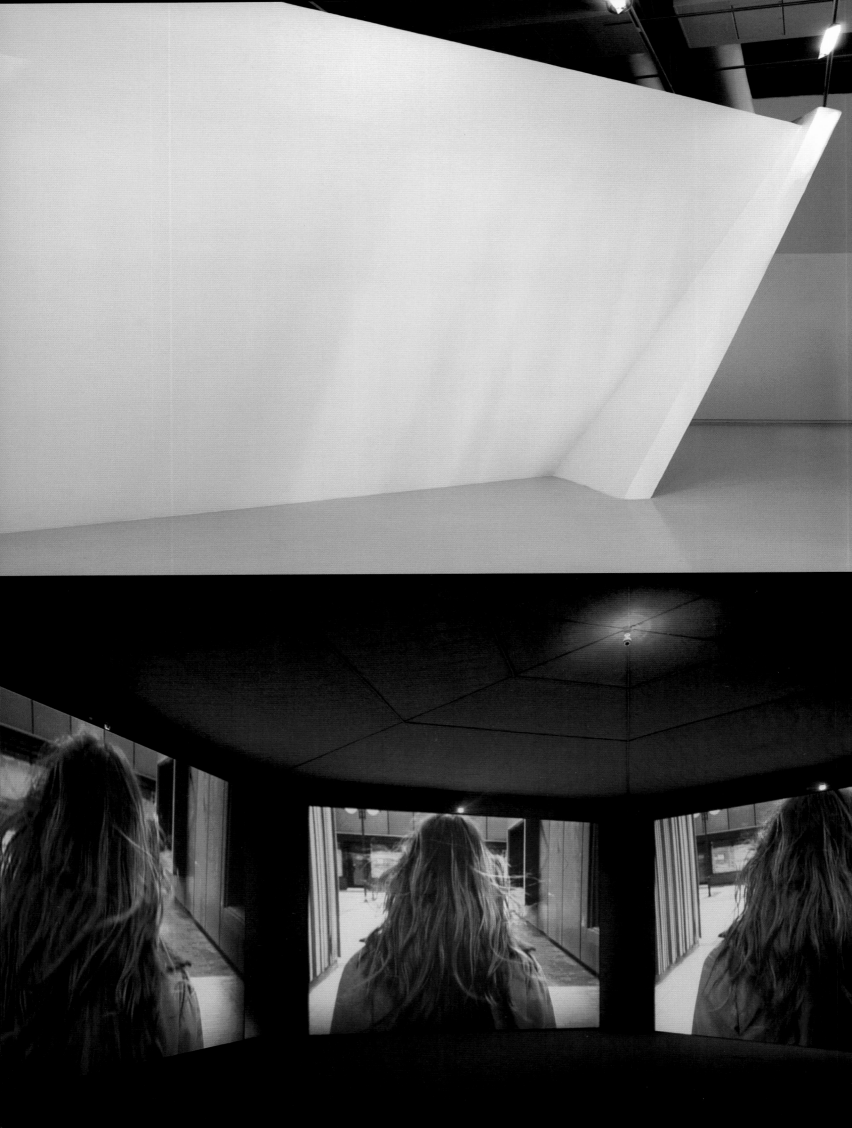

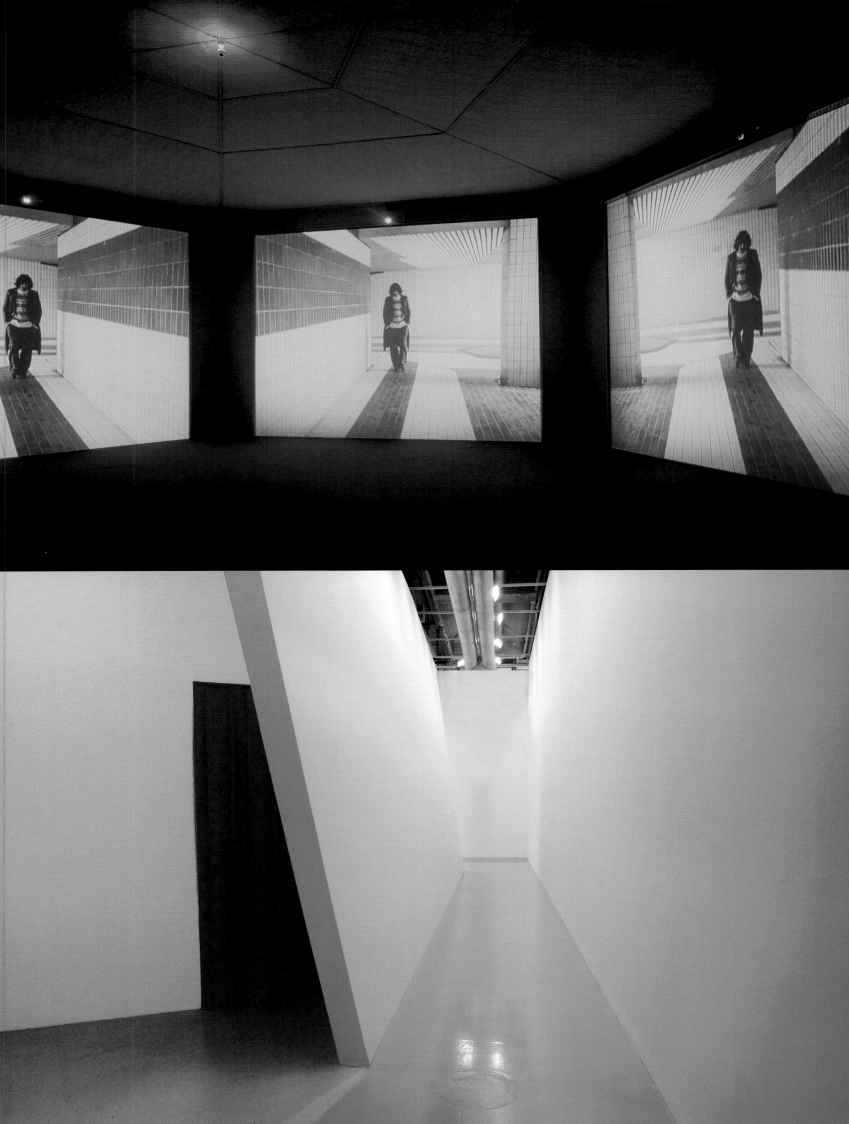

Eva Rothschild

BORN
1972, Dublin, Ireland

LIVES AND WORKS
London, England

Eva Rothschild received her MA (1999) from Goldsmith's College, London, and her BA (1993) from University of Ulster, Belfast. She has exhibited her sculptures and objects in solo exhibitions at the Kunsthalle Zürich (2004, catalogue); The Modern Institute, Glasgow (2004, 1999); Galleria Francesca Kaufmann, Milan (2003); Project Art Gallery, Dublin (2003); Modern Art, London (2003); Els Hanappe Underground, Athens, Greece (2001); and *Peacegarden*, The Showroom, London (2001, traveled to Cornerhouse, Manchester, Titanik Galerie, Turku, Finland, and Centre for Contemporary Art, Glasgow, catalogue).

Group exhibitions include: *Breathing the Water,* Galerie Hauser, Wirth, and Presenhuber, Zurich (2003); *This Was Tomorrow,* New Art Centre Sculpture Park and Gallery, Salisbury, England (2003); *Objects in Mirror Are Larger Than They Appear,* Badischer Kunstverein, Karlsruhe, Germany (2003, catalogue); *Electric Dreams,* Barbican Gallery, London (2002); *Early One Morning,* Whitechapel Art Gallery, London (2002, catalogue); *My Head Is on Fire but My Heart Is Full of Love,* Charlottenbourg Museum, Copenhagen (2002, catalogue); *Troubleshooting,* Arnolfini Gallery, Bristol, England (2001); *Brown,* The Approach, London (2001); *Zig-Zag,* Thomas Cohn Gallery, São Paulo (2000); *Proper,* Center for Contemporary Art, Vilnius, Lithuania (2000); *Utopias,* Douglas Hyde Gallery, Dublin (1999); *High Red Centre,* Centre for Contemporary Art, Glasgow (1999); *Habitat,* Centre for Contemporary Photography, Melbourne (1998); *European Couples,* Transmission Gallery, Glasgow (1997); *Deep Signal,* Gasworks, London (1996); and *Into the Void,* Ikon Gallery, Birmingham, England (1996).

SELECTED BIBLIOGRAPHY

Eva Rothschild. Exhibition catalogue. Zurich: JRP/Ringier Kunstverlag, in association with Kunsthalle Zürich, 2004.

Grant, Catherine. "Early One Morning." *Flash Art* 54 (October 2002): 49.

Higgie, Jennifer. "Paint It Black: Jennifer Higgie on Eva Rothschild." *Frieze,* no. 55. (November – December, 2000): 78-79.

Peacegarden. Exhibition catalogue. London: The Showroom, 2001.

Slyce, John. "Random Rules: Eva Rothschild and Keith Tyson." *Flash Art* 36 (July – September 2003): 82-85.

In Eva Rothschild's sculptures, the magical meets the minimal, a convergence that reveals a duality of interests and serves to undermine purity of form. Rothschild inherits certain formal concerns from artists of the 1960s and 1970s (the American Minimalists and British sculptors such as Anthony Caro), and she engages with issues of phenomenological perception and material literalness. At the same time, the iconography of mysticism and new-age spiritual practices is a frequent inspiration. Her works elucidate the human search for transcendence, whether through the internal actions of meditation and mind-altering drugs or through external triggers, such as viewing art or the communal spirit one can experience at large concerts and festivals.

Grounded in the cultures of experimentation, self-actualization, and protest that defined the late 1960s and early 1970s, "new age" spirituality conflates belief systems from Eastern philosophy and religion with Western traditions of Theosophy, transcendentalism, and Spiritualism. Rothschild harnesses this panoply of influences by using found materials, such as crystal balls and incense sticks, and mining the archive of universally resonant forms, such as spheres and pyramids. Formally speaking, Rothschild does not sculpt solid volumes so much as she *inscribes space*, which is delineated by perforations and interlocking elements. Her works in Plexiglas engage in an interplay between two-dimensional planes and the three-dimensional forms they conjure. She uses narrow strips of wood to similar effect in works such as *Fort Block* (2004); here, the strips outline abstracted mountain ranges or pyramids in space. Her interest in a reduced vocabulary of elemental shapes echoes Minimalism and the pursuit of purity of form for form's sake. But in a divergence from the absolutism of that attitude, Rothschild questions whether archetypal forms, such as the sphere or the pyramid, can ever be seen for their form alone or whether they will forever be inscribed with layers of spiritual and psychic meaning.

In her sculpture *Disappearer* (2001–4), a semi-sphere of clustered multicolored joss sticks is mounted to the wall, suggesting the natural structure of a dandelion or a microcosmic organic arrangement. The sticks are meant to be burned during their exhibition, and the scent conjures associations ranging from sacred rituals to mundane room accessorizing. The accoutrements of new-age practices—from incense to candles to mystical rings—carry weight as culturally and psychically specific signifiers, but they also call to mind a more generalized quasi-spirituality characteristic of youthful protest and soul-searching. The multivalent status of these materials as agents of both pure belief and counterculture show-and-tell is at the crux of Rothschild's investigations. The resulting works are not about belief per se; instead, they serve as ciphers for the projection of belief into them. As the artist has noted, with some skepticism, "The searcher starts to search for objects and images to furnish their desire rather than jump into the murky water of real discovery." For Rothschild the works are about the desire to find meaning in objects beyond the mere facts of their physical existence. Her sculptural gestures question and comment on how we use objects as triggers or vessels of belief, either as pure embodiments or, more suspiciously, as gauges of the commodification of belief itself. —*Elizabeth Thomas*

EVA ROTHSCHILD
Second Sun, 2004
vinyl
200×316 in. (508×802 cm)
Courtesy of the artist; The Modern Institute,
Glasgow; and Modern Art, London

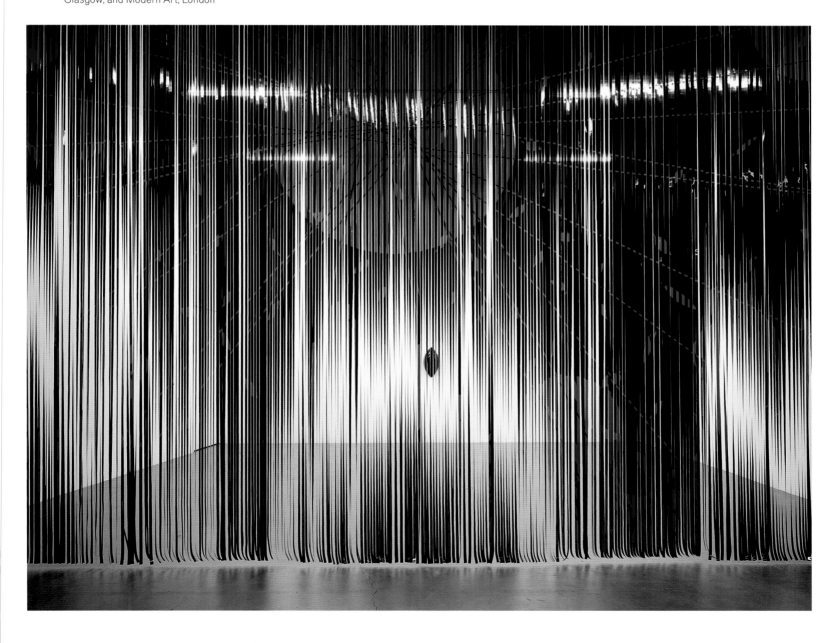

below
EVA ROTHSCHILD
Disappearer, 2001–4
incense sticks
installation dimensions variable
Courtesy of the artist; The Modern Institute,
Glasgow; and Modern Art, London

right
Fort Block, 2004
lacquered wood
108 × 81 × 75 in. (273 × 205 × 190 cm)
Courtesy of the artist; The Modern Institute,
Glasgow; and Modern Art, London

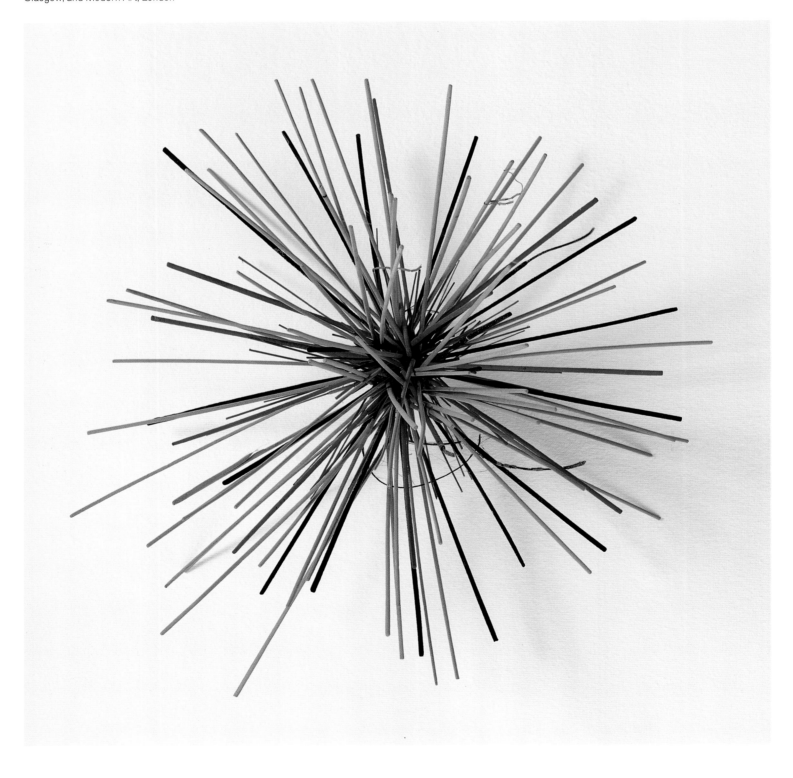

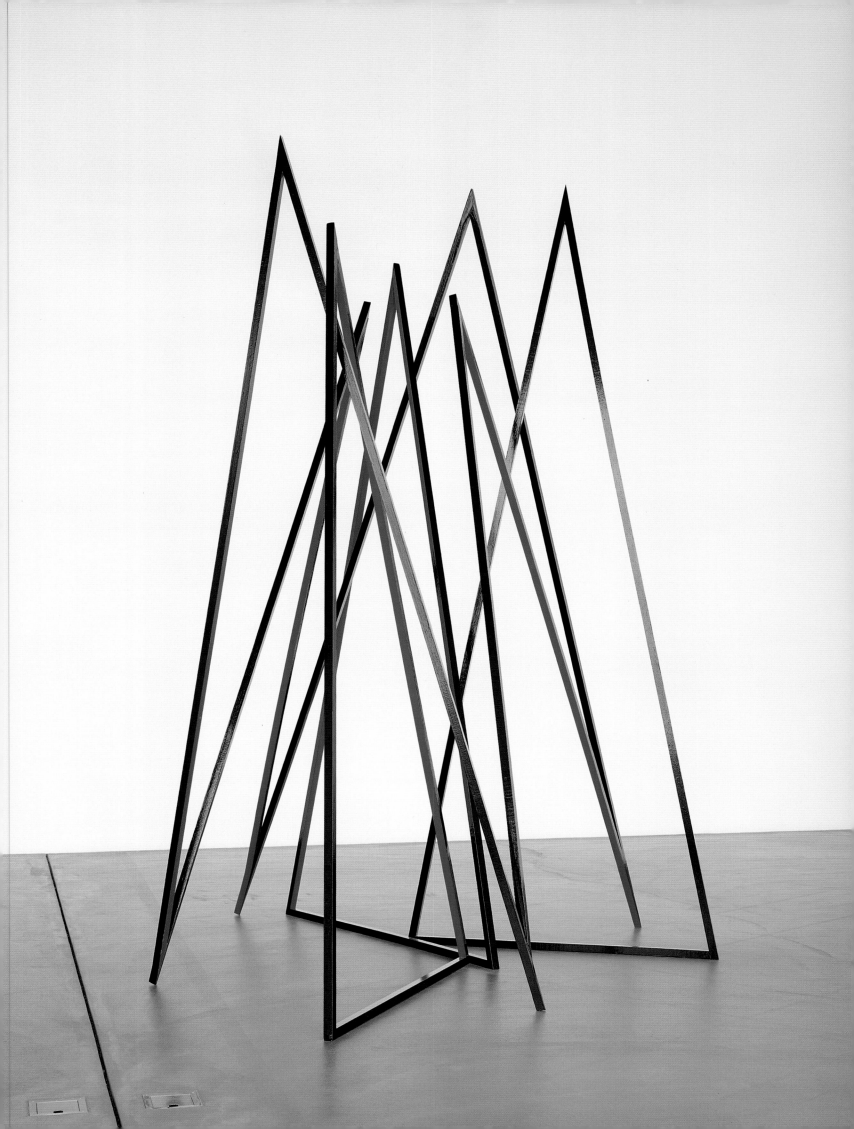

Yang Fudong

While at the China Academy of Fine Arts in Hangzhou, Yang Fudong staged a performance that presaged his later film projects. For the work entitled *Elsewhere*, the artist remained completely silent for a period of three months. In this way, he came to understand the psychological dimension of everyday communication. His recent photographs and films continue to engage with subject matter that is psychologically dense, by interpolating philosophical questions of existence into the patterns of everyday life. He exploits the power of mood and environment in quiet tableaux where most of the action, if it can be considered as such, takes place within the interior world of his subjects. Silence persists, as his actors offer nuanced performances—brooding, musing, and dreamily contemplating.

The film *An Estranged Paradise* (1997–2002) chronicles a young man's disenchantment with his environment and captures a condition of ennui typical of many young people on the brink of maturation, unsure of what they will become and how fate and external factors will conspire in the realization of their ideal futures. More important perhaps, it exposes the internal struggle of the characters, whose extreme self-awareness and predilection for self-analysis have the potential to alienate them from each other and from the experience of everyday life. In the photographic series *The First Intellectual* (2000), the protagonist embodies Yang and his peers' real-life struggle to achieve their goals, and the frustration implicit therein. A young man, in corporate attire, lifts his hand to launch a brick at an unknown subject or destination. Bloodied and disheveled, with papers strewn about him, the figure is rebelling against an assault, the cause of which is unclear. The unidentifiable enemy might have hurled the first brick, but the victim's injury and disorientation could also have been caused by internal demons; the subject seems equally powerless against both.

Seven Intellectuals in Bamboo Forest is the artist's most ambitious project to date, involving five separate films and some two hours of running time. The work is an epic journey, revolving around seven poets and artists as they move through several phases of experience in their quest to transcend earthly life. According to common lore, the so-called seven intellectuals lived during the Wei and Jin Dynasties (third and fourth centuries), passionately pursuing ideals of liberty, artistic freedom, and individual enlightenment. *Part 1* (2003) of Yang's project depicts the group of young adults confronting the power of the landscape on a journey to the famous Yellow Mountain. The youths are coming of age intellectually and socially, and the film captures a moment in which naiveté coexists with profound philosophical ponderings— larger discussions, triggered by the landscape, about desire, loss, beauty, fear, fragility, guilt, love, civilization, and their place within it. Over the course of the series, the subjects negotiate youthful ideals with the realities of life, as they move from the awe-inspiring landscape in *Part 1* to the chaotic city in *Part 2* (2004). In parts three through five, yet to be completed, the characters seek refuge in the countryside and on a utopian island of "Peach Blossoms" before settling into everyday urban life, confident enough in their powers of self-reliance to return to the big city and thrive. Yang's aesthetic borrows from visual paradigms of Chinese filmmaking from the 1920s, but the space and time of his storytelling are deliberately ambiguous. Evocative of the past in mood and costuming, Yang's films function as modern, yet timeless fables—as timeless and universal as the human desire to make sense of life and love and death and our individual place in the world.—*Elizabeth Thomas*

BORN
1971, Beijing, China

LIVES AND WORKS
Shanghai, China

Yang Fudong graduated from the China Academy of Fine Arts, Hangzhou, in 1995. His video works have been screened in solo exhibitions at MediaScope, New York (2004); S10, Shanghai Siemens Business Communication Systems Ltd., Shanghai (2003); The Moore Space, Miami, Florida (2003, traveled to Trans>area, New York); and BüroFriedrich, Berlin (2003).

Group exhibitions and screenings include: *China Now,* Gramercy Theater MoMA, New York (2004); *Fuckin' Trendy!* Kunsthalle Nürnberg, Nuremberg, Germany (2004); *Happiness: A Survival Guide for Art and Life,* Mori Art Museum, Tokyo (2003, catalogue); *Avicon (Asian Video Art Conference),* Videoart Center, Tokyo (2003); *Outlook–International Art Exhibition,* Technopolis, The Factory and Benaki Museum, Athens, Greece (2003, catalogue); *Out of the Red: La génération émergente,* Trevi Flash Art Museum, Italy (2003); *The Paradise [12],* Douglas Hyde Gallery, Dublin (2003); *Utopia Station* and Chinese Pavilion, 50th Venice Biennale (2003, catalogue); *Alors la Chine?* Musée national d'art moderne, Centre Pompidou, Paris (2003, catalogue); *Camera,* Musée d'art moderne de la Ville de Paris (2003, catalogue); *Documenta 11,* Kassel, Germany (2003, catalogue); *Art in General,* 4th Annual Video Marathon, New York (2003); *Urban Creation,* 4th Shanghai Biennale (2002, catalogue); *Living in Time: Contemporary Artists from China,* Hamburger Bahnhof, Berlin (2001); Yokohama Triennial, Japan (2001, catalogue); and *Ecofugal,* 7th International Istanbul Biennial (2001, catalogue).

SELECTED BIBLIOGRAPHY
Kee, Joan. "Yang Fudong." *Tema Celeste* 92 (July–August 2002): 56–59.

Movius, Lisa. "Celluloid Purgatory: Shanghai's Independent Cinema Inches Forward." *Asian Wall Street Journal,* November 8, 2002.

Obrist, Hans-Ulrich, and Yang Fudong. "Hans-Ulrich Obrist Camera Interviews: Interview with Yang Fudong." *Yishu: Journal of Contemporary Chinese Art* 2, no. 3 (September 2003): 61–70.

Perlez, Jane. "Casting a Fresh Eye on China with Computer, Not Ink Brush." *New York Times,* December 3, 2003.

Yang Fudong. "A Thousand Words: Yang Fudong Talks about the *Seven Intellectuals.*" *Artforum* 42, no. 1 (September 2003): 182–83.

below
YANG FUDONG
still from
Seven Intellectuals in Bamboo Forest, Part 1, 2003
35mm film transferred to DVD;
black and white, sound
29 min.
Courtesy of the artist and Shangart Gallery, Shanghai

overleaf
stills from
Seven Intellectuals in Bamboo Forest, Part 2, 2004
35mm film transferred to DVD;
black and white, sound
30 min. approx.
Courtesy of the artist and Shangart Gallery, Shanghai

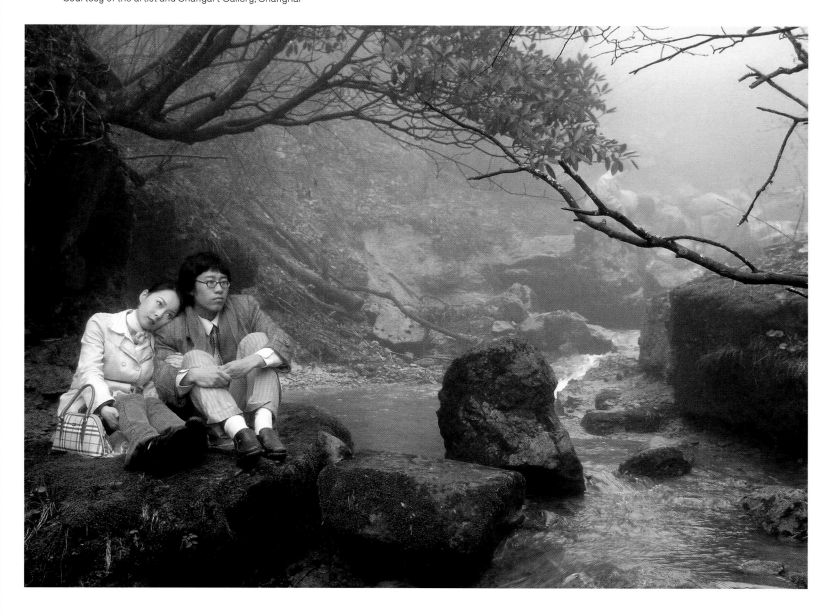

Works in the Exhibition

Dimensions are in inches and centimeters; height precedes width precedes depth.
Works listed as "untitled" are yet to be named.

Tomma Abts

Koene, 2001
acrylic and oil on canvas
18 7/8 × 15 in. (48 × 38 cm)
Collection of Constance R. Caplan,
Baltimore

Mennt, 2002
acrylic and oil on canvas
18 7/8 × 15 in. (48 × 38 cm)
Private collection, London

Noene, 2002
acrylic and oil on canvas
18 7/8 × 15 in. (48 × 38 cm)
Private Collection;
courtesy of greengrassi

Ert, 2003
acrylic and oil on canvas
18 7/8 × 15 in. (48 × 38 cm)
Boros Collection, Germany

Zeyn, 2003
acrylic and oil on canvas
18 7/8 × 15 in. (48 × 38 cm)
Goetz Collection, Munich

Feihe, 2004
acrylic and oil on canvas
18 7/8 × 15 in. (48 × 38 cm)
Collection of Joel Wachs

Nomde, 2004
acrylic and oil on canvas
18 7/8 × 15 in. (48 × 38 cm)
Private collection;
courtesy of greengrassi

Pawel Althamer

Film, 2004
performance, ongoing
Courtesy of the artist;
Foksal Gallery Foundation, Warsaw;
and neugerriemschneider, Berlin;
commissioned by
2004–5 *Carnegie International*,
Carnegie Museum of Art, Pittsburgh

Film Trailer, 2004
video; color, sound
1:20 min. approx.
Courtesy of the artist;
Foksal Gallery Foundation, Warsaw;
and neugerriemschneider, Berlin;
commissioned by
2004–5 *Carnegie International*,
Carnegie Museum of Art, Pittsburgh

Francis Alÿs

Virtues, 1992
oil and encaustic on canvas on wood
8 3/4 × 13 1/16 × 13/16 in.
(22.2 × 33 × 2 cm)
Courtesy of the artist

study for
Painting and Punishment, 1995
oil and encaustic on canvas
6 11/16 × 5 1/8 × 13/16 in.
(17 × 13 × 2 cm)
Courtesy of the artist

El Soplón (The scavenger), 1995–2002
oil, encaustic, and collage
on canvas on wood
9 7/8 × 7 3/4 × 11/16 in.
(25 × 19.7 × 1.7 cm)
Courtesy of the artist

(Untitled)
Le Cochon dans le Cochon, 1996
oil, encaustic, and tracing
paper on wood
11 3/16 × 13 11/16 × 3/4 in.
(28.4 × 34.8 × 2 cm)
Courtesy of the artist

study for *El Soplón*
(The scavenger), 1996
oil, graphite, and color photograph
on tracing paper
9 1/2 × 11 7/8 in. (24 × 30 cm)
Courtesy of the artist

drawings, 1997–2004
pencil and oil on tracing paper;
100 sheets approx.
various dimensions
Courtesy of the artist

photographs and documents,
1997–2004
20 sheets approx.
various dimensions
Courtesy of the artist

The Prophet in the Prophet, 1999–2001
oil and encaustic on canvas on wood
15 1/6 × 18 9/16 × 15/16 in.
(38.5 × 47 × 2.4 cm)
Courtesy of the artist

Untitled, 2001
oil and encaustic on cloth and wood
10 5/8 × 6 3/4 × 1 1/16 in.
(27 × 17 × 2.7 cm)
Courtesy of the artist

Untitled, 2002
oil, enamel, and encaustic on Masonite
7 3/4 × 11 5/8 × 13/16 in.
(19.7 × 29.5 × 2 cm)
Courtesy of the artist

Untitled, 2002
oil and encaustic on wood
7 11/16 × 6 × 1 3/16 in.
(19.5 × 15.2 × 3 cm)
Courtesy of the artist

Cabinet, 2003
oil on canvas on wood
5 1/2 × 7 1/2 × 13/16 in.
(14 × 19 × 2 cm)
Courtesy of the artist

Untitled, 2004
oil and encaustic on canvas
15 × 11 7/16 in. (38 × 29 cm)
Courtesy of the artist

Untitled, 2004
oil and encaustic on canvas
13 9/16 × 10 5/8 × 1 3/16 in.
(34.5 × 27 × 3 cm)
Courtesy of the artist

Untitled, 2004
oil and encaustic on Masonite
10 13/16 × 7 7/8 × 13/16 in.
(27.5 × 20 × 2 cm)
Courtesy of the artist

Untitled, 2004
oil and encaustic on Masonite
7 7/8 × 5 3/16 × 13/16 in.
(20 × 13 × 2 cm)
Courtesy of the artist

Untitled, 2004
oil and encaustic on Masonite
7 7/8 × 5 3/16 × 13/16 in.
(20 × 13 × 2 cm)
Courtesy of the artist

Untitled, 2004
oil and encaustic on canvas;
2 parts
5 1/2 × 7 7/8 × 13/16 in.
(14 × 20 × 2 cm) each
Courtesy of the artist

Untitled, 2004
wood and enamel paint
8 1/4 × diam. 3 5/16 in.
(21 × diam. 11 cm)
Courtesy of the artist

Untitled, 2004
wood
98 × 3 5/16 × 25 1/2 in.
(250 × 10 × 65 cm)
Courtesy of the artist

Mamma Andersson

Stairway to the Stars, 2002
oil on canvas
70 7/8 × 85 1/16 in. (180 × 216 cm)
Collection of Moderna Museet,
Stockholm

Installation, 2003
oil on panel
37 × 48 7/16 in. (94 × 123 cm)
Collection J.K. Brown
and Eric Diefenbach, New York

Traveling in the Family, 2003
oil on panel
36 1/4 × 48 1/16 in. (92 × 122 cm)
Collection of Christian Larsen,
Stockholm

Heimat Land, 2004
oil on canvas
31 1/2 × 110 1/4 in. (80 × 280 cm)
Collection of Jill and Dennis Roach,
Los Angeles

*Så gladeligt hand uti hand, fallera,
nu gå vi till fågel Fenix land, fallera,
till det sagoland, som skiner av
smaragder och rubiner, nu gå vi till
fågel Fenix land, fallera*, 2004
oil on canvas
19 11/16 × 68 7/8 in. (50 × 175 cm)
Collection of Mr. Pontus Bonnier,
Stockholm

untitled, 2004
oil on canvas
43 5/16 × 59 1/16 in. (110 × 150 cm)
Courtesy of the artist;
Galleri Magnus Karlsson, Stockholm;
Stephen Friedman Gallery, London;
and David Zwirner, New York

untitled, 2004
oil on canvas
35 7/16 × 68 7/8 in. (90 × 175 cm)
Courtesy of the artist;
Galleri Magnus Karlsson, Stockholm;
Stephen Friedman Gallery, London;
and David Zwirner, New York

untitled, 2004
oil on canvas
28 6/16 × 58 11/16 in. (72 × 149 cm)
Courtesy of the artist;
Galleri Magnus Karlsson, Stockholm;
Stephen Friedman Gallery, London;
and David Zwirner, New York

untitled, 2004
oil on panel
35 7/16 × 68 7/8 in. (90 × 175 cm)
Courtesy of the artist;
Galleri Magnus Karlsson, Stockholm;
Stephen Friedman Gallery, London;
and David Zwirner, New York

Workshop, 2004
oil on canvas
19 11/16 × 68 7/8 in. (50 × 175 cm)
Collection of Dianne Wallace, New York

Chiho Aoshima

untitled, 2004
digital wall mural
16 × 108 ft. (487.7 × 3,291.8 cm)
Courtesy of the artist and Blum & Poe,
Los Angeles; commissioned by
2004–5 *Carnegie International*,
Carnegie Museum of Art, Pittsburgh

Kaoru Arima

Untitled (The dream of a trainer), 1997
graphite, colored pencil, acrylic,
and ink on newspaper
20 7/8 × 15 9/16 in. (53 × 39.5 cm)
Courtesy of the artist
and Cellar Gallery, Nagoya

*Untitled (I would have been happier
had I remained a frog)*, 1997
graphite, colored pencil, acrylic,
and ink on newspaper
22 13/16 × 14 15/16 in. (58 × 38 cm)
Courtesy of the artist
and Cellar Gallery, Nagoya

*Untitled
(To support is this man's job)*, 1997
graphite, colored pencil, acrylic,
and ink on newspaper
18 1/2 × 12 5/8 in. (47 × 32 cm)
Private collection, New York

*Untitled (Why can't I do anything
more than this?)*, 1997
graphite, colored pencil, acrylic,
and ink on newspaper
20 7/8 × 15 9/16 in. (53 × 39.5 cm)
Collection of Gallery Honjoh, Tokyo

*Untitled (It always takes
roots on earth)*, 2000
graphite, colored pencil, acrylic,
and ink on newspaper
21 7/16 × 15 9/16 in. (54.5 × 39.5 cm)
Courtesy of the artist
and Cellar Gallery, Nagoya

*Untitled (It's your turn to secrete
shiny liquid from your mouth)*, 2000
graphite, colored pencil, acrylic,
and ink on newspaper
22 7/16 × 14 15/16 in. (57 × 38 cm)
Courtesy of the artist
and Cellar Gallery, Nagoya

Untitled (Not made of flesh), 2000
graphite, colored pencil, acrylic,
and ink on newspaper
21 1/4 × 15 3/8 in. (54 × 39 cm)
Courtesy of the artist
and Cellar Gallery, Nagoya

Untitled (So stubborn), 2000
graphite, colored pencil, acrylic,
and ink on newspaper
21 7/16 × 15 15/16 in. (54.5 × 40.5 cm)
Collection of Tatsumi Sato, Hiroshima

*Untitled (They don't know that
they are of one body)*, 2000
graphite, colored pencil, acrylic,
and ink on newspaper
21 1/4 × 15 3/8 in. (54 × 39 cm)
Courtesy of the artist
and Cellar Gallery, Nagoya

*Untitled (Will you accept
five million people?)*, 2000
graphite, colored pencil, acrylic,
and ink on newspaper
20 1/16 × 11 5/8 in. (51 × 29.5 cm)
Private collection, Aichi

Untitled, 2002
graphite, colored pencil, acrylic,
and ink on newspaper
21 7/16 × 15 15/16 in. (54.5 × 40.5 cm)
Collection of the artist;
courtesy of Cellar Gallery, Nagoya

Untitled (Come inside), 2002
graphite, colored pencil, acrylic,
and ink on newspaper
21 7/8 × 13 9/16 in. (55.6 × 34.5 cm)
Courtesy of the artist
and Cellar Gallery, Nagoya

Untitled (Heaven and Earth), 2002
graphite, colored pencil, acrylic,
and ink on newspaper
21 7/8 × 13 3/4 in. (55.6 × 35 cm)
Collection of the artist;
courtesy of Cellar Gallery, Nagoya

Untitled (Will you give up?), 2002
graphite, colored pencil, acrylic,
and ink on newspaper
18 1/2 × 12 3/8 in. (47 × 31.4 cm)
Courtesy of the artist
and Cellar Gallery, Nagoya

Untitled, 2003
graphite, colored pencil, acrylic,
and ink on newspaper
22 1/16 × 14 in. (56 × 35.6 cm)
Collection of Tezukayama Gallery,
Osaka

Untitled, 2003
graphite, colored pencil, acrylic,
and ink on newspaper
22 1/16 × 14 in. (56 × 35.6 cm)
Courtesy of the artist
and Cellar Gallery, Nagoya

Untitled, 2003
graphite, colored pencil, acrylic,
and ink on newspaper
22 7/16 × 12 3/8 in. (57 × 31.4 cm)
Courtesy of the artist
and Cellar Gallery, Nagoya

Untitled, 2003
graphite, colored pencil, acrylic,
and ink on newspaper
22 1/16 × 14 3/16 in. (56 × 36 cm)
Courtesy of the artist
and Cellar Gallery, Nagoya

Untitled, 2003
graphite, colored pencil, acrylic,
and ink on newspaper
22 1/16 × 14 in. (56 × 35.6 cm)
Collection of Masato Iwata, Aichi

Untitled, 2003
graphite, colored pencil, acrylic,
and ink on newspaper
22 7/16 × 12 3/8 in. (57 × 31.4 cm)
Courtesy of the artist
and Cellar Gallery, Nagoya

Untitled, 2003
graphite, colored pencil, acrylic,
and ink on newspaper
22 5/16 × 14 in. (56.7 × 35.6 cm)
Courtesy of the artist
and Cellar Gallery, Nagoya

Untitled, 2003
graphite, colored pencil, acrylic,
and ink on newspaper
22 7/16 × 15 15/16 in. (57 × 40.5 cm)
Courtesy of the artist
and Cellar Gallery, Nagoya

Untitled, 2003
graphite, colored pencil, acrylic,
and ink on newspaper
22 5/8 × 13 3/8 in. (57.5 × 34 cm)
Collection of Kodama Gallery, Osaka

Untitled, 2003
graphite, colored pencil, acrylic,
and ink on newspaper
22 7/16 × 12 3/8 in. (57 × 31.4 cm)
Collection of Mitsuhiro Kaji, Osaka

Untitled, 2003
graphite, colored pencil, acrylic,
and ink on newspaper
21 1/8 × 15 3/8 in. (53.7 × 39 cm)
Collection of Yuzo Kato, Osaka

Untitled, 2003
graphite, colored pencil, acrylic,
and ink on newspaper
21 7/16 × 15 15/16 in. (54.5 × 40.5 cm)
Courtesy of the artist
and Cellar Gallery, Nagoya

Untitled, 2003
graphite, colored pencil, acrylic,
and ink on newspaper
22 1/16 × 14 in. (56 × 35.6 cm)
Collection of Yuzo Kato, Osaka

Untitled, 2003
graphite, colored pencil, acrylic,
and ink on newspaper
21 7/16 × 15 3/8 in. (54.5 × 39 cm)
Courtesy of the artist
and Cellar Gallery, Nagoya

Untitled, 2003
graphite, colored pencil, acrylic,
and ink on newspaper
22 5/8 × 15 15/16 in. (57.5 × 40.5 cm)
Collection of Tezukayama Gallery,
Osaka

Untitled, 2003
graphite, colored pencil, acrylic,
and ink on newspaper
21 7/16 × 15 15/16 in. (54.5 × 40.5 cm)
Collection of Yukinari Shimono, Tokyo

Untitled, 2003
graphite, colored pencil, acrylic,
and ink on newspaper
22 7/16 × 12 3/8 in. (57 × 31.4 cm)
Courtesy of the artist
and Cellar Gallery, Nagoya

Untitled, 2003
graphite, colored pencil, acrylic,
and ink on newspaper
20 7/8 × 15 9/16 in. (53 × 39.5 cm)
Collection of Cellar Gallery, Nagoya

Untitled, 2003
graphite, colored pencil, acrylic,
and ink on newspaper
21 7/16 × 15 15/16 in. (54.5 × 40.5 cm)
Collection of Fukugan Gallery, Osaka

Untitled, 2003
graphite, colored pencil, acrylic,
and ink on newspaper
22 13/16 × 15 15/16 in. (58 × 40.5 cm)
Courtesy of the artist
and Cellar Gallery, Nagoya

Untitled, 2003
graphite, colored pencil, acrylic,
and ink on newspaper
22 5/8 × 13 in. (57.5 × 33 cm)
Collection of Hisanao Minoura, Aichi

Untitled, 2003
graphite, colored pencil, acrylic,
and ink on newspaper
22 13/16 × 14 9/16 in. (58 × 37 cm)
Collection of the artist and
Cellar Gallery, Nagoya

Untitled, 2003
graphite, colored pencil, acrylic,
and ink on newspaper
20 7/8 × 15 9/16 in. (53 × 39.5 cm)
Collection of Hisanao Minoura, Aichi

Untitled, 2003
graphite, colored pencil, acrylic,
and ink on newspaper
21 7/16 × 15 15/16 in. (54.5 × 40.5 cm)
Collection of Yukinari Shimono, Tokyo

Untitled, 2003
graphite, colored pencil, acrylic,
and ink on newspaper
21 7/16 × 15 15/16 in. (54.5 × 40.5 cm)
Courtesy of the artist
and Cellar Gallery, Nagoya

Untitled, 2003
graphite, colored pencil, acrylic,
and ink on newspaper
22 1/16 × 13 3/8 in. (56 × 34 cm)
Collection of the artist;
courtesy of Cellar Gallery, Nagoya

Untitled, 2003
graphite, colored pencil, acrylic,
and ink on newspaper
22 7/16 × 12 3/8 in. (57 × 31.4 cm)
Collection of Gallery Iskra, Nagoya

Untitled, 2003
graphite, colored pencil, acrylic,
and ink on newspaper
22 1/16 × 14 3/16 in. (56 × 36 cm)
Courtesy of the artist
and Cellar Gallery, Nagoya

Untitled, 2003
graphite, colored pencil, acrylic,
and ink on newspaper
21 1/8 × 15 9/16 in. (53.7 × 39.5 cm)
Collection of Takanori Ebihara, Tokyo

Untitled, 2003
graphite, colored pencil, acrylic,
and ink on newspaper
21 7/16 × 15 15/16 in. (54.5 × 40.5 cm)
Collection of Takanori Ebihara, Tokyo

Untitled, 2003
graphite, colored pencil, acrylic,
and ink on newspaper
21 7/16 × 15 15/16 in. (54.5 × 40.5 cm)
Courtesy of the artist
and Cellar Gallery, Nagoya

Untitled, 2003
graphite, colored pencil, acrylic,
and ink on newspaper
22 1/2 × 14 in. (57 × 35.6 cm)
Courtesy of the artist
and Cellar Gallery, Nagoya

Untitled, 2003
graphite, colored pencil, acrylic,
and ink on newspaper
22 7/16 × 12 3/8 in. (57 × 31.4 cm)
Courtesy of the artist
and Cellar Gallery, Nagoya

Untitled, 2003
graphite, colored pencil, acrylic,
and ink on newspaper
21 7/16 × 15 15/16 in.
(54.5 × 40.5 cm)
Courtesy of the artist
and Cellar Gallery, Nagoya

Untitled, 2003
graphite, colored pencil, acrylic,
and ink on newspaper
22 7/16 × 12 5/8 in. (57 × 32 cm)
Courtesy of the artist
and Cellar Gallery, Nagoya

Untitled, 2003
graphite, colored pencil, acrylic,
and ink on newspaper
22 1/16 × 14 in. (56 × 35.6 cm)
Courtesy of the artist
and Cellar Gallery, Nagoya

Untitled (He gave me a name), 2003
graphite, colored pencil, acrylic,
and ink on newspaper
21 7/16 × 15 15/16 in.
(54.5 × 40.5 cm)
Courtesy of the artist
and Cellar Gallery, Nagoya

Untitled (Impossible), 2003
graphite, colored pencil, acrylic,
and ink on newspaper
22 1/16 × 13 3/8 in. (56 × 34 cm)
Collection of Fukugan Gallery, Osaka

Untitled (Phew), 2003
graphite, colored pencil, acrylic,
and ink on newspaper
22 5/8 × 13 3/4 in. (57.5 × 35 cm)
Collection of Mitsuhiro Kaji, Osaka

Untitled (Ring), 2003
graphite, colored pencil, acrylic,
and ink on newspaper
21 7/16 × 15 15/16 in.
(54.5 × 40.5 cm)
Courtesy of the artist
and Cellar Gallery, Nagoya

*Untitled (Selling leaves
while I wait)*, 2003
graphite, colored pencil, acrylic,
and ink on newspaper
21 7/16 × 15 15/16 in.
(54.5 × 40.5 cm)
Courtesy of the artist
and Cellar Gallery, Nagoya

Untitled, 2004
graphite, colored pencil, acrylic,
and ink on newspaper
22 1/16 × 14 15/16 in. (56 × 38 cm)
Courtesy of the artist
and Cellar Gallery, Nagoya

Kutlug Ataman

Kuba, 2004
40-channel video installation
with tables and chairs; color, sound
Commissioned by Artangel and
co-produced by 2004–5 *Carnegie
International*, Carnegie Museum of Art,
Pittsburgh; Lehmann Maupin Gallery,
New York; Thyssen-Bornemisza Art
Contemporary (T-B A21), Vienna;
and Theater der Welt, Stuttgart

John Bock

Meechfever, 2004
single-channel video; color, sound
30 min. approx.
Courtesy of Klosterfelde, Berlin,
and Anton Kern Gallery, New York;
co-commissioned by
2004–5 *Carnegie International*,
Carnegie Museum of Art, Pittsburgh,
and Fondazione Nicola Trussardi, Milan

untitled sculptures
from *Meechfever*, 2004
mixed media
various dimensions
Courtesy of Klosterfelde, Berlin,
and Anton Kern Gallery, New York;
co-commissioned by
2004–5 *Carnegie International*,
Carnegie Museum of Art, Pittsburgh,
and Fondazione Nicola Trussardi, Milan

Lee Bontecou

Untitled, 1958–59
welded steel and canvas
19 1/2 × 10 × 11 in. (49.5 × 25.4 × 28 cm)
Collection of the artist; courtesy of
Knoedler & Co., New York

Untitled, 1962
welded steel, wood,
and canvas construction
65 × 111 × 20 in. (165 × 282 × 50.8 cm)
Abrams Family Collection, New York

Untitled, 1962
welded iron, canvas, wire, and velvet
54 × 55 × 15 in. (137.2 × 139.7 × 38 cm)
Collection of the National Gallery
of Art, Washington, D.C.; gift of the
Collectors Committee, 2004.44.1

Untitled, 1975
graphite on gessoed plastic paper
8 × 16 7/8 in. (20.3 × 42.9 cm)
Private collection; courtesy of
Knoedler & Co., New York

Untitled, 1976
graphite and colored pencil
on gessoed plastic paper
9 1/16 × 11 1/8 in. (23 × 28.3 cm)
The Judith Rothschild Foundation
Contemporary Drawings Collection

Untitled, 1976
graphite and colored pencil
on gessoed plastic paper
15 × 11 1/8 in. (38 × 28.3 cm)
Collection of the artist; courtesy
of Knoedler & Co., New York

Untitled, ca. 1977
white clay
5 × 13 1/2 × 6 1/4 in.
(12.7 × 34.3 × 15.9 cm)
Collection of the artist; courtesy
of Knoedler & Co., New York

Untitled, ca. 1980–2001
welded steel, porcelain, wire mesh,
silk, and wire
90 × 99 × 60 in.
(228.6 × 251.5 × 152.4 cm)
Collection of the artist; courtesy
of Knoedler & Co., New York

Untitled, 1982
charcoal pencil and white pencil
on brown paper
19 1/4 × 26 3/16 in. (49 × 66.5 cm)
Miller Meigs Collection, Oregon

Untitled, 1982
casein on primed plastic paper
13 × 13 in. (33 × 33 cm)
Private collection; courtesy of
Knoedler & Co., New York

Untitled, 1983
welded steel, porcelain, cloth, wire
mesh, and wire
23 × 23 × 23 in. (58.4 × 58.4 × 58.4 cm)
Collection of the artist; courtesy
of Knoedler & Co., New York

Untitled, 1985
welded steel, porcelain, silk,
wire mesh, and wire
22 × 26 × 19 in. (56 × 66 × 48.3 cm)
Collection of Dora G. Flash

Untitled, 1987
printer's ink on primed plastic paper
12 × 12 in. (30.5 × 30.5 cm)
Collection of Tony and Gail Ganz,
Los Angeles

Untitled, 1987
printer's ink on primed plastic paper
11 1/2 × 10 3/8 in. (29.2 × 26.4 cm)
Private collection, New York

Untitled, 1987
paint on primed plastic paper
13 1/4 × 9 3/4 in. (33.7 × 24.8 cm)
Collection of Daniel Weinberg
and Elizabeth Topper, Los Angeles

Untitled, 1987
graphite and colored pencil on paper
9 1/2 × 12 1/2 in. (24 × 31.8 cm)
Collection of Museum of Contemporary
Art, Chicago; gift of the artist in honor
of Elizabeth A. T. Smith

Untitled, 1987
graphite and colored pencil on paper
9 1/2 × 12 1/2 in. (24 × 31.8 cm)
Collection of UCLA Hammer Museum;
promised gift of the artist
in honor of Ann Philbin

Untitled #2, 1987
paint, pastel, and colored pencil
on paper
12 1/2 × 10 in. (31.8 × 25.4 cm)
Collection of the artist; courtesy
of Knoedler & Co., New York

Untitled, 1989
graphite on paper
18 1/8 × 24 in. (46 × 61 cm)
Private collection; courtesy of
Knoedler & Co., New York

Untitled, 1993
steel, porcelain, wire mesh, and wire
12 × 15 × 9 in. (30.5 × 38 × 23 cm)
Collection of the artist; courtesy
of Knoedler & Co., New York

Untitled, 1994
welded steel, porcelain,
wire mesh, silk, and wire
22 × 29 × 17 in. (56 × 73.7 × 43.2 cm)
Collection of the artist; courtesy
of Knoedler & Co., New York

Untitled, 1996
colored pencil on black paper
30 × 26 in. (76.2 × 66 cm)
Collection of the artist; courtesy
of Knoedler & Co., New York

Untitled, 1996
welded steel, porcelain,
wire mesh, silk, and wire
61 × 55 × 74 in. (155 × 139.7 × 188 cm)
Collection of the artist; courtesy
of Knoedler & Co., New York

Untitled, 1996
welded steel, porcelain,
wire mesh, cloth, and wire
30 × 32 × 14 in. (76.2 × 81.3 × 35.6 cm)
Collection of the artist; courtesy
of Knoedler & Co., New York

Untitled #4, 1998
graphite on paper
8 1/2 × 11 in. (21.6 × 28 cm)
The Judith Rothschild Foundation
Contemporary Drawings Collection

Untitled, 1999
colored pencil and silver pencil
on black paper
12 × 9 3/4 in. (30.5 × 24.8 cm)
Collection of the artist; courtesy
of Knoedler & Co., New York

Untitled, 1999
colored pencil on paper
24 × 18 in. (61 × 45.7 cm)
Collection of the artist; courtesy
of Knoedler & Co., New York

Robert Breer

ATOZ, 2000
16 mm film; color, sound
5:45 min.
Courtesy of the artist
and &: gb agency, Paris

What Goes Up, 2003
16 mm film; color, sound
4:37 min.
Courtesy of the artist
and &: gb agency, Paris

Fernando Bryce

Inter-American Affairs, 2004
ink on paper; 230 drawings
8 1/4 × 11 3/4 in. (21 × 29.8 cm)
11 3/4 × 16 1/2 in. (29.8 × 42 cm)
16 1/2 × 23 5/8 in. (42 × 60 cm)
Courtesy of the artist
and Galerie Barbara Thumm, Berlin

Kathy Butterly

Clam, 1996
porcelain, earthenware, and glaze
4 1/2 × diam. 3 1/4 in.
(11.4 × diam. 8.3 cm)
Collection of Elizabeth Levine, New York

Nancy's Beans, 1996
porcelain, earthenware, and glaze
5 × diam. 3 1/4 in. (12.7 × diam. 8.3 cm)
Collection of Elizabeth Levine, New York

Sow, 1996
porcelain, earthenware, and glaze
4 3/8 × diam. 3 1/8 in. (11 × diam. 8 cm)
Collection of Judy Graf Klein, Brooklyn

Sumo, 1996
porcelain, earthenware, and glaze
5 1/16 × 4 7/8 × 3 in.
(12.9 × 12.4 × 7.6 cm)
Courtesy of the artist and
Tibor de Nagy Gallery, New York

Batter Up, 1997
porcelain, earthenware, and glaze
4 1/4 × diam. 3 1/2 in.
(10.8 × diam. 8.9 cm)
Collection of Mark Pollack, New York

Frosty, 1997
porcelain, slip, and glaze
4 × diam. 2 7/8 in. (10.2 × diam. 7.3 cm)
Collection of Elizabeth Levine, New York

Red Shimmy, 1997
porcelain, slip, and glaze
4 5/8 × diam. 2 3/4 in. (11.8 × diam. 7 cm)
Collection of Judith Schwartz, New York

Tonic, 1997
porcelain, slip, and glaze
5 1/4 × diam. 2 1/2 in.
(13.3 × diam. 6.4 cm)
Collection of Elizabeth Levine, New York

Float 2, 1999
porcelain, earthenware, and glaze
5 7/8 × diam. 3 3/16 in. (15 × diam. 8 cm)
Collection of Elizabeth Levine, New York

Nerfana, 1999
porcelain, earthenware, and glaze
5 7/8 × diam. 3 1/4 in. (15 × diam. 8.3 cm)
The Carol and Arthur Goldberg
Collection

Swimmin' Hole, 1999
porcelain, earthenware, and glaze
5 3/16 × diam. 2 1/2 in.
(13 × diam. 6.4 cm)
Collection of Myrna Aronoff,
San Francisco

Bonnet, 2000
porcelain, earthenware, and glaze
7 5/16 × 2 3/16 × 3 1/4 in.
(18.6 × 5.6 × 8.3 cm)
Collection of Elizabeth Levine, New York

Overgrown, 2001
porcelain, earthenware, and glaze
7 1/4 × 2 15/16 × 2 7/8 in.
(18.4 × 7.5 × 7.3 cm)
Collection of Mark Pollack, New York

Ready, 2001
porcelain, earthenware, and glaze
6 7/8 × 3 1/8 × 2 1/4 in.
(17.5 × 8 × 5.7 cm)
Collection of Elizabeth Levine, New York

Stuck in the Muck, 2001
porcelain, earthenware, and glaze
6 1/4 × 4 1/2 × 2 1/2 in.
(15.9 × 11.4 × 6.4 cm)
Collection of Elizabeth Levine, New York

Undercover, 2001
porcelain, earthenware, and glaze
6 5/8 × 3 3/4 × 3 in.
(16.8 × 9.5 × 7.6 cm)
Collection of Barrie Schwartz
and Patrick Hayne, New York

Duo, 2002
porcelain, earthenware, and glaze
5 3/8 × 4 3/8 × 4 1/4 in.
(13.7 × 11.1 × 10.8 cm)
Collection of T. Hall Cannon

Lickety, 2002
porcelain, earthenware, and glaze
6 3/8 × 3 5/8 × 3 7/8 in.
(16.2 × 9.2 × 9.8 cm)
Collection of Carnegie Museum of Art;
A. W. Mellon Acquisition Endowment
Fund and Martha Mack Lewis Fund,
2003.23.1

Trip, 2002
porcelain, earthenware, and glaze
7 3/8 × 4 × 3 3/4 in.
(18.7 × 10.2 × 9.5 cm)
Collection of Carnegie Museum of Art;
A. W. Mellon Acquisition Endowment
Fund and Martha Mack Lewis Fund,
2003.23.2

Gatherings, 2003
porcelain, earthenware, and glaze
4 1/2 × 3 1/4 × 3 in. (11.4 × 8.3 × 7.6 cm)
Collection of Ann Kaplan, New York

Hat Trick, 2003
porcelain, earthenware, and glaze
5 1/2 × 5 3/4 × 4 3/4 in.
(14 × 14.6 × 12.1 cm)
Courtesy of the artist
and Tibor de Nagy Gallery, New York

Heavy Head, 2003
porcelain, earthenware, and glaze
3 3/8 × 6 × 3 3/4 in. (8.6 × 15.2 × 9.5 cm)
Courtesy of the artist
and Tibor de Nagy Gallery, New York

Mask, 2003
porcelain, earthenware, and glaze
4 7/8 × 3 5/8 × 2 1/4 in.
(12.4 × 9.2 × 5.7 cm)
Courtesy of the artist
and Tibor de Nagy Gallery, New York

On My Mind, 2003
porcelain, earthenware, and glaze
5 1/8 × 3 5/8 × 3 3/4 in.
(13 × 9.2 × 9.5 cm)
Courtesy of the artist
and Tibor de Nagy Gallery, New York

Sow 2, 2003
porcelain, earthenware, and glaze
4 1/2 × diam. 5 in. (11.4 × diam. 12.7 cm)
Collection of Joel Wachs

Maurizio Cattelan

Now, 2004
wax, human hair,
polyester resin, and clothes
life-size
Courtesy of Marian Goodman
Gallery, New York

Paul Chan

*Happiness (finally) after 35,000 Years
of Civilization—after Henry Darger
and Charles Fourier*, 2000–2003
digital animation and screen;
color, sound
17:20 min.
Courtesy of the artist and
Greene Naftali Gallery, New York

*Now Let Us
Praise American Leftists*, 2000
single-channel video;
black and white, sound
3:30 min.
Courtesy of the artist and
Greene Naftali Gallery, New York

Anne Chu

Four Mountain Views: No. 1, 2004
fabric, wire, and cast urethane
Courtesy of the artist;
303 Gallery, New York;
and Victoria Miro Gallery, London

Four Mountain Views: No. 2, 2004
fabric, wire, and cast urethane
Courtesy of the artist;
303 Gallery, New York;
and Victoria Miro Gallery, London

Four Mountain Views: No. 3, 2004
fabric, wire, and cast urethane
Courtesy of the artist;
303 Gallery, New York;
and Victoria Miro Gallery, London

Maranao Man, 2004
cast bronze
Courtesy of the artist;
303 Gallery, New York;
and Victoria Miro Gallery, London

Nine Hellish Spirits: No. 1, 2004
smoke-fired ceramic
Courtesy of the artist;
303 Gallery, New York;
and Victoria Miro Gallery, London

Nine Hellish Spirits: No. 2, 2004
smoke-fired ceramic
Courtesy of the artist;
303 Gallery, New York;
and Victoria Miro Gallery, London

Nine Hellish Spirits: No. 3, 2004
smoke-fired ceramic
Courtesy of the artist;
303 Gallery, New York;
and Victoria Miro Gallery, London

Nine Hellish Spirits: No. 4, 2004
smoke-fired ceramic
Courtesy of the artist;
303 Gallery, New York;
and Victoria Miro Gallery, London

Nine Hellish Spirits: No. 5, 2004
smoke-fired ceramic
Courtesy of the artist;
303 Gallery, New York;
and Victoria Miro Gallery, London

Robert Crumb

Fritz the Cat Becomes a Drug Addict,
ca. 1960s
ink and mixed media on paper
10 × 7 1/2 in. (25.4 × 19 cm)
Courtesy of Heritage Galleries
and Auctioneers

Games People Play, ca. 1960s
ink and mixed media on paper
9 × 7 in. (22.9 × 17.8 cm)
Collection of Morris Orden, New York

Untitled (Yetti), ca. 1960s
ink and mixed media on paper
10 × 7 5/8 in. (25.4 × 19.4 cm)
Collection of Jeffrey Peabody, New York

Total Destruction Is at Hand, 1960–61
ink and mixed media on paper
8 1/2 × 5 1/2 in. (21.6 × 14 cm)
Collection of Eric Sack, Philadelphia

Arcade no. 25, August 1962
watercolor on paper
8 1/4 × 6 3/4 in. (21 × 17 cm)
Courtesy of Heritage Galleries
and Auctioneers

Arcade no. 29, December 1962
watercolor on paper
8 1/4 × 6 3/4 in. (21 × 17 cm)
Courtesy of Heritage Galleries
and Auctioneers

Fritz the Cat, 1965
ink and mixed media on paper;
10 sheets
13 × 9 1/2 in. (33 × 24 cm) each
Collection of Eric Sack, Philadelphia

Fuckin' Queer Jew, 1966
ink and mixed media on paper
10 1/3 × 8 1/3 in. (26.3 × 21 cm)
Collection of Eric Sack, Philadelphia

Vendome Sketchbook, 1966
ink and mixed media on paper
10 1/2 × 8 in. (26.7 × 20.3 cm)
Courtesy of Heritage Galleries
and Auctioneers

Meatball, 1967
for *Zap Comix*, no. 0, 1968
ink and mixed media on paper; 4 sheets
11 1/4 × 8 2/3 in. (28.6 × 22 cm) each
Collection of Eric Sack, Philadelphia

*Mr. Natural, The Man From
Affiganistan* for *The East Village Other*,
vol. 3, no. 3, 1967
ink and mixed media on paper
17 1/2 × 11 1/2 in. (44.5 × 29.2 cm)
Collection of Eric Sack, Philadelphia

cover art for *Zap Comix*, no. 1, 1967
ink and mixed media on paper
11 × 8 1/2 in. (27.9 × 21.6 cm)
Collection of Victor Moscoso,
Woodacre, California

alternate cover art
for *Zap Comix*, no. 1, 1967
ink and mixed media on paper
9 1/2 × 7 1/4 in. (24 × 18.4 cm)
Collection of Eric Sack, Philadelphia

Can the Mind Know It?
for *The East Village Other*,
vol.3, no.43, 1968
ink and mixed media on paper
16 × 11 in. (40.6 × 28 cm)
Collection of Eric Sack, Philadelphia

Guess I'm Just Neurotic
for *Yellow Dog*, vol.1, no.6, 1968
ink and mixed media on paper
12 × 8 1/2 in. (30.5 × 21.6 cm)
Collection of Eric Sack, Philadelphia

Haw Haw, 1968
ink and mixed media on paper
10 × 7 in. (25.4 × 17.8 cm)
Collection of Martin and Rebecca
Eisenberg, Scarsdale, New York

Kosmic Kapers for *Zap Comix*,
no.0, 1968
ink and mixed media on paper
10 × 7 1/2 in. (25.4 × 19 cm)
Courtesy of Heritage Galleries
and Auctioneers

cover art for
R. Crumb's Head Comix, 1968
ink and mixed media on paper
13 × 10 in. (33 × 25.4 cm)
Collection of Eric Sack, Philadelphia

Robert Crumb Self-Portrait, 1968
ink and mixed media on paper
9 × 5 in. (23 × 12.7 cm)
Collection of Eric Sack, Philadelphia

alternate cover art for *Zap Comix*, 1968
ink and mixed media on paper
10 × 8 1/2 in. (25.4 × 21.6 cm)
Collection of Eric Sack, Philadelphia

cover art for *Zap Comix*, no.2, 1968
ink and mixed media on paper
11 × 8 1/2 in. (28 × 21.6 cm)
Courtesy of Heritage Galleries
and Auctioneers

alternate cover art
for *Zap Comix*, no.3, 1968
ink and mixed media on paper
12 × 9 1/2 in. (30.5 × 24 cm)
Collection of Eric Sack, Philadelphia

covers of *Zap Comix*, nos. 0, 1, 2, and 8,
1968–present
comic books; offset lithograph on paper
9 1/2 × 6 3/4 in. (24.1 × 17.1 cm) each

Despair, 1969
ink and mixed media on paper
13 × 9 3/4 in. (33 × 24.8 cm)
Collection of Eric Sack, Philadelphia

Hi-Lites of Detroit, cover art
for *Motor City Comix*, no.1, 1969
ink and mixed media on paper
12 1/4 × 9 1/4 in. (31 × 23.5 cm)
Courtesy of Heritage Galleries
and Auctioneers

alternate cover art
for *Head Comix*, 1969
ink and mixed media on paper
13 1/4 × 10 1/4 in. (33.7 × 26 cm)
Courtesy of Heritage Galleries
and Auctioneers

cover art for *Instant Comix*, 1969
ink and mixed media on paper
10 × 7 1/2 in. (25.4 × 19 cm)
Courtesy of Heritage Galleries
and Auctioneers

It's Really Too Bad for *(Plunge into
the Depths of) Despair*, 1969
ink and mixed media on paper
14 7/8 × 11 in. (37.8 × 28 cm)
Collection of Eric Sack, Philadelphia

Mr. Natural Gets Bored with Life, 1969
ink and mixed media on paper
10 × 7 1/2 in. (25.4 × 19 cm)
Courtesy of Heritage Galleries
and Auctioneers

Poor Old USA
for *Mr. Natural*, no.1, 1969
ink and mixed media on paper
10 × 7 1/2 in. (25.4 × 19 cm)
Courtesy of Heritage Galleries
and Auctioneers

Lenore Goldberg
for *Motor City Comix*, no.2, 1970
ink and mixed media on paper
14 7/8 × 12 1/8 in. (37.8 × 30.8 cm)
Collection of Eric Sack, Philadelphia

Motor City Comix, no.2, 1970
comic book; offset lithograph on paper
9 × 7 in. (22.9 × 17.8 cm)
Collection of the artist

cover art for
San Francisco Comics, no.2, 1970
ink and mixed media on paper
19 × 11 in. (48.3 × 28 cm)
Collection of Eric Sack, Philadelphia

cover art for
San Francisco Comics, no.3, 1970
ink and mixed media on paper
19 × 11 in. (48.3 × 28 cm)
Collection of Eric Sack, Philadelphia

Underground Hotline
for *San Francisco Comics*, no.3, 1970
ink and mixed media on paper
14 7/8 × 12 in. (37.8 × 30.5 cm)
Collection of Eric Sack, Philadelphia

Whiteman Meets Bigfoot, 1970,
for *Home Grown Funnies*, no.1, 1971
ink and mixed media on paper;
22 sheets
14 × 11 in. (25.5 × 28 cm) each
Private collection, Paris

cover art for
Bijou Funnies, no.6, 1971
ink and mixed media on paper
15 × 12 in. (38 × 30.5 cm)
Collection of Eric Sack, Philadelphia

cover art for
Mr. Natural, no.2, 1971
ink and mixed media on paper
12 × 8 1/2 in. (30 × 21.6 cm)
Courtesy of Heritage Galleries
and Auctioneers

Mr. Natural on the Bum Again
for *Mr. Natural*, no.1, 1971
ink and mixed media on paper
15 × 12 in. (38 × 30.5 cm)
Collection of Eric Sack, Philadelphia

Promethian Enterprises 3, 1971
ink and mixed media on paper
10 3/4 × 9 3/4 in. (27.3 × 24.8 cm)
Collection of Eric Sack, Philadelphia

A Word to You Feminist Women
for *Big Ass Comics*, no.2, 1971
ink and mixed media on paper
13 × 9 1/2 in. (33 × 24 cm)
Collection of Eric Sack, Philadelphia

A Word to You Feminist Women
for *Big Ass Comics*, no.2, 1971
ink and mixed media on paper
10 1/4 × 7 5/8 in. (26 × 19.4 cm)
Collection of Jeffrey and Jeanne
Levy-Hinte, New York; courtesy of
Paul Morris Gallery, New York

alternate cover art for *Zap Comix*,
no.5, 1971
ink and mixed media on paper
12 1/4 × 9 1/4 in. (31 × 23.5 cm)
Courtesy of Heritage Galleries
and Auctioneers

Another Four Years
for *San Francisco Comics*, no.4, 1972
ink and mixed media on paper
14 3/4 × 11 3/8 in. (37.5 × 28.9 cm)
Collection of Eric Sack, Philadelphia

Bellboy Meets Stewball
for *American Splendor*, no.4, 1972
ink and mixed media on paper
14 × 11 in. (35.6 × 28 cm)
Collection of Eric Sack, Philadelphia

On the Street with Shuman the Human
for *The People's Comics*, 1972
ink and mixed media on paper
14 5/8 × 11 3/8 in. (37 × 28.9 cm)
Collection of Eric Sack, Philadelphia

R. Crumb Presents R. Crumb, 1973,
for *Zap Comix*, no.7, 1974
ink and mixed media on paper; 3 sheets
13 1/2 × 9 in. (34.3 × 23 cm) each
Collection of Eric Sack, Philadelphia

cover art for
Arcade: The Comics Revue, no.3, 1975
ink and mixed media on paper
14 × 11 in. (35.6 × 28 cm)
Collection of Eric Sack, Philadelphia

Frosty the Snowman for
Arcade: The Comics Revue, no.4, 1975
ink and mixed media on paper; 6 sheets
14 × 11 in. (35.5 × 28 in.) each
Private collection, Paris

Sketchbook, November 7, 1975, 1975
ink and mixed media on paper
9 × 7 in. (23 × 17.8 cm)
Collection of the artist

That's Life for
Arcade: The Comics Revue, no.3, 1975
ink and mixed media on paper; 5 sheets
13 3/4 × 10 1/2 in. (35 × 26.7 cm) each
Courtesy of Paul Morris Gallery,
New York

cover art for
American Splendor, no.4, 1979
ink and mixed media on paper
11 3/4 × 8 3/4 in. (29.8 × 22.2 cm)
Courtesy of Heritage Galleries
and Auctioneers

It's a Hup Ho World
for *CoEvolution Quarterly*, no.21, 1979
ink and mixed media on paper
13 × 9 1/4 in. (33 × 23.5 cm)
Collection of Eric Sack, Philadelphia

cover art for
American Splendor, no.5, 1980
ink and mixed media on paper
13 1/4 × 10 1/2 in. (33.7 × 26.7 cm)
Collection of Eric Sack, Philadelphia

covers of *Weirdo*, nos.1–28,
1980–present
comic books; offset lithograph on paper
10 5/8 × 8 1/4 in. (27 × 21 cm) each

Bop It Out, 1980
ink and mixed media on paper; 4 sheets
13 3/4 × 10 1/2 in. (35 × 26.7 cm) each
Collection of Jerry Zolten

*Sketchbook, June 21, 1981–
October 31, 1983*, 1981–83
ink and mixed media on paper
9 × 7 in. (23 × 17.8 cm)
Collection of the artist

The Maggies (Oral History)
for *American Splendor*, no.7, 1982
ink and mixed media on paper
14 × 11 in. (35.6 × 28 cm)
Collection of the artist

alternative cover art
for *Weirdo*, no.8, 1982
ink and mixed media on paper
17 × 14 in. (43.2 × 35.6 cm)
Courtesy of Heritage Galleries
and Auctioneers

Hypothetical Quandry, 1984
ink and mixed media on paper
17 × 14 in. (43.2 × 35.6 cm)
Collection of the artist

*Sketchbook, May 24, 1987–
October 11, 1988*, 1987–88
ink and mixed media on paper
9 × 7 in. (23 × 17.8 cm)
Collection of the artist

Cave Wimp for *Zap Comix*, no.12,1988
ink and mixed media on paper;
11 sheets
17 × 14 in. (43.2 × 35.6 cm) each
Courtesy of Heritage Galleries
and Auctioneers

I'm Grateful for *Weirdo*, no.25, 1989
ink and mixed media on paper
14 × 17 in. (35.6 × 43.2 cm)
Collection of the artist

cover art for *Weirdo*, no.22, 1989
ink and mixed media on paper
17 × 14 in. (43.2 × 35.6 cm)
Collection of Eric Sack, Philadelphia

Mr. Natural the Stand-up Comic, 1990
ink and mixed media on paper
12 1/4 × 9 1/4 in. (31 × 23.5 cm)
Collection of Jerry Zolten

Sketchbook, May 1990–
October 3, 1990, 1990
ink and mixed media on paper
9 × 7 in. (23 × 17.8 cm)
Collection of the artist

Sketchbook, October 1990–
October '91, 1990-91
ink and mixed media on paper
9 × 7 in. (23 × 17.8 cm)
Collection of the artist

Sketchbook, August 2, 1994–
November 23, 1998, 1994-98
ink and mixed media on paper
9 × 7 in. (23 × 17.8 cm)
Collection of the artist

Mr. Natural and Flakey Foont Thinkin'
About Death and Stuff, 1997
ink and mixed media on paper
14 × 11 in. (35.6 × 28 cm)
Collection of W. G. Revine

Sketchbook, April 26, 1999–
January 4, 2002, 1999-2002
ink and mixed media on paper
9 × 7 in. (23 × 17.8 cm)
Collection of the artist

A Day in Our Beautiful Life, 2000
(with Aline Kominsky-Crumb)
ink and mixed media on paper;
2 sheets
14 × 11 inches (35.5 × 28 cm) each
Collection of the artist

Story of My Life, November 13, 2000
ink and mixed media on paper
8 × 12 3/4 in. (20.3 × 32.4 cm)
Collection of Dorothy and Martin
Bandier; courtesy of Jack Tilton Gallery

Evil Karma, September 26, 2001
ink and mixed media on paper
11 × 8 in. (28 × 20.3 cm)
Courtesy of Paul Morris Gallery,
New York

The New Patriots, November 21, 2001
ink and mixed media on paper
11 × 14 in. (28 × 35.6 cm)
Courtesy of Paul Morris Gallery,
New York

People…AIEEE…, November 24, 2001
ink and mixed media on paper
11 × 13 3/4 in. (28 × 35 cm)
Courtesy of Paul Morris Gallery,
New York

It's All Quite Logical, March 29, 2002
ink and mixed media on paper
14 1/2 × 8 1/2 in. (36.8 × 21.6 cm)
Courtesy of Paul Morris Gallery,
New York

R. Crumb and His Little Pal, 2002
ink and mixed media on paper
14 1/2 × 19 3/4 in. (36.8 × 50 cm)
Courtesy of Paul Morris Gallery,
New York

The Way of All Flesh, April 30, 2002
ink and mixed media on paper
12 × 9 3/4 in. (30.5 × 24.8 cm)
Courtesy of Paul Morris Gallery,
New York

Fanny and Joe, 2003
ink and white correction fluid on paper
10 1/2 × 9 3/4 in. (26.7 × 24.8 cm)
Collection of Carnegie Museum of Art;
Milton Fine Fund, 2004.12

Some Heavy Shit, August 23, 2003
ink and mixed media on paper
11 × 10 1/2 in. (28 × 26.7 cm)
Courtesy of Paul Morris Gallery,
New York

Bastardos, February 23, 2004
ink and mixed media on paper
11 × 13 3/4 in. (28 × 35 cm)
Courtesy of Paul Morris Gallery,
New York

Days O My Youth, 2004
ink and mixed media on paper
14 × 11 in. (35.6 × 28 cm)
Collection of the artist

Untitled
(*Carnegie International* poster), 2004
ink and mixed media on paper
15 1/2 × 11 5/8 in. (39 × 30 cm)
Collection of the artist; commissioned
by 2004–5 *Carnegie International*,
Carnegie Museum of Art, Pittsburgh

Jeremy Deller

Chronicles 1:29:15,
Galatians 2:10,
John 1:4:9,
and *Proverbs 11:28*,
2004
plastic shopping bags
edition of 5000
Courtesy of the artist;
Gavin Brown's enterprise, New York;
and The Modern Institute, Glasgow;
an on-going series originally
commissioned for the Frieze Art Fair,
London, 2003, and re-commissioned
by 2004-5 *Carnegie International*,
Carnegie Museum of Art, Pittsburgh

Breaking News (working title), 2004
site-specific 4-channel
video installation
Courtesy of the artist;
Gavin Brown's enterprise, New York;
and The Modern Institute, Glasgow;
commissioned by
2004-5 *Carnegie International*,
Carnegie Museum of Art, Pittsburgh

Philip-Lorca diCorcia

untitled series, 2003–4
10 chromogenic color prints
72 × 48 in. (183 × 122 cm) each
Courtesy of the artist
and Pace MacGill, New York

Peter Doig

Pelican (Stag), 2003
oil on canvas
108 1/2 × 79 in. (275.6 × 200.7 cm)
Courtesy of Michael Werner Gallery,
Cologne/New York

By a River, 2004
oil on canvas
78 3/4 × 73 1/4 in. (200 × 186 cm)
Private collection; courtesy of
Contemporary Fine Arts Berlin

House of Pictures (Carrera), 2004
oil on canvas
78 3/4 × 118 1/2 in. (200 × 301 cm)
Promised gift of Gayle and Paul Stoffel
to the Dallas Museum of Art

Lapeyrouse Wall II, 2004
oil on canvas
78 3/4 × 98 1/2 in. (200 × 250 cm)
Courtesy of Contemporary Fine Arts,
Berlin; Michael Werner Gallery,
Cologne/New York;
Gavin Brown's enterprise, New York;
and Victoria Miro Gallery, London

Metropolitain
(House of Pictures), 2004
oil on canvas
108 1/2 × 78 3/4 in. (275.6 × 200 cm)
Collection of Pinakothek der Moderne,
Munich; acquired by Freunde der
Pinakothek der Moderne (PIN);
courtesy of Contemporary Fine Arts,
Berlin

Purple Jesus (Black Rainbow), 2004
oil on canvas
47 1/2 × 27 1/2 in. (120.7 × 69.9 cm)
Courtesy of Contemporary Fine Arts,
Berlin; Michael Werner Gallery,
Cologne/New York; Gavin Brown's
enterprise, New York; and Victoria
Miro Gallery, London

Red Boat (Imaginary Boys), 2004
oil on canvas
78 3/4 × 73 1/4 in. (200 × 186 cm)
Courtesy of Contemporary Fine Arts,
Berlin; Michael Werner Gallery,
Cologne/New York;
Gavin Brown's enterprise, New York;
and Victoria Miro Gallery, London

Trisha Donnelly

Rio, 1999
single-channel video installation,
projected 5 × 7 in. approx.;
color, sound
6:30 min, looped
Courtesy of the artist
and Casey Kaplan, New York

Dark Wind, 2002
sound installation
Courtesy of the artist
and Casey Kaplan, New York

Night Is Coming, 2002
single-channel video installation,
projected; color
2 min., looped
Courtesy of the artist; Casey Kaplan,
New York; and Air de Paris, Paris

Letter to Tacitus, 2004
performance, ongoing
Courtesy of the artist
and Casey Kaplan, New York;
commissioned by
2004–5 *Carnegie International*,
Carnegie Museum of Art, Pittsburgh

Harun Farocki

Eye/Machine I, 2001
2-channel video installation;
color, sound
25 min.
Courtesy of the artist and
Greene Naftali Gallery, New York

Eye/Machine II, 2002
2-channel video installation;
color, black and white, sound
15 min.
Courtesy of the artist and
Greene Naftali Gallery, New York

Eye/Machine III, 2003
2-channel video installation;
color, sound
18 min.
Courtesy of the artist and Greene
Naftali Gallery, New York;
co-commissioned by Institute of
Contemporary Arts, London, and
2004–5 *Carnegie International*,
Carnegie Museum of Art, Pittsburgh

Saul Fletcher

Untitled #1, 1997
chromogenic color print
5 × 5 in. (12.7 × 12.7 cm)
Courtesy of the artist and
Anton Kern Gallery, New York

Untitled #23, 1997
chromogenic color print
5 × 5 in. (12.7 × 12.7 cm)
Courtesy of the artist and
Anton Kern Gallery, New York

Untitled #74, 1997
chromogenic color print
5 × 5 in. (12.7 × 12.7 cm)
Courtesy of the artist and
Anton Kern Gallery, New York

Untitled #80, 1997
chromogenic color print
3 1/2 × 3 1/2 in. (8.9 × 8.9 cm)
Courtesy of the artist and
Anton Kern Gallery, New York

Untitled #101, 1999
chromogenic color print
3 1/2 × 3 1/2 in. (8.9 × 8.9 cm)
Courtesy of the artist and
Anton Kern Gallery, New York

Untitled #118, 2000
chromogenic color print
5 1/2 × 7 in. (14 × 17.8 cm)
Courtesy of the artist and
Anton Kern Gallery, New York

Untitled #121, 2000
black-and-white Polaroid
3 1/2 × 4 1/2 in. (8.9 × 11.4 cm)
Courtesy of the artist and
Anton Kern Gallery, New York

Untitled #136, 2000
chromogenic color print
3 1/2 × 2 1/2 in. (8.9 × 6.4 cm)
Courtesy of the artist and
Anton Kern Gallery, New York

Untitled #141E, 2000
black-and-white Polaroid
3 1/2 × 4 1/2 in. (8.9 × 11.4 cm)
Courtesy of the artist and
Anton Kern Gallery, New York

Untitled #143D, 2001
black-and-white Polaroid
3 1/2 × 4 1/2 in. (8.9 × 11.4 cm)
Courtesy of the artist and
Anton Kern Gallery, New York

Untitled #155, 2004
chromogenic color print
6 1/4 × 8 in. (15.9 × 20.3 cm)
Courtesy of the artist and
Anton Kern Gallery, New York

Untitled #156, 2004
chromogenic color print
5 1/2 × 4 1/4 in. (14 × 10.8 cm)
Courtesy of the artist and
Anton Kern Gallery, New York

Untitled #157, 2004
chromogenic color print
7 × 5 1/2 in. (17.8 × 14 cm)
Courtesy of the artist and
Anton Kern Gallery, New York

Untitled #158, 2004
chromogenic color print
5 1/2 × 4 1/4 in. (14 × 10.8 cm)
Courtesy of the artist and
Anton Kern Gallery, New York

Untitled #159, 2004
chromogenic color print
5 1/2 × 7 in. (14 × 17.8 cm)
Courtesy of the artist and
Anton Kern Gallery, New York

Untitled #160, 2004
chromogenic color print
7 × 5 1/2 in. (17.8 × 14 cm)
Courtesy of the artist and
Anton Kern Gallery, New York

Untitled #161, 2004
chromogenic color print
5 1/2 × 6 3/4 in. (14 × 17 cm)
Courtesy of the artist and
Anton Kern Gallery, New York

Untitled #162, 2004
chromogenic color print
7 × 5 1/2 in. (17.8 × 14 cm)
Courtesy of the artist and
Anton Kern Gallery, New York

Untitled #163, 2004
chromogenic color print
5 1/2 × 6 3/4 in. (14 × 17 cm)
Courtesy of the artist and
Anton Kern Gallery, New York

Untitled #164, 2004
chromogenic color print
8 × 6 1/2 in. (20.3 × 16.5 cm)
Courtesy of the artist and
Anton Kern Gallery, New York

Untitled #165, 2004
chromogenic color print
7 × 5 1/2 in. (17.8 × 14 cm)
Courtesy of the artist and
Anton Kern Gallery, New York

Untitled #166, 2004
chromogenic color print
5 1/2 × 6 3/4 in. (14 × 17 cm)
Courtesy of the artist and
Anton Kern Gallery, New York

Untitled #167, 2004
chromogenic color print
5 1/2 × 4 1/4 in. (14 × 10.8 cm)
Courtesy of the artist and
Anton Kern Gallery, New York

Untitled #168, 2004
chromogenic color print
5 1/2 × 6 3/4 in. (14 × 17 cm)
Courtesy of the artist and
Anton Kern Gallery, New York

Untitled #169, 2004
chromogenic color print
7 × 5 1/2 in. (17.8 × 14 cm)
Courtesy of the artist and
Anton Kern Gallery, New York

Untitled #170, 2004
chromogenic color print
7 × 5 1/2 in. (17.8 × 14 cm)
Courtesy of the artist and
Anton Kern Gallery, New York

Isa Genzken

Empire/Vampire III, #1, 2004
metal, glass, mirror foil, lacquer,
plastic, fabric, and wood
66 5/16 × 21 7/16 × 29 1/8 in.
(168.4 × 54.5 × 74 cm)
Courtesy of
Galerie Daniel Buchholz, Cologne

Empire/Vampire III, #2, 2004
metal, plastic, straw, pasta,
lacquer, and wood
93 5/16 × 39 5/16 × 27 9/16 in.
(237 × 100 × 70 cm)
Courtesy of
Galerie Daniel Buchholz, Cologne

Empire/Vampire III, #3, 2004
plastic, lacquer, metal, fabric,
kernels, and wood
70 7/8 × 27 9/16 × 17 11/16 in.
(180 × 70 × 45 cm)
Courtesy of
Galerie Daniel Buchholz, Cologne

Empire/Vampire III, #4, 2004
metal, plastic, lacquer, fabric,
photograph, and wood
78 3/4 × 29 1/2 × 34 5/8 in.
(200 × 75 × 88 cm)
Courtesy of
Galerie Daniel Buchholz, Cologne

Empire/Vampire III, #5, 2004
metal, glass, plastic, lacquer, seeds,
shells, and chestnuts
64 9/16 × 23 5/8 × 17 11/16 in.
(164 × 60 × 45 cm)
Courtesy of
Galerie Daniel Buchholz, Cologne

Empire/Vampire III, #6, 2004
metal, glass, lacquer, plastic, seeds,
stones, paper, and wood
65 3/4 × 24 13/16 × 27 9/16 in.
(167 × 63 × 70 cm)
Courtesy of David Zwirner, New York

Empire/Vampire III, #13, 2004
metal, glass, lacquer, plastic,
photographs, mirror foil, and wood
77 15/16 × 33 1/16 × 20 1/16 in.
(198 × 84 × 51 cm)
Courtesy of
neugerriemschneider, Berlin

Empire/Vampire III, #14, 2004
metal, plastic, glass, lacquer,
fabric, pasta, flowers, and wood
68 1/8 × 25 9/16 × 17 11/16 in.
(173 × 65 × 45 cm)
Courtesy of
Galerie Daniel Buchholz, Cologne

Empire/Vampire III #16, 2004
metal, glass, lacquer, plastic,
artificial fur, leather, and wood
65 3/4 × 23 5/8 × 18 1/8 in.
(167 × 60 × 46 cm)
Courtesy of
Galerie Daniel Buchholz, Cologne

Empire/Vampire III, #18, 2004
metal, lacquer, plastic, fabric,
photograph, shells, and wood
78 3/4 × 32 11/16 × 2 11/16 in.
(200 × 83 × 52.6 cm)
Courtesy of
Galerie Daniel Buchholz, Cologne

Empire/Vampire III, #19, 2004
plastic, metal, glass, fabric,
lacquer, paper, and wood
126 × 39 5/16 × 29 1/2 in.
(320 × 99.9 × 75 cm)
Courtesy of
Galerie Daniel Buchholz, Cologne

Empire/Vampire III, #20, 2004
plastic, leather, lacquer,
metal, and wood
67 3/4 × 24 13/16 × 17 3/4 in.
(172 × 63 × 45 cm)
Courtesy of
Galerie Daniel Buchholz, Cologne

Mark Grotjahn

Untitled (Red Orange
Butterfly Green MG03), 2003
oil on linen
51 × 25 in. (129.5 × 63.5 cm)
Courtesy of the artist;
Blum & Poe, Los Angeles;
and Anton Kern Gallery, New York

Untitled
(White Butterfly MPG03), 2003
oil on linen
60 × 50 in. (152.4 × 127 cm)
Courtesy of the artist;
Blum & Poe, Los Angeles;
and Anton Kern Gallery, New York

Untitled (Black Butterfly
Blue Mark Grotjahn 2004), 2004
oil on linen
60 × 50 in. (152.4 × 127 cm)
The Frank Cohen Collection;
courtesy of Anton Kern Gallery,
New York

Untitled (Black Butterfly Filled
In Black Mark Grotjahn 2004), 2004
oil on linen
70 × 35 in. (177.8 × 89 cm)
Courtesy of the artist;
Blum & Poe, Los Angeles;
and Anton Kern Gallery, New York

Untitled (Green Butterfly
Red Mark Grotjahn 04), 2004
oil on linen
60 × 50 in. (152.4 × 127 cm)
Courtesy of the artist;
Blum & Poe, Los Angeles;
and Anton Kern Gallery, New York

Untitled (Lavender Butterfly/
Jacaranda Over Light Green), 2004
oil on linen
67 × 50 in. (170.2 × 127 cm)
Courtesy of the artist;
Blum & Poe, Los Angeles;
and Anton Kern Gallery, New York

Untitled
(Mag Blue Butterfly Over Red), 2004
oil on linen
41 × 35 in. (104 × 89 cm)
Courtesy of the artist;
Blum & Poe, Los Angeles;
and Anton Kern Gallery, New York

Untitled (White Butterfly Filled
In White Mark Grotjahn 04), 2004
oil on linen
84 × 32 in. (213.4 × 81.3 cm)
Courtesy of the artist;
Blum & Poe, Los Angeles;
and Anton Kern Gallery, New York

Untitled (Yellow Butterfly
Orange Mark Grotjahn 2004), 2004
oil on linen
60 × 50 in. (152.4 × 127 cm)
Courtesy of the artist;
Blum & Poe, Los Angeles;
and Anton Kern Gallery, New York

Untitled
(Yellow Butterfly Over Red), 2004
oil on linen
48 × 38 in. (122 × 96.5 cm)
Courtesy of the artist;
Blum & Poe, Los Angeles;
and Anton Kern Gallery, New York

Rachel Harrison

Untitled (Perth Amboy), 2001
chromogenic color print
19 × 13 1/4 in. (48.3 × 33.7 cm)
Courtesy of the artist and
Greene Naftali Gallery, New York

Untitled (Perth Amboy), 2001
chromogenic color print
15 1/4 × 19 1/4 in. (38.7 × 49 cm)
Courtesy of the artist and
Greene Naftali Gallery, New York

Untitled (Perth Amboy), 2001
chromogenic color print
12 1/2 × 19 1/4 in. (31.8 × 49 cm)
Courtesy of the artist and
Greene Naftali Gallery, New York

Untitled (Perth Amboy), 2001
chromogenic color print
13 3/4 × 19 3/4 in. (35 × 50 cm)
Courtesy of the artist and
Greene Naftali Gallery, New York

Untitled (Perth Amboy), 2001
chromogenic color print
13 × 18 3/4 in. (33 × 47.6 cm)
Courtesy of the artist and
Greene Naftali Gallery, New York

Untitled (Perth Amboy), 2001
chromogenic color print
18 1/2 × 14 in. (47 × 35.6 cm)
Courtesy of the artist and
Greene Naftali Gallery, New York

Untitled (Perth Amboy), 2001
chromogenic color print
19 1/4 × 13 1/4 in. (49 × 33.7 cm)
Courtesy of the artist and
Greene Naftali Gallery, New York

Untitled (Perth Amboy), 2001
chromogenic color print
14 1/4 × 20 in. (36.2 × 50.8 cm)
Courtesy of the artist and
Greene Naftali Gallery, New York

Untitled (Perth Amboy), 2001
chromogenic color print; edition of 6
13 1/2 × 19 in. (34.3 × 48.3 cm)
Courtesy of the artist and
Greene Naftali Gallery, New York

Untitled (Perth Amboy), 2001
chromogenic color print
13 3/4 × 19 in. (35 × 48.3 cm)
Courtesy of the artist and
Greene Naftali Gallery, New York

Untitled (Perth Amboy), 2001
chromogenic color print
13 1/4 × 20 in. (33.7 × 50.8 cm)
Courtesy of the artist and
Greene Naftali Gallery, New York

Untitled (Perth Amboy), 2001
chromogenic color print
18 1/2 × 13 1/4 in. (47 × 33.7 cm)
Courtesy of the artist and
Greene Naftali Gallery, New York

Untitled (Perth Amboy), 2001
chromogenic color print
13 1/4 × 18 1/2 in. (33.7 × 47 cm)
Courtesy of the artist and
Greene Naftali Gallery, New York

Untitled (Perth Amboy), 2001
chromogenic color print
14 1/4 × 20 in. (36.2 × 50.8 cm)
Courtesy of the artist and
Greene Naftali Gallery, New York

Untitled (Perth Amboy), 2001
chromogenic color print
20 × 15 1/2 in. (50.8 × 39.4 cm)
Courtesy of the artist and
Greene Naftali Gallery, New York

Untitled (Perth Amboy), 2001
chromogenic color print
14 1/2 × 19 1/2 in. (36.8 × 49.5 cm)
Courtesy of the artist and
Greene Naftali Gallery, New York

Slipknot, 2002
mixed media
54 × 21 1/2 × 36 in.
(137.2 × 54.6 × 91.4 cm)
Collection of Scott J. Lorinsky,
New York

Marathon Station, 2004
mixed media with video
36 × 36 × 74 in. (91.4 × 91.4 × 188 cm)
Courtesy of the artist;
Greene Naftali Gallery, New York;
and Arndt & Partner, Berlin

Note to Self, 2004
mixed media
15 × 18 × 41 in. (38 × 45.7 × 104 cm)
Courtesy of the artist;
Greene Naftali Gallery, New York;
and Arndt & Partner, Berlin

Silent Account, 2004
mixed media
47 × 46 × 69 in.
(119.4 × 116.8 × 175.3 cm)
Courtesy of the artist;
Greene Naftali Gallery, New York;
and Arndt & Partner, Berlin

Slippery Slope, 2004
mixed media
26 × 37 × 12 in. (66 × 94 × 30.5 cm)
Courtesy of the artist;
Greene Naftali Gallery, New York;
and Arndt & Partner, Berlin

Carsten Höller

Solandra Greenhouse, 2004
Solandra maxima (golden chalice vine),
aluminum, acrylic, grow lights, strobe
lights, and steel wire
16 1/2 × 12 × 30 ft.
(502.9 × 365.8 × 914.4 cm)
Courtesy of the artist;
Casey Kaplan, New York;
and Schipper & Krome, Berlin;
commissioned by
2004–5 *Carnegie International*,
Carnegie Museum of Art, Pittsburgh

Katarzyna Kozyra

The Rite of Spring, 1999/2004
6-channel video installation;
color, sound
Collection of Zacheta
National Gallery of Art, Warsaw

*Non so piu cosa son, cosa faccio
(I don't know anymore what I am,
what I'm doing)*, 2004
performance, October 9, 2004
Courtesy of the artist and
Postmasters Gallery, New York;
commissioned by
2004–5 *Carnegie International*,
Carnegie Museum of Art, Pittsburgh

Jim Lambie

Psychedelic Soul Stick, 2001
bamboo, belt, button badge, beads,
cigarette packet, thread, and wire
50 × diam. 2 in. (127 × diam. 5 cm)
Private collection

Bleached Highlights, 2002
mirrors, shoes, and enamel paint
29 1/8 × 118 1/8 × 8 in.
(74 × 300 × 20.3 cm)
Private collection; courtesy of
The Modern Institute, Glasgow;
Sadie Coles HQ, London;
and Anton Kern Gallery, New York

untitled (door), 2004
wood and gloss paint
Courtesy of the artist;
The Modern Institute, Glasgow;
Sadie Coles HQ, London;
and Anton Kern Gallery, New York

untitled group of sculptures, 2004
mixed media
various dimensions
Courtesy of the artist;
The Modern Institute, Glasgow;
Sadie Coles HQ, London;
and Anton Kern Gallery, New York

untitled site-specific installation, 2004
vinyl tape on floor
Courtesy of the artist;
The Modern Institute, Glasgow;
Sadie Coles HQ, London;
and Anton Kern Gallery, New York

Mangelos

Paysage de la guerre, m. 4, 1942–44
tempera on printed paper
9 1/16 × 12 5/8 in. (23 × 32 cm)
Collection of
Mrs. Zdravka Bašičević, Zagreb

Paysage de la mort, m. 4, 1942–44
tempera on paper
7 7/8 × 10 5/8 in. (20 × 27 cm)
Collection of
Mrs. Zdravka Bašičević, Zagreb

*Négation de la peinture
(Der Blue Boy)*, m. 5, 1951–56
tempera on printed paper
9 1/2 × 6 1/8 in. (24 × 15.6 cm)
Collection of
Mrs. Zdravka Bašičević, Zagreb

Tabula Rasa, 1–12, m. 5, 1951–56
tempera on cardboard and board;
12 elements
6 elements: 7 7/16 × 5 5/8 in.
(18.9 × 14.3 cm) each
6 elements: 5 5/8 × 7 7/16 in.
(14.3 × 18.9 cm) each
Collection of
Mrs. Zdravka Bašičević, Zagreb

Tabula rasa, 5, 1951–56
tempera on cardboard
8 1/2 × 11 in. (21.6 × 28 cm)
Collection of
Mrs. Zdravka Bašičević, Zagreb

Alfabet (gl.) (Alphabet [gl.]), 1952
tempera on printed paper,
staple-bound in cardboard cover;
24 sheets
8 9/16 × 6 in. (21.8 × 15.2 cm) each
Collection of
Mrs. Zdravka Bašičević, Zagreb

Homage à Pythagora, 1953
oil and tempera on cardboard
11 × 9 5/8 in. (28 × 24.5 cm)
Collection of
Mrs. Zdravka Bašičević, Zagreb

Pythagora 2, 1953
tempera and oil on printed paper,
perfect-bound in cloth-covered
cardboard; 27 sheets
6 5/16 × 4 3/4 in. (16 × 12 cm) each
Collection of
Mrs. Zdravka Bašičević, Zagreb

Documents d'un expériment, 1954
tempera on paper,
staple-bound in paper; 10 sheets
4 7/8 × 6 5/8 in. (12.4 × 16.8 cm) each
Collection of
Mrs. Zdravka Bašičević, Zagreb

Les paysages des mots, 1957
tempera on printed paper,
staple-bound in cardboard; 75 sheets
6 3/16 × 4 7/16 in. (15.7 × 11.3 cm) each
Collection of
Mrs. Zdravka Bašičević, Zagreb

Non Credo, m. 6, 1957–63
tempera on cardboard
18 1/8 × 26 5/8 in. (46 × 67.6 cm)
Collection of
Mrs. Zdravka Bašičević, Zagreb

Théorie des conventions, m.6, 1957–63
oil on wooden board
14 15/16 × 29 1/2 in. (38 × 75 cm)
Collection of
Mrs. Zdravka Bašičević, Zagreb

Gottschalksbuch, ca.1961–63
tempera on printed paper, bound in
cloth-covered cardboard; 30 sheets
11 7/8 × 9 1/16 in. (30 × 23 cm) each
Collection of
Mrs. Zdravka Bašičević, Zagreb

Les exercices, begun in 1961
tempera on printed paper,
bound in cardboard; 39 sheets
8 3/16 × 7 7/8 in. (20.8 × 20 cm) each
Collection of
Mrs. Branka Stipančić, Zagreb

Am Beginn war es kein Wort,
ca. 1963–70
tempera on gold leaf over cardboard
19 1/8 × 22 3/16 in. (48.6 × 56.4 cm)
Collection of Fundação de Serralves,
Museu de Arte Contemporânea,
Porto, Portugal

Nema dve logike Hegel misli isto
kao i njegov šuster (There are no two
logics, Hegel thinks the same as
his shoemaker) m.7, 1964–70
tempera on cardboard
23 9/16 × 15 3/4 in. (59.9 × 40 cm)
Collection of Mrs. Zdravka Bašičević,
Zagreb, and Peter Freeman, Inc.,
New York

Jahrensbuch, begun in 1970
tempera on printed paper,
perfect-bound in plastic-covered
cardboard; 76 sheets
11 1/4 × 8 1/4 in. (28.6 × 21 cm) each
Collection of
Mrs. Zdravka Bašičević, Zagreb

Civilisation no. 2, m. 8, 1971–77
tempera on printed paper,
bound in paper; 11 sheets
8 1/2 × 4 3/16 in. (21.6 × 10.6 cm) each
Collection of
Mrs. Zdravka Bašičević, Zagreb

Manifest Hamurabi
(Manifesto Hammurabi), m.8, 1971–77
(a.d. in andu u tonia)
acrylic on wood panel
24 1/8 × 17 5/16 in. (61.3 × 44 cm)
Collection of
Mrs. Zdravka Bašičević, Zagreb

Portrait of mangelos, m.8, 1971–77
oil on canvas
12 13/16 × 9 1/4 in. (32.5 × 23.5 cm)
Collection of
Mrs. Zdravka Bašičević, Zagreb

Relations manifesto, m.4 – m.8,
1971–77
oil on globe made from
plastic and metal
14 15/16 × diam.10 1/4 in.
(38 × diam.26 cm)
Collection Musée national d'art moderne,
Centre Georges Pompidou/
Centre de création industrielle, Paris

Rimbaud no. 2 (1874–1891),
m.8, 1971–77
acrylic on globe made from
wood, paper, and metal
11 7/16 × diam. 8 11/16 in.
(29 × diam. 22 cm)
Collection of
Mrs. Zdravka Bašičević, Zagreb

Tezo o filozofiji
(Theses on philosophy), 1972
tempera on printed paper,
perfect-bound in leather-covered
cardboard; 29 sheets
6 1/2 × 4 5/8 in. (16.5 × 11.8 cm) each
Collection of
Mrs. Zdravka Bašičević, Zagreb

Verzeichnis, 1976
tempera on printed paper and
imitation leather cover; 11 sheets
5 5/8 × 4 11/16 in. (14.3 × 12 cm) each
Collection of
Mrs. Zdravka Bašičević, Zagreb

Energija (Energy)
(in Greek alphabet), 1977
acrylic on board
19 5/8 × 29 1/2 × 2 1/2 in.
(49.9 × 75 × 6.4 cm)
Collection of
Mrs. Zdravka Bašičević, Zagreb

Manifest o ćulu orijentacije no.3
(Manifesto on sense of
orientation no.3), 1977
tempera on newspaper
16 15/16 × 22 5/8 in. (43 × 57.5 cm)
Collection of Musée national d'art
moderne, Centre Georges Pompidou/
Centre de création industrielle, Paris

Energija (Energy), ca.1977–78
gold leaf and acrylic on globe
made from plastic and metal
13 × diam. 10 1/4 in. (33 × diam. 26 cm)
Collection of
Mrs. Zdravka Bašičević, Zagreb

Hegel Globus
(Hegel Globe), ca. 1977–78
silver leaf and acrylic on globe
made from plastic and metal
14 15/16 × diam. 10 1/4 in.
(38 × diam. 26 cm)
Collection of
Mrs. Zdravka Bašičević, Zagreb

Hegel kritik der logik, ca.1977–78
gold paint and acrylic on globe
made from plastic and metal
14 15/16 × diam.10 1/4 in.
(38 × diam. 26 cm)
Collection of
Mrs. Zdravka Bašičević, Zagreb,
and Peter Freeman, Inc., New York

Intuicija je stvar instinkta (Intuition is
a matter of instinct), ca. 1977–78
tempera and gold paint on cardboard
26 1/8 × 17 11/16 in. (66.4 × 45 cm)
Collection of
Mrs. Zdravka Bašičević, Zagreb,
and Peter Freeman, Inc., New York

Krleža no.1, ca. 1977–78
acrylic on globe made from
plastic and metal
11 7/16 × diam.10 1/4 in.
(29 × diam. 26 cm)
Collection of
Mrs. Zdravka Bašičević, Zagreb

Le manifest de la civilisation no. 2,
ca.1977–78
acrylic on globe made from wood,
metal, and paper
18 1/8 × diam. 14 3/16 in.
(46 × diam. 36 cm)
Collection of
Mrs. Zdravka Bašičević, Zagreb,
and Peter Freeman, Inc., New York

Le manifeste sur la machine,
ca.1977–78
acrylic and plastic letters on globe
made from wood, metal, and paper
18 1/8 × diam. 14 3/16 in.
(46 × diam.36 cm)
Collection of
Mrs. Zdravka Bašičević, Zagreb

Le manifest sur la machine no. 3,
ca.1977–78
acrylic on wood panel
24 1/8 × 17 5/16 in. (61.3 × 44 cm)
Collection of
Mrs. Zdravka Bašičević, Zagreb

Le travail mécanique – le penser
fonctionnel, ca.1977–78
gold leaf on globe made from
wood, metal, and printed paper
18 1/8 × diam.14 3/16 in.
(46 × diam.36 cm)
Collection of Muzej
suvremene umjetnosti, Zagreb

Manifest de la relation, mngls
no. 3 – no. 8, ca.1977–78
acrylic and grafitto on globe made
from plastic and metal
14 15/16 × diam. 10 1/4 in.
(38 × diam. 26 cm)
Collection of
Mrs. Zdravka Bašičević, Zagreb

Manifest diguraški / Jighora Manifesto,
ca.1977–78
acrylic and gold leaf on globe made
from plastic and metal
14 15/16 × diam. 10 1/4 in.
(38 × diam. 26 cm)
Collection of
Mrs. Zdravka Bašičević, Zagreb

Manifest o Alfi (Manifesto on Alfa),
ca.1977–78
acrylic on wood panel
43 5/16 × 29 1/2 in. (110 × 75 cm)
Collection of
Mrs. Zdravka Bašičević, Zagreb

Manifest o fotografiji no.4
(Manifesto on photography no. 4),
ca.1977–78
acrylic on wood panel
24 3/16 × 17 5/16 in. (61.4 × 44 cm)
Collection of
Mrs. Zdravka Bašičević, Zagreb

Manifest o mišljenju no.1
(Manifesto on thinking no.1),
ca.1977–78
acrylic on wood panel
17 3/8 × 13 3/4 in. (44 × 35 cm)
Collection of
Mrs. Zdravka Bašičević, Zagreb

Manifest vlaškovuličanski
(Manifesto of Vlaška Street),
ca.1977–78
acrylic on globe made
of plastic and metal
14 15/16 × diam. 10 4/16 in.
(38 × diam. 26 cm)
ARTEAST COLLECTION 2000+,
Moderna Galerija, Ljubljana

A-Bombe manifest
(A-Bomb manifesto), 1978
tempera on printed paper
10 7/8 × 8 3/8 in. (27.6 × 21.3 cm)
Collection of
Mrs. Zdravka Bašičević, Zagreb

Dilema-manifest
(Dilemma-manifesto), 1978
tempera on printed paper
10 7/8 × 16 3/4 in. (27.6 × 42.6 cm)
Collection of
Mrs. Zdravka Bašičević, Zagreb

Energija (Energy), 1978
tempera and oil on globe made
of wood, metal, and printed paper
17 3/8 × diam. 14 3/16 in.
(44 × diam. 36 cm)
Collection of Mario Bruketa,
San Francisco

Energija (Energy)
(in Glagolitic alphabet), 1978
acrylic and oil on globe made of
wood, metal, and printed paper
18 1/8 × diam. 14 3/16 in.
(46 × diam. 36 cm)
Collection of Peter Freeman, Inc.,
New York

Manifesti (Manifestos), 1978
silkscreen on paper,
staple-bound in cardboard; 52 pages
8 1/16 × 5 7/8 in. (20.5 × 15 cm) each
Collection of
Mrs. Zdravka Bašičević, Zagreb

Shid-theory (no art), 1978
silkscreen on paper; 4 sheets
13 3/4 × 9 13/16 in. (35 × 25 cm) each
Collection of
Mrs. Zdravka Bašičević, Zagreb

Noart, 1981
chalk on school slate
8 3/8 × 11 1/16 in. (21.3 × 28 cm)
Collection of
Mrs. Zdravka Bašičević, Zagreb

Mane tekel fares, 1987
acrylic and tempera on globe made
from wood, metal, paper, and plastic
22 13/16 × diam. 13 3/4 in.
(58 × diam. 35 cm)
Collection of
Dr. Ljubomir Radovančević, Zagreb

Kitschmanifestidee, a.d. 2381 (?)
tempera on tin foil
12 × 8 11/16 in. (30.5 × 22 cm)
Collection of
Mrs. Zdravka Bašičević, Zagreb

Manifesto on the machine no. 2,
ca. 1977–78
acrylic and gold leaf on globe
made from plastic and metal
15 × 10 1/4 in. (38 × 26 cm)
Collection of
Mrs. Zdravka Bašičević, Zagreb,
and Peter Freeman, Inc., New York

Numberconcept Pitagoras,
ca. 1977–78
plastic letters and acrylic on globe
made from wood, metal, and paper
18 1/8 × diam. 14 3/16 in.
(46 × diam. 36 cm)
Collection of
Mrs. Zdravka Bašičević, Zagreb

Rimbaud no.1 (1854–1874),
ca. 1977–78
acrylic on globe made from
wood, metal, and paper
11 7/16 × diam. 8 11/16 in.
(29 × diam. 22 cm)
Collection of Mladen Stilinović, Zagreb

Skica za manifest o kiču
(A sketch for the kitsch manifesto),
ca. 1977–78
gold leaf and acrylic on globe
made from plastic and metal
14 15/16 × diam. 10 1/4 in.
(38 × diam. 26 cm)
Collection of
Mrs. Zdravka Bašičević, Zagreb

Viši svet logički je nemoguć
(A world on a higher level is logically
impossible), ca. 1977–78
tempera and gold paint on cardboard
17 × 26 1/4 in. (43.2 × 66.7 cm)
Collection of
Mrs. Zdravka Bašičević, Zagreb

Julie Mehretu

Untitled (Stadia I), 2004
ink and acrylic on canvas
144 × 108 in. (365.8 × 274.3 cm)
Courtesy of the artist and
The Project, New York/Los Angeles

Untitled (Stadia II), 2004
ink and acrylic on canvas
144 × 108 in. (365.8 × 274.3 cm)
Courtesy of the artist and
The Project, New York/Los Angeles

Untitled (Stadia III), 2004
ink and acrylic on canvas
144 × 108 in. (365.8 × 274.3 cm)
Courtesy of the artist and
The Project, New York/Los Angeles

Untitled (Stadia excerpt), 2004
ink and acrylic on canvas
36 1/4 × 37 1/8 in. (92 × 94.3 cm)
Courtesy of the artist and
The Project, New York/Los Angeles

Untitled (Stadia excerpt), 2004
ink and acrylic on canvas
36 1/4 × 47 1/8 in. (92 × 119.7 cm)
Courtesy of the artist and
The Project, New York/Los Angeles

Untitled (Stadia/Expo), 2004
ink and acrylic on canvas
120 × 264 in. (304.8 × 670.6 cm)
Courtesy of the artist and
The Project, New York/Los Angeles

Senga Nengudi

R.S.V.P., 1975–77
nylon mesh and sand
96 × 12 in. (243.8 × 30.5 cm)
Courtesy of the artist and
Thomas Erben Gallery, New York

R.S.V.P. VI, 1976
nylon mesh and sand
32 × 12 × 18 in. (81.3 × 30.5 × 45.7 cm)
Courtesy of the artist and
Thomas Erben Gallery, New York

Inside/Outside, 1977
nylon mesh, rubber, and foam
60 × 24 in. (152.4 × 61 cm)
Collection of Burt Aaron,
Detroit, Michigan; courtesy of
Thomas Erben Gallery, New York

R.S.V.P. No.1, 1977
nylon mesh and sand
installation dimensions variable
Courtesy of the artist and
Thomas Erben Gallery, New York

R.S.V.P. XI, 1977
nylon mesh, rubber, and sand
90 × 24 in. (228.6 × 61 cm)
Courtesy of the artist and
Thomas Erben Gallery, New York

R.S.V.P. XII, 1977
nylon mesh and sand
48 × 60 in. (122 × 152.4 cm)
Courtesy of the artist and
Thomas Erben Gallery, New York

Sand Mind (working title), 2004
site-specific installation
of sand and earth
29 × 13 ft. (883.9 × 396.2 cm)
Courtesy of the artist and
Thomas Erben Gallery, New York;
commissioned by
2004–5 *Carnegie International*,
Carnegie Museum of Art, Pittsburgh

untitled site-specific installation, 2004
mixed media
180 × 60 × 10 in.
(457.2 × 152.4 × 25.4 cm)
Courtesy of the artist and
Thomas Erben Gallery, New York;
commissioned by
2004–5 *Carnegie International*,
Carnegie Museum of Art, Pittsburgh

Oliver Payne
and Nick Relph

Driftwood, 1999
single-channel video; color, sound
25 min.
Courtesy of the artists and
Gavin Brown's enterprise, New York.

Comma, Pregnant Pause, 2004
single-channel video; color, sound
30 min. approx.
Courtesy of the artists and
Gavin Brown's enterprise, New York;
commissioned by
2004–5 *Carnegie International*,
Carnegie Museum of Art, Pittsburgh

Araya
Rasdjarmrearnsook

Reading Inaow for Female Corpse, 2001
single-channel video; color, sound
5:54 min.
Courtesy of the artist

Neo Rauch

Waldmann, 2003
oil on canvas
63 × 118 1/8 in. (160 × 300 cm)
Collection of Rudolf Scharpff, Stuttgart;
courtesy of Galerie EIGEN + ART,
Leipzig / Berlin

Brandung, 2004
oil on canvas
82 11/16 × 106 5/16 in. (210 × 270 cm)
Courtesy of Galerie EIGEN + ART,
Leipzig / Berlin, and David Zwirner,
New York

Grotte, 2004
oil on canvas
98 7/16 × 82 11/16 in. (250 × 210 cm)
Courtesy of Galerie EIGEN + ART,
Leipzig / Berlin, and David Zwirner,
New York

Quecksilber, 2004
oil on canvas
19 11/16 × 15 3/4 in. (50 × 40 cm)
Private collection, Berlin;
courtesy of Galerie EIGEN + ART,
Leipzig / Berlin

Sekte, 2004
oil on canvas
98 7/16 × 82 11/16 in. (250 × 210 cm)
Courtesy of Galerie EIGEN + ART,
Leipzig / Berlin, and David Zwirner,
New York

Zoll, 2004
oil on canvas
82 11/16 × 157 1/2 in. (210 × 400 cm)
Courtesy of Galerie EIGEN + ART,
Leipzig / Berlin, and David Zwirner,
New York

Ugo Rondinone

Roundelay, 2003
6-channel video installation projected
on six walls that form a hexagon;
color, sound
8:54 min., looped
Courtesy of the artist;
Eva Presenhuber, Zurich;
and Matthew Marks Gallery, New York

Everyone Gets Lighter, 2004
aluminum, acrylic, glass, and neon
15 × 31 × 10 ft.
(457.2 × 944.9 × 304.8 cm)
Courtesy of the artist;
Eva Presenhuber, Zurich;
and Matthew Marks Gallery, New York

Eva Rothschild

2ndprize, 2004
vinyl curtain
204 3/4 × 118 1/8 in. (520 × 300 cm)
Courtesy of the artist;
The Modern Institute, Glasgow;
and Modern Art, London

Blackdog, 2004
wood and lacquer
70 7/8 × 35 7/16 × 19 11/16 in.
(180 × 90 × 50 cm)
Courtesy of the artist;
The Modern Institute, Glasgow;
and Modern Art, London

Disappearer, 2004
incense sticks
installation dimensions variable
Courtesy of the artist;
The Modern Institute, Glasgow;
and Modern Art, London

High Life, 2004
leather and steel support
118 1/8 × 19 11/16 × 19 11/16 in.
(300 × 50 × 50 cm)
Courtesy of the artist;
The Modern Institute, Glasgow;
and Modern Art, London

Stalker, 2004
leather, wood, and lacquer
78 3/4 × 70 3/4 × 39 3/8 in.
(200 × 179.7 × 100 cm)
Courtesy of the artist;
The Modern Institute, Glasgow;
and Modern Art, London

Valley of the Kings, 2004
wood, leather, and lacquer
110 1/4 × 78 3/4 × 63 in.
(280 × 200 × 160 cm)
Courtesy of the artist;
The Modern Institute, Glasgow;
and Modern Art, London

Yang Fudong

*Seven Intellectuals in Bamboo Forest,
Part 1*, 2003
35mm film transferred to DVD;
black and white, sound
29 min.
Courtesy of the artist
and Shangart Gallery, Shanghai

*Seven Intellectuals in Bamboo Forest,
Part 2*, 2004
35mm film transferred to DVD;
black and white, sound
30 min. approx.
Courtesy of the artist
and Shangart Gallery, Shanghai

Contributors

Curator of the 2004–5 *Carnegie International*, Laura Hoptman was appointed curator of contemporary art at Carnegie Museum of Art in 2001. She had previously served as assistant curator in the Department of Drawings at the Museum of Modern Art, New York, from 1995 to 2001; guest curator at the Museum of Contemporary Art, Chicago, from 1993 to 1995; and curator of the Bronx Museum of the Arts, New York, from 1987 to 1990.

Hoptman has organized numerous exhibitions on contemporary art, including the reinstallation of the permanent collection (2003) and *Hello, My Name Is...* (co-organized with Elizabeth Thomas), both at Carnegie Museum of Art, Pittsburgh (2003), and *Drawing Now: Eight Propositions*, Museum of Modern Art, Queens (2002). At MoMA, Hoptman was co-curator of *Love Forever: Yayoi Kusama, 1958–1968* (1998), and curator of, among others, *Project #60: John Currin, Elizabeth Peyton, Luc Tuymans* (1997); both exhibitions were cited as one of the ten best exhibitions of the year by *Artforum*.

Among Hoptman's recent publications are *Drawing Now: Eight Propositions* (Museum of Modern Art, 2002) and *Yayoi Kusama* (Phaidon Press, 2000). She was also the co-editor of *Primary Documents: A Sourcebook for East and Central European Art since the 1950s*, jointly published in 2003 by the Museum of Modern Art and MIT Press. Her articles have appeared in *Parkett, Flash Art, Harper's Bazaar,* and other periodicals.

As assistant curator of contemporary art at Carnegie Museum of Art, Elizabeth Thomas has assisted in all aspects of the 2004–5 *Carnegie International*. She has also been involved with the reinstallation of the museum's permanent collection and has been the organizing curator for a series of project exhibitions, including commissioned works with Diane Samuels, Jesse Bransford, and Christian Jankowski. Prior to this appointment, Thomas was a curatorial fellow at the Walker Art Center, Minneapolis, where she worked on exhibitions and catalogues, including *Painting at the Edge of the World* (2001) and *The Home Show* (2000).

Thomas was a contributing writer to *An International Legacy: Selections from Carnegie Museum of Art* (American Federation of Arts, 2003), and she has written texts on contemporary art, culture, and design for numerous publications, including *TEN by TEN* magazine, *Scream: 10 Artists × 10 Writers × 10 Scary Movies*, and the forthcoming Walker Art Center collection catalogue.

Over the last decade, Francesco Bonami, the Manilow Senior Curator at the Museum of Contemporary Art, Chicago, has served as curator for many international exhibitions in Europe and the United States (with accompanying catalogues), including the 2003 Venice Biennale; *Manifesta 3*, European Biennial of Contemporary Art, Ljubljana, Slovenia (2001); *Examining Pictures*, Museum of Contemporary Art, Chicago, Whitechapel Art Gallery, London, and UCLA Hammer Museum, Los Angeles (1999); *Unfinished History*, Walker Art Center (1998–99); and *TRUCE: Echoes of Art in an Age of Endless Conclusions*, Second Site Santa Fe Biennale (1997). He is currently at work on *Universal Experience: Art, Life and the Tourist's Eye*, Museum of Contemporary Art, Chicago (2005).

Bonami is a widely published author of books, catalogue essays, articles, and reviews. His recent publications include *The Fourth Sex: Adolescent Extremes* (Charta, 2003) and the monograph *Maurizio Cattelan* (Phaidon Press, 1999).

Gary Garrels has been chief curator in the Department of Drawings at the Museum of Modern Art in New York since 2001. Prior to this appointment, he was the Elise S. Haas Chief Curator and curator of painting and sculpture at the San Francisco Museum of Modern Art. He has also served on the curatorial staffs of the Walker Art Center, Minneapolis; Dia Center for the Arts, New York; and the Massachusetts Institute of Technology's Hayden Gallery, Cambridge. An organizer of numerous exhibitions featuring contemporary artists from around the world, Garrels' recent exhibitions include retrospectives of the conceptual artist Sol LeWitt (2000) and the Swiss multimedia artist Dieter Roth (2004).

He is the author of *Sol LeWitt: A Retrospective* (Yale University Press, 2000) and, with Robert Storr, *Willem de Kooning: The Late Paintings, The 1980s* (San Francisco Museum of Modern Art and Walker Art Center, 1995).

Sarah Hromack joined the staff of Carnegie Museum of Art's contemporary art department in 2002, after graduating from the Maryland Institute College of Art, Baltimore. Prior to this appointment, she had been a researcher in the contemporary art department at the Baltimore Museum of Art, where she worked on Helen Molesworth's *Work Ethic* exhibition.

Midori Matsui is a Tokyo-based art critic and scholar. She has written extensively on Japanese and Western art and culture, and she teaches at Tama and Musashino Art universities. Her critical perspective combines a strong regional focus with an international outlook and reputation.

Matsui writes for a wide variety of periodicals and is the author of *Art in a New World: Post-Modern Art in Perspective* (Asahi Press, 2000). She was a contributing author to *Wolfgang Tillmans* (Phaidon Press, 2002), *Painting at the Edge of the World* (Walker Art Center, 2001), *Public Offerings* (Thames & Hudson, 2001), and *Takashi Murakami: The Meaning of the Nonsense of the Meaning* (Abrams, 2000). Matsui is currently writing a book about contemporary Japanese art in its cultural context.

An independent art critic, curator, and historian, Cuauhtémoc Medina teaches at the National University of Mexico, where he is a researcher at the Instituto de Investigaciones Estéticas. He is a member of Teratoma, a group of curators, critics, and anthropologists based in Mexico City, and is a visiting professor at Bard College's Center for Curatorial Studies. In 2002 Medina was appointed associate curator of Latin American art at Tate Modern, London, following his tenure as curator of contemporary art at the Museo Carrillo Gil in Mexico City.

He is the author of *Graciela Iturbide* (Phaidon Press, 2001) and has written numerous articles for scholarly and popular periodicals, including *Flash Art* and *Third Text*. He is a regular contributor to Mexico City's *Reforma* newspaper.

Jean-Pierre Mercier is a librarian, comics publisher, and professional journalist living in Paris. In 1992 and 2000, he was the organizing curator for exhibitions of Robert Crumb's work at the Musée des Bandes Dessinées in Angoulême, France, where he is also the scientific advisor.

Mercier is the editor and translator of the French edition of Crumb's work, and he regularly publishes reprints of French classic comics. He has written numerous articles on French and American comics, and offers classes on comics to librarians, teachers, and professors.

Elizabeth A. T. Smith is the James W. Alsdorf Chief Curator at the Museum of Contemporary Art in Chicago. Her recent MCA exhibitions and publications include *Lee Bontecou: A Retrospective* (2003, with Ann Philbin); *Donald Moffett: What Barbara Jordan Wore* (2002); and *Matta in America: Paintings and Drawings of the 1940s* (2001). Formerly a curator at the Museum of Contemporary Art, Los Angeles, Smith has organized numerous exhibitions there, including *The Architecture of R. M. Schindler* (2001); *At the End of the Century: One Hundred Years of Architecture* (1998); *Cindy Sherman: Retrospective* (1997); *Urban Revisions: Current Projects for the Public Realm* (1994); and *Blueprints for Modern Living: History and Legacy of the Case Study Houses* (1989).

Smith is the co-editor of *Lee Bontecou: A Retrospective* (Abrams, 2003) and author of *Case Study Houses: The Complete CSH Program* (Taschen, 2002) and *Techno Architecture* (Thames & Hudson, 2000).

Branka Stipančić is an art critic and independent curator based in Zagreb, Croatia. In 2003, she was the organizing curator for a retrospective exhibition on Mangelos at the Fundaçâo de Serralves, Museu de Arte Contemporânea, Porto, traveling in 2004 to Neue Galerie, Graz, Fundació Antoni Tàpies, Barcelona, and Kunsthalle Fridericianum, Kassel. Recently, Stipančić was co-curator of *The Baltic Times*, Museum of Contemporary Art, Zagreb (2001); *Chinese Whispers*, apexart, New York (2000); *Aspects/ Positions*, Museum moderner Kunst Stiftung Ludwig, Vienna (1999); and *The Future Is Now*, Museum of Contemporary Art, Zagreb (1999).

She was curator at the Museum of Contemporary, Zagreb, from 1983 to 1993, and also served as director of Soros Center for Contemporary Art from 1993 to 1996. She is the author of *Mangelos nos. 1 to 9 1/2* (Fundaçâo de Serralves, Museu de Arte Contemporânea, Porto, 2003) and *Connections— Contemporary Artists from Australia* (HDLU, Zagreb, 2002).

Rirkrit Tiravanija was born in Buenos Aires, studied in Canada and the United States, and now lives and works in Bangkok, Berlin, and New York, where he teaches at Columbia University. An artist best known for installations that invite the public to interact socially in museum or gallery environments, Tiravanija has exhibited his work at the Venice Biennale (1999), the Berlin Biennial for Contemporary Art (1998), Site Santa Fe (1997), Museum of Modern Art, New York (1997), the Kunstverein in Hamburg, Germany (1996), and the 1995 *Carnegie International*, to name but a few from an extensive list of invitational, group, and one-person shows in Asia, Europe, and North America. Tiravanija's work is represented in the permanent collection of Carnegie Museum of Art, Pittsburgh.

Photo Credits

Per-Erik Adamsson, 51–53

Branko Balić, 178 FIG.3

Will Brown, 80

A. Burger, 213–215

Boris Cvjetanović, 175, 177 FIGS.1 AND 2, 179 FIG.4, 180 FIG.6, 182–183 FIGS.7 AND 9, 184

D. James Dee, 91–93

Marc Domage, 83–85

Martin Jenkinson, 128–129

Knut Klaßen, 67–69

Jochen Littkemann, 135–137

A. Maranzano, 95

Paolo Pellion, 96

Michal Raz-Russo, 74 FIG.6

Stefan Maria Rother, 189–191

Howard Sheronas, 163–164

©Solo Syndication, 97

Mladen Stilinović, 180 FIG. 5

Richard A. Stoner, 107, 109–110 FIGS.1 AND 2, 113–115 FIGS.3, 4, AND 5, 117–118 FIGS.6 AND 7, 120–121 FIG. 8, 122, 124–125, 127, 140, 165 bottom

Uwe Walter, 205–207

Joshua White, 155–157

Carnegie Museum of Art Staff

Richard Armstrong, *The Henry J. Heinz II Director*
Maureen Rolla, *Assistant Director*

Curators of Art and Architecture
Laura Hoptman, *Curator, Contemporary Art*
Elizabeth Thomas, *Assistant Curator, Contemporary Art*
Sarah Nichols, *Chief Curator and Curator of Decorative Arts*
Elisabeth Agro, *Assistant Curator, Decorative Arts*
Louise Lippincott, *Curator, Fine Arts*
Linda Batis, *Associate Curator, Fine Arts*
Tracy Myers, *Curator, Heinz Architectural Center*
Raymund Ryan, *Curator, Heinz Architectural Center*

Administration
Meg Bernard, *Director of Development*
William Devlin, *Information Systems Manager*
Champ Knecht, *Financial and Administrative Manager*
Lynn Corbett, *Executive Secretary to the Director*
Sarah Hromack, *Departmental Assistant*
Amber Morgan, *Departmental Assistant*
Divya Rao, *Departmental Assistant*
Julia Wozniak, *Development and Administrative Assistant*

Conservation
Ellen J. Baxter, *Chief Conservator and Paintings Conservator*
Rhonda Wozniak, *Objects Conservator*
Diane Schwabe, *Secretary*

Education
Marilyn Russell, *Curator and Chair*
Patricia Jaconetta, *Assistant Curator*
Emily Gaines Buchler, *Education Specialist, School and Teacher Programs*
Nikki Faychak Kalcevic, *Program Specialist, Children's Classes*
Deborah Starling Pollard, *Community Liaison Specialist*
Madelyn Roehrig, *Program Specialist, Adult Classes*
Lucy Stewart, *Education Specialist, Public Programs*
Mary Ann Perkins, *Education Associate, Adult and School Group Tours*
Darnell Warren, *Program Associate, Children's Classes*

Group Visits and Program Registration
Erik Schuckers, *Group Visits Coordinator*
Robert Luka, *Education Assistant*
Judy Reese, *Education Assistant*

Carnegie Institute Trustees